Performing Vulnerability

Emily L. Hue

PERFORMING VULNERABILITY

Risking Art
and Life in
the Burmese
Diaspora

University of
Washington Press
Seattle

Copyright © 2025 by the University of Washington Press

Design by Mindy Basinger Hill

Composed in Minion Pro, Safiron, and Helvetica Light

All rights reserved. No part of this publication may be reproduced or transmitted in any form or by any means, electronic or mechanical, including photocopy, recording, or any information storage or retrieval system, without permission in writing from the publisher.

UNIVERSITY OF WASHINGTON PRESS uwapress.uw.edu

LIBRARY OF CONGRESS CATALOGING-IN-PUBLICATION DATA
Names: Hue, Emily L., author.
Title: Performing vulnerability : risking art and life in the Burmese diaspora / Emily L. Hue.
Description: Seattle : University of Washington Press, [2025] | Includes bibliographical references and index.
Identifiers: LCCN 2024059300 | ISBN 9780295753607 (hardcover) | ISBN 9780295753614 (paperback) | ISBN 9780295753621 (ebook)
Subjects: LCSH: Human rights in art. | Refugees as artists—New York (State)—New York. | Expatriate artists—New York (State)—New York. | Artists—Burma. | Performance art—Political aspects—New York (State)—New York. | Art, Burmese—Themes, motives—21st century. | Human rights advocacy—Political aspects. | Politics in art.
Classification: LCC NX650.H78 H84 2025 | DDC 701/.04581—dc23/eng/20250127
LC record available at https://lccn.loc.gov/2024059300

∞ This paper meets the requirements of ANSI/NISO Z39.48-1992 (Permanence of Paper).

To Burma's artists
and activists.
To my family.

Contents

ix	Acknowledgments
1	Introduction
52	Chapter One. The Humanitarian Industry: The Rise and Fall of Human Rights Heroine Aung San Suu Kyi
97	Chapter Two. Diversity and Refuge in the Museum: The Guggenheim's *No Country*
144	Chapter Three. Freedom of Expression, Asylum, and Elastic Vulnerability: The Art of Chaw Ei Thein
188	Chapter Four. Htein Lin: Unraveling the Dissident Body and Buddhist Transcendence
229	Epilogue
235	Notes
273	Bibliography
295	Index

Acknowledgments

The pages that follow are blueprints for possibilities, ones that would be impossible without collective efforts. My deepest gratitude for the beautiful, brazen, and imaginative work of artists Chaw Ei Thein, Htein Lin, Wah Nu, Tun Win Aung, and Sopheap Pich, whose work is the beating heart of this project. Thank you in particular to Ma Chaw Ei and Ko Tin, for opening their Elmhurst home and sharing their work and stories with me; especially to Ma Chaw Ei for supporting this project from beginning to end.

I have been an uninvited settler on the traditional, current, and future lands and unceded territories of the Lenape and Canarsie peoples in New York and the Cahuilla, Luiseño, Serrano, and Tongva peoples in Riverside, California. I am grateful and indebted to these peoples and their lands, especially from which to write and create. To be in good relation with different spaces that I have called "home" has been tantamount in this project. My own Shan and Chinese ancestors' experiences of contested borders and movement across their homelands of Namtu, Lashio, Maymyo, and Yangon in Burma/Myanmar and Guangdong, China, also sit at the forefront of my mind as this book comes to light.

I thank my family, especially my parents, Yuan Kyi "Margaret" Lee/ Daw Thein Kyi and Hone Ngoon "Henry" Hue/U Aung Ngwe, for their unfaltering love and support and from whom I received a first grasp of what community means. Thank you to the Hues, the Lees, the Hsus, the Miyakes, and the Takemotos, including aunties, uncles, many cousins and

their children, all of whom allow me to infinitely grasp at this meaning. I hope you know that your diasporic journeys and sacrifices are never far from my mind. Thank you to John LoPresto, Carol Chin, Jeannie Chan, Jason Wu, and Daonne Huff—chosen kin who have fed my spirit and kept my head up these many years. Thank you to those elders and ancestors who came before and future ones who will come after. Without you, none of this would be possible.

Thank you to Burmese diasporic communities in New York, especially in Bensonhurst, Brooklyn, and Elmhurst, Queens, who have raised me up throughout this project and raised me long before. Living between blurred realities of research and (home) community life is not seamless. Transitions were made easier by Tim Aye Hardy, Ye Lin, the members of 3Medium, Dr. Zaw Oo, Hnin Haymar, Sandaya Aung Win, Daw Mar Mar Aye, Sandi Tun, Simone Jacobson, Sidd Joag, Todd Lester, Rodney Dickson, "Jane," and Ye Taik. I thank them for allowing me to share in their perspectives of how Burmese diasporic art makes its home in New York and beyond. Thank you to Sayama Than Than Win, Saya U Saw Tun, and Ko MYPH, for their support of and patience with all students trying to learn their mother tongues. These lessons have been invaluable.

Early stages of the scholarly part of this project would not have been completed without the generous support of the Henry MacCracken Fellowship at New York University, the FLAS fellowship at SEASSI at the University of Wisconsin, Madison, and the Asian American Studies Institute at the University of Connecticut. Each of these opportunities afforded me the time, space, and means with which to conduct research, wrestle with language, and commit to writing the project into existence. Thank you to academic mentors and peers that I have encountered over the years and whose feedback and supportive energy is weaved into these pages, especially through my home conferences of the annual American Studies Association and the annual Association of Asian American Studies. It is in this spirit that I thank brilliant friends such as Jih-fei Cheng, Mike Atienza, Ma Vang, Kit Myers, Tom Sarmiento, Long Bui, Douglas Ishii, Christopher Eng, Chad Shomura, Lee Ann Wang, Brian Chung, Wendy Sung, Simi Kang, Melissa Phruksachart, Ren-yo Hwang, Sony Coráñez

Bolton, Mejdulene Shomali, Lila Sharif, Vinh Nguyen, Elena Shih, Patty Ahn, Karen Hanna, A. J. Kim, Joo Ok Kim, Ashvin Kini, Yumi Pak, Thea Quiray Tagle, Evyn Lê Espiritu Gandhi, and Heidi Amin-Hong.

This project would not have been possible without the guidance and support of various people, institutions, academic associations, fellowships, and collectives. I thank those who have made institutions such as Vassar College, the University of Connecticut, New York University, and the University of California, Riverside places to write, research, and teach. Thank you to Christine Balance, Linta Varghese, and Eve Dunbar, who encouraged me to pursue this journey in the first place. Thank you to Thuy Linh Tu, my graduate advisor, whose unwavering support, measured wisdom, and continual cheerleading inspires to always move forward. Thank you to Arlene Dávila, Aisha Khan, Lok Siu, Crystal Parikh, Karen Shimakawa, and Cathy Schlund-Vials, whose support in coursework and fellowship, generosity in reading, and anchoring spirit have nurtured early drafts. To my beloved extended cohort(s) in graduate school/the legion, especially: forever EHs Eva Hageman and Elliott H. Powell; buddy of buddies Marisol LeBrón and hypebuoy Jenny Kelly, beacons of intuitive advice and grounding; officemate-boo Justin Leroy; and big sib Ronak Kapadia. I also include in this the heart and efforts of collective community in the work of Liza Williams, Carmen Phillips, Marlon Burgess, champion co-dissertators Vivian Huang and Lezlie Frye, Rana Jaleel, A. J. Bauer, Zach Schwartz-Weinstein, Manijeh Moradian, Zenia Kish, and Stuart Schrader.

My deep gratitude to Mariam Lam, my UCR Chancellor's postdoctoral mentor and friend and the Presidential Postdoctoral Fellows' Program, for their advocacy, support, and community, especially for junior faculty of color, women, queer, and trans folx. Thank you to friends I've made through this fellowship, such as Jasmine Syedullah, Iokepa Casumbal-Salazar, Juliann Anesi, and Jolie Chea. My sincere thanks to Ann Baker, Clare Counihan, Laura Helper, and Liz Ault, for their careful and attentive labors on the finer points of writing and editing. Thanks to my colleagues in the Program for Southeast Asian Text, Ritual, and Performance at UC Riverside, such as Christina Schwenkel, Victoria Reyes, David Biggs, Muhamad Ali, Weihsin Gui, Rican Vue, and Charmaine Craig, for their critical labors

in shifting the tenor of what interdisciplinary and critical area studies can be. Thank you to my colleagues from the University of Washington's Luce Grant "Decolonizing Pedagogies": Celia Lowe and Linh Thủy Nguyễn, Tri Phuong, Jenna Grant, Nazry Bahrawi, Vicente Rafael, Judith Henchy, Kathleen Gutierrez, Rick Bonus, Sylvia Nam, and Linda Trinh Võ—our recent seasons of gathering to examine the un/boundedness between Asian American studies and Southeast Asian studies has resonated in ushering this book to fruition. Thank you to filmmakers and scholars Emily Hong, Mariangela Mihai, Miasarah Lai, and the Ethnocine Collective, for the way they have shifted global perceptions of dissidence in Southeast Asia and beyond. Earlier iterations of sections of chapters 1 and 3 been previously published in the *Critical Ethnic Studies Journal* and in LIT: *Journal of Literature Interpretation and Theory*; I am grateful to those publications to include these parts here.

My deep gratitude to dearest Donatella Galella, Crystal Baik, and Xóchitl Chávez, whose joys and struggles I count with my own in Riverside, California, as we have tried to eke out home. Boundless thanks to my weekly Monday writing group and the "no" committee of Josen Masangkay Diaz and Davorn Sisavath, my closest and most generous critics and collaborators over the last fifteen years. My thanks to cheer section and dear friends of the Friday writing crew, including Imani Kai Johnson, Anthea Kraut, and our fearless convener, Liz Przybylski. Thanks to colleagues who orbit in departments elsewhere but are no less appreciated: Stephen Sohn, Robb Hernández, Gloria Kim, and Jodi Kim.

Thanks to my colleagues in the Department of Ethnic Studies past and present: Edward Chang, Alfonso Gonzales Toribio, Paul Green, Keith Harris, Anthony Macías, Alfredo Mirandé, Alisa Bierria, and Robert Perez; all have kept department life necessarily collaborative. I am especially grateful for interdisciplinary camaraderie and teaching alongside Wesley Leonard, Adrián Félix, Jasmin Young, Jennifer Nájera, Gerald Clarke, and Irum Shiekh. My thanks to the administrative staff of the unit formerly know as the MDU, especially Geneva Amador, for always trying to find creative solutions to bureaucratic impasses. Thank you to all students past, present, and future, who keep me accountable as a teacher and collaborator and

whose own fights for the next world keep me hopeful. Thank you especially to Chu May Paing, Sneha George, Kenneth Lee, HL Doruelo, Maya Shah, Allan Zheng, Val Chacon, Ray Pineda, Nathaly Ortiz, Sung Kim, Minh Duong, and Shani Tra, in whom I get to see the shape of this future up close.

Thank you to the Center for Ideas and Society, especially Katharine Henshaw and Dylan Rodríguez, who maintain it as a nexus of creation and champion various faculty commons, including Performing Difference. In this configuration I thank Kimberly Guerrero, Anusha Kedhar, Melissa Wilcox, Courtney Baker, Judith Rodenbeck, María Regina Firmino-Castillo, and Mark Minch-de Leon for community. I thank comrades in UC FTP formations, who have helped me understand and better enliven abolitionist practices, especially Setsu Shigematsu, João Costa Vargas, Charmaine Chua, Ken Ehrlich, Madison Brookshire, SA Smythe, and Nick Mitchell. My infinite gratitude to the generous feminist reading praxis of Lucy Burns, Deborah Wong, Sarita See, Tammy Ho, Mimi Nguyen, Neda Atanasoski, and Yến Lê Espiritu, who have engaged and shepherded different iterations of this writing at different stages through workshops and talks. Parallel infinite thanks to the anonymous reviewers of the manuscript, whose repeated, careful, and deep readings gave me guidance when I most needed it—labors I hope to pay forward. Thank you to UWP staff, especially editor Mike Baccam, who has ushered this book into publication with the utmost care, foresight, and integrity.

Thank you to Remy, for unconditional love, snuggles, and boops. I am ever thankful for Keith Miyake, for his love, care, support, and patience through some of the most challenging and inspiring parts of this journey. There is no person quite like my partner, colleague, comrade, and most cherished confidant, who understands the daily grind of this work like he does. You shape what is sacred about home.

Performing Vulnerability

Introduction

In March 2013, at the international symposium "Performance and Justice: Representing Dangerous Truths" at New York's John Jay College of Criminal Justice, exiled Burmese artist Chaw Ei Thein was awkwardly rushed off the stage during Q&A.[1] In her own performance Chaw Ei Thein had bound her hands and gagged herself, simulating the state-sanctioned torture of political prisoners by prison guards.[2] In her postperformance Q&A session in the same room, the first in the lineup, the emcee forgot to give her a microphone.[3] So she had to yell her story to the audience: how she, like many fellow Burmese artists, had been detained in police custody for several days for staging performance art in downtown Yangon.[4] She told the audience that since her exile in 2009, she constantly thought about how to communicate this history through art despite the threat of further detainment; she then admitted that she "found the torture positions . . . kind of beautiful."[5] In the pregnant pause that followed, audience members appeared somewhat uncomfortable, with some averting their gazes from the stage. The emcee ended the Q&A session and directed Chaw Ei Thein off the stage—in part to ready the space for the next artist but also apparently to push through the audience's discomfort.

Chaw Ei Thein found herself sidelined by the emcee and the audience, her narrative not wholly rejected but not necessarily celebrated either. Subsequent artists brought their creative teams to the stage and answered questions pertaining to inspiration, process, and hopes for the future. Other pieces in the symposium ranged from a discussion on American

director Frederick Wiseman's film *Titicut Follies* (1967), which weighs the legal processes of hospitals for the "criminally insane"; the contemporary theatrical works of Spanish theater artist Angélica Liddell, who thematically addresses child soldiers, femicide, and immigration; and the work of Jean Graham-Jones, a Chile-based playwright and director, who discusses the role of human rights in his play "Villa + Discurso," about a fictional former concentration camp's future.[6] The emcee's pivot seemed to resolve the pause in the room, with artists proceeding as though the emcee had set an expectation that they could freely discuss historical and national traumas but not necessarily personal and community ones. This event took place at the close of the free public three-day symposium and called on participants to adapt spaces of theater as human rights forums. Organizers established this space for critical engagement and free expression. In an intimate black box theater space, the audience sat in folding chairs in front of the stark black stage lit by a bright spotlight to watch screenings and performances. Afterward, in intimate Q&A conversations, the symposium participants described their journeys to human rights activism in varied legal, scholarly, and medical settings.[7]

At first Chaw Ei Thein's work seemed to corroborate the symposium's overall goal of facilitating human rights testimony as moves toward attaining justice for survivors of various forms of state violence and their allies. This free symposium, convened at a historic New York public school in a cosmopolitan hub of the international arts market, attempted to bridge the expanse between juridical human rights discourse and the quotidian work of human rights activism in the arts. After all, at such events, organizers attempt to translate, extend, and even critique the obtuse role of juridical human rights in seemingly nonjuridical forums of the arts. Here juridical human rights discourses reference the language and practices that attempt to administer international human rights law by holding individuals and nations accountable for human rights violations, including state-sanctioned violence against civilians. This work is interpreted and practiced every day by various human rights activists, who often work under legal, humanist, and service provider banners to facilitate dialogue on the part of witnesses, governments, and laypeople alike.

Here, too, displaced artists hope to seed future encounters with scholarly and activist audiences. They engender economic and physical risks at one of many intersections between arts and humanitarian industries, which seem to rely on "how well" suffering is represented. Throughout this analysis I use the term "humanitarian industry" to name a dense network of advocacy, including liberal human rights and democracy activists, nonprofit and nongovernmental organizers, and movement campaigns that together stimulate capitalist growth and aid based on legible demonstrations of suffering. Within this industry, embodying vulnerability can be critical to assuring displaced artists' livelihoods. The moment when Chaw Ei Thein "fails" at legibility highlights the informal contract between asylum-seeking artists expected to express suffering and audiences who are expected to reciprocate with compassion. Deviance from these unspoken scripts disrupts the expectations of the room, as demonstrated by the discomfort of the audience and the stage managers not knowing how to proceed. These artists broaden the scope of what is possible when audiences sit in the discomfort of a situation in which the artist communicates human rights violation but refuses to appear as a naturalized victim of militarized state violence. Both audience and artist experience discomfort at multiple levels, and this discomfort is seeded in multiple directions. There is the discomfort of the audience's unmet expectations from not knowing the context of the artist's suffering and the discomfort of the artist as they risk rejection of their "beautiful" self-injury. How do these discomforts amplify each other? To what end do they unsettle the "human rights subject" from becoming realized or even recognized in spaces of performance?

The stakes are very high for artists. Illegibility as a human rights subject can deflate the chances for the financial and political support that is critical to navigating displacement deep into the aftermath of exile. Yet the sidelining of Chaw Ei Thein's testimony illuminates the tacit disagreement between performers, organizers, and audience over how cultural producers should embody suffering so that it may be legible as a claim to human rights. At the moment when the organizers invited the artist to express her interpretation of political torture freely and her creative labor gestured *beyond* the juridical of the present and *beyond* the formal stage, she met a

bristled reaction to how her freedom of expression should look, feel, and sound. The emcee's "keep-moving" energy ensured that the public, made up of students, faculty, and visual arts and theater practitioners, would bear witness to and affirm a bracketed version of freedom of expression.[8]

In the broader arenas of human rights and immigration advocacy, it is key for displaced artists who survive political conflict to code their suffering in the most legible discourse of "freedom." Organizations across the Global North have cited the principle of "freedom of expression" in defending journalists, artists, and dissidents who are censored and punished by their local governments over purported acts of counterterrorism, national security breaches, and religious extremism.[9] Yet in this version of artistic expression, Chaw Ei Thein's interpretation of her artistic freedom escaped the confines of audience expectations. In addition to its widely accepted definition of freedom of expression, Article 13 of the United Nations Declaration of Human Rights stipulates that every person should have "the right to freedom of movement and residence in the borders of each state" and "a right to leave any country, including their own, and be able to return."[10]

As these human rights are not enforceable, particular state responses to displaced communities who have fled their country of origin highlight goals of either "temporary" encampment or "permanent" resettlement. Current international protocol to "rescue" and resettle displaced communities assign these communities political status as internally displaced persons (IDPs), asylees, or refugees, while host nations and nongovernmental organizations (NGOs) attempt to offer legal, medical, and resettlement services. International communities hope to hold individual governments responsible through tribunals and human rights commissions. Yet, at national borders and especially after crossing borders, displaced communities' freedom of expression is impacted by their freedom of movement, and vice versa.[11] This link between movement and expression operates at the microcosmic level of performative exchanges in humanitarian and arts spaces and between displaced artists and their interlocutors, especially as audience expectations of performances' legibility affect artists' livelihoods. When an exiled artist moves between humanitarian and arts spaces,

"freely" performing self-injury in a formal institutional setting—where that work may not necessarily be legible—they might risk a future move to an artist's residency or fellowship. Conversely, a diasporic community site may be more receptive to work that is tied to freedom of expression, but performing at community sites does not necessarily equate to freedom of movement to the kind of sites that can sustain an artist's work or help build a case for resettlement.

At public forums where humanitarian industries and arts markets converge, even a most eager commitment to "free expression" or "freedom of movement" can sometimes miss opportunities to support displaced artists, especially when they live under a different set of conditions than forced displacement, authoritarianism, or military rule. Events at the John Jay symposium highlight the sustained possibility that interlocutors in arts and humanitarian spaces can sometimes drown out displaced artists' testimony; exchanges often result in informal but impactful expectations of artists to facilitate linear narratives of successful rescue of displaced communities from economic and political dispossession once they demonstrate their vulnerability to these forces.

Merriam-Webster's Collegiate Dictionary indicates the word vulnerable comes from the Latin word *vulnus,* "to wound," meaning "capable of being both physical or emotionally wounded." However, its submerged etymological history shows another meaning that has gone dormant in the English language since the 1600s: "having the power to wound." The chameleon condition of being vulnerable, or vulnerability, can thus include a person's own corporeal and psychic experiences of being harmed and that person's latent power to refract such experiences back to others. My goal is to examine this latent quality of vulnerability in the work of cultural producers who are susceptible to injury by state and humanitarian violence while also subverting assumptions about their agency through their performances. This is not meant to imply that this process necessarily emphasizes resilience or that survivors must project healed selves to audiences after life-altering ordeals, nor that they wield "the power to wound others" in a punitive way. A "healed" self implies a human rights subject who is possessed of human rights and thus whole. Rather, by reorienting toward vulnerability in their

potentially reciprocal exchanges with audiences, artists unsettle the often racialized, gendered, ableist, and sometimes coercive dynamics of the arts and humanitarian industries.

Within this potential for both "being wounded" and "having the power to wound," a reliance on the body or its absence by exiled and asylum-seeking artists becomes central. In a parallel vein, scholars theorizing the wound as a site of generativity instead of as a locale of static loss is also palpable. In the field of trauma studies, scholar Marianne Hirsch calls trauma "in its literal meaning, a *wound* inflicted on the body," while her contemporary Roberta Culbertson identifies the impossible process of communicating trauma that can relinquish spoken and even conscious reckoning with pain: "No one's experience is more one's own than harm to one's own skin, but none is more locked within that skin, played out within it with actions other than words in patterns of consciousness below the everyday and the constructions of language."[12] Yet, if trauma is "locked within that skin," what possibilities exist for artists who offer to "reopen" their own wounds? What does it mean to make an art of it? What kinds of limitations and gains do artists encounter within arts and humanitarian industries and beyond as a result of performances of self-injury or, for some artists, abstraction of the body altogether?

Performance and refugee studies scholar Allison Jeffers contends that these acts upon the skin are expressive: "Skin that is deliberately wounded by the 'owner' of that skin when more literal speech is impossible becomes 'a deeply eloquent form of testimony, where a plea is made for social recognition.'"[13] However, rather than considering onstage self-injury a more perfectible version of testimony, what might it mean to sit with a discomfort that turns both artist and audience decidedly *away* from testimony? Chaw Ei Thein's performance, and others like it, exemplify how exiled and asylum-seeking artists encounter various levels of foreclosure from support when they express deviance, perversity, or pleasure onstage. Even so, in Chaw Ei Thein's reflection on the form and intent of her performance—a paradoxical juxtaposition of beauty and torture—she did not merely present the exceptional or grotesque aspects of torture, but asserted her agency as an artist who subverts the assumed constraints on the art itself. Her

example demonstrates the importance of what performative excesses to legible human rights testimony, witnessing, or compassion unearth: she situates even broader planes for freedom of expression, especially those gestures that exceed the distinctions between silence and speech, visibility, and invisibility.

Moving Between the Arts and Humanitarian Industries

The following inquiry follows diasporic artists and activists from Burma and their supporters in New York, tracing how they and their allies unsettle juridical human rights discourse within supranational spaces of humanitarian benevolence and the arts. It explores what these previously described constraints reveal about how arts and humanitarian interlocutors determine acceptable forms of freedom of expression circulating at the intersection of arts fundraising and institutionalized human rights activism. Conversely, it also explores the convergence of international arts markets and humanitarian industries and their reliance on diasporic artists' contributions to contemporary visual culture and performance in their goals to diversify their museums, galleries, and events. What political, economic, and social structures uphold the intersections between arts and humanitarian industries that are built on "how well" suffering is represented? What forms of economic and social value accrue to the lives of performers as a result of performances of vulnerability—both onstage and in their applications for asylum and "emergency" art exhibitions and residencies? What do artists' strategies tell us about the freedoms they seek as they navigate the discourse surrounding human rights and humanitarian aid within the diversification of international art institutions?

Contemporary Burmese artists exiled in the late 2000s and early 2010s sought asylum in New York in the aftermath of civilian protests against Burma's state militarization, including its mass incarceration of dissident communities.[14] Earlier, because of the 1980 Refugee Act, thousands of refugees from wars in Southeast Asia had arrived in the United States, shifting the racial, economic, and political landscape of migration and human rights writ large. In the time and space of today's post-9/11 New

York, and in light of Burma's transitions in and out of authoritarianism, artists' choices to creatively represent suffering, including torture and self-injury, risk illegibility among multiple audiences. When considering the risks of illegibility and retraumatization in order to attain freedom of expression, it becomes clear that there are other ethical concerns around where and when displaced artists should seek continued support. Within the scope of the international arts market, fellowships and residencies have sometimes become stopgap measures for arts advocates to use in addressing urgent relocation of cultural producers facing threat of imminent physical danger from their own governments. In other scenarios, where states of emergency have ended, artists continue to survive on these opportunities, on traveling exhibitions, and on short-term stays abroad. These latter gigs become elongated means of livelihood and chances for long-term networking and marketing for diasporic artists.

When defining the scope of the international arts market, it is imperative to note that the question over where the creative economy begins and where "the market" enters in has enlivened debates among economists, art historians, and cultural theorists. In his exhaustive study of "the economy of the visual arts" in the twenty-first century, John Zarobell, an artist, curator, and international studies theorist, examines how globalization has impacted the transnational intersections of arts and commerce.[15] Zarobell examines funding negotiations by art dealers, gallerists, artists, donors, and investors in nonprofit and state-run museums, global biennials, art fairs, galleries, international auction houses, artist residencies, and artist collectives as the hubs that foster the commercial growth attributed to the arts in its most apparent and legible forms. Adopting Zarobell's view, this analysis treats these arenas and these agents as comprising the scope of the international arts market but rejects a singular definitive "art market" that privileges Eurocentric histories as the center versus the periphery of the art world.[16] In this project, those who design to provincialize European centers as art hubs also engage in what some scholars have deigned "art risk," which refers to potential financial loss in procuring or producing art as an asset. As Zarobell says, "The mere fact that the term 'art risk' exists demonstrates the broader trend toward what John Lanchester (2014) has

called securitization, or the process of reconfiguring just about everything as though it were an asset class."[17] In expanding on the notion of art risk, which attempts to make sense of investors' capitalizing on plural arts markets, I argue that Chaw Ei Thein's encounter speaks to the vulnerability that some artists themselves endure: art that *risks* physical, economic, and political ramifications and that disrupts the terms by which markets attempt to capture whether artists are worthy of short- or long-term investment. In addition, artists who have been exiled, seek asylum, or experience recent refugee status contribute to the transnational economies of both the international arts market and humanitarian industries in ways that situate art risk as a multidirectional enterprise. I further consider that while mainstream filmmakers, performance artists, and media producers may be distinct sets of social actors, the visual culture and performances they create meanwhile cultivate powerful representations of Burma, human rights, and art risk that thematically appear in adjacent arts market arenas.

Rather than an exhaustive study of the legibility and illegibility of asylum-seeking artists, this analysis explores the relationships between artists, the global arts market, and humanitarian industries that sometimes produce conditions of unfreedom under the liberal guise of freedom. These rubrics embed visible suffering as a currency that drives humanitarian campaigns and have historical precedence in histories of empire between the United States and countries in Asia. Historian Heather Curtis argues that the global expansion of US humanitarianism has deep ties to late nineteenth-century debates around the role of photographs of "distant suffering" taken by transnational evangelicals working in Asia, particularly in missionary movements during the late 1890s famines in India. Meant to gather sympathy and inspire action, this "pictorial humanitarianism" was furthered by missionaries, moral reformers, and investigative journalists who were emboldened by the emerging technologies of the camera and printing techniques, which made possible the mass reproduction of original photographs in popular periodicals and the circulation of illustrations, engravings, and cartoons.[18] Curtis credits the perfect storm of US industrialization, the expansion of international markets, the development of travel and communication technologies, the intensification of imperialism

and burgeoning transnational reform networks, and the unprecedented growth of the foreign missionary movement as key factors in the US public's fascination with morally "uplifting" those experiencing famine and poverty abroad.[19]

Even so, there were still debates between evangelical communities, government officials, and the public about the sensationalism around the visual culture of distant suffering and whether it was the most effective and trusted means of galvanizing financial, political, and religious support for the "downtrodden."[20] For example, in the archives of the popular periodical *Cosmopolitan*, Curtis notes how "sufferers" were photographed in masses of unnamed gaunt nude bodies paired with graphic descriptions of India's "starving millions" as a testament to their worthiness of salvation.[21] In contrast, the same communities were labeled as "heathens" when they were depicted engaging in non-Christian religious and cultural rituals.[22] This particular moment could be interpreted as an instance of emergence and convergence, between an industry (the international arts market) built on both a desire for and a distaste for the visual culture surrounding vulnerable Asian bodies, which served as a foundation for a US-based social movement (the humanitarian industry). Throughout chapters 1 and 2 I explore how at the turn of the twentieth century, during the interwar periods and later during the Cold War, other convergences between the international arts market and US humanitarian aid industry facilitate what I call "economies of vulnerability." These structures of philanthropic capitalism, (celebrity) humanitarian campaigns, and international museum curation account for the landscapes in which contemporary diasporic artists must work with metrics of vulnerability today.

Building on studies of diaspora, migration, humanitarianism, feminist/queer inquiry, visual arts, and performance, this analysis focuses on a constellation of artists, activists, and their supporters as they strategically leverage performances of vulnerability, often to excess, to navigate their livelihoods in resettlement. It explores the unspoken aesthetic and affective metrics that funders count as "good" suffering worthy of support and based on how it looks, feels, and sounds. Through visual and performance analysis and ethnography, this project tracks the hierarchies produced by

the global arts market and humanitarian industries around the aestheticization of suffering, often positing who deserves rescue from state-supported authoritarianism and militarization via humanitarian benevolence. It also tracks how artists performatively render vulnerability as a means to access funding, art spaces, financial livelihood, and stability in US resettlement. Conversely, it attempts to understand why NGOs and corporate funders only intermittently support diasporic artists who illuminate state surveillance, detainment, and censorship and how these artists must cultivate other means of legibility or refuse it altogether in order to thrive. Thus, this work engages interdisciplinary analyses of both the mundane and the spectacular works of Burmese diasporic artists alongside granters' and curators' efforts to support them, specifically at the intersection of the arts and humanitarian industries.

Economies of Vulnerability: Exchanges in Radical Empathy

Studies of refugee and asylum-seeking communities often focus on structural disparities in wealth, in access to language, and in job opportunities within refugee resettlement programs. At times these studies have defined the success of a refugee's resettlement based on neoliberal discourses of transformation in the arenas of economic mobility, language, and occupation.[23] In their applications for political support or asylum, refugees and asylum-seekers are usually asked by NGOs to report on their experiences of economic and political vulnerability living under stringent state media censorship, surveillance, militarized state violence, and displacement. They also must produce narratives of economic and political vulnerability in order to receive aid from the state or NGO to further their resettlement cause.[24]

These needs-assessments of refugee and asylum-seekers' struggles often cohere in economic and political statistics that obscure their relationship to the liberal humanism they encounter in the arts and humanitarian industries. While some scholars have turned to statistical analyses of resettled communities' increases in education, language skills, and occupational

mobility as measures of freedom, those who seek asylum as activists and artists also imagine freedom as the freedom to pursue particular content, themes, and connection to their audiences. Simultaneously, these granular aspects of freedom of expression and freedom of movement, which are not always clearly set out within the juridical human rights discourse, exceed any notion of "freedom" as only related to escaping human rights abuses in their country of origin.

If economies of vulnerability rely on exchanges between those seeking freedom of expression and freedom of movement and those who are in a position to grant aid, then the exchanges gesture to the complicated logics of gift, return, and debt. Critical refugee studies and feminist/queer theorist Mimi Nguyen powerfully argues that in the case of asylum-seekers and refugees caught in the wake of US empire, the assumed "gift of freedom" (or resettlement) is necessarily coercive and even demands a recipient's perpetual indebtedness to "pay" in terms of both economic and cultural capital in the United States.[25] Artist and Southeast Asian diasporic arts scholar Việt Lê furthers Nguyen's argument in his comparative examinations of Vietnamese, Cambodian, and Laotian diasporic postwar art. He theorizes the possibility of deflecting the passivity associated with "receiving" the gift of freedom by using the concept of "returns" or reciprocal forms of art-making, such that "artistic production [are] gifts that undermine (neo) colonial logic of eternal indebtedness."[26]

In a similar vein, I look to uncover the nonlinear paths to freedom that artists pursue in the transnational and diasporic circulation of their work, the freedom to move with their work, and the moments of freedom in their art-making processes (that contend with constraint), not necessarily as they are relegated to states of political asylum and resettlement alone. Economies of vulnerability are one arena through which the international arts market and the humanitarian industry collide. The humanitarian industry sets the cultural, economic, and political conditions by which asylum-seekers and refugees, as well as other diasporic artists, might qualify for NGO or state assistance only when they are able to "perform" vulnerability to a certain set of standards. At the most extreme, according to the 1951 Geneva Convention, an asylum-seeker hoping to attain refugee status

must repeatedly corroborate a convincing story of individual persecution in their previous home and show that this persecution would continue if they were to be returned.[27]

The arts market is able to regulate which themes and which artists might receive support for exhibitions, directly impacting subsequent media coverage and increasing artists' chances when in competition for residencies and fellowships. However, the arts market does not necessarily function like humanitarian campaigns of the past or present, nor do humanitarian endeavors always involve the arts market, even if they might rely on "artful" means of corroborating testimony. When displaced artists perform vulnerability onstage, they engage in a form of exchange with their funders and audience members—even without the guarantee of a financial reward or a permanent residence status, whether seeking a future fellowship, grant, short-term gig, or networking opportunity to be in community with others. Funders themselves set powerful precedents with their contributions to diversifying arts industries while setting patterns for what is deemed worthy of curation and investment. This is an economy.

In the reception of Chaw Ei Thein at the Q&A session of March 2013, during that symposium specifically designed to be empathetic, it became glaringly apparent that not all human rights violations nor their artistic representations carry the same value. Thus, when considering the exchanges that take place within economies of vulnerability, performances of vulnerability are not explicitly assigned value as an exchangeable commodity. Nevertheless, they might be "paid" in terms of the audience's response through the donors, curators, and granters present, who may be able to facilitate artists' applications to future residencies or funding opportunities or keep them in mind for future collaborations.

Empathy underscores the underlying relations of power that artists and their supporters seek to transform when they encounter each other as disparately positioned humanitarian and arts interlocutors. I am not interested in recuperating empathy as a transactional unidirectional feeling of uncritical guilt followed by an action of support that originates from a donor and is cast onto a recipient. Feminist archivists Michelle Caswell and Marika Cifor have argued that *radical* empathy can address structures of

(colonial) violence in both private and public arenas while simultaneously acknowledging the power inequities between "self" and "other": "The notion of empathy we are positing assumes that subjects are embodied, that we are inextricably bound to each other through relationships, that we live in complex relations to each other infused with power differences and inequities, and that we care about each other's well-being. This emphasis on empathy takes bodies and the bodily into account."[28] In adapting the notion of the archive to the realm of performance, "radical empathy" between artists and their supporters invokes deep-seated, deeply felt, and communicable care that recognizes power differentials between disparately situated communities. Especially created around "relationships of mutual obligation that are dependent on culture and context," radical empathy suggests that embodied suffering can disrupt assumed permanent positions of those as caregivers and care recipients, echoing third world feminist and transnational feminist critiques of paternalistic notions of "rescuer" and "victim."[29] In theorizing economies of vulnerability, this inquiry attests to the economic but also the political and physical risks artists take when embodying vulnerability for their livelihoods alongside the agency needed for taking on the uncompensated toll of this work over the course of their careers. Economies of vulnerability also track the aftermath of affective exchanges that result in disruptions of power among those deemed donors and patrons versus those deemed vulnerable cultural producers in arts and humanitarian industries. Questions that arise from tracking these economies are: What is the relationship of exchange between artists and the arts and humanitarian industries? How do these groups come to converge? What shared values do arts and humanitarian industries uphold? How do they help facilitate Burmese diasporic art movements?

Economies account for the different types of compensation for participating in the venues that bring together arts and humanitarian industries. I was paid a nominal amount for my role as a graduate student participant on a panel at the same symposium. Had the artists been paid a similar amount, their time spent during previous days' rehearsals, curtain calls, and technical run-throughs, in addition to their actual performances and Q&A sessions, were not well compensated. These New York–based artists

were also balancing their "day job" work schedules. Clearly, they had to weigh the financial compensation against other less tangible forms of value of the performances, such as the opportunity to participate in an assembly of communities interested in human rights and to network with international advocates.

While this analysis does not hope to cover the whole of the commodification of the arts in the global marketplace, it does focus on one particularly prominent feature of the performance and visual arts of exiled and diasporic artists: the seemingly elusive aspect of physical vulnerability in exchange for the support that goes into the work itself. A feature of economies of vulnerability is the way artists themselves disrupt assumed inequities in the transactions within these economies; another is the assumed positionalities of supporters—the patrons, funders, curators, and granters—who are posed to "relieve" suffering against the actual "sufferers." Lauren Berlant considers the inequities between those positioned to "relieve suffering" and those considered "sufferers" when the former, after witnessing a scene of vulnerability, might "withhold compassionate attachment, to be irritated by the scene of suffering in some way."[30] Berlant identifies the experimentative impulse that audiences and performers engage in when trying to deviate from a powerful script of aid—impulses that may expose the limits of compassion and can be riddled with disparities of racial, political, spatial, and economic power between assumed spectators and sufferers: "The sufferer is *over there*. You, the compassionate one, have a resource that would alleviate someone else's suffering. But if the obligation to recognize and alleviate suffering is more than a demand on consciousness... then it is crucial to appreciate the multitude of conventions around the relation of feeling to practice where compassion is concerned."[31] Exiled artists and their interlocutors work to bridge this gap between "here" and "there," and Berlant's poignant question of how compassion is arrived at has ramifications for how affective responses that fall out of line with compassion may be sidelined, to the economic and political detriment of artists and their supporters. This work aims to demonstrate how artists who collapse the geographic and psychic distance between sites of conflict and sites of reconciliation through their performances insist

on an aesthetics built on vulnerability even when they do not necessarily mean to gain a permanent institutional home for their art nor permanent resident status for themselves. Often the work does not result in a stable income or a long-term accumulation of wealth after these exchanges with the arts and humanitarian industries.

This notion of "resource" as something given from the compassionate interlocutor who witnesses the sufferer is not simply a one-time transaction. At stake in the economic language applied to exchanges of compassion is that they garner shifting value in the form of potential future invitations and networking opportunities. Displaced artists often accept risk to meet the unspecified demands of arts and humanitarian industries' interlocutors as part of their inheritance of asylum, which may not always materialize in future professional opportunities. This is not to simply call out lack of accountability within discourses of witnessing, compassion, or even radical empathy to support displaced artists. Rather, it is to imagine what is possible when contextualizing how artists themselves imagine their and others' agential roles in the arts and humanitarian economies that bank on portrayals and performances of suffering as well as advocacy offstage.

Economies also name the transactions that result *after* performances of suffering, when artists are expected to ask audiences to bear witness and deliver subsequent empathy toward displaced communities. Artists and their supporters are not working just to avoid precarity. Rather, their creative practices underscore working *within* their precarity of political and economic status, seeking asylum, potential surveillance, and potential retraumatization from past events. In these economies, vulnerability operates as both a form of currency and a form of agency, allowing artists to exceed the terms of and stretch out the humanitarian and arts investment in locating their displaced communities in need of support.

At times, legible and palatable suffering relies on an audience's bearing witness but also falls to the artist to justify their experiences in legible enough terms to gain audience support in these arenas. Just as artist Chaw Ei Thein positions herself as an exiled Burmese artist onstage for scrutiny by a global human rights public—and, more broadly, as a brown, Burmese, Southeast Asian, feminine presenting body—she is expected to divulge

and even stylize her personal and national traumas in a palatable way to international interlocutors. This pressure is not relegated to this one artist. At the intersections between the arts and humanitarian industries, these tendencies can corroborate the systems in which asylum-seekers and refugees *must* participate in order to continue their work. *Performing Vulnerability* seeks to name the very systems of exchange between asylum-seekers and their livelihoods, which flourish in spaces that bridge the humanitarian and arts industries.

In both arts and humanitarian industries, some cultural producers have been spectacularly excised from an authoritarian state and then featured as new arrivals in an unfamiliar arts or media scene. They may possess cultural capital and political cache among funders and granters, but any initial "buzz" can dissipate and may not necessarily sustain a livelihood in the long term.[32] These economies cohere when artists are neither wholly resistant nor entirely complicit, but they do forward an alternative set of relations to humanitarianism, capitalism, human rights movements, the diaspora, and community care. Performances of physical vulnerability can accrue both capitalist and noncapitalist forms of value in artists' lives as they seek to challenge the affective, spatial, and temporal structures of both humanitarian and arts industries. Even as these latter industries seek the "transformation" of artists into legible human rights subjects, their refusal to simply cleave to norms of legibility attests to their hope to make these economies work for them. Thus, in addition to illuminating the interrelated dynamics that amplify and compound artists' traumatic experiences, artists' freedom-making disrupts and expands on the assumed value of representing traumas of militarized violence.

A Note on the Aesthetics of Vulnerability

This work responds to a provocation by interdisciplinary scholars of sociology and art Ratiba Hadj-Moussa and Michael Nijhawan, who argue that neither classical sociological theorists nor Émile Durkheim, Karl Marx, or Pierre Bourdieu fully address the knotty intersections between suffering, art, and aesthetics.[33] Hadj-Moussa and Nijhawan suggest that classical

sociological theory often predetermines aesthetic value as a function of social relations rather than conceptualizing aesthetics as cohering relationships of power.[34] If one counters that aesthetics are a necessary result of social structures having to do with the conditions of art's production, then accordingly the circulation of the work produces its own economies based in aesthetic value attached to suffering.

This analytical approach, centering diasporic circulation, suggests that human rights subjects are not simply defined through the affirmation of their suffering by the state, by NGOs, by arts institutions, or by human rights activists. This mode is attentive to illiberal humanism, which Kandice Chuh argues broadly describes as the unrecognized refusal to adhere to forms of governance that promise "freedoms" (that is, liberal humanism) that dictate ways of life. These refusals are "directed toward the protection and flourishing of people and of ways of being and knowing and of inhabiting the planet that liberal humanism, wrought through the defining structures of modernity, tries so hard to extinguish."[35] Following Chuh's interpretation of a mode of aesthetics that "inhabits the suppressed contradictions of modernity ... [and] is, categorically, the particular that is subsumed by the universal," this project ruminates on a particular racialized aesthetics of vulnerability, including self-injury and abstraction of body, that marks the intentioned risk that exiled diasporic artists take in the face of proposed rescue by interlocutors in arts and humanitarian industries.[36] Examining aesthetics as being rooted in how diasporic artists invoke physical vulnerability more robustly interrogates how humanitarian and arts interlocutors project onto artists affective and performative assumptions of suffering.

I borrow from geographer Jessie Speer who, drawing on Marx and Terry Eagleton, uses aesthetics to describe the encounter between the sensate (or lively and feeling but often racialized) body and the world. As Speer notes, Eagleton aptly describes how aesthetics, or "how the world strikes the body on its sensory surfaces," captures the irreducibility of art as either labor or free expression in a capitalist society that seeks to exploit the difference.[37] As an artist cultivates an aesthetic of vulnerability, blurring the lines between exploited labor and an unapologetically sensate life, they refuse full alienation from their body by these same industries that pur-

port to free them. A critical line of inquiry is the role of the aesthetics (of vulnerability) in response to suffering, especially with regard to juridical human rights discourses within arts and humanitarian spaces. Conversely, the circulation of Burmese diasporic art illuminates the contradictions within collaborative projects of humanistic diversification of international art institutions, which rely on these communities and their embodiment of vulnerability.

Chaw Ei Thein's performance operates under a global trend in which refugees and asylum-seekers increasingly turn to lip-sewing, hunger strikes, gagging, mooring at sea, and bondage in their protest over the unlivability of encampment, detention, and the effects of contemporary immigration policies.[38] These increasingly ubiquitous forms of protest against militarization and systems of detainment also illuminate the often-ignored afterlife of humanitarian projects.[39] How do migrants, asylum-seekers, and refugees continue to contend with humanitarian rescue narratives after arriving at an assumed safe haven? How do they interact at the interstices of various economies of vulnerability as propagated by arts and humanitarian interlocutors?

Dominant discourses about refugee and asylum-seeking artists' representations of spiritual, psychic, and physical trauma after having left their countries of origin can halt unsavory questions of how agency, pleasure, aesthetics, and play factor into the physically taxing work of self-injury. As Burmese exiled artists counteract the dehumanizing effects of Burma's state violence through their agential acts, they insist on revisiting the role of the state *and* the disciplinary measures of humanitarian rescue in the daily bodily comportment of their diasporic lives. This is not to suggest that apparatuses of authoritarian state violence and humanitarian benevolence, nor artists' efforts to cope with them, are analogous. The point here is that when artists are expected to confess and make visible their traumatic experiences of systemic detainment, imprisonment, and migration for financial sustenance after displacement, they risk intervening in the aesthetic and political viability of their work in the diaspora. The notion of afterlife anchors the forthcoming analyses of performances, events, and exhibitions and includes charting the continued disciplining effects

of humanitarian discourse that artists and their supporters must engage with after an initial debut of work.

On Elastic Vulnerability

"Elastic vulnerability" names a constellation of gestures that artists perform onstage and later translate offstage as petitioners of both the US state and the arts and humanitarian industries; these gestures aim for the "freedoms" promised by global discourses of human rights. This project's call to elasticity also builds on scholarship that considers how Burmese diasporic cultural producers adapt forms of expressive culture in order to contend with the legacies of colonialism and Burma's state violence. What Tamara Ho calls "flexible tactics of displacement" consider the literary tactics that Burmese women writers in particular have strategically engaged in to cultivate agency in the face of masculinist, Orientalist, and Western feminist and human rights framings of their work and their lives.[40] The current project expands on the property of elasticity to further consider both macro and micro forms of diasporic movement in the work of visual and performance artists, mostly from Burma, and attends to what they propose in excess of who or which narratives are "rescuable." At their most extreme, gestures of self-inflicted gagging, binding, and blindfolding express both artists' struggles with military violence and censorship from the Burmese state as well as the fraught conditions of their resettlement, knowing the dominant humanitarian discourses suggest they are "free." Alternatively, elastic vulnerability also names artists' playful narrative deflections, transcendent meditative gestures, and bodily abstractions from being legible in order to create the necessary distance from the tiring aspects of self-injury, anticipating when arts and humanitarian audiences shift their interest.

To recognize the roots of vulnerability—upsetting the power dynamics of "injured" versus "healer" as well the potential for performers to facilitate communication—I pair vulnerability with the adjective *elastic*. Elastic means to be flexible, adaptable, or possess the ability to expand and contract but also quickly "recover" or "return" to a previous state or even resume a former shape. The term elastic captures the spirit in which artists

must sometimes jarringly adapt the positions of their bodies onstage, from being at ease to being physically taxed while they reimagine self-injury and abstraction for varied audiences. The nature of elasticity, or the ability to expand, adapt, stretch, contract, and then snap back to a base state without breaking, also helps describe the narrative flexibility artists use both on- and offstage. Elastic vulnerability can also describe how artists narrate their vulnerabilities to varied audiences and the improvisational tweaks they must make to sate or defy expectations. The documentation of elastic vulnerability attempts to track the intangible and inconsistent ways in which both arts and humanitarian industries reward artists and their advocates. Thus, examining elastic vulnerability pays necessary attention to how artists and activists subvert scenarios in which they are expected to perform hegemonic versions of resistance and categorizes the latter as overt and militant protest in the streets. This work also complicates notions of compliance and complicity, such that enacting silence or laying prostate do not necessarily indicate powerlessness. Ultimately, these interventions expand how arts and humanitarian interlocutors might define what counts as freedom versus the constraint that artists experience; they can subsequently address what robust types of support might be possible for artists and each other in their respective industries.

On a granular level, attaching the term elastic to vulnerability illuminates the porous and fungible tissue of the wound, its capacity to generate flesh and healing substance where there was less before, its sensory and sensational properties of acting out. Enacting elastic vulnerability momentarily suspends time, invites audiences to go to a recreated place and time of wounding, pauses there, and then returns to the present. Displaced artists do not maim others in the same way that they have been maimed, but they do subject audiences and patrons to momentary discomfort and pleasure in the hope of transporting them to radical forms of openness that generate new worlds. Artists may momentarily return to sites of trauma and reclaim them, in corporeal and psychological ways but also in geographic and temporal ones. How much artists choose to open up and by what manner they reorder the steps by which to heal themselves and their communities is up to them. This is necessarily a process with fits and starts

and can leave open the possibility of arriving at no firm resolution. With elastic vulnerability, artists open themselves up to experiences of both leaving and returning, which requires them to work between multiple sensory registers in order to convey the constraints of militarization and incarceration alongside their hopes for futurity. Rather than a static injury to one's body, vulnerability is a conduit that highlights an artist's dynamic simultaneous process of innovation and reclamation of the afterlife of the traumas they have been subjected to. Thus the elasticity of vulnerability names how artists manifest nonlinear and multiple symbolic returns to an initial site of state violence, and also the stretched-out afterlife of these performances among multiple audiences within the arts and humanitarian industries in which artists seek future opportunities. Elastic vulnerability is not an inherent nor permanent powerlessness, but an activating and flexible mode of wrestling with power.

Contemporary artists' turn to art traditions of self-injury and abstraction that risk the body is not necessarily new. Artists who are engaged in self-injury draw on the long postcolonial tradition in both Asia and the Americas that compounds responses to the violence of imperialism and the subsequent, often militarized humanitarian "rescue." Performance traditions that rely on artists risking self-injury are frequently discussed in terms of the radical postcolonial feminist arts of the 1960s to 1980s. Artists such as Coco Fusco, Yoko Ono, Ana Mendieta, and Marina Abramović come to mind, as they have subversively engaged how radical feminist offerings of the body can disrupt the sensibility of who and what constitute self-possession of the body in mainstream transnational and US feminist movements of the 1970s. Mendieta's haunting *Silueta* series of photos, capturing her own body laying nude across remote landscapes, documents the sensory and psychic discomforts of movement across inhospitable borders. Performance and queer studies theorist José Esteban Muñoz calls this "performing a modality of brownness that leaves resonant indentions on the world" or "vital materialist after-burns."[41] Similarly, Fusco and Guillermo Gomez Peña trouble the notion of the "primitive" spectacle when they satirize colonial world's fairs by posing as subjects of a fictitious Amerindian tribe and then gauging audiences' unwitting responses.[42]

Queer and feminist studies of performance have taken these illiberal gestures of vulnerability into account when considering the impact of these artists' commentaries on how racialized and gendered vulnerability to violence is deemed appropriate for some bodies but not others. Theorists Jack Halberstam, Celine Parreñas Shimizu, and Aihwa Ong invoke modes of strategic complicity, such as "radical passivity," where forms of protest may end the subject's life; "bondage," referring to sadomasochistic sexual practice; and the deflecting of "refugee love," that is, resisting forms of Western feminist compassion. Muñoz has articulated queer color performance as a means of minoritarian world-making, motioning to a "there and then to come."[43] His understanding of queer futurity sets up a parallel template by which to understand the decolonial, abolitionist, and illiberal worlds that the artists featured here hope to build. I do not mean to simply "include" Burmese diasporic expressive culture as part of these lineages if it leads to only recuperating its legibility, since this would be counterintuitive to some of the core tenets of the analysis. But directing attention to Burmese diasporic art that attempts to evade both Burma's state surveillance and the narratives that recuperate humanitarian rescue might demonstrate how artists in exile embody responses to calls to belong—from both authoritarian states as well as arts and humanitarian interlocutors in the Global North.

Sustained attention to instances of elastic vulnerability reveals as much about how artists and survivors of military dictatorship cope as about how they face the concurrent extraction of their labor within diversity and inclusion initiatives at the intersection of the global humanitarian and arts industries. For example, outside of a performance space, artists still must work at several jobs, they must find funding, and they must secure gallery space while still creating pieces that straddle the need to be commercial enough or "cutting-edge" enough. Through competitive temporary residencies and fellowships, artists make extended use of exhibition and community gathering spaces, transforming them into makeshift galleries and alternative forums in which to tackle the ongoing structural constraints of life in resettlement that also inform the content of their work. As they contest their positions as victims in extrajuridical forums, asylum-seekers and refugees trouble the

assumed spaces where freedom might live, including within the constraints of NGO organizing spaces, university forums, religious centers, and living spaces that become makeshift exhibition spaces. Artists also use these spaces and opportunities to line up future exhibitions without any assurance that going through the process will guarantee permanent residence or housing for their work or themselves. The debates that cohere therein provide insight into how, why, and by what mechanisms performances of economic and political vulnerability become prevalent yet unstable means of livelihood for artists and activists in exile.[44] While they may not be discrete instances of spectacular military violence or spectacular rescue, these quotidian constraints do influence how experiences of "freedom of expression" can be at times fleeting or, alternatively, palpable.

In these spaces, tracking elastic vulnerability homes in on the overlooked ways in which artists, granters, supporters, and arts and academic institutions at times align to shape timely debates around the granting process of human rights initiatives. Humanitarian and arts industry interlocutors and artists alike often find themselves working within the precarious time lines of fellowships, grants, and events, as well as under the often-mercurial initiatives of liberal academic and arts institutions that do not necessarily track with exiled and asylum-seeking artists' "time lines" of (artistic) freedom. As refugee and asylum-seeking artists and activists turn to self-injury and abstraction, they wrestle with the notion that resettlement alone promises boundless political and economic freedoms, including freedom of expression and freedom of movement. Artists may also reject the idea that there is a linear time line or end point to attaining these freedoms. The experiences of an exiled or diasporic artist, once they have secured a grant or an exhibition, challenge the notion that they are realized human rights subjects fully possessed of "freedom of expression" and "freedom of movement." Thus, recurring patterns of artists transgressively rendering more time, materials, space, and positions than were thought possible also shape inquiry of how reflexive and diaspora-oriented methods account for the artful and elastic compressions of distance, scale, and time in their work.

Unsettling Witness, Testimony, and Silence

In the context of the juridical arena, international human rights institutions such as the International Criminal Court (ICC) and the United Nations (UN) render the traumas of militarized violence visible and speakable. This has made the genre of witness and testimony significant for survivors of human rights abuse.[45] Historically, the legibly vulnerable figure seen in humanitarian media is deserving of aid as a result of some communicable injury, and thus the subject is read as human. Yet some have called attention to tribunals as limited forums in which survivors of human rights abuse must rehearse their traumas indefinitely if they hope to claim economic aid or asylum.[46] Scholars such as Joseph Slaughter have argued that the compulsory narrative mechanisms that undergird tribunals and international criminal courts are a way for survivors to testify to their suffering in order to aid the prosecution of war criminals, not necessarily as a path for survivors to gain their own healing. Slaughter, in his now canonical work on human rights and the novel, *Human Rights, Inc.*, attributes the ubiquity of these mechanisms to the entrenchment of bildungsroman, a literary convention that develops a protagonist's character or "coming of age," often in the face of adversity, and incorporates them into a community (here, the national body). For Slaughter the danger in the marketability and replicability of the bildungsroman is that it scaffolds the power of universal human rights discourses within contemporary development projects in the Global South. In these spaces, not being apprehended as "human" or not being endowed with Western, liberal, individualist sensibilities positions some communities as perpetual victims unless or until they submit to these discourses of beautification in their claim to "human personhood": "Efforts to deploy the 'politics of shame' by, and in behalf of, those 'suffering the paradoxes of rights' are clearly necessary, but they are also not sufficient or reliable in eliciting their desired ameliorative response."[47] What is this "ameliorative work" but a type of aesthetic work—a fashioning of the human rights subject with recognizable sentience to be "worthy" of rehabilitation or care by the state and international interlocutors?

Human rights and critical literary theorist Joel Pruce has suggested that

"bearing witness" to these testimonies can still be a "critical act," because by "witnessing, in the sense that nongovernmental organizations (NGOs) . . . act in and of [themselves,] because by being present, by bearing witness to crimes, violators are denied impunity. Geopolitically, being labeled as an abusive regime has negative effects on legitimacy and reputation and therefore witnessing may discourage abuse."[48] However, what is the purchase of these testimonies for communities "testifying" in assumedly nonjuridical forums and reclaiming agency over their experiences? While bearing witness may have long-term effects, how does the condition of survivors sharing their traumas undergird the affirmation of their freedom of expression or freedom of movement by others?[49]

During periods of civil unrest in Burma, such as during the 1988 and 2007 student protests and in the period following Cyclone Nargis in 2008, as well as during the most recent 2021 military coup, the state has historically put restrictions on the ability to assemble in public. The state established curfews and prohibited the assembly of groups larger than five people—assuming those would be people under suspicion of plotting antigovernment activity. Australia-based anthropologist Monique Skidmore, author of *Karaoke Fascism: Burma and the Politics of Fear*, observes that under the 2004 State Peace and Development Council regime, the government surveilled internet cafes, publishing houses, bookstores, teahouses, libraries, and museums and intermittently closed universities, all to prevent political organizing.[50] While these conditions have framed contemporary Burmese cultural production, popular accounts of this censorship speaks to a pernicious pattern of how "silence," implicitly equated to a lack of freedom of expression, is considered endemic to the country.

For example, Christina Fink's book *Living Silence* is a popular account of the strategies of survival used by Yangon journalists, farmers, monks, students, and others during periods of martial law and military surveillance in Burma over the last several decades.[51] Fink's account affirms the tone of many popular Western media interpretations of Burmese cultural work: "Burma is such a vibrant and lively place, yet many subjects are off limits or talked about only in whispers behind closed doors. People in Burma

are reluctant to speak up because they are never sure who is listening. To protect themselves and their families, Burmese participate in creating the silence that constrains many aspects of their lives."[52] For Fink, "silence" is such a pervasive structuring political force in Burma that cultural workers are unable to generate work unless silence is broken. Especially since the 1988 military coup, predominantly English-language discourses from both Burmese and non-Burmese scholars and activists have identified silence as the key to the Burmese state's authoritarian sensibilities even in times of less political unrest.[53] In 2003 a notable review from scholar Kyaw Yin Hlaing, a former military government advisor who now directs the Yangon-based Center for Diversity and National Harmony (CDNH), criticized Fink's text for what the author deemed an overemphasis on dissenting voices to military rule: "The fact that most people Fink interviewed appeared to be politically conscious people with strong anti-military sentiment also makes the book rather problematic . . . their unhappiness with the military regime often leads them to exaggerate their experiences with the government."[54] Both accounts frame how some anthropological discourse has the potential to reinforce the totalizing logic of Burma's "closed-door" and "ironfisted" policies or, alternatively, to insist that dissident experiences and tellings are "exaggerated."[55] Neither account necessarily leaves room for understanding how multigenerational, locally displaced, and far-reaching diasporic communities conceptualize notions of freedom under a legacy of militarized policing that does not rely on testimony alone.

The assumed failure of Burmese civil society to flourish is framed as the result of the military government's stifling of the right to freedom of speech, the seemingly most potentially liberatory outlet for citizens only when allowed out from behind closed doors. In this formula, testimony or speech is the antidote to silence. Comparatively, in the aftermath of the wars in Southeast Asia in the 1970s and the subsequent authoritarian regimes in Bhutan, Cambodia, the Philippines, and Vietnam, "breaking" or "shattering" silence about these periods (usually referring to media repression and censorship) has become a notable trope in contemporary scholarly discussions about democracy movements in these nations.[56]

Yet, why would analyzing testimony alone not work in the context of the Burmese diasporic arts scene? This analysis elaborates on a performance studies approach to diasporic artists' own insistence on bodily vulnerability, especially as the latter theorizes the value in evading testimony. Performance theorist Julie Salverson has critiqued testimony as its own genre within performance art and theater, arguing that the conceit of a single "authentic" history of postconflict trauma and state violence derived from testimony alone inevitably falls short.[57] These critiques of testimony challenge the genre and how it has already been deployed in juridical forums in ways that can work against those providing it. For example, within international human rights tribunals and spaces of human rights advocacy, as Ian Patel notes, experts' curation of spoken testimony as a primary source of evidence can potentially "risk the disenfranchisement of witnesses from the meaning and uses to which their testimony is assigned."[58] For Salverson and Patel, exporting testimony for diverse uses can create distance between the witness and their sense of ownership over their testimony.

This is not to fault the role of testimony as a healing component for communities who have experienced collective trauma. Notably, performance and refugee studies theorists Michael Balfour and Nina Woodrow call attention the important role that personal narrative plays in refugees' performances in specific genres, such as verbatim theater (performance of refugee or asylum-seeker transcripts), testimonial theater (refugees "performing" their experiences on stage), or playback theater (improvised interpretations of personal refugee stories). These genres are meant to deploy testimony as means of rectifying imbalances of power between refugees and various publics.[59] But these critiques also highlight how testimony, as deployed by human rights interlocutors, can sometimes recreate an imbalance of power between those delivering and those receiving testimony. This same imbalance can also bleed into how humanitarian and arts spaces echo similar juridical frameworks to evaluate artists. The same pressures may produce other affective responses and strategies and become illegible to the very human rights and arts interlocutors who hope to support displaced communities (asylum-seeking artists among them). What if, instead, humanitarian and arts interlocutors turn to alternative avenues for

community-oriented arts and reconciliation, not necessarily as "solutions" for the fallibility of testimony as a genre? Rather than as a binary between speech and silence, seen and unseen, imprisoned and freed, authoritarian and democratic, counterhegemonic Burmese diasporic expressive culture illuminates the limitations of speech and visibility as sole indicators of freedom of expression.

Comparatively, many Asian Americanist feminist scholars of literature and theater, such as King-Kok Cheung, Patti Duncan, Laura Kang, and Trinh T. Minh-ha, have theorized silence as the rejection of forces of militarized state policing, misogyny, racism, intergenerational trauma, language disciplining, and economic disenfranchisement.[60] In their interpretations, silence is not simply the absence of speech; it also signals other forms of communication that are immediately placed in a hierarchy, with regard to being heard as the most liberatory. Duncan draws on Michel Foucault when she suggests that the act of speaking or confessing is a fraught concept, as it "does not necessarily lead to liberation from power; rather it acts as the very process by which power is produced."[61] Instead of conflating an absence of speech as a loss of freedom, these theorists disaggregate how histories of diasporic migration are conveyed through speech or testimony that include but are not limited to migration, asylum-seeking, encampment, detainment, and multiple resettlement(s). Taking a cue from anticoup activists in Burma also helps to reconcile alternate deployments of silence: not as a *lack* of speech, but as a performative means of reclaiming public space from militarized occupation. On the recent two-year anniversary of the military coup in February 2023, streets in many of Burma's cities and rural areas fell quiet as pro-democracy activists called for a "silent strike," emptying the streets of people and closing businesses.[62] The stakes for Burmese activists and artists who currently live under the coup are different than those living outside the country, but some of the powerful tactics of evasion that artists and activists rely on are modes that also translate to diasporic contexts. While Burmese diasporic artists deal with legacies of state violence in their lives, they also simultaneously negotiate other intersecting forms of racialization as silenced apolitical Asian communities upon their arrival to the United States. These communities' acknowledgment of the "loss" of speech allows

room for intentionally letting go of humanitarian and humanist language as the only means for confronting concurrent histories of militarized trauma, which are often obscured in a US context.

Burma's Time Line in Asian/American Histories: Reconciling "Recent" Refugee Arrivals with the Diaspora

Throughout this project, the question of how to sense Burma in the popular imagination becomes urgent for artists and their supporters within arts and humanitarian industries. As Burmese diasporic artists have fled the threat of political persecution in the last two decades, their arrivals fit asynchronously with other time lines of Asian American, Southeast Asian, and refugee histories, specifically in the history of arts and humanitarian industries in New York. In the case of migrations by Burmese to the United States, recent asylum-seekers, political dissidents, and migrants disrupt assumptions of who and what moments constitute the "becoming" of contemporary Asian American subjects.[63]

In a 2014 report by the Asian & Pacific Islander American Scholarship Fund (APIASF), refugees from Bhutan and Burma were identified as "invisible newcomers" and the most quickly growing group of refugees migrating to the United States.[64] The identifier invisible newcomer, which links novelty and invisibility, promises a politics of visibility as potentially liberatory for some refugee populations at the cost of eliding both refugees of the past and future ones yet to be. Taking a broader view of the compounded displacements of the Burmese diaspora, I borrow from Kandice Chuh, who recognizes that the transnational convergences of intra-Asian, European, and US empires has resulted in migrations that challenge hegemonic paradigms of Asian (American) arrivals to the United States.[65] Similarly, Burmese migrations to the United States "slip into" the lacunae between more commonly recognized upticks in migration that are partly motivated by periods of relaxed US immigration restrictions. These movements contribute to how Burmese communities elastically fit in and sometimes exceed the bounds of who qualifies as part of recent Asian American histories.

I partly attribute Burma's "out of bounds" quality to its historical fit within a regional framework of US-based area study and popular media in the wake of World War II, as nationalist forces in the country fought for independence. Before the war, Burma was both a recent subject of Japanese occupation and two centuries of British colonial rule.[66] After independence from those colonial powers and a series of uprisings and attempts at democratic governance between 1948 and 1954, a succession of militarized governments took hold in the country, including a coup that ushered in General Ne Win's Burmese Way to Socialism in 1962.[67] Concurrently, the United States gained considerable influence over most of the world's industrial production and maritime trade, increased its military dominance over Europe's former colonies, and committed to "contain" communism globally during the Cold War.[68] The parallel formation of Asian area studies programs was supported by grants from the Ford Foundation, the Fulbright Foundation, the Rockefeller Foundation, and later by East Asian universities' funding to ameliorate visions of postwar Asia as perpetually weakened.[69]

This discursive "rescue" effort reverberated in how the first US and European civil servants to claim "Southeast Asia" were often trained in a specific Southeast Asian language in order to gather information about the cultures, social structures, languages, arts, and legal systems of the territories where they served.[70] In 1955 D. G. E. Hall's locative anthropological description of Southeast Asia as an " anthropologist's paradise" and "a "chaos of race and languages" in whose "mountains and jungles live the remnants of a great variety of people representing the early stages of its ethnological history," was symptomatic of some British and American scholars' racialized classification of Southeast Asia as a primitive space.[71] Hall and others insisted on the region's vulnerability to underdevelopment if not for the US and European civil servants who were beginning to produce national historiographies.[72] Yet, one could argue that this approach also diminished contentious debates over sovereignty and the decolonization actions happening at borders and in territories that comprised Southeast Asia.

In years since, generations of scholars who have inherited the legacies of this era have contended with the aftermath of how area studies might

more directly address the shifting geopolitics in the region in ways that do not simply reify Eurocentric discourse.[73] Carlo Bonura and Laurie Sears have noted that in the contemporary moment, "rethinking the practice of area studies is not a call for 'better' or 'more precise' or 'more steadfastly scientific knowledge,'" but "a call to come to terms with politics, tensions, and gaps involved in the production of knowledge about a particular region of the globe."[74] As the contemporary turn in area studies has recognized the shortcomings of engaging peoples and places solely through regional study, some scholars in area studies have critiqued Asian American studies scholarship for reifying the same regional divisions in recognition of their identities and political statuses.

According to Sylvia Yanagisako, while Asian studies as a category juxtaposes various social units characterized by diverse political, linguistic, and religious aspects, Asian American studies has somewhat essentialized Asian studies as a monolithic entity.[75] Yanagisako's argument leads me to engage with Asian Americanist scholarship that has sought to not simply acknowledge but to also refuse approaches that frame Southeast Asia and those subjects therein as a monolith. I draw from scholarship at the nexus of critical refugee studies and Southeast Asian American studies that attempts to firmly grasp how subjects of empire in Southeast Asia and its diaspora have contended with the specificity of their "homeland" legacies, including the particularities of borders, rather than with the monoliths of identity and nation across various displacements, migrations, generations, and resettlement. Yến Lê Espiritu has argued that this departure toward a "critical refugee study" is an active recognition of refugees as "intentionalized beings" who possess and enact their own politics rather than of refugees who are acted upon by war alone: "Critical refugee study scholarship conceptualizes the 'refugee' as a critical idea but also as a social actor whose life, when traced, illuminates the interconnections of colonization, war, and global social change."[76] Authors in these overlapping fields have historically demanded attention to shifting understandings of sovereignty, freedom of expression, freedom of movement, and world-making as they encounter others from parallel contexts upon diasporic movement.

What happens when Asian American studies and Southeast Asian stud-

ies consider overlapping temporalities in which dissonant waves of refugee migration are out of sync or unaccounted for within the dominant trajectories of US humanitarian benevolence? How does the particularity of each community's migration history present a conundrum to narratives of "recent arrival"? When the Burmese diaspora becomes submerged within broader narratives of Asian American history, how might this change current understandings of race and migration, inclusion and exclusion, as well as exile and arrival in the (Southeast) Asian American landscape?

Building within Asian American studies and reclaiming social sciences and humanities from its previous colonial implications with regard to Southeast Asia, scholars such as Rick Bonus, Lê Espiritu, and Linda Vo have shifted the sociological and historical paradigms around Asian American community formation in the US racial and cultural landscape to account for Filipino and Vietnamese migration with respect to contemporary forms of empire.[77] Even in these instantiating moments, Southeast Asian Americanists have been concerned with how Southeast Asia's intermittent visibility in US popular media prior to the Vietnam War has resulted in the uneasy inclusion of Southeast Asian communities (under the banner of "Asian American") as refugee, migrant, and exile populations. Subsequently, Vietnamese, Hmong, Laotian, and Cambodian communities (disparities withstanding) have come to comprise Southeast Asian America writ large in these studies of migration in the wake of imperialist wars in Southeast Asia.[78]

The analytic "Southeast Asian America" highlights the challenge of capturing how race and ethnicity travel by other names when they intersect with other experiences of border crossings, political status, indigeneity, and gendered and sexualized experiences at the nexus of empire, nationalism, and humanitarianism. Some scholars of Southeast Asian racialization in education in the latter half of the twentieth century have argued that intergenerational conflict and trauma are legacies of imperial and nationalist wars in Southeast Asia and have been undertheorized in the lives of survivors and their descendants.[79] Jon Iftikar and Samuel Museus also emphasize that US imperialism can help us better understand and teach about Southeast Asian American experiences, with the caveat

that the effects of imperialism also work in tandem explicitly with white supremacy and capitalism. For them it is especially vital to disaggregate "poverty" to underscore some Southeast Asian Americans' generational wealth pre-migration, to elucidate access to language and occupational mobility in the United States due to previous experiences with colonial infrastructure in refugees' countries of origin, and, for others still, the dissolution of formerly agrarian livelihoods through which pre-migration knowledge and skills are not valued within US education and society.[80] These disparities still contribute to the dualistic ways that Southeast Asian Americans are socially constructed and taught about in the United States, as Iftikar and Museus note, "as model and deviant minorities (e.g., as gang members, dropouts, and welfare sponges), depending on the context."[81]

Critical refugee studies intervenes in these moments of rupture. One of the more visible iterations of this burgeoning field is the Critical Refugee Studies Collective, a community of scholars, artists, and activists who have sought to reverse the dehumanization of refugees by rejecting the imperialist gaze and frames that include "sensational stories, savior narratives, big data, colorful mapping, and spectator scholarship."[82] Instead they insist on "humane reciprocal paradigms, dialogues, visuals and technologies" that "actively avoid the objectification of refugees while still attempting to illustrate crises and address refugee needs."[83] I acknowledge these aforementioned critiques as a way to sit with the productive tensions that exist between area studies and ethnic studies, and I situate *Performing Vulnerability* as invested in these debates when (Burmese) communities' diasporic migration frustrates both Asian and Asian American studies' disciplinary logics of organization.

The irregularities of Burmese diasporic community formation push the fields of Southeast Asian studies, Southeast Asian American studies, and critical refugee studies to account for the particularities of displacement from those regions and borders within (Southeast) Asia to the Americas considered more "minor." The slippage between categories of "refugee," "immigrant," and "exile" are not easily contained in some cases. In 1967, in the aftermath of the Ne Win–led military coup, Chinese immigrants and their descendants in Burma became targets of racial violence and

socioeconomic exclusion by Burmese nationalists, leading to Sinophobic riots. As a result, some Burmese-Chinese communities were "pushed" out of Burma and "pulled" to the United States by the Hart-Celler Act.[84]

According to Joseph Cheah, scholar of Burmese migration and Buddhism, under this logic they already unofficially met the 1951 definition of "refugee" according to the United Nations.[85] At the same time, Cheah contends, those Burmese-Chinese who ended up in the United States "re-ethnicized" themselves by changing their names in order to claim Chinese identity, settling more easily into businesses, networks, and political milieus within existing Chinese communities in the United States. Since these histories of "re-ethnicization" seem to fall in the cracks between other periods of more easily legible Asian immigrant and refugee histories in the United States, they end up being read as a case of upward class mobility enabled by racial passing. However, this simplified equation does not necessarily engage the historical illegibility of subjects from Burma in the United States who deal with multiple legacies of postcolonial, nationalist, and militarized authoritarian violence. As Lê Espiritu cautions, narratives that attempt to propose assimilation as the solution to "the refugee problem" flatten out the complexity of the disparate histories between displacement, arrival, and resettlement, "thereby reducing the specificities of [refugees'] flight to a conventional story of ethnic assimilation."[86]

Further into the post–Vietnam War era of the Cold War, the institutionalization of the 1980 Refugee Act meant a sudden increase in economically and physically dispossessed refugee populations from Southeast Asia in the United States. Burmese communities' inclusion within refugee histories of resettlement in the Global North unsettles previous paradigms of immediate post-1980 Refugee Act migrations. This work's focus on diasporic time lines draws seemingly disparate US and Burmese Cold War–era national events into conversation as they shore up critical sites and moments of displacement that scaffold prevalent themes in Burmese diasporic art. Korean Americanist and feminist scholar Crystal Baik theorizes about the role that diasporic cultural works play in mediating submerged historiographies of the Cold War as provocative points of disorientation. As she writes, "Conjuring contradictory memories precluded from dominant

historiography, this reinterpretation of the past as plural transforms one's orientation toward the future insofar as the present moment embodies a pressing sense of multiplicity that cannot be easily pacified."[87]

To consider these events as markers of the plural pasts of disparately situated Burmese subjects is to recognize their hopeful investment in potentially overlapping liberatory futures. In both 1988 and 2007, student, civilian, and nonviolent *sangha* protests against military rule in Burma uprooted political artists and activists fleeing state retribution and contributed to their initial migrations. During these periods the state shut down universities, enacted state-sanctioned curfews, and outlawed public assembly in spaces of religious worship to prevent civilian political organizing. These interruptions extended many artists' and activists' time to degree, influenced the content of their work, and catalyzed their entry into the diaspora. Here, too, in the context of other Southeast Asian migrations to the United States, Burmese diasporic communities are not necessarily legible, though the legacies of the 1980 Refugee Act implicate the communities from Burma who came to the United States in the late 1980s through the 2000s.

Between the years 2000 and 2015, the population of refugees from Burma/Myanmar who were officially counted in the US Census grew from 17,000 to 168,000; this number includes Karen, Kachin, and Chin refugees who moved to the Midwest and the South by the thousands every year.[88] Under the term "Burmese diasporic subjects," the category "Burma/Myanmar" is constituted of at least 135 different ethnic groups, each with a fraught history of ethnic minority nationalism that conflicts with the statecraft of the Burman majority.[89] As of 2019, Myanmar is fourth on a list of the world's countries from which the highest number of asylum-seekers and refugees have fled, taking into the consideration the 1.1 million communities of Rohingya Muslims the state has displaced.[90] Additionally, popular media rarely mentions these communities in terms of land dispossession or Islamophobic xenophobia, and these nuances get reduced to blanket terms of "ethnic conflict" alone.

Following a decade of elected civilian government, in February 2021 a brutal military coup ousted the civilian-led National League of Democracy

government. The military instituted a nationwide lockdown on internet access, media outlets, and NGOs, and has detained hundreds of governmental officials, some of whom have died in custody under suspicions of torture.[91] While maintaining "business as usual" through the touting of military-led tours through seemingly quiet Burmese cities meant to show peace and calm to international journalists, there have also been reports on the incarceration of and maiming and killing of local journalists, artists, protestors, and civilians, including youth participating in the Civil Disobedience Movement (or CDM) consisting of marches and labor strikes.[92] Given Burma's compounded histories of upheaval, in which over 680,000 are already displaced (including Rohingya refugees at the Bangladesh border), another 200,000 from Kayah, Kayin, Shan, and Kachin states became internally displaced persons after the coup. Meanwhile, military factions of these ethnic groups are engaged in armed fighting with the coup's military forces.[93] These displaced populations are not politically recognized as refugees and are embroiled in conflicts of political, economic, and land-based sovereignty within the state. In considering US data on asylum-seeking populations from Burma, this data is complicated by the fact that ethnic minority groups may not identify as Burmese due to their complicated relationship to the Burman ethnic majority. With these statistics in mind, current census data and other "official" forums that may categorize those who have fled the violence of the Burmese state remains incomplete. However, rather than viewing these realities as an anomaly, the artists featured in this book insist on such "incompleteness" as part of the compounded legacies of previous military coups and intervention from the Global North and the processes that continually impact diasporic communities and their work.

Upon migration, these communities' differences get collapsed into the category "Burmese," which then become a catchall for disparate intergenerational histories of movement, religious affiliation, sovereignty, and ethnonational recognition. When it comes to data on refugee resettlement, the specific conditions of various communities' mass upheaval that precede refugee status are often aggregated with data on the migration of immigrant communities who have encountered other reasons

for movement. Acknowledging these complexities, this project offers the term "Burmese diasporic communities" to refer to numerous generations and ethnonational waves of migration. At times the term also refuses the easy categorization of "refugee" as distinctly knowable and separate from "asylum-seeker," "migrant," or "immigrant" community. These formations trouble core assumptions around histories of "recent" arrival and overshadow longer histories of empire.

While art in the tumultuous 2010s coheres a particular cohort of artists for the purposes of this book, recognizing the asynchronous elements of Burmese diasporic dispersal in friction with US Asian immigration acts and Cold War politics complicates hegemonic histories of US immigration. This is not simply to "include" diasporic Burmese and Burmese America(ns) as necessary parts of an Asian American ontology, but to reconsider the rubrics of how Southeast Asians are racialized as vulnerable, or, alternatively, as a drain on the legal and political systems in ways that can transfer to humanist-oriented systems of art and commerce meant to support them in their migration and resettlement. These are particular systems that sometimes align them with other communities of color, especially in the contemporary diversification efforts in arts and humanitarian markets.

This analysis follows the "Burmese diaspora" to attend to some of the difficulties of encapsulating the moving demographics of Southeast Asian America and contextualizes the shifting political and affective terrains that recent refugees and asylum-seekers face upon their diasporic movements to the United States. Cultural producers living in between the temporary residencies offered by the United States and Europe, and who comprise a part of these communities of refugees and asylum-seekers, also deal with varied manifestations of white supremacy, racial capitalism, xenophobia, and misogyny, specifically in humanitarian and arts spaces.[94] Thus, elastic vulnerability also offers a pedagogical strategy for engaging the question of agency and movement within and in excess of racialized and gendered human rights discourses, especially in arts and humanitarian spaces, often well intended and in support of artists.

New York as a Locus for Diaspora, Humanitarianism, and the Arts

When pursuing this research it has become increasingly apparent that a "diasporic" space is not solely defined as a place exclusively "outside" of Burma or outside of the state's censorship and military rule. Rather, the diasporic aspects of Yangon, New York, and Chiang Mai, along with the experiential legacies of military violence, are often determined by survivors' sense of temporal, ontological, and geographic proximity to these forces. New York became a fitting venue for an inquiry into diasporic culture due to the dense networks of informal galleries, museums, and NGOs. These spaces house artists' and activists' "post"-conflict narratives and disrupt when and where appropriate research of diasporic communities should take place. This current project tracks how displaced and diasporic artists wrestle with the afterlife of their previously known authoritarian landscapes and subsequent humanitarian interventions. It is informed by the backdrop of New York City. In New York, conditions under which exiled and refugee artists labor—despite expectations of a cosmopolitan and international arts hub—are not necessarily a paradigmatic place of free expression. However, the unique and specific intersection of arts and humanitarian industries in the city embed themselves in the lives of these artists and shape the way the legacies of both authoritarianism and humanitarian benevolence continue to take root in artists' and advocates' lives on- and offstage. Thus I limit the scope of many of my arguments to primarily US-based and sometimes New York–based iterations. The nexuses of humanitarian and arts funding manifests differently in other cities and inevitably varies by region throughout the diaspora. These dynamics also reveal how Burmese diasporic art has a reflexive relationship to the disparate community entities and stakeholders that anchor their production and circulation.

During my fieldwork I encountered wide-ranging diasporic community initiatives in New York, such as myME, a mobile education project that encourages underage Burmese tea shop workers to get secondary education; the Burma Global Action Network, a social media/internet-based resource group for humanitarian actions associated with Burma; the Myanmar

American Musical Arts Society, comprised of Burmese classical arts, musicians, and dance practitioners and preservationists; and 3Medium, a Burmese-language rock cover band that fundraises for medical and educational supplies for internationally displaced persons. Community members, families, friends, and other activists and advocates brought all these organizations to my attention. Members of these organizations comprise, in some part, the audiences who repeatedly showed up at community events, fundraisers, and exhibitions. Curious as to why diasporic community members show up to artists' presentations and performances but why the formal art market itself seemed to only pick certain types of artists to curate and promote, I narrowed my focus within these communities' labors to highlight the outlying type of art considered subversive or untenable to most diasporic communities and how this art goes unrecognized as arts in conversation with human rights work.

This work looks at the period from 2008 to 2019 and offers a snapshot of the dialectical relationship between the international arts market and the humanitarian industry in the lifeworlds of exiled artists who sought out the spaces open to curating and exhibiting their work. Some artists featured in this study temporarily or permanently lived and worked in ethnic enclaves of the Williamsburg and Greenpoint neighborhoods of Brooklyn and in Elmhurst in Queens—which all have been increasingly gentrified since. These places also present moving sets of relationships between newer and older generations of arrivants in the United States. Artists moved through exhibition spaces in Chelsea, Chinatown, and the Upper East Side neighborhoods in Manhattan as part of negotiating their livelihoods while pursuing fellowships or temporary engagements. These gigs fostered encounters between artists representing "Southeast Asia," "Burma," and other underrepresented communities within international museum settings.

During the initial research phase for this project, the thought of taking a research trip to Burma to research the contemporary political landscape felt foreclosed. On the heels of student and civilian protests during 2007 uprisings, this foreclosure drew me to the question of how Burmese diasporic artists deal with the predicament of transporting histories that often

evade the traditional parallel forms of archiving and curation. In the decade of civilian government preceding the 2021 coup, there were burgeoning efforts on the part of local Burmese scholars and international research societies to further establish state-supported research around national archives and culture in the context of the country's "opening up." While these events spurred the urgency for this work, the research of politically sensitive subjects comes with differentiated and measured amounts of risk for all parties involved. Even as internationally recognized fellowships such as the Fulbright have been available for US citizens, such support for artists and scholars to travel to Burma has been inconsistent due to the fluctuating risks of traveling there.[95] As a result of these conditions, and to avoid risking the safety of dissident artists and their work due to Burmese censorship, I committed myself to focusing this project on New York. The artists and their supporters I encountered manifested a scene that unfolded over the course of a decade but, due the increasing cost of living and upticks in xenophobic state policies in both Myanmar and the United States, these scenes have largely shifted away from the locus of New York and now manifest in metropoles in East and Southeast Asia such as Bangkok, Singapore, Hong Kong, and Tokyo.[96]

At the same time, there has been ongoing work in Yangon to nurture visual arts and performance traditions. To name only a handful, performance and visual artists Aye Ko of New Zero Art Space, the late Nyein Chan Su of Studio Art Gallery, and Moe Satt, creator of the annual performance art festival *Beyond Pressure*, have attempted to document shifting scenes of contemporary art in Burma. There is also momentum among the women's performance art scene that means to interrupt notions of everyday space, including at ports, megamalls, and marketplaces, such as Emily Phyo, Ma Ei, Phyu Mon, Yin Nan Wai, and Zoncy, all of whom were featured in the documentary *For My Art*.[97] Natalie Johnston, a curator originally based in New York, relocated to Yangon in 2012 and founded Myanm/art, an "art gallery, exhibition space and reading room featuring emerging contemporary artists from Myanmar."[98] The Creative Resistance Fund has noted the stability around a flourishing arts scene in Yangon in a post-transition moment that features exhibitions of artists, musical

concerts, poetry readings, dance events, life drawing sessions, artist talks, lectures, and tours.[99] Informed by renewed international investment and interest in the country, art scenes in Yangon have flourished with increased infrastructure in international arts funding and urban development projects prior to the most recent coup.

While I acknowledge the simultaneous and parallel connections between growing diasporic art sites, I resist the notion that the examination of one diasporic site (like New York) can even begin to translate, neatly adhere to, or analogously represent nationalist or humanitarian geopolitics of another site (like Yangon). In the case of Burma and Southeast Asia more broadly, especially as those expelled from the nation-state have most often relocated to bordering countries or to refugee encampments on the borders rather than farther abroad. The specific dynamics of how human rights advocates frame artists as coming from either "authoritarian" or democratic spaces, whether "free" or "unfree," is rightly frustrated by these contingencies.

In New York, recent arrivals also deal with legacies of a post-9/11 world, where overall securitization and the presence of police and Immigration and Customs Enforcement (ICE) officers have increased, while national austerity measures in the arts affects nonprofit organizations. Recent immigrants, migrants, refugees, and asylum-seekers coming from nations experiencing both "postauthoritarian" transitions and ongoing militarized regimes must also deal with the blows dealt by the recent US administration in the form of travel and asylum bans. Upticks in fascist state responses to noncitizens, such as the increased implementation of deportations and xenophobic immigration policies, have affected how recent arrivals are subject to quickly shifting regimes of racialization. These conditions also contribute to ongoing pressures that artists, their advocates, and granters have faced in terms of making frugal and curatable work possible. These actors contend with shifting rental markets, lack of access to galleries, and limited or time-sensitive resources available to asylum-seeking and diasporic artists on residency or fellowship in New York. Together these processes create a mise-en-scène in which Burmese diasporic artists and others labor to find the "right space" to install or in which to perform

timely work, all while trying to respond to conditions "at home," however physically far they remain from Burma. These artists must also contend with curatorial trends toward diversification that represent transnational and regional connections with Southeast Asia as well as the shifting geopolitical relationships around human rights between the United States and countries of Southeast Asia, which exceed conversations about the Cold War and cohere around more recent refugee arrivals, immigration restrictions, and deportations.

Mixed Methods: Performance and Ethnography

Between 2012 and 2014 I conducted twenty formal interviews with audiences, curators, artists, and community organizers who hosted events attended by funders, patrons, foundation representatives, curators, other artists, and Burmese diasporic community members. These interviews lasted between ten minutes and two and a half hours. I also conducted a handful of informal interviews of varying lengths among attendees and audience members at Burmese diasporic performance and community events; interviewees included representatives from grant institutions, curators, patrons, and other artists. These mixed interviews have allowed me, in part, to attend to the textual, performative, and ethnographic dimensions of artists' and activists' work. During the interviews it became clear that, more than "evidencing" vulnerability, the relationships fostered through art and fellowship, patronage, corporate donation, nonprofit fundraising, and residencies reveal an asymmetric relationship between aid "recipient" and "donor." When discussing trends in the funding streams among the circuits of Burmese diasporic artists and their allies, the names of certain organizations repeatedly came up as supporters. I also spoke with the organizers and nonprofit workers who advocate on behalf of artists and collaborate on shows' themes, publicity materials, and exhibition and performance sites.

The interviews took place in varied spaces, including school cafeterias, office buildings, galleries, meditation centers, and university lecture halls in Manhattan, Brooklyn, Queens in New York City and at Cornell University

in Ithaca, New York. In some transient moments the details of a performance space, an artist's talk, or a gathering of community members helped contextualize how diasporic subjects assemble community rather than the responses during interviews themselves. While most interviewees reside in and around New York City, they also travel and exhibit their works in Yangon, Myanmar, at Burma-Thailand border cities such as Chiang Mai, Thailand, and at academic conferences focused on Southeast Asia, in places such as DeKalb, Illinois, and Ithaca, New York.[100] In the spirit of transparency, I am a second-generation Burmese American cis woman of Shan and Chinese descent who grew up in Brooklyn, New York, and for whom questions of political sensitivity with regard to diasporic cultural production are both personal and political.

With these disparate spaces in mind, I work against the dominant understandings of Burmese expressive culture made under censorship as "in need of rescue" and expressive culture made in the Global North as innately "free." This mode requires that both artists and myself engage in conversations not easily categorized as traditional ethnography, resisting the idea that diasporic communities living outside their national contexts have no stake in humanitarian or artistic production. Reflexive ethnographic inquiry requires that scholars remain flexible to and cognizant of our differentiated and privileged access as researchers but also not diasporic subjects who must face the Burmese state on a daily basis. Neither for those living in the diaspora do the sets of data one "collects" in the field neatly adhere to social scientific quantification or qualification.

For this reason and others I draw on both performance studies and ethnographic inquiry to account for how artists wrestle with the messiness of freedom within humanitarian and arts industries, as well as how they and their advocates experiment with performative claims to freedom that exceed the language of human rights. This work builds on the scholarship in critical refugee studies, specifically on the work of Lê Espiritu and Lan Duong in their articulation of "feminist refugee epistemology" that insists on political possibilities of "what off-screen violent acts remain unmarked" with regard to naturalized representations of spectacular military atrocity against women.[101] My focus on artists' performative and performance work

at the intersection of humanitarian and arts industries aims to broaden what worlds are possible when decentralizing the visual encounter of (refugee) women as naturalized victims of military atrocities.[102] I gravitate toward the speculative role of performance as being what helps artists straddle the line between what Lê Espiritu and Duong call "off-screen violent acts" and "joy and survival practices that play out in the domain of the everyday."[103] In a more granular sense I suggest that artists' off-screen labors include how they creatively adapt violent scenarios of rescue and also how they mediate moments of violence with moments of joy and survival in order to obtain grants and find networks to sustain themselves "off-screen."

While Lê Espiritu and Duong situate the term off-screen in primarily unseen visual encounters that happen every day, I look to how artists' maneuver across the blurred line between the everyday and the performative to address the felt, the illegible, the theatricalized, the purposefully hidden, and the strategically inaudible. In a parallel arena, performance theorist Diana Taylor, who has analyzed the work of Madres de Plaza de Mayo activists who demanded accountability from the Argentinian government for their disappeared children in the wake of civil-military dictatorship, performance necessarily attends to how "the archive exceeds the live."[104] Taylor convincingly argues that artists and activists are particularly adept at embodying knowledge so that postconflict societies may not forget the imminent presence of the state disappearance of political agitators and student activists. For her "the repertoire" is a politically enabling set of performative rituals that "enact embodied memory: performances, gestures, orality, movement, dance, singing, in short, all those are usually thought as ephemeral and non-reproducible." Parallel authoritarian regimes' management of national archives have inspired historians, archivists, and feminist and queer cultural theorists to take seriously the ephemera and traces often left out of official state archives — "haunting," "memory," and "affect" — as the foundations for tracing occluded participants in history.[105] Thus performance as a medium, with live and felt attributes, provides some refuge from these dangers of "capture" by the state and international rescuers.

The purpose of this work is not to reveal or expose what is purposefully

hidden, but to luxuriate within artists' and cultural producers' invitations to *sense* their vulnerability alongside them in both their everyday labors and their staged works, as well as to contextualize where and when freedom lives for them rather than assume how it exists according to others. Critical refugee studies and feminist theorist Fiona Ngô has suggested that the regulatory discourse of citizenship is limited by the pretext of visibility: "The dominance of the equation of visibility with representation and, ultimately, with power is problematized by the narrow registers of representation and recognition that one must adhere to if one wishes to access the power of publicity, of belonging."[106] Ngô turns to how the aestheticization of refugee bodies intervenes in imperial forms of visuality, especially as war-centered governance and surveillance have sought to regulate other aspects of what is sensate and sensible about refugee communities. Similarly, to engage diasporic cultural production that happens at the nexus of global art and the humanitarian industries is to remain flexible to those vulnerabilities that artists and organizers employ, often as overlapping axes through which they engage with each other. This combination of methods attends to how artists and their advocates employ performative tactics that allow them to wrestle *more* "freedom" out of both liberal and illiberal mechanisms of the arts and humanitarian industries, often by grasping onto "freedom" beyond the scope of liberal humanist expectations.

Thus I draw attention to what is at stake in both the affective and performative power of the range of whispers, murmurs, chants, covering of one's body in plain sight, and self-restraint that artists experiment with in encounters with diverse tactics of Burmese state policing and surveillance and, alternately, to acts that exceed the distinctions between silence and speech, visibility and invisibility.[107] When it comes to freedom of expression, a mixed-method approach takes seriously how an artist might propose groans or whispers as an effective means of communicating to the audience, even if it does not line up with expectations of "testimony." If an artist is dealing with expressing freedom of movement, a mixed-method approach pays attention to how they might deepen the notion of moving freely across borders or within encampment by invoking micromovements

of Buddhist meditative gestures many use when coping with displacement. Given the role of diasporic art's circulation within this book, I examine these same modes of performance as they dare to frame the "unspeakable"—highlighting the quotidian limitations of visibility, speech, and testimony as modes that automatically enact freedom (of expression) in arts and humanitarian spaces. In a parallel vein, Asian Americanist cultural theorist Cathy Schlund-Vials has articulated how, in the aftermath of the Khmer Rouge genocide, remembering is not only about "giving voice" to those who have passed but has a role to play in the context of debates around national reconciliation.[108] In a parallel vein, Allison Jeffers cautions against the prevalent concept of "giving voice" to refugees in theater work: the ethical implications are fraught with neocoloniality for those speaking on noncitizens' behalf instead of holding space for those communities to be heard from directly.[109] This book's orientation toward a range of responses that exceed the legibly visible and audible provides one approach for considering how dissidents, including artists, have made use of the Burmese state's enforcement of censorship and surveillance in the throes of authoritarian violence while also reimagining arts-based and humanitarian invocations of freedom.[110]

Organization of Content

The first two chapters establish the roles of and relationships between the arts market and the humanitarian industry as they advocate for human rights on behalf of diasporic artists. This broader expressive culture, which includes Burma as a site of human rights concerns, recognizes how these two industries inform one another in the lives of Burmese diasporic artists and activists. The subsequent two chapters are organized thematically to foreground the possibilities and limitations that select strategies of elastic vulnerability offer to Burmese diasporic artists and activists while simultaneously centering the debate over how we imagine the human rights subject and the "rescued" body as free. The analyses shed light on how elastic vulnerability becomes implemented in tension with different

discursive projects of human rights, including but not limited to asylum, freedom of expression, and diversity and inclusion initiatives.

Chapter 1, "The Humanitarian Industry: The Rise and Fall of Human Rights Heroine Aung San Suu Kyi," focuses on the contemporary and historical stakes of the humanitarian industry surrounding Burma/Myanmar and the centrality of the figure of Aung San Suu Kyi, a political prisoner and human rights icon who figures heavily in any human rights discussion about Burma and its political transition.[111] The metonymic relationship between Aung San Suu Kyi and Burma in film, media, and actual events highlights the aesthetic predicament of how scholarly and popular media representations frame Burma as both a carceral and a rescuable body that seemingly necessitates feminist and humanitarian rescue.

One of the key concerns of this chapter is to foreground the ways in which the humanitarian industry traffics in these aesthetic efforts, which often go unreconciled, as a way to map the politics of humanitarian intervention as well as contemporary discursive projects of rescue. Alongside a grounding of the role of celebrity forays into humanitarian efforts, key to the analysis is a feminist and performance studies approach to the trope of violated space rendered in contemporary film, music, and visual culture. I examine these mechanisms briefly using media circulating around Aung San Suu Kyi's time under house arrest, including the 2009 humanitarian work of the band U2 to free Aung San Suu Kyi, the activist afterlife of 1990s and early 2000s Hollywood biopics, the support work of funders and granters, and a brief analysis of Aung San Suu Kyi's speeches upon her "return" to New York.[112] This analysis of Aung San Suu Kyi's aesthetic "transformations" in the performative iterations of film, news, and popular media reveals the power of the "rescuable human rights subject" (mired within an unfree landscape) as it orients discourses of rescue in twenty-first-century human rights activism.

In chapter 2, "Diversity and Refuge in the Museum: The Guggenheim's *No Country*," I examine the tensions between the humanitarian industry and the international arts market that were at play in a 2012 show at the Guggenheim Museum in New York City titled *No Country*, which featured a diverse selection of emerging digital, visual, and new media artists

from Southeast Asia and addressed existing debates around migration and cosmopolitanism. The show was also undergirded by $40 million in funding by the Union Bank of Switzerland, a bank previously noted for its collusion with Nazi genocide and the Nazis' theft of security bonds from Holocaust victims, survivors, and heirs. The works presented in the show, by artists who had primarily grown up in the wake of genocidal wars and authoritarian conflict in Southeast Asia, manifested the tensions of how the museum hails artists' cosmopolitan subjectivities while artists themselves invoke the legacies of racialized state violence in the displacement of rural folk craft and documentation of Indigenous dispossession. This analysis also draws on concerns in critical refugee studies, postcolonial studies, area studies, and critical ethnic studies that focus on the prevalence of "borderless" discourse as it reproduces and reifies settler-colonial, economically mobile, and entrepreneurial subjects in tension with refugee subjectivities. Rather than unidirectional, this analysis ultimately shores up how large-scale museums work (sometimes in productive friction with artists' goals) to evidence vulnerability, both on artists' behalf and for their own relevance within the international arts market.

Chapter 3, "Freedom of Expression, Asylum, and Elastic Vulnerability: The Art of Chaw Ei Thein," uncovers the tensions wrought through contemporary technologies of "rescuing" art and displaced artists through curation and arts funding. I examine how the (formerly) exiled visual and performance artist Chaw Ei Thein combines self-injury, including gagging and blindfolding, to invoke freedom of expression in *excess* of attaining political asylum. Bringing to the foreground diasporic artists' journeys of displacement and detainment before their migration to the United States, artists' self-injury reveals transnationally linked political and economic conditions that constrain their migration. In these scenarios the United States is not the terrain of universal experiences of freedom. The interdependent relationship between foundation granters and grantees illustrates how each contributor needs to address their role beyond the simple formula of "benevolent patron supports exiled artist" in order to sustain each other. Chaw Ei Thein, who has been supported by fellowships and networks made possible by the Asia Cultural Arts Council, a

funding hub for Asian artists visiting New York, and freeDimensional, an arts grant and resource organization, confronts the United States as a site where artists must contend with a higher degree of artistic freedom punctuated with new constraints. By weaving in the programming work of freeDimensional, I examine how the most ardent supporters of exiled artists corroborate narratives of vulnerability on their behalf in ways that take cues from a broader humanitarian landscape surrounding Burma, refugee arrival, and dissident art.

Chapter 4, "Htein Lin: Unraveling the Dissident Body and Buddhist Transcendence," further illuminates the diasporic collaborations of exiled artists to redefine the terms by which they access freedom of expression in excess of humanitarian terms of "safety"—the terms of which are narrowly set out by some nonprofit organizations that support asylum-seekers upon resettlement. The chapter begins with an analysis of a 2012 exhibit titled *Yay-Zeq*, which featured sites of enclosure (pencil portraits of refugee camp life, archival political pamphlets on democracy movements, and taped video performances of incarcerated dissidents). Htein Lin, a survivor of political incarceration and refugee encampment, insists on "unraveling" the diasporic dissident body through performative binding and unbinding, meditation, and repeated use of symbols of Buddhist transcendence.[113] In this focus on unraveling, I examine how the artist disrupts international curatorial efforts to institutionalize performance art that, by design, is not meant to leave a trace. However, in the specific show *Yay-Zeq* and in other solo works by Htein Lin, elastic vulnerability hinges on the artist's creative unraveling of the goals of the international arts market, granters, and funders to chart specific paths for artists' freedom. In this spirit I illuminate the work of the Asian Arts Council in assisting artists in their acclimation to short-term fellowships in New York. Taken together, exiled artists and granters capitalizing on the language of "vulnerability" refuse to simply "overcome" *previous* political violence and insist on unraveling these experiences through the lens of *present* processes of migration and resettlement.

Ultimately, this work is a multivalent and interdisciplinary consideration of a vexed imaginary, with artists staking claims to freedom of expression

and freedom of movement while showing the limits that juridical human rights discourse imposes on them when naming their constraints within arts and humanitarian industries.[114] It is my most fervent hope that the dialogues traced here might reflect back to artists and their advocates, to the challenges they have encountered, and to our collective dreams for a world in which freedoms of expression and movement may be most robustly inhabited and lived.

1

The Humanitarian Industry
The Rise and Fall of Human Rights Heroine Aung San Suu Kyi

If you scanned the website of the rock band U2 in 2009, you would find it full of videos of screeching fans at all stops of the group's 360° Tour.[1] U2's mission for the tour, to circle the world, resulted in the highest-grossing tour at the time, with 7.2 million tickets sold and $736 million earned.[2] In one video the band stops in Dublin, where Bono, U2's lead singer, announces the recipient of the annual Amnesty International Ambassador of Conscience Award: Aung San Suu Kyi, who at the time was under house arrest at her estate in Burma.[3] Teens feverishly waved black-and-white cardboard masks of her face glued to wooden sticks. Fans could download a PDF of her face from U2's website; the mask came with instructions to cut out the eyes along neon pink lines, which makes wearing it seem less like an act of solidarity and more like a costume party. Bono's comments on the concert website say that fans could "wear [the mask] to work or college, when you're at home drinking a cup of tea . . . especially at U2 shows when the band plays 'Walk On,'" a tribute written for the detained leader in 2000.[4]

In this same clip, Bono's voice booms in the background as he likens Aung San Suu Kyi to as "powerful a voice and as strong as a leader in these times as Dr. King and Nelson Mandela were in their times." Ironically, it is Bono's booming voice that speaks in her place, comparing her to two Black male leaders internationally lauded for their nonviolent approaches to white supremacy in the United States and South Africa. The crowd meets these comparisons to Mandela and King, also imprisoned for civil

FIGURE 1. Printout of a page from U2's promotional material from the Walk On Tour, featuring Aung San Suu Kyi's face as a wearable mask. Photo by the author.

disobedience, with deafening cheers. When the cheers of the crowd are at their most climactic point, Bono urges, "Do you have a picture of her? Take it out. Do you have a mask? Put it on. Stand with her. Let us become her. Our face, our face. Aung San Suu Kyi!"

This battle cry to "become" her through the symbolic replacement of her voice, eyes, and mouth helped the predominantly white Irish audience to consummate a desire for proximity to Aung San Suu Kyi while projecting themselves as her comrades, even as substitutes for her "powerful voice." While U2 projects antiracist freedom movements onto Irish fans' spectacular version of a Burmese protest—where actual Burmese protestors are conspicuously absent—they situate the deracination of Aung San Suu Kyi as a necessary step toward highlighting the power of human rights protest to free others (fig. 1).

This example highlights the limited terms of some humanitarian proj-

ects in the twenty-first century: the freedom to *occupy* the body of the other in the name of human rights, to "share our humanity" to the point of performatively puppeteering other bodies. Political theorists Jemima Repo and Riina Yrjölä have theorized that the contemporary humanitarian industry follows a dominant aid-and-development model in which the "liberal project of civilization culminat[es] in an ostensibly paradoxical relationship to otherness."[5] In other words, they suggest, otherness is regulated in humanitarian industries to the point when racial and gender differences manifest; these differences are made to seem inconsequential. U2's spectacle titillates because "becoming Aung San Suu Kyi" dramatizes the endemically violent neoliberal condition of claiming human rights in the name of others. The concert producers and the band enact a symbolic occupation of Aung San Suu Kyi as the other, managing her racialized and sexualized difference for consumers as rescuable through occupation.[6] This occupation necessitates that Aung San Suu Kyi is attributed excessive vulnerability to the point where humanitarian interlocutors speak in her stead, transforming her into a rescuable subject while symbolically transforming themselves into victims of authoritarian state violence in order to sell the box-office-breaking experience of the concert itself.

U2's humanitarian efforts, and other spectacular gestures in the name of humanitarianism, illuminate the "transformative" potentiality of human rights discourse: interlocutors perpetuate rescue by affirming the racial(ized) and gender(ed) vulnerability of victims, who are only "freed" from militarized violence once human rights are discursively attached to them. Such pervasive patterns of managing rescuability have become embedded in the aesthetic milieu of the contemporary global humanitarian industry. These patterns extend the afterlife of spectacular moments of racialized and gendered vulnerability of popular figures, including celebrities and political prisoners, into the lives of refugees and asylum-seekers as they are discursively freed from being displaced communities without human rights and transformed into resettle-able communities endowed with human rights. Since the inception of humanitarian visual culture in late nineteenth-century colonial photography, those seeking to use artistic and ethnographic documentation to further humanitarian causes have

dealt closely with adjusting the perception of the conditions of hardship and suffering, as part of what art historian Francesco Zucconi identifies as the ever-changing relationship that images have to the institutionalization of humanitarian practice.[7]

In light of concertgoers' and U2's neoliberal management of racialized and gendered difference, how does the contemporary global humanitarian industry seek to transform assumedly vulnerable "victims" of localized state violence into transnational subjects possessed of human rights? What does the popular culture and film milieu surrounding Aung San Suu Kyi reveal about the relationship between performers, filmmakers, mediamakers, and others who intimately occupy the vulnerable (dissident) body to the point of obliteration? How does the humanitarian industry employ these representations in order to structure and normalize an aesthetics of vulnerability through the adjacent economies of giving and receiving?

First, by "humanitarian industry" I delimit the scope here to mean the webs of financial and political support, including but not limited to the grants and funding initiatives by nonprofits, governmental organizations, community organizations, and corporate institutions, that advocate for cultural workers. Cultural workers are the filmmakers, journalists, writers, artists, performers, and others who face imminent threats to their well-being because of their work. This claim is not meant to overshadow the labor of those who do not identify as cultural workers when applying for asylum, nor those who provide direct services in the humanitarian industry. Workers who labor under the umbrella of "humanitarian aid" most often include nonprofit workers, medical personnel, and international legal advocates who devise legal, medical, and political support for those under immediate threat of physical and/or political violence. Philanthrocapitalists and "celanthropists" (celebrity philanthropists) are a historical part of the scaffolding for the delivery of this aid in the humanitarian industry, a process that some have called a "'smokescreen' for corporations encroaching on areas which were previously nonprofit" and "a neoliberal practice in which 'charitable' activity becomes a means to increase corporate power—by stealth, and with an ostensibly moral alibi."[8]

Scholars of international relations, immigration, and humanitarianism

have examined the effects these diverse direct services (and providers) impose on displaced communities and how these services are always at risk of being less efficient, less inclusive, and less accessible.[9] In some cases scholars have noted the violence humanitarian service providers have perpetrated, especially in situations where withdrawing or withholding aid is a political show of strength to blockade war criminals but that can directly affect a distressed population caught in the cross fire.[10] Adjacent studies of the humanitarian industry have examined the commercial side of nonprofit and governmental fundraising, highlighting how the bulk of donor-based funds get siphoned off by the organizations themselves to offset operational costs rather than provide emergency aid.[11] Still other studies of the information and technology pieces of the humanitarian supply chain show that if donor behavior could be better addressed, the distribution of goods and services would be positively affected.[12] Together these assessments uphold the figures of the donor and the aid worker as key actors in how the humanitarian industry could work "better" in transforming the lives of recipients of goods and services. In these studies the donor and aid worker are the figures without whom already precarious supply chains, funding, and means of distribution would not exist.

My focus here lies in the mechanisms of financial and political support within the humanitarian industry that continue to create new values to racialized and gendered vulnerability, especially in showcasing vulnerability as still critical *after* emergency aid is delivered. Artists, grant writers, documentarians, filmmakers, journalists, scholars, and activists undertake this creative labor to provide a historical and political context into which threatened cultural workers can enter after political upheaval and displacement. Their efforts also have the potential to transform the popular imagination around displaced subjects and inform contemporary debates around migration. Collectively, these workers animate an aesthetics of vulnerability to both gain support for and help constitute the material and experiential contours of the humanitarian industry. Thus, naming the humanitarian industry as an industry highlights the densely networked policy, advocacy, fundraising, and marketing structures of humanitarian work that are increasingly oriented toward profit for survival, distribution,

and organizational sustainability among nonprofits, NGOs, and governmental institutions. But naming the humanitarian industry as an industry also disaggregates the vital labor encompassed in the underwritten processes, actors, and organizations—usually expended by diasporic artists (sometimes dissidents) and their advocates—whose industrious efforts to be legible and supported also make possible the other sectors of the humanitarian industry.

I begin with an exploration of how theatricalizing and financing rescue is part of the foundation of the contemporary humanitarian industry and how Burma fits into this legacy. The focus then shifts to the production of refugees' and asylum-seekers' vulnerability in popular films, in concerts, in celebrations of Aung San Suu Kyi in the Burmese diaspora, and in the performative afterlife of the circulation of all of these. The analysis includes a critique of the championing of performances of rescue within the biopic *The Lady* (2011) and the action film *Beyond Rangoon* (1994), extending the analysis to the performances at human rights fundraising events that circulated after these films premiered. Subsequent events included fundraisers on behalf of Aung San Suu Kyi, U2's Walk On Concert Tour, and a historic speech by Aung San Suu Kyi in New York after her release from house arrest in 2012. At these events, human rights interlocutors employed shifting rubrics of what makes Aung San Suu Kyi rescuable from domestic violence and militarized occupation and, alternatively, what made her ripe for transformative vindication from state-sanctioned ethnic cleansing. These examples reveal how human rights interlocutors must often manage dominant narratives of rescuability driven by popular film and media and must subsequently champion ethnic harmony and heteronormative domesticity on behalf of rescuable subjects in their work off-screen as well.

The term "rescuability" operates in a specific way within third world, women of color, and postcolonial feminist theories. In Chandra Talpade Mohanty's 2003 revisitation of her famous "Under Western Eyes" essay, the provisional concept of "third world womanhood" assembles a diverse set of troubling human rights imaginaries of "oppressed women of the Global South," in which overlapping tropes of poverty, victimization, lack of education, tradition, and domesticity reify rationales for liberal and

Western feminist intervention.[13] Rescue (discursively or physically) means distancing or removing afflicted subjects from the conditions that are considered innate to spaces in the Global South. In a parallel vein, Gayatri Spivak's canonical theorization in "Can the Subaltern Speak?" elaborates on racialized renderings of *sati* or *suttee* (ritual widow self-immolation), which are commonly read as either instances of "white men saving brown women from brown men" or religious Hindu widows "wanting to die." Ultimately, Spivak argues, these limited interpretations render the self-immolating widow's subjectivity unlocatable.[14] In this vein, such very familiar arguments can be extended to consider less familiar performance, visual, and film projects that operate under the broad agenda of humanitarian advocacy, where the absences and presences of racialized feminine subjects, whether "rescuable" or not, catalyze "live" humanitarian projects off-screen.

Thus, several of the scenarios presented aestheticize rescue within a cultural text or event in which a vulnerable subject is deemed in need of removal from a violent landscape. The focus then pivots to a consideration of how humanitarian interlocutors structure the norms of the humanitarian industry as they extend these scenarios of rescue of displaced communities in the performative afterlife of these encounters. By tracking how a performance's afterlife is activated following an event or film screening—moving between textual and performative analysis—it is possible to highlight how the humanitarian industry (and its economies of vulnerability) comes alive in the transitions between major and minor moments, as well as in seemingly major and minor spaces: the former overtly marked as moments of humanitarian spectacle and the latter more mundane. Pointing out transitions between major and minor moments and spaces of the humanitarian industry also affirms how various actors agitate under the constraints of economies of vulnerability in which vulnerability can have shifting, informal, and elastic value. Here, within these economies, the actors proliferate additional modes of enterprise in the performance arts and visual cultures and in human rights activism. In other words, by tracking the lingering events that occur outside discrete spaces and time designated for "rescue," it is possible to see how some interlocutors within the humanitarian industry further embed rescue into

the industry's everyday machinations while others deviate from it. Rather than critiques geared toward the in/efficiency of services or, alternatively, toward the quickening of time lines of refugees' acclimation to resettlement, the analysis illuminates critical times and spaces in which various actors wrangle with economies of vulnerability to manifest equitable lifeworlds for displaced communities all while still deeply entrenched in the humanitarian industry.

The Humanitarian Industry: How Specters of Activism, Humanitarian Celebrity, and Popular Culture Make a Scene

Historians Robert Bremner and Alisa Zhulina note that at the turn of the twentieth century, US philanthropy broadened its focus to building institutions for transforming society, specifically through the wealthy elite's taking a huge role in the funding of the arts, education, and cultural institutions as a vehicle for offloading their surplus wealth for the public good.[15] Celebrity studies scholar Jo Littler notes that early celebrity industrialists saw several benefits to philanthropic enterprise, one being as a way to elevate donors' social status or "to cleanse the[ir] names [as] wealthy industrialists from the taint of corruption"; these forays were "a means to bring greater recognition to their name, and to rid it from the smell of exploitation" while shaping the causes of the future welfare state.[16] Thus, for families like the Carnegies, the Rockefellers, and the Mellons, from the early twentieth century to the interwar years (between World Wars I and II) the early forms of philanthrocapitalism or providing "counterweight to the brutality of capitalism" led to building education and arts venues as a type of humanitarian activism and staking claim to a lasting cultural legacy.[17] Laying groundwork in the mid-twentieth century for the following decades, the connection between US corporations and philanthropy shifted to operate as a form of "soft power" through which arts and cultural diplomacy abroad served to "soften" the sting of strained foreign policy during the Cold War. These labors set the stage for the enmeshing of humanitarian advocacy as a way to frame the international arts market within US popular culture.

The historical entanglement of humanitarian enterprise and museums—a

prominent facet of the contemporary international arts market—shapes the backdrop of economies of vulnerability that contemporary artists must wrestle with (discussed later). At this juncture the focus is on how celebrities (and often CEOs and those in the entertainment industry) have played an increasingly larger role in transnational projects for global corporate growth that motivate local governance abroad to accommodate projects. One notable example is the United Nations' creation of Goodwill Ambassadors who, while brokering zones of celebrity philanthropy, further enable global corporate investment in local development regimes for famine relief, education, health services, and the arts in the Global South.[18]

Some practitioners have cited the colonial project that is implicit in the exponential growth of the humanitarian industry since 1989, growing from $500 million to $22 billion by 2018.[19] In an op-ed for Al Jazeera, social anthropologist Janaka Jayawickrama, who has worked in the aid side of the industry for over twenty-five years among disaster and conflict-affected communities, levies a critique of the industry in pointing to international aid as premised on "a fast-phase, top-down and resource heavy basis" that is primarily driven by UN agencies and NGOs, which often employ a "medicalized approach—diagnosis and intervention" to human rights crises.[20] According to Jayawickrama, these spaces reinforce how workers embedded in this industry are positioned in extractive, missionary, and colonial practices: "A colleague from Afghanistan once told me international humanitarian workers comprise three categories: missionaries (those who come to help and change the affected communities), misfits (those who do not fit in their own societies, so they become humanitarian workers) and mercenaries (those who come for the money). Of course, there are honest, committed, and genuine humanitarian workers, however, they are a minority and most of the time leave the field in frustration."[21] The implication of the presence of "missionaries, misfits, and mercenaries" in Jayawickrama's somewhat tongue-in-cheek assessment belies the racialized and gendered militarized saviorism that recenters the transnationally mobile humanitarian aid worker as a presumed source of benevolent capitalist action. In 2018 the Center for Global Development calls similar attention to the mismatch between humanitarians' intent and effects by means of a

"humanitarian business model" that orients the global humanitarian sector as "supply- rather than demand-driven" and, as a result, mismatches donors' funding practices with the specific needs of aid groups who assist "populations in need."[22] Scrutinizing the neocolonial elements within this "humanitarian aid model," widening what is considered the scope of the humanitarian industry, could more robustly account for how other types of organizations, advocacy programs, and performative encounters unevenly proliferate capitalist extraction in the name of human rights.

Focusing on the performative aspects of these encounters also situates the contradictions of the humanitarian industry purporting to "empower" vulnerable subjects in settings that reiterate vulnerability as a necessary component of not only their livelihoods but of others in the industry itself. Lilie Chouliaraki, a scholar of communication studies and (celebrity) humanitarian activism, identifies the "theatricality" of humanitarianism; it results in the celebrity "branding" of crises and can further amplify the public presence of human rights organizations themselves. However, these celebrity efforts to communicate human rights crises do not necessarily translate into sustained political, economic, or structural support in the lives of those directly affected by human rights conflict: "The logic of the theater, however, is not simply a logic of moral education but also of the market. It is by way of association, by putting a famous 'name to a message' and having 'people like you in our corner,' that the performance of humanitarian discourse can amplify the power of the organization. This logic of associational representation introduces a commercial dimension to the communicative structure of celebrity."[23]

Here the language that describes the theater, or in this case the figurative proscenium of celebrity humanitarianism with market logics, lends itself to a reexamination of what exchanges of power are happening at the level of the market, but also *in excess* of it. Furthermore, Chouliaraki notes that in recent decades, the "posthumanitarian" turn has spurred on celebrity activists and corporations, whose communication styles circumvent first-person accounts of atrocity in order to capitalize on branding opportunities. For this very reason she contextualizes how skeptics have devoted a bulk of the field to researching reasons to be wary of celebrity

humanitarianism's purported "authenticity" on several grounds, namely, "that it is linked to the historical power relations of humanitarianism: commodification, which spectacularizes suffering; and neocolonialism, which denies sufferers their own voices."[24] In a parallel fashion, Mary Mostafanezhad, in her analysis of Angelina Jolie's impact as an UNHRC representative delegated to address the conditions of Burma-born refugees and exiles on the Burma-Thailand border, speaks to similar accounts of interviewees reflecting on the "moral support" of the celebrity's visit that did not necessarily shift the material conditions of the refugee camp.[25] In light of Chouliaraki's and Mostafanezhad's arguments about the hegemonic power relations in celebrity humanitarian projects, Aung San Suu Kyi's positioning as a martyr primed for rescue — through occupation — could simply be an example of these hegemonic operations gone too far.

However, it is important to stress that Aung San Suu Kyi's entanglements with popular media underscore the theatrical efforts of diasporic cultural producers and others working in the humanitarian industry to play and experiment with affective and performative investments in subjects of human rights to forward their own goals. Aung San Suu Kyi herself has occupied the limelight as a celebrity human rights icon, political prisoner, and politician who has traversed the boundary between those defined in popular culture as rescuable or part of "populations in need" and state-level official engaged in purported acts of rescue. This slippage is possible because contemporary scenarios of rescue have a deeper history in the context of US military imperial maneuvers in Asia during the Cold War.

Yettaw's "Returns" to Southeast Asia: Humanitarian Landscapes Revisited

U2's desire to engage the "transformative" property of rescue fostered both a sense of intimacy and temporary occupation of Aung San Suu Kyi's body. Coincidentally, U2's concert tour kicked off a series of unfortunate events that might explain how spectacular celebrity humanitarianism helps shape the landscape in which popular urgent racialized and gendered narratives

of "rescue" thrive at the level of international human rights policy. U2 launched the 360° Tour just two months before American Vietnam War veteran John Yettaw was arrested for intruding on Aung San Suu Kyi's estate, where she had been under house arrest for nearly fifteen years.[26] Although he had never met her, Yettaw said he swam to her compound across Inya Lake, the largest lake in Yangon, to warn her that her life was "in danger": he had had premonitions of an impending assassination plot by the Burmese military.[27] After discovering him in her home and asking him to leave, Aung San Suu Kyi allowed Yettaw to stay due to his health complications from diabetes and epilepsy. Journalists later discovered that Yettaw was a Vietnam War veteran who suffered from post-traumatic stress disorder and had recently left his family to pursue a Mormon spiritual journey that included work at an orphanage in Vietnam, before heading to Burma.[28] Following this uninvited occupation of the home, Yettaw was arrested and charged for entering a restricted zone and breaking Burma's immigration regulations. The Burmese state dismissed the charges when a US senator vouched for his return to the United States three days later.

On May 13, 2009, Aung San Suu Kyi and two of her staff were arrested for violating the terms of her house arrest by accepting Yettaw into her home; she was later taken to Insein Prison then returned to house arrest once again. Her arrest and subsequent trial received worldwide condemnation by then–United Nations secretary general Ban Ki-Moon, by the United Nations Security Council, by various governments in the Global North, and by South Africa, Japan, and the Association of Southeast Asian Nations. In juxtaposing these events, which occurred within months of each other, pervasive logics of rescue consistently claimed Aung San Suu Kyi as a metonymic site of humanitarian intervention, spiritual sanctity, nonviolence, and maternal martyrdom, even as efforts to transform Burma through occupation worked against her actual freedom from incarceration. The specter of Yettaw's military service in wars in Southeast Asia, as well as his religiously motivated "benevolent" orphanage work forty years later (which preceded his attempt to "save" Aung San Suu Kyi), bring into focus the outcomes of late twentieth-century US militarized humanitarian

endeavors. While Yettaw's actions before his "rescue mission" at Aung San Suu Kyi's estate may seem incidental, the timeliness of events well captures the layered histories of US humanitarian intervention in the region.

These simultaneously ecstatic and violent scenarios of U2 and Yettaw's "failed rescues" highlight how the humanitarian industry extols or rejects celebrity human rights icons, which in turn helps maintain flexible and diffuse definitions of "freedom" and "democracy" that are changeable given the political environment. In this example, the (corporate) interests of the Global North conveniently align with those of popular liberal human rights discourses endorsed by international policymakers. These rescue endeavors of specific archetypes happen at the level of official policy, but they can also be further capitalized upon by interlocutors at the level of the humanitarian industry when it suits them, with lax attention to the aftermath of essentializing and collapsing disparate groups, time lines, or geographies of survivors of militarized violence, of the United States, and of regional imperialisms.

Since the start of the Cold War, humanitarian interlocutors have projected rescue narratives onto primarily (Southeast) Asian women in the industries of transnational adoption and sex work in the long aftermath of militarization of the Asia-Pacific region. Feminist sociologist Elena Shih has examined some of the contemporary counterparts of these industries in relationship to the nonprofit industrial complex—including voluntourism (aid work volunteering that perpetuates tourist industries) and philanthrocapitalism.[29] Shih's work, focused on Thailand, which shares a border with Burma, is one example of many that show tourist economies are scaffolded by the industries of Christian missionizing and sex work, both of which ingratiate local governments and populations to the existence of transnational rescue projects. In a related fashion, the US occupation in Vietnam, of which Yettaw was a part, resulted in infamous humanitarian spectacles of both vulnerability and benevolence, such as in Operation Babylift: after an initial failed mission that resulted in the death of 138 Vietnamese refugees, the United States airlifted 2,500 children out of Vietnam. Only after the children were placed with American families did people discover they were not, in fact, orphans.[30] In parallel

studies, scholars have also revealed contradictory US wartime policies, where state officials deemed it necessary for soldiers to have access to sex workers at "rest and relaxation centers" in Korea and Vietnam during the height of the Cold War while disparaging sex work economies at home.[31] These policies show the embedded quotidian nature of US and intra-Asian imperialisms and their effects on localized economies subsequently built on tourism by and service to imperial powers.[32] A wealth of transnational and feminist critique has posited that the legacies of the Korean War, the Vietnam War, and US incursions into the Philippines continue to make women, children, and queer communities vulnerable to labor exploitation as well as racialized and sexualized violence.[33] That being said, Burma fits somewhat differently into the popular imagination of humanitarian rescue during the Cold War and beyond, due to its history of isolationism and international economic sanctions.

Hierarchies of Value: Burma, Mass Media, and the Global Humanitarian Industry

Until recent years, the history of humanitarian intervention between Myanmar and the United States has been characterized by a formal relationship of intermittent economic sanctions and isolationist policies. While Western European nations and the United States have boycotted trade with some Burmese companies in the past, such actions have not stopped regional relationships at the Burma-China border that have privately supplied Burmese military with arms. This trade has exacerbated intrastate conflicts between the Burman majority state government, which holds these arms and Shan, Karen, and Kachin minority militias.[34] In the late 1990s some US pundits and policy critics decried the government's draconian surveillance programs, poor labor regulation, and institutionalization of martial law going unchecked by an international community.[35] John G. Dale, an anthropologist of the Burmese pro-democracy movement, observed that during the influx of corporate responsibility initiatives, which were meant to aid this movement, "even some influential Burmese activists in exile concluded that the pro-democracy movement (in the country itself) had

been politically hijacked by non-governmental organizations of the Global North that see in Burma only an opportunity to advance their particular human rights agendas."[36]

Yet Burma complicates the question of how spectacularity is achieved within human rights media and whether it can be the most effective venue for disseminating information about what activists are experiencing and what types of support they are requesting from international audiences. Especially important is the uneven circulation of news films and other media campaigns that produce hierarchies of witnessing, where certain publics are positioned as prime targets for humanitarian proselytizing and others as recipients of outreach. Sally Engle Merry, Meg McLagan, Faye Ginsburg, and other anthropologists of media have foregrounded the use of communication and digital media technologies by NGOs and human rights activists to mediate contemporary human rights claims intended for consumption by the Global North.[37] For McLagan, this category spans genres that include print, photography, film, and new digital media and engenders new social practices in the field of human rights activism. According to McLagan, the emergence of organizational structures that provide platforms for production, distribution, and circulation also proliferated new social practices, such as media training for activists in the field, creating outlets for distribution, and channeling media for classrooms, home video, movie theaters, online platforms, governmental forums (e.g., the US Congress), and intergovernmental forums (such as the UN World Conference on Human Rights).[38]

There is a primacy of what counts as spectacular, who produces it, and who is subsequently deemed rescuable in the context of Burma's human rights causes. In building on the work of feminist media scholars, it is critical to consider how the disruption of circulation of human rights media within liberal democracies and "authoritarian" contexts and by diasporic (including asylum-seeking and refugee) communities, points to the spectrum on which "democratic nations" are prone to surveillance and "authoritarian nations" can be architects of spectacular media visibility. Here economies of vulnerability might present another metric by which to understand how disparate actors within the humanitarian industry

communicate trauma and shared experiences in a way that circumvents simply feeding the humanitarian industry for the sake of visibility and audibility. In nations where media censorship has been a key feature of governance, the uneven and surreptitious circulation of human rights media is not often tracked, sometimes for the protection of those on film and sometimes for those circulating this media. These clandestine circulations disrupt neat notions that this work flows from resource-rich Global North sites of production and ideological creation of human rights norms and then trickles back down to the Global South, that is, sites of assumed human rights violations. As McLagan notes, the power of documentary, filmmaking, and media material produced by NGOs and media activists (not all from the Global South) heavily rely on international circulation to circumvent punitive governments, armies, and corporations to bring together communities of international interlocutors who may be able to offer support.[39]

While on its face popular film does not necessarily track as "human rights media," the following examples, which render Burma's experience through the fateful origin story of Aung San Suu Kyi, unexpectedly trouble this category, achieving awareness of Burma's authoritarian policies as well as decrying its effects on dissidents. While human rights media proliferate mediated forms of witnessing, these popular films' fixation on violent landscapes and human rights subjects' resilience achieve policy-oriented ends through their circulation while also motivating human rights-interested publics to act. However, as these films invite witnessing among broad audiences, they also feature troubling fictive landscapes as stand-ins for actual ones and broaden ways to editorialize who and what becomes defined as rescuable and worthy of support in humanitarian industries. Rather than considering such norms of rescuability as an anomaly, various arenas within the humanitarian industry reproduce Aung San Suu Kyi's story as a narrative of maternal and heteronormative domesticity under siege that allows different publics—filmmakers, actors, journalists, NGO organizations, and so forth—to participate in extending logics of rescue beyond the boundaries of the humanitarian industry. How might beginning from a place of unequal and differentiated positioning, and positions-in-transit,

for those deemed "vulnerable" lead to a more expansive rubric of vulnerability, even *economies* of vulnerability, and reveal how interlocutors play with the value of rescuability within arts and humanitarian industries?

Exiled at Home: Reviving the Incarcerated Heroine in Landscapes of Rescue

In an interview for an arts and culture publication upon her release from house arrest in 2011, Aung San Suu Kyi spoke of the consistent freedom of spirit and psyche she maintained while under house arrest: "After I was released, people used to keep asking me, 'What is it like to be free?' . . . And it was very difficult for me to answer—I always felt free. As far as my state of mind was concerned, I didn't feel any different . . . People ask me about what sacrifices I've made and I always answer that I've made no sacrifices—I've made choices."[40] The interviewer describes Aung San Suu Kyi's disposition as being in excess of what most people would be capable of: "To most people, this might seem like inhuman stoicism. Aung San Suu Kyi, plainly, is not most people." In the span of this short interview the journalist also focuses on Aung San's physicality; she is described as "small and delicate as a sparrow," such that "she is still, at 66, arrestingly beautiful."[41] The significance of reporters' descriptions of her physical fragility and beauty being alternated with her political prowess and transformative strength to "overcome" house arrest attest to the racialized and feminized exceptionality of Aung San Suu Kyi.

In a critical essay about Burmese media in the wake of authoritarian rule, feminist media theorist Lisa Brooten has argued that this representation of Aung San Suu Kyi during her incarceration as both diminutive and beautiful fortify the latter's "symbolic role as the most powerful feminine personification of besieged democracy alive."[42] Furthermore, Brooten suggests that these hegemonic representations help rationalize Orientalist "protection scenarios" leveled toward Burma, which preserve the United States as a "comparatively mature, masculine form of democracy run by highly competent yet compassionate leaders working to promote freedom and democracy worldwide."[43] Extending the work of other Burmese femi-

nist scholars such as Tinzar Lwyn, Burmese Americanist feminist scholar Tamara Ho taps into the peculiar singularity wherein Aung San Suu Kyi becomes the conduit by which global audiences engage a "romance" with Burmese human rights issues in the global sphere. As Ho explains, "Aung San Suu Kyi's unique intersectionality and singular ability to translate the Burmese situation to a global audience during her house arrest has become overdetermined and the *primary* avenue and harbinger of change."[44] Both fictional and documentary films have inspired humanitarian projects meant to support Burmese communities while at the same time reinforcing feminine-identified subjects as perpetually caught in the cross fire of human trafficking, economic disenfranchisement, or intra-ethnic and military violence.[45] Extending Ho's incisive analyses of the tropes of Burmese femininity at the forefront of discursive battlegrounds of both Orientalist fantasy and militarized atrocity, these films also structure the humanitarian landscape that surrounds Burma in recent decades.

It is worth noting here that popular media often narrate Aung San Suu Kyi's story in a linear fashion that segues from growing up in a destiny-bound family to fulfilling her father's legacy upon her return from worldly education and diplomatic experiences abroad. Her father, Bogyoke (General) Aung San, Burma's "father of independence" against British and Japanese colonization, was assassinated when she was two years old. Aung San Suu Kyi attended school abroad in England, India, and Japan, eventually taking a postundergraduate internship at the United Nations and subsequently living in New York for three years. She completed her undergraduate degree at Oxford University and stayed on in London where she met her husband, Michael Aris, a scholar of Tibet, and they had two sons.

In 1988, the same year that she began her doctoral studies in Burmese literature at the School of Oriental and African Studies in London, she was to called home to Rangoon (now Yangon), the capital city of Burma, when her mother, Daw Khin Kyi, suffered a stroke. This year was also significant within Burma's political history, as it is often defined as a watershed moment for student, sangha, and civilian-led, mostly nonviolent mass protest. Aung San Suu Kyi became reenmeshed in local Burmese politics, cohering her work with democratic movements and forming the political

party called the National League of Democracy (NLD), which spoke out against increased militarization of police against peaceful protests, surveillance, and economic inflation. At this time Aung San Suu Kyi was widely celebrated as "the Lady," "Amay Suu," or "Mother Suu of the Burmese nation," rather than as a beacon of human rights to political dissidents.[46] International media framed Aung San Suu Kyi's return to Burma as a destined political move on the part of this "prodigal daughter" to take up a political legacy of a "free Burma" that her father attempted to create at an earlier historical moment.

After less than a year in Burma, the ruling military junta placed Aung San Suu Kyi under house arrest and gave her the option of permanent exile, which she declined. After this ultimatum, popular media construed Aung San Suu Kyi as sacrificing the possibility of being with her English husband and children, who were periodically allowed to see her while she was under house arrest. She was released from house arrest in 2010, and in 2016 was subsequently elected to state counsellor, which is equivalent to a Burmese Parliament representative. She had become an official of the government apparatus rather than its most infamous opponent.[47]

Countering a strictly linear telling of her story, the filmic representation of Aung San Suu Kyi is entangled with the broader time line of humanitarian and human rights activism writ large, which has transformed Burma's rescuability in the popular imagination. The period between 1988 and the early 2000s, Aung San Suu Kyi's house arrest dovetails with trends within the global humanitarian industry that commodified biographic accounts of human rights heroes and heroines on an international scale. That time frame saw a release of a string of biopics that featured similarly charismatic protagonists, mostly Black and Latinx men, whom scholars and film critics often identify with international struggles for human rights and whose political struggles and periods of incarceration inspired international social movements. These films became tableaus onto which audiences could extol protagonists' virtues vis-à-vis their racialized masculinities, as they indelibly shifted the political and religious landscapes of early twentieth-century Indian independence, 1990s South African apartheid, and 1960s US civil rights struggles.[48]

In this oeuvre, Aung San Suu Kyi concurrently became the subject of many biographies, human rights campaigns, performances, and visual artists, including two English-language films, *Beyond Rangoon* and *The Lady*. Both films touch upon recent histories of civilian uprising; they bring into sharp relief the submerged histories around global media representations of Burmese women's racialized femininities on- and off-screen. They also contend with historical Hollywood representations of Burma that vanish Burmese people through abstract landscapes of warfare and military infrastructure. Ho invokes journalist Edith Mirante's catalog of Hollywood's representations of Burma, including films such as *Road to Mandalay* (1926), *Mandalay* (1934), and *The Girl from Mandalay* (1936). All present tropes of white women in jeopardy against a backdrop of Southeast Asia, where Burmese people are merely part of the landscape.[49] Burma's fictionalization further exists in interstitial battles over the Asia-Pacific region throughout World War II. Midcentury European and American films such as *Bombs over Burma* (1945), *Bridge on the River Kwai* (1957), and *Objective Burma!* (1945) take notable liberties in their historical representations of the country that suit the political narrative of the Allied war effort. These films depict Burma as a colonial battleground between British, Chinese, US, and Japanese forces.[50] Especially given the paucity of available media from the country during times of heightened media censorship and surveillance in subsequent decades, these Hollywood landscapes have stood in for global viewers' sense of reality about the country.

Fetishizing Dissidence and Making Dissidents in *Beyond Rangoon*

Beyond Rangoon stars American actress Patricia Arquette as tourist Laura Bowman, a young bereft white mother and widow whose husband and son were killed during an attempted robbery at their home in the United States. After this harrowing ordeal, Laura travels to Burma on a journey to seek spiritual and emotional solace.[51] Upon arrival, she wakes up from a traumatic recurring nightmare in which she relives the home invasion that took her family. To calm her nerves, she goes for a walk at night and unwittingly

FIGURE 2. Still from the film *Beyond Rangoon*. The actress, Adelle Lutz, playing Aung San Suu Kyi (unarmed), faces off with military personnel.

gets swept into pro-democracy movements in Yangon in 1988; she is struck by Aung San Suu Kyi's "beauty" during a silent standoff between Aung San Suu Kyi and military personnel. Both *The Lady* and *Beyond Rangoon* feature similar "stand-off scenes" that attempt to recreate the disrupted harangue of protests in 1988 in which Aung San Suu Kyi neutralizes the conflict by silently gazing head on, nearly casting a spell on militarized police force, which starts to disarm as she initiates an almost magical "pause" to the chaos of crackdowns on unarmed civilians (see fig. 2).

While the "appearances" of Aung San Suu Kyi's character in the film are brief, her influence on the mapping of Burma for the global imagination through a Western feminist lens is indelible. Aung San Suu Kyi's character in *Beyond Rangoon* is a catalyst for the political development of Laura Bowman, the Western feminist savior figure who realizes her dream to give medical care to refugee families when she escapes Burma via the Burma-Thailand border. As sociologist Matthew Hughey notes, "the white savior complex" in film may seem to be "racially charged saviorism [that] is an essentially conservative, postcolonial device that rationalizes right-wing paternalism," but this trope's execution "knows no political

boundaries and is pliable to contradictory and seemingly antagonistic agendas."[52] This aligns with the idea of Laura's political transformation from an individualized American widow to a symbolic messianic mother and doctor figure who shepherds refugee women and children recently wronged by the military. The film adheres to what Hughey sees as "interracial depictions of friendly and cooperative race relations [that] thus eschew any blatant dispatch of white supremacy"; its disavowal of Laura's presence in Burma belongs to legacies of American and European military occupation in the region.[53] To execute this story arc, the filmmakers obscure the country's colonial and political history and focus on decontextualized internal Burmese political strife.

Due to a lack of permits from the Burmese government in the early 1990s, the world the filmmakers create in *Beyond Rangoon* exists beyond Burma's borders and was filmed in Pelak, Malaysia. The production was also a mission to test legal encounters by baiting the rules on what would be considered unfavorable representations of Burma's SPDC government, which took power in 1988 after civilian protests, per the state's censorship laws.[54] British director John Boorman said he chose to film in Malaysia because of the similarities between Malaysian and Burmese jungle terrains and the timeliness of simultaneous anti-Burmese government sentiments in Malaysia in the early nineties.[55] Malaysian officials who had at first approved the film were in support of shedding light on the Burmese government's expulsion of one million Muslims from Burma into Bangladesh, rendering them stateless. However, in 1994, when Malaysian officials entered into trade talks with Burma, the Malaysian government asked that no reference be made to Burma in the film's script. During filming, the movie used the title "Beyond," and the crew was allowed to film in Malaysia only by promising that the film be set in an imaginary Southeast Asian nation.[56]

This "skirting of boundaries" became a directive in the Malaysia-based production process as well in the notable tension within the film's narrative around the Burmese state's threat to the white-grieving-mother-and-widow-turned-protagonist, an allegory for Aung San Suu Kyi. While the film alludes to a place "beyond," the film's language also marks the different types of political status that the crew and some actors had to deal with

from Burmese authorities sent to surveil the production. Publicity about the filming process, a spectacle in Pelak, also invited onlookers to empathize with how the cast and crew dealt with the various types of censorship they encountered. This included the surveillance of filming by Malaysian officials as well as by SLORC agents (Burmese military double agents), who infiltrated the film posing as cast and crew and reported back to their headquarters in Burma. As the threat of exile looms for the characters in the film who run from military police, the production process actually did subject Burmese and Malaysian cast and crew members to real-time suspicion of political activity for their involvement in the film. In other words, the film's plot allows Boorman to lead us into the pseudofictional lives of refugees, asylum-seekers, rebels, immigrants, and detainees while *creating* new de facto dissidents on set.

In Sheffield, England, three months after filming finished, Boorman reported feeling uneasy, confirming the presence of SLORC agents in the midst of his crew when on set. He even went as far as to say, "SLORC are notoriously devious in their activities and I had this fear that they were going to plant drugs on me. I can tell you, I was very relieved to get out of there."[57] In this seemingly minor off-screen admission the director negates potentially collaborative possibilities of aesthetics of vulnerability with his now-distant cast and crew. Instead of him proposing to work together to establish what conditions of risk he and his crew would be willing to shoulder, he forgoes solidarity with his disparately situated colleagues and recenters his own version of an endemically dangerous Burma. Boorman's admission highlights how easily the conditions of the surrounding humanitarian industry are able to infuse "fictional" scenarios with very real risk for dissidents and asylees, where filmmakers may proliferate racialization and gendering of human rights subjects as prime for rescue in ways that catalyze on-screen projections into becoming off-screen realities.

Ironically, Boorman helped create a version of "Burma" for his audience that he was eager to escape; it is a space from which he suggested citizens must persistently escape physical threats, subterfuge, and surveillance. Underwritten in this fictionalized version of Burma is the privilege of a white British filmmaker and the film's protagonists to embody the freedom

to leave seemingly inherently violent landscapes they want the audience to experience as "real." By the same token, the filmmaker deftly avoids any deeper engagement of the history of ethnonationalism and disproportionate violence against ethnic minority women by the military government in Burma and defaults to favorable treatments of Aung San Suu Kyi's character, which is often contrasted to the violent landscape that bore her. Boorman did not share the privilege of feeling relief from moving across borders and away from this space with some of his cast and crew. Rather, the production team risked retraumatization and further reembedded military political surveillance into the actors' and crew's lives.

This perspective is not to disavow the agency of anyone working on set who may acknowledge and accept the risks associated with their own acts of dissidence to be able to represent the historical period that preceded filming. Rather, it is to momentarily emphasize the role of the filmmakers in the Global North as willing architects of majoritarian narratives of dissidence against the Burmese state that *rely on* courting danger in the lives of actual dissidents to add transformative "reality" to their rescuable rendering of pseudofictional worlds for mass consumption. Not wholly unlike U2's "transcendence" of race and gender through a performance of occupation of Aung San Suu Kyi, *Beyond Rangoon*'s occupation of the dissident body on screen seeks to proliferate dissidents in order to sell the "reality" of the film. *Beyond Rangoon* circulated in the aftermath of 1988 student and civilian uprisings in Burma, while similarly violent moves to render "the real" within mainstream film representations of Burma precipitated the country's actual political transition. This is not to suggest causation so much as to consider how the correlation of these invitations to both witness and rescue are built into the structure of the film and its parting messages for audiences to get involved in humanitarian causes associated with Burma.

Realizing Carceral Landscapes in *The Lady*

The Lady is based loosely on Aung San Suu Kyi's own essays and published letters to her husband while she was under house arrest.[58] However, this

biopic about Aung San Suu Kyi's life, along with *Beyond Rangoon*, represent her as a heroic martyr and as a victim of a toxic relationship with the authoritarian state. Both filmmakers achieve a sense of danger enshrouding Aung San Suu Kyi by themselves taking calculated risks in the production process. By relying on and even courting the performativity of the state's surveillance, filmmakers are able to enliven elements of the militarized landscape and thereby frame them as inherently burdened by military violence. As a result, Aung San Suu Kyi's heroism and vulnerability to harm is more easily highlighted in terms of fragile heteronormative kinship and the ruinous masculinist landscapes from which dissidents are fleeing.

At times the filmmakers achieve this vulnerability by positioning Aung San Suu Kyi as the foil to their theatricalization of the panoptic Burmese state. For example, the film opens with a scene of generals debating on how to detain Aung San Suu Kyi and arrest her coconspirators while military police secure the compound with barbed wire and wooden blockades. The actress playing Aung San Suu Kyi—Chinese Malaysian martial arts, action, and dramatic film star Michelle Yeoh—watches, mostly silent as this militarized police intrusion happens. She calmly and tersely whispers to her children before and after the invasion to warn them about what to expect when guards in military vehicles pull up to the compound.[59] There is a moment when the camera fixates on a guard's hands prying the house number "54" off the front door, to complete the transformation of the home of a beloved heroine into an official space of state detainment.

Here, violations of the Burmese domestic space, beginning with the militarization of the intergenerational family home, mark physical violence against dissidence within the nation as foundational to the protagonist's family history. Based on satellite images and over two hundred family photographs, Paris-based action filmmaker and producer Luc Besson, along with the film's production team, went to great lengths to recreate her family compound in a full-scale model.[60] This attempt to apply a scalar reality onto scenes of intrusion by military police also extended to how the crew staged the whole city of Yangon as a site of detainment and terroristic threat to Burmese homes by the state through a series of recreations of the arrests of various allies of Aung San Suu Kyi, including writers, comedians,

FIGURE 3. Still from the film *The Lady*. The actress, Michelle Yeoh, playing Aung San Suu Kyi, stares out from inside her compound at the military soldiers stationed directly outside.

and satirists, each while sitting in their home. Combined with suspenseful violins in the musical score, the film constructs the stories of an unnamed few, followed by the story of the famous satirical poet and cartoonist Zarganar, as they are sent to Insein Prison, then bloodied by guards and kept in cages alongside wild dogs. The film sequences in succession various home-to-prison scenes to focus on those who came under suspicion of antigovernment political activity and were subsequently subjected to torture, including beatings, caging, and stress positions.[61] In effect, the protagonist's extended family history acts as a stand-in for the treatment of dissidents' family homes and the city of Yangon writ large (fig. 3).[62]

However, the trope of rampant military intrusion into public and private space borders on role play, considering that the filmmakers were subjected to brief and overt state surveillance during filming, in contrast to the sustained and daily realities of many of Burma's political prisoners. The offstage work of recreating Yangon and the experience of being under state threat brought Besson and his team momentary grief from both Burmese and Thai authorities. Besson, who has over fifty film credits to his name, notes his "commitment or stupidity" in interviews, recalling how he filmed some footage in Burma secretly and pretended to be an aloof tourist. His

The Humanitarian Industry 77

own desire to create a deeper sense of intimacy with Aung San Suu Kyi's place of residence, which motivated him to engage in a seventeen-hour affair with censorship and state surveillance, added yet another layer of "reality" to the facsimile of 1988 Yangon that he later staged in Thailand.[63] *Time* magazine, which reported this interchange, was the only publication allowed on the set during the principal hours of photography, due to the filmmakers' attempts to protect themselves from the scrutiny of the Thai government, as the latter was forging closer relationships to Burma's generals at the time.[64]

As a biopic, *The Lady* has the potential to rescript more interior moments that could potentially reject liberal feminist rescue of Aung San Suu Kyi but opts not to. The film also establishes a sharp physical contrast between the shadows of Aung San Suu Kyi's Yangon compound—framed by curtains fluttering but never fully pulled back—and her deferred life—represented in the stark light(ness) of her residence in London. This play on her domestic space as shadow animates her isolation as a singular hope for Burma's future. In contrast, every time the phone rings, the sound pairs on screen with the brightness of the open space of her family's residence in London as rain patters on glossy, reflective windowpanes. Reinforcing the polarity between the "safe" life Aung San Suu Kyi could have had if she had just "chosen" exile with a life under house arrest, this cinematographic dynamic between light and dark contributes to the global exaltation of Aung San Suu Kyi as a steadfast Buddhist martyr with an unshakable meditative presence. Aung San Suu Kyi's presence on screen theatricalizes the appearance of a "light in the dark." On the film set she is all but engulfed in shadows were it not for a partially lit window—symbolically just out of reach of a promised visibility in Burma's potentially human rights–laden future. In turn the film invites audiences to whittle down their hopes for Burma in terms of one rescue versus the rescue of unnamed others. As a function of the biopic genre, this move to secure Aung San Suu Kyi's heroic yet vulnerably racialized femininity trapped by a masculinist state overshadows any broader or more complex crises that Burma's people face.

Feminist theorists such as Ellen Gorsevski have noted the "timeless" Burmese femininity that Aung San Suu Kyi strategically embodies as part of

her public political persona, which relies on her posturing as an inherently natal and pious Buddhist destined for nonviolent protest. In particular, Gorsevski analyzes Aung San Suu Kyi's "visual rhetoric," which is signified through what the author sees as celebrated qualities of femininity: her "subtle demeanor" and "petite frame." These signifiers of "essentialized womanhood" can sometimes present a problematic paradigm through which Aung San Suu Kyi gets examined.[65] At the same time, Gorsevski invokes Elizabeth Minnich in order to revisit the notion of strategic essentialism, which "characterizes humans not by mortality but rather by natality, [and] can be effective in enabling nonviolent activists to convey messages and achieve political goals through uplifting and transformative persuasion in the public sphere."[66] In assessing the representations of Aung San Suu Kyi in film, Gorsevki defines an essentialized and universal femininity that, I argue, obscures race and heterosexuality as central to these definitions of "natality"; this definition glosses over how "strategic essentialism" can at times rely heavily on colonial and imperial renderings of *racialized* femininity to be successful.[67]

To characterize women leaders as superhuman emblems of natality despite circumstances of state militarization defines these communities by a proclivity to give life ad infinitum. This familiar trope presupposes the burden of bearing not just children or biological life, but the social reproduction of dissident and familial kinship in perpetuity. The expectation of Aung San Suu Kyi's timeless capacity to "give life" to her supporters and the nation even while incarcerated situates liberal feminists' underscoring of Aung San Suu Kyi's Burmese-ness as exceptionally underwritten. The film's continual focus on her being caught in the time and space of house arrest—not quite with her comrades in prison but also not part of the public sphere—ties her racialized femininity to a capacity to both perpetually rescue Burma—with the Global North's help—and to perpetually *be rescued*. The film's on-screen projection of Aung San Suu Kyi's Burmese femininity, racialized as both heroic and in need of rescue, has been critical for broader humanitarian discourses about Burma off-screen.

As *The Lady* provides a sense of unfettered access to Aung San Suu Kyi, the projection of her racialized and feminized capacity to foster the

familiar and the family pervades the performative aspects of the film's international circulation and subsequent humanitarian projects. Even the film's international reception was made possible by producers' and filmmakers' connections to global diplomatic cultural institutions in France and Thailand but not in Burma itself. The film's 2011 release coincided with the relatively recent release of Aung San Suu Kyi from house arrest. As one NPR reviewer, Ella Taylor, said of the film, "The Aung San Suu Kyi we see in *The Lady* is pretty much torn from the headlines—a vision of smiling Gandhian equanimity, unfazed by threats or the gun-waving thugs sent by the generals to keep her from galvanizing the opposition."[68] Her timely release made the film's portrayal of a vulnerable love-torn patriot and wife now returned to public life even more salient, as journalists, filmmakers, and cast also narrated her political career, incarceration, and subsequent long-awaited release using mainly terms of familial and liberal rescue.

On December 4, 2011, the international screening tour of *The Lady* stopped at the historically renowned New York satellite of the Asia Society, a global nonprofit organization, cultural foundation, and exhibition space for the dissemination of Asian arts and cultures. Previously called Asia House, the Asia Society was founded by John D. Rockefeller III in 1956 as part of a philanthrocapitalist project to maintain relationships between the United States and countries of Asia during the Cold War.[69] The film screening was funded with the support of Human Rights Watch, an international NGO that documents human rights abuses, and the Open Society Foundation, an international grant-making initiative intended to shape public policy and support for the building of "democratic" societies worldwide. Dylan Rodríguez has argued that organizations like the Open Society, under its founder, George Soros, have co-opted notions of dissent back into bourgeois liberal democracy.[70] Rodríguez includes the Open Society in his broader critique of stunted liberal progressivism within the nonprofit industrial complex writ large: "The imperative to protect—and, in Soros's case, to selectively enable with funding—dissenting political projects emerges from the presumption that existing social, cultural, political, and economic institutions are in some way perfectible, and that such

dissenting projects must not deviate from the unnamed 'values' which serve as the ideological glue of civil society."[71]

The film's premiere at the Asia Society speaks to how dissent and human rights championing can fall prey to what Rodríguez calls perfectibility, wherein narratives that fall outside of the transformative premise of human rights can still be co-opted to propagate future humanitarian projects.[72] In these "live" supranational spaces by which filmmakers and producers performatively invoke Aung San Suu Kyi's freedom, the fictional filmic renderings brush elbows with humanitarian funders and their witnessing and grant-making initiatives, which seek to enact postauthoritarian liberal democracy. The Asia Society already had a donor base that would make sense for this event, since the film premiere came on the heels of other similar events over the years, such as Burmese and Southeast Asian musical demonstrations and book events. The excitement around Aung San Suu Kyi's coincidental release from house arrest also meant the lobby was packed and several red carpets inside the venue were lined with journalists hoping to get a snapshot of Michelle Yeoh next to her own face on the promotional poster for *The Lady*. The sold-out film screening and Q&A session held later for patrons, artists, and staff was a transnational affair. World-renowned Taiwanese director Ang Lee moderated the conversation and the Q&A between Yeoh and Besson.[73]

Actions by the cast and crew at the Asia Society premiere extended the language of "family" and familiarity to live audiences, to the point where descriptions of Aung San Suu Kyi's maternal, filial, and familial characteristics resounded as though she were *their* mother. The society's website featured a report on the events, describing Besson's investment in *The Lady* as "mostly interested in what is deep inside this slightly-built woman who possesses the strength to fight the Burmese military. 'Her weapon is basically love because she loves her country, loves her husband, loves her children. That's the only weapon of mass construction that she has,' said the director."[74] By calling "love" her only "weapon of mass construction," Besson relies on the discourse of "weapons of mass destruction," often used to rationalize US and European involvement in the Global War on Terror

as a war against enemies of democracy. Besson invokes the global political stakes of "weapons of mass construction" to precisely describe Aung San Suu Kyi's motherly duty—her racialized and gendered love and devotion to the nation and her family—as her most revelatory contribution to today's humanitarian and democracy movements. The director and the film invite the international community, as an extended family, to in turn proliferate and defend his maternal heroine as needed. Besson's gesture folds the notion of "family" back into the liberal heteronormative expectations of kinship structures and around the human rights-laden individual subject of Aung San Suu Kyi. In other words, this "familial" intimacy not only transforms Aung San Suu Kyi's figure in the audiences' eyes on screen; it also allows filmmakers, directors, actors, casts, crews, and, by extension, global audiences to transform themselves into members within a family structure that would rescue one of its own under duress.

In the Q&A Yeoh was asked about the significant weight loss she underwent to achieve Aung San Suu Kyi's delicate frame and about learning Burmese to affect her voice.[75] While these may be normalized sexist questions that are par for the course of the Hollywood film industry, this collapse, between the actress's body and speech to approximate the "real" Aung San Suu Kyi, is a constant reminder of the easy conflation by the public and the actress's own intimacy with the political figure and the person behind the persona. However, in this scenario, Yeoh deflected the fixation on Aung San Suu Kyi's frame by giving answers that foregrounded her own familiarity with Aung San Suu Kyi's family. To prepare for the role, Yeoh solicited the help and insights of Aung San Suu Kyi's son, Kim Aris. Upon meeting the real Aung San Suu Kyi for the first time over the phone before filming began, Yeoh said that the encounter made her feel as if she was "catching up with a family member," making Aung San Suu Kyi that much closer in reach. During a break in filming in December 2010, Yeoh even flew to Yangon to meet with her in person, and recounted the story at various world premieres: "It was like visiting a family friend . . . She held my hand. I was mesmerized."[76] The BBC reported that during their visit Yeoh and Aung San Suu Kyi spent an unprecedented amount of time together, first at Aung San Suu Kyi's lakeside estate and then while

lingering at the airport before Yeoh's departure.[77] Yeoh's trip also coincided with the first time Kim Aris had seen his mother in the decade she had been under house arrest.

Yeoh's happening upon a family reunion off-screen in order to establish a deeper sense of familial intimacy for the audience on-screen highlights the ease with which filmmakers have attempted to blur the line between reality and fiction. As *Time* reported at the time of filming, Thein Win, an activist now in exile, attended political party meetings with Aung San Suu Kyi before fleeing Burma in 1991. His eyewitness account of Aung San Suu Kyi being played by an unlikely "Bond girl" tips Yeoh's portrayal ever more to the side of the "real," as he vouches for the authenticity of Yeoh's performance in his capacity as Aung San Suu Kyi's NLD contemporary: "Take Malaysian-born actress Michelle Yeoh, the former Bond girl who plays Suu Kyi. Yeoh not only strongly resembles the lissome Nobel laureate, but also occupies the part so convincingly that Besson calls it 'perfect for her.'" "From the moment I saw this actress," says Thein Win, a Burmese actor playing a member of Suu Kyi's National League for Democracy (NLD), "I thought, 'She is Daw [Aunt] Suu.'"[78] Making affective and bodily intimacy with Aung San Suu Kyi's story even more tangible to readers, the *Time* journalist continues, "He wept real tears during the scene in which Yeoh as Suu Kyi bids farewell to her sons before her incarceration. It was heartbreaking to watch."[79]

In this spirit, Burma is not just a speculative landscape onto which audiences observe the politics of rescue or make family connections through the film's publicity. Rather, the circulation of the film extends the politics of family and rescue to satellite spaces in which filmmakers invite participants to invest in ventures of global philanthropy and human rights activism. When such proliferations of humanitarian space give further credence to Western feminist and humanist projects of rescue, they sometimes do so in excess of what formal nation-states can achieve by drawing on the foundation of "soft power" that historical forebearers in philanthrocapitalism of the mid-twentieth century made possible. In 2014 Aung San Suu Kyi and Michelle Yeoh not only had several occasions to meet, but also founded the Suu Foundation together, "a humanitarian organization

dedicated to health and education reform in Myanmar."[80] Registered as a nonprofit organization in the United States and governed by a board whose strategic vision was developed in consultation with Aung San Suu Kyi in her formal capacity as a state counsellor of Burma, the foundation's projects include infrastructural efforts focused on road safety, emergency medicine, vocational training, and job creation throughout Burma. Deepening the background of ties between corporate interests and global development, Yeoh sits on the small board of the organization with her real-life partner Jean Todt, a former CEO in the motor racing industry with ties to Ferrari and Peugeot Sport and is a United Nations special envoy for road safety as well as a member of the board of directors for the International Peace Institute (IPI), a nonprofit policy think tank.[81] Together Yeoh and Todt do not fit squarely into what Jo Littler calls the "philanthrocapitalist 'celanthropy' mould," but they still join others who participate as "CEOs who have become celebrities beyond the industry they are in (such as Richard Branson or Bill Gates) as well as entertainment-based celebrities who become involved with charitable ventures (such as Sting or Annie Lennox)."[82]

Aung San Suu Kyi and Yeoh reunited in March 2014 to formally unveil their foundation to a group of 350 international and local journalists at a freedom-of-press conference hosted by the historical East West Center in Honolulu, Hawai'i.[83] Given Burma's history of media censorship as a critical function of military rule, this particular event about freedom of the press was intended as a collaborative time for those in attendance but also as a reflection of the goals of the country's political transition at a strategic time and place. At the unveiling Aung San Suu Kyi described the foundation as a "simple, but necessary cause" to help rebuild Myanmar's healthcare and education system, starting with Yangon University and the Yangon General Hospital: "Just as Daw Suu has made a difference, you and I can bring hope to help and bring dignity to the people of Myanmar."[84] These interlocutors mapped Burma's embrace of the transnational and pan-Southeast Asian (feminist) sisterhood that exists outside the country's formal borders that is deeply enmeshed in the advancement of broader Asia-Pacific dialogues. Subsequently, this performative arena brings to bear the discursive way in which Burma's "fictional landscapes" have had

a role to play in sculpting some of the current realities of the humanitarian industry surrounding Burma—a real landscape built on the implicit and explicit rescue of familial subjects therein. The point here is not to decry famous humanitarian interlocutors' involvement wholesale. Rather, it is to acknowledge the fraught relationships that foster the convergence between heavily aestheticized, marketed, curated, fictional landscapes of rescue and the celanthropic causes that have the power to adversely affect the on-the-ground fates of those communities represented on screen and in future generations.

The selection of the East West Center for such a foundational proclamation, for both global journalists and Burma's diasporic communities in Hawai'i, afforded additional regional political significance to the event itself. The event built on the reputation of the East West Center as a nonprofit organization that is partially funded by the US government, which has been synonymous with debates around foreign policy in the Asia-Pacific region since its inception in the midst of the Cold War in 1960.[85] Then–US secretary of state and former First Lady Hillary Rodham Clinton and former First Lady Laura Bush were present via videoconference in order to deliver messages of support as honorary co-chairs of the foundation.[86] The year before this event Clinton had infamously stated her hopes to "pivot" US foreign policy to the Pacific as part of ongoing American militarization of the region under the Barack Obama administration.[87] The convergence of these various global players, spurred on by the film, created a prescient stage on which more global players might lay a stake in Burma's future. As the East West Center notes, its dual branches in Honolulu and Washington DC and the strategic location of the unveiling establish a timely bond between spaces of official and unofficial human rights policy, connecting Burma and the United States and solidifying "familial dialogue" as a key to perception of the former's human rights record.[88]

A critical element to producing this rescuable landscape lies in how films cultivates Burma as an inherently hostile territory from which feminized vulnerable subjects rarely escape. For the filmmakers, vulnerable subjects' legibility as human rights subjects rely on their capacity to overcome struggles without succumbing to the Burman-centric, Buddhist-centric,

and patriarchal demands of the nation, not necessarily to the pressures of humanitarian knowability. Simultaneously, diasporic cultural producers' and human rights advocates' work off-screen contends with the Burmese state during its initial years of transition and struggle with how these forces structure their experiences of belonging in the diaspora.

Aung San Suu Kyi: Navigating the "Live" Diasporic Appeals of Humanitarian Engagement

On September 22, 2012, Aung San Suu Kyi visited Queens College in New York City, her first international speaking engagement post-release from house arrest in 2010. She was making a stop on her way to Washington DC to receive the US Congressional Medal of Honor for her commitment to the democratic process in Burma. The event was described in local and international media as a long-awaited reunion between Aung San Suu Kyi and the American public. I relay an alternative trajectory of events noting the role of advance planning by Burmese diasporic communities, who used nonprofits networks to find the means to put the event together, as well as the competing intradiasporic ideals operating during the procession of events that at times underserved the complexity of Burmese state affairs and their effect on various diasporic communities present and not present. These different analyses lay bare the US and intra-Burmese nationalisms within broader humanitarian discourses of rescuability, within the humanitarian industry itself, and Aung San Suu Kyi's assumed maternal and spiritual capacities to unite the Burmese nation through liberal democratic iterations of universal human rights and nonviolence. The celebration of her release from house arrest was one of the motivating factors that cohered the event. Yet the event also situates how a focus on her release (attributed to human rights campaigns) obfuscated ongoing genocidal and carceral state logics, even those historically embodied by some of Aung San Suu Kyi's policy directives.

Months before the event, dozens of community members, including Burmese diasporic artists and activists, some of whom were exiled, used their social media networks in Burma and in New York and met bimonthly

in person at Manhattan's Chinatown to organize Aung San Suu Kyi's "return." The provisional meeting space for Burmese diasporic community members who spearheaded the event was a converted warehouse that housed the two nonprofit organizations Project Reach and Free Dimensional (fD). Free Dimensional's main goal is to provide funds to "cultural workers in distress" when they are being persecuted by their home governments. I first encountered this meeting space in my fieldwork, due to its advocacy work on behalf of several Burmese diasporic artists who had been in exile at the time. Project Reach is devoted to supporting youth and adult collaboration in grassroots organizing for social justice, hosting workshops and teacher and staff training and development to develop skills in the community to combat ability bias, racism, sexism, homophobia, and immigrant discrimination.

While at first this connection might seem happenstance, this shared Chinatown space, a locus for community organizing by various nonprofits, had previously hosted intersecting events, including makeshift gallery exhibits, small film screenings, artist visits, training sessions, and community meetings. Together the atmosphere created the possibility of hosting the welcome event at all. With this particular event, the present community members wondered how to make sure Aung San Suu Kyi was able to receive questions, who would introduce her, how they would honor her, and what the procession would entail. The group decided that the appropriate locus for the event was the borough of Queens, and specifically the neighborhood of Elmhurst, where many Burmese immigrants and refugees had resettled in the 1980s to the 2000s.[89] The event was open and free to the community, a fact highlighted by the choice of venue, Queens College, one of the campuses of New York's public university system, arguably the largest in the country with its twenty-five campuses.

The Queens College event drew over two thousand Burmese immigrants from homes as far away as Virginia and Florida, in addition to broader audiences based in New York.[90] By midmorning attendees had already been waiting in line for more than four hours, some since dawn, to get a seat in the crowded lecture hall in the Coldon Center. There were banners hanging in the main entrance to the hall, as well as smaller posters mass

produced from a pencil sketch of Aung San Suu Kyi's face by the artist Min Kyaw Khine. The posters, with her image backlit in red—the color of the NLD's flag—provided event details in Burmese and English. Shortly it became apparent that the event was not just representative of diasporic communities gathering for a united cause (as was put forth at previous meetings); it also highlighted the various tensions over claims regarding Aung San Suu Kyi's capacity to mother the nation from afar (from abroad or while incarcerated) that have historically been debated.

Not everyone attending was there in support of the event. Waiting around the perimeter of the gates and stairs leading up to the event entrance (fenced in behind blue wooden NYPD barriers) were Queens College students from Muslim community organizations holding posters in red and black ink. The protestors outside, marked collectively as non-Burman and non-Buddhist (whether individually identified or not) provided dissent to the idea that this was a universal celebration. They were imploring Aung San Suu Kyi, newly elected to the Parliament seat at that time, to speak directly about the Burmese government's noncondemnation of acts of arson, violent attacks, and antagonism against stateless Rohingya Muslim communities that had been carried out by some fringe factions of militant Buddhist monks. While the popular news reportage around the event made these student protests marginal, the mix of interests represented at the event reveals a particular desire on the part of diasporic communities from Burma living in the United States to foster a relationship to a Burma-in-transition and to also hold Aung San Suu Kyi accountable as a representative of the state—that is, not solely as a global human rights icon. The cordoned-off group of protestors provided a counternarrative to the Burmese state-in-transition on display for the US audience, including diasporic communities who were there to celebrate.

This moment is significant as it exposes the uneven pattern by which Burmese diasporic communities are often considered an undifferentiated whole through their subsequent migration to the United States. Within Myanmar, the issue of the state represented by the Burman majority population versus ethnic minorities has been highly contested. Upon migration, all diasporic communities from Burma become classified as "Burmese"

in official censuses. Even as they may be predominantly Chin, Kachin, Karen, or Rohingya refugee populations who have fled the ethnonationalist violence of the Burmese state in recent decades, these differences are collapsed in official US state forms of data collection around their migrations. While advancing in the line waiting to get inside the event, I stood in front of three international students from Burma who belonged to the same collegiate preparatory school program in Yangon, all of whom planned to eventually return to Burma after finishing their bachelor degrees.[91] When asked when they had first heard of Aung San Suu Kyi and why they had decided to come to the event, one responded that he always admired her sacrifice even though he was not old enough to remember a time when she was not under house arrest. Another student responded: "When it comes to politics, I'm not sure. But I find the sacrifice for her family very touching. I've only been here for a year and I call my mom and ask for Burmese recipes. I don't know how Daw Suu did it, to be away from her family like that."[92]

Notably, many at the event, including myself, were utilizing the space as both an occasion to consider Aung San Suu Ky's return to "us" and to consider the affective and historical presence of so many community members in the United States, assembled from near and far to witness the event. The event marked an occasion to symbolically reunite with both the nation and the diaspora and even challenge the mixed versions of "community": some members were not present, some had passed, and some had recently suffered exile from the state.[93] As planned months before, the volunteer staff at the event circled the crowds, giving out schedules and holding jars with slips of paper to gather questions for Aung San Suu Kyi. Many people, including children, were dressed in traditional Burman formal clothes, including *htamein* and *paso*, the sarong-like bottoms worn on special occasions. There were also handfuls of audience members dressed in the traditional dress of Mon, Karen, and Shan ethnic minority groups. During the welcome processional for Aung San Suu Kyi, as she was applauded and led to the stage, some community members (likely handpicked in advance) were ushered onto the stage in pairs to shake her hand, give her flowers, bow in thanks, and whisper a few words in her ear

in passing. Here the work to cultivate the "right" space and "appropriate time" to invoke ethnoreligious nationalism made itself known in who was invited to celebrate the terms of Aung San Suu Kyi's reunion among a global human rights public and in the way the procession unfolded.

The contrast between students outside protesting in support of stateless Rohingya communities and community members inside performing their diasporic nationalism for the Burmese state through their traditional ethnic minority dress illustrates the competing registers of nationalism between those that are deemed acceptable and those who are not. Though in attendance for the "same" event, some participants inside were assembled to bear witness to performative invocations of liberal democratic reform in Burma as informed by "human rights." Others were imploring the Burmese state to render a fuller sense of transparency around anti-Muslim policies in 2012. By 2024 these policies have reached a fever pitch in what is now an ongoing Islamophobic genocide within the nation and its borders. Aung San Suu Kyi's presence at the event allowed some of those present to affix their own narratives of personal and national sacrifice onto her mythic maternal affect toward the nation and its diaspora; others, who did not fit this narrative, were literally cordoned off from the main event and remained offstage.

In the English-language session Aung San Suu Kyi addressed the crowd while clothed in a demure black and gray htamein and shawl set, with flowers in her hair.[94] She opened with a note of gratitude and maternal indebtedness, on message with previous invocations of her as mother of the nation: "Thank you very much. A very warm welcome. Not just to me. But to other people from Burma. You have welcomed them as if they were one of your own." She followed with a story about her experiences living in New York for three years, beginning in 1968, while she completed an internship at the United Nations.

Admonishing her own flaws like a practiced comedian, Aung San Suu Kyi used an allegory to describe her initial introduction to New York, which reminded her of a vastly different place and time: her visit to Insein Prison, a site famous for state-sanctioned torture of dissidents:

> I remembered New York on the day I went to Insein Prison. I was taken to the room where I was to be kept and it was a five-star residence by Burmese prison standards. They opened the door, I walked in. After they had gone through the preliminaries the wardens went out and they shut the door. An iron door. There was this clamp. There were all these bars on the windows. And I thought, this is prison. This is just like the books. This is the way they write about it. And I remembered my first visit to New York where I was surprised it was supposed to be like that. So the reason I remembered New York was not because I felt New York was like prison but I was interested in the fact that you can be surprised when you find out that things really do happen the way that you have learned they happen. Or things really are as you have been told they are. So I hope that you will all understand what it is like to struggle for human rights and democracy in Burma. It is just the way you've heard about it. It may seem to you not quite real until you meet it face to face. And then you know what it's really like to struggle for democracy and freedom.[95]

Aung San Suu Kyi's encounter with prison "as you've heard about it" and with New York skyscrapers "as seen in postcards" attempts to relate the disparity between the finite space of imprisonment and the freedom of cosmopolitan movement in a large city. This performative tactic humanizes herself to a mixed New York audience of supporters, Queens residents, students, politicians, and diasporic communities. At first Aung San Suu Kyi relates to the audience as someone who once walked the same familiar city streets then shifts registers to vouch for her own familiarity with detainment. In this move she communicates that her freedom, once "like ours," is something easily taken away and coheres the audience's empathy around the intimate life of political detention to make it more relatable. In her speech, when specifically addressing Queens College students, she asked them to take seriously their democratic rights such as voting and opining in public, urging them to consider their privileges in comparison "to young people elsewhere"; the "youth in her country suffer ill education."[96] This

The Humanitarian Industry

set of speeches, imploring those present to commit to local and Burmese democratic processes, occurred at the same time and only a stone's throw away from Muslim American student protesters struggling to be heard on the issue of violence against Rohingya Muslims in Burma. The context highlights the conundrum of nonjuridical spaces in which human rights issues are debated in the most public of forums.

This performative disruption to Aung San Suu Kyi's seamless return to public life—as distinctly Burman, Buddhist, and nationalist—shows how disparate attendees, under the pretense of an undifferentiated Burmese diaspora, are able to imagine the Burmese state rehabilitating itself in very different directions. Rather than marring this vision of a timeless Aung San Suu Kyi as a peacekeeper, the event organizers found alternate ways to try to support a less blemished vision of a new Burma. The event's outlook seemed optimistic: upon Aung San Suu Kyi's release, the country would resolidify goals of ethnic harmony. Simultaneously, the events provided a publicity opportunity for local politicians to draw on humanitarian discourse and participate, through celebrity contacts, within localized manifestations of the humanitarian industry. In currying favor among constituents, the reunion allowed Aung San Suu Kyi's historic return to also manifest a particular vision of an inclusive liberal multicultural immigrant Queens welcome to a cosmopolitan visitor and local politicians and Queens residents as supportive of this transformative vision for a potentially rescuable version of Burma, a version outside of its own geography. In the process this powerful event maintained the status quo of sidelining less visible and audible subjects. The broader project of ethnoreligious harmony in Burma was a secondary concern to the narrative of transformation of subjects who were, at that point, not necessarily as vocally defended. More than a decade later, international pundits and policymakers have continued to express concern over the ongoing Islamophobic state and extrajudicial violence against civilians in the country. It is through a framework attuned to political, ethnic, and economic disparities within the Burmese diaspora that momentarily centered a challenge to (humanitarian) aesthetics of vulnerability and assailed the primacy of celebrity figures in the humanitarian industry.

The Future Cost of Iconicity for Contemporary Human Rights Landscapes

Since 2017, news reports have documented the displacement of almost 750,000 Rohingya Muslim refugees from Burma's Rakhine state into Bangladesh and other parts of South and Southeast Asia.[97] The then-civilian government, under the de facto leadership of Aung San Suu Kyi, has downplayed the widespread extrajudicial physical violence against Rohingya peoples, businesses, and homes. Before her most recent detainment, Aung San Suu Kyi's comments to international news outlets refuted the ethnic cleansing going on in Myanmar, stating that ethnic cleansing "is too strong an expression to use for what is happening."[98] In 2019, alongside global resurgences of fascism and xenophobia, some reports from Burma downplayed the effects of similar campaigns as individual "incidents" carried out by the local military.[99] International humanitarian organizations, including the UNHRC, have labeled these incidents as possible crimes against humanity and genocide.[100]

In the summer of 2017, musician Bob Geldof, a contemporary of U2's and the organizer of Live Aid in 1985, spoke out on what he called the "assent" of Aung San Suu Kyi to the issue of Rohingya displacement and genocide. In his statement he refused to continue to be a recipient of the same Freedom award she had received, given in recognition of work on human rights: "I would be a hypocrite now were I to share honors with one who has become at best an accomplice to murder, complicit in ethnic cleansing and a handmaiden to genocide."[101] In late 2017 U2 similarly composed a statement to their fans after several failed attempts between their and her representatives to speak with her:

> Who could have predicted that if more than 600,000 people were fleeing from a brutal army for fear of their lives, the woman who many of us believed would have the clearest and loudest voice on the crisis would go quiet? For these atrocities against the Rohingya people to be happening on her watch blows our minds and breaks our hearts . . . so we say to you now what we would have said to her: the

violence and terror being visited on the Rohingya people are appalling atrocities and must stop. Aung San Suu Kyi's silence is starting to look a lot like assent.[102]

Here the trope of a voice "that was supposed to be the loudest and clearest" that has instead "gone quiet" continually fixates on the stunting of Aung San Suu Kyi's potential upon release. Geldof's and U2's testimonies demonstrate how the afterlife of humanitarian work, which insists on the amplification of human rights subjects' voices, can repeatedly occlude the same voices and, more expansively, impact subsequent communities in order to stay on the "right side" of humanitarian history and *perpetuate* the industry itself.

By the end of 2018 Amnesty International revoked its world-renowned Ambassador of Conscience Award that U2 had once so fiercely offered up to Aung San Suu Kyi during its 360° Tour.[103] Even in light of these attempts to recall accolades, the future of Rohingya communities still currently displaced between Bangladesh and Myanmar's borders remains unsure, while global condemnation of the current military coup that took power in February 2021 remains high. What this fall from grace attests to is the contradictory terms of global public esteem for Aung San Suu Kyi's "silence," strength, and steadfastness to her political commitments, to respect for the rule of law, and to a liberal approach to human rights. She seems to have betrayed their trust. Yet, in these moments, calls to identify assent and dissent often serve to further alienate supporters and survivors away from the cause of humanitarian outcry in the first place. John Yettaw's speculative premonition about Aung San Suu Kyi's demise and the events that followed, all framed as ways to effectively "protect" her, raises questions about how, why, and for whom international solidarity movements rely on the consumption of the right trespassing figures, who then become even more vulnerable to invasive rescue scenarios at a whim.[104]

In February 2021 the military coup that deposed Myanmar's civilian elected government secreted away or incarcerated over two hundred state officials, including Aung San Suu Kyi, whose whereabouts and status were unknown. This is not to compare or collapse distinct periods of state violence, nor the global efforts to resettle disparate communities that followed

them. However, the global conversation around Burma's human rights record reemerges at a critical moment. As the possibility of sustained human rights engagements with assumedly "postauthoritarian nations" is on the rise, such engagements must contend with the aftermath of broader humanitarian and state optics in order to recuperate subjects once considered dissidents, especially those who resist being continually dispossessed or even violently excised and effaced by the state. The Suu Foundation, in the absence of Aung San Suu Kyi, reports on its website that it has taken on COVID-19 vaccination efforts in the country as well as "humanitarian relief" actions for persons dealing with "forced eviction, imprisonment, and other human rights abuses," all alongside issuing, through their trusted partner organizations, assistance for "basic needs, foods, mosquito nets, rice, oil, salt, beans, and emergency medicine."[105] Given the current state of safety concerns for communities living under the coup who remain anonymous, information such as the length of time this relief will be offered and the extent to which the relief has been distributed, is not independently verifiable. For the Suu Foundation, whose goals are to "support the victims of human rights abuses across Myanmar, to record evidence of crimes and to bring these to the attention of the right international bodies," the public is asked to trust the organization at its word.[106] The foundation, like other philanthrocapitalist charity projects, could still run the risk of what senior voluntary sector veteran Michael Edwards (who was previously of Oxfam, Save the Children, the World Bank, and the Ford Foundation) says are common pitfalls of "produc[ing] a flurry of weak projects which tend to be small scale, few of which are truly self-sustaining, and in which 'mission drift' is common."[107] In the case of Myanmar, previous turns to a "post"-authoritarian discourse is a cautionary tale of how authoritarian regimes can and will continually leave their long-term mark in the state infrastructure and ongoing mass displacement of the present.

The transformative property of Aung San Suu Kyi's persona from prodigal daughter to humanitarian icon to fallen hero in the wake of recent and ongoing Islamophobic and nationalist-fueled massacres reveals as much about the fraught optics and processes of global accounting of human rights violation in the twenty-first century as it reveals about patterns

of humanitarian engagement that are left in the wake of genocide and nationalist upheaval. The predicament of scholarly and popular archival practices that gender the Burmese nation as ineffectively effeminate at some moments and brutally masculinist at others with regard to humanitarian intervention is not new. The price of deviance from the script of what global, liberal human rights "transformation" purports to do for some subjects further extends the afterlife of what Tamara Ho calls the "romance of human rights" for others. In this case, contemporary interlocutors of Aung San Suu Kyi have sought to unpack this romance gone wrong, such that the human rights community's excoriation of her figure is instructive of the ways in which the "right kind" of transformation narrative may be imperfectly applied to other dissident and trespassing subjects. If U2's condemnation is the height of their plan for advocacy, what does an exiled artist's continuous work illuminate about other avenues for freedom-making on different terms that *exceed* rescuability? What roadblocks or eases do artists and their advocates navigate in the afterlife of rescue, or at the intersection of the humanitarian industry and international arts' markets that make these other avenues possible? How does addressing how norms of rescuability within the humanitarian industry set the stage for asking how artists' and granters' refusals to cleave to norms of rescuable affect will in turn also shape the lives of asylum-seeking and refugee artists? What types of terms do these instances set up for other refugees, exilic communities, and asylees seeking to be in the good graces of dominant humanitarians for the purpose of agency and movement? This is achieved, in large part, by engaging the flexible positionality of refugees, asylees, and diasporic subjects as proximal statuses instead of as disparate ones, engaging at every turn a discourse of transformation to discipline these subjects as palatable according to shifting neoliberal host nations' desires around diverse inclusion.

2

Diversity and Refuge in the Museum
The Guggenheim's *No Country*

Among the minimalist white expanse of gallery shelves in the Solomon R. Guggenheim Museum in New York stands a set of forty identical white plaster busts of General Aung San, the revered father of Burma's national independence. The installation *White Piece #0132: Forbidden Hero (Heads)* is comprised of forty eerily similar bald white casts that may remind some US audiences of Smashing Pumpkins's front man, Billy Corgan. In rows of five per shelf, each bust is turned away from the audience and toward the wall, backlit by a neon white light. The busts' positions obscure the face contours of this "forbidden" hero, a mythic and polarizing figure often credited with changing the tide of Burma's national history between World Wars I and II.[1] Leading up to the end of World War II, the general worked with the Japanese Imperial Army, then with Allied forces, to secure independence from British colonial rule; he was eventually assassinated by his Burmese military peers. He did not live to see the country's independence come to fruition. In the installation the symbolic separation of the general's head and neck from the rest of his body is noteworthy. The decapitation of his likeness seems to signify the casting off of the old guard in the wake of Burma's postindependence rebirth. June Yap, the curator of the exhibit, observes that the Burmese state placed restrictions on the use of the general's likeness when martial law was imposed in 1989.

White Piece #0132: Forbidden Hero (Heads) is the only installation in the exhibit that melds into the environment of the Guggenheim gallery, its

FIGURE 4. *White Piece #0132: Forbidden Hero (Heads)*, 2012. Forty plaster busts, each approx. 20cm × 9cm × 23cm, placed on a backlit set of shelves. Collection of Solomon R. Guggenheim Museum, New York. Used with permission. Courtesy of NNNCL Workshop.

sterile aesthetic seamlessly blending into the Guggenheim's white modernist architecture. The busts were part of the inaugural Southeast Asian art exhibition *No Country*, which featured emerging artists from South and Southeast Asia who had not been prominently featured in the postcolonial art influx of the 1990s among international art collectors.[2] Moreover, *No Country* was the Guggenheim's first comprehensive exhibition to address contemporary South and Southeast Asian art.[3] This melding symbolically captured how Burma in 2012, one year into an elected civilian government after decades of authoritarian rule, was accepted and celebrated by international art peers (fig. 4).

According to the press release announcing the exhibit, curator Yap chose the title *No Country* after the first line of a William Butler Yeats poem, "Sailing to Byzantium" (1928), which also had been adopted by Cormac

98 Chapter 2

McCarthy for his novel *No Country for Old Men* (2005). Sailing nods to a premeditated traversal of borders and, in this case, the imperial acquisition of diverse perspectives and development by the museum. Yap also nods to the plot of McCarthy's novel, which centers the theme of the illicit drug trade across the US-Mexico border. This mélange of metaphors sets the tone of encounter that estranges an American audience from familiar visions of Southeast Asia as a site of US warmaking in the 1960s and 1970s while reinforcing notions of the US-Mexico border as a place of illegal transaction and border policing. The curatorial statement also nods to the border-affirming racial projects that simultaneously divide the United States and Mexico without confronting either the settler colonization of Native lands or Southeast Asia as an undifferentiated region of communist contagion during the Cold War. In this spirit, Yap's statement notes that one of the main motivations for the *No Country* exhibit is to investigate the notion of culture as "fundamentally borderless."[4] At first blush this phrasing may seem an innocuous curatorial mission statement. However, the following analysis takes a cue from the many facets of borderlessness that curators, funders, and artists explored within the show as a means of both evading and confronting histories of dispossession in rural borderlands and the survival of folk art under globalization.[5]

The Guggenheim's incorporation of work by artists Wah Nu and Tun Win Aung, a couple with a rising profile within contemporary Burmese and Southeast Asian art, signals the nascent tensions that exist around how museums exhibit the works of diasporic artists in order to translate their local histories of nationalist struggle for a global audience. The couple's series *1000 Pieces (of White)* includes existing works and was timed to coincide with Yap's curation of *No Country*. Ranging from mementos compiled from their own childhoods to new collaborative work, Wah Nu and Tun Win Aung's open-ended or, better, neverending project includes objects, images, prints, and film footage, all pertaining to the theme of memory.[6] As Yap suggests, the artifacts are partially "concealed" beneath a layer of white (in paint or framed in white) as a means of recollection, "piecing together the memory of the figure also reveal its incompleteness, emphasizing that which has been lost."[7]

Yap chose just a handful of works from *1000 Pieces (of White)* to exhibit as part of *No Country* to represent "the couple's more politically inflected experiences" and to reference the figure of Burmese independence leader General Aung San in some form.[8] Even as Aung San was considered a national hero during the interwar period, Yap notes that the Burmese state placed restrictions on the use of his likeness when martial law was imposed in 1989. It also instituted bans on the use of the image of his daughter, Aung San Suu Kyi, in the aftermath of subsequent civilian uprisings. Thus the piece's name, pairing "forbidden" and "hero" expresses the tension between celebration and trepidation in the revival of both art and political traditions that were previously forbidden by the Burmese state. The work's debut at the Guggenheim provided an unprecedented platform for artists to push what was politically possible in 2012, under a newly civilian Burmese government, and test what was permissible to showcase abroad about Burma's censored history without state pushback.

The busts featured in *White Piece #0132: Forbidden Hero (Heads)* were produced in Ywalut, a village located in a predominantly Mon ethnic minority state, using a type of plaster casting method practiced by artist Tun Win Aung's family. The material is often reserved for Buddhist spiritual statues only. Wah Nu's and Tun Win Aung's traditional approach to modern unblemished surfaces contrasts with popular international media footage of Burmese civilian unrest met by state violence, the kind of images censored by the Burmese state from popular media. Elsewhere in the series the artists present refurbished national archival footage of post–World War II state ceremonies, enshrining them in white boxes and introducing them to potentially unfamiliar audiences with an interest in Southeast Asia and its postcolonial histories.

In the previous chapter I proposed nonviolent protest, film production, concerts, screenings, and speeches as arenas of performance that allow activists to access the terrain of "rescuability" in celebrity humanitarian efforts and the entertainment industry. The discussion now pivots to a consideration of how artists also intervene in adjacent spaces of the international arts market (e.g., museums), wherein histories of rescue, nationalist violence, genocide, and the option of live "rescue" are foreclosed.

In some cases contemporary museums position underrepresented artists as a testament to liberal democracy and the diversification of mainstream institutions as a type of "rescue" or "salvage." When invited to collaborate, some artists unsettle the deeply embedded ethos of ethnonationalism and rescue in the museum, producing experiences of excess and inscrutable archives that challenge the types of "diversity" that the museum is perhaps originally hoping to achieve. What do artists gain by disrupting corporate efforts to cleanse museums of their part in the acquisition of artifacts through militarized conquest?

Not coincidentally, funding for *No Country* fell under the umbrella of what might be euphemistically termed "artwashing," with wealthy donors and institutions trying to disassociate their money from its past use, cleansing their reputations through philanthropic private and nonprofit investments in art and real estate (while also enjoying the accompanying tax breaks).[9] In 2012 the Guggenheim embarked on the UBS MAP Global Art Initiative, a five-year financing initiative with the Union Bank of Switzerland (UBS), a global wealth management entity. This mutually beneficial initiative diversified the Guggenheim's international profile, distinguished UBS's global brand, and deepened each entity's economic stakes throughout the world. The Guggenheim hired several emerging curators from underrepresented regions of South Asia, Southeast Asia, Latin America, the Middle East, and North Africa to curate traveling regional exhibits of visual installations by artists from these regions.

At an estimated cost of $40 million, the initiative was the largest investment UBS had made in the arts and also the largest project the Guggenheim had ever undertaken.[10] UBS's assistance also helped the Guggenheim sustain funding in times of increased national arts funding austerity.[11] Richard Armstrong, director of the Guggenheim Foundation, stated that the initiative "hop[ed] to challenge our Western-centric view of art history. Our global aspiration is to become familiar with these places, but that calls for people power and a sense of adventure. We certainly have the latter."[12] This ambitious sense of "adventure" builds on a discourse of crossing borders, global acquisition, and exploration that can sometimes reinscribe "the West" as an origin point for diversification of the museum, such that the

West is still responsible for bringing art from anonymity to knowability for patrons.[13] The contemporary museum, a prominent sector of the international arts market, is still a fraught space with its own struggles of confronting colonial violence.

To make sense of how artists navigate the international arts market as they cross national borders and push discursive ones, the discussion is guided by the following questions: What is the relationship between the international arts market and the humanitarian industry when these entities cohere narratives of ethnonationalism, genocide, and refuge in the context of the museum? What does the discourse of a borderless world both allow and foreclose for artists who wrestle with freedom of movement in their lived experience? What does a focus on Southeast Asia's borders do for artists who draw a link between ethnonationalism, indigeneity, and life in the diaspora, within the debate over what constitutes diversity in the international arts market?

Nicolas Bourriaud says "relational aesthetics," or the intersubjective meaning-making around art engendered between artists and audiences in the spirit of open-ended social experimentation, plays a vital role. Bourriaud's now-famous coinage has been critiqued for overemphasizing curators as key brokers in the conversation between the public and artists. In other words, consideration must be given to how the Guggenheim cultivates its profile of being fluent in the cosmopolitan movement of artists and markets, notwithstanding its hiring of June Yap, a transnationally situated curator who was tasked with diversifying the museum's dialogues.[14] Claire Bishop and Bourriaud's other critics suggest that relational aesthetics can privilege the immediate site-specific contact between an artist and their surroundings to the point of predetermining liberation (or the opposite) from capitalist exchange.[15] Bishop proposes that rather than leaving social experimentation itself as the goal of relational art, "relational antagonisms" might better describe how artists can concretely shift social relations: putting social and class frictions directly to work in institutional space through dialogue and negotiation, not irrespective of content but with intended ripple effects beyond the biennale or museum. Bishop notes: "The relations produced by their performances and installations are marked by

sensations of unease and discomfort rather than belonging, because the work acknowledges the impossibility of a 'micro-topia' and instead sustains a tension among viewers, participants, and context."[16]

Events in 2012 and the debates they unearthed regarding diversity and inclusion highlight the challenges arts institutions face when they seek to transform access and equity through seemingly humanitarian measures.[17] Critiques of Bishop suggest that staging class, social friction, and race into an "antagonistic" relation accurately captures how artists and audiences, specifically of *No Country*, situate conflicting past, present, and future geographies of Southeast Asia as a means to refuse the veneer of diversity and ethnic harmony in mainstream arts institutions that diversify markets and content. Art institutions can rehearse narratives of borderless acquisition as benevolent and inclusive while also disassociating from and further obscuring their own histories of colonial violence. Some contemporary museums' curatorial patterns—to more aggressively pursue both "indigenous" and "post"-colonial art—can yoke the financial future of today's museums to humanitarian benefactors while performatively erasing (settler)-colonial wrongs of the past by museums and corporations. The discomforting conditions under which artists sometimes put themselves exist in sustained tension with the corporate philanthropists and banking conglomerates that anchor (militarized) humanitarian investment as necessary to keep contemporary museum spaces financially solvent.

In light of the extractive and, I argue, racialized and "borderless" financial discourse taking place regarding museum diversification, the Guggenheim's inclusion of *No Country*'s artists loosens previous curatorial stringency between classifications of folk art and high art. The stakes are high: the rationale for benevolent acquisition can place the onus on artists to participate even more fully as agents in diversification and financial securitization of the museum. With regard to economies of vulnerability, this move asks artists to invest a great deal of energy in processes that may not nourish them nor their projects of racial justice. Artists and activists are able to supplement and subvert the discourse around borderless capital and acquisition by playing with the aesthetics around borders themselves: whether reimagining physical borders between nations, challenging borders

of display in museum space, or confounding borders between distinct arts markets through unexpected content. These manipulations reveal the contradictions of corporate philanthropy and humanitarian investment in militarized histories (in terms of curated content) at the cost of hiding others (in order for the museum to be financially viable). Such contradictions require artists to shift and in out of modes of legible excess through their use of materials and narrative, to experiment with genres and exhibition practices that might mean the loss of favor in the eyes of curators and other art industry interlocutors.

In a prescient moment in 2012, *No Country*'s artists ask which artistic mediums and discursive modes robustly address racialized difference alongside anticolonial insurrection. Several artists counteract the criteria by which curators satisfy diversification initiatives by playing with notions of rescue, rehabilitation, and salvageability in abstract sculptural forms and archival footage that refuse erasure of histories of border crossing. *No Country*'s artists treat postwar histories of race-making, nationalist movement, and state-mandated borders as tender subjects worth reexamination instead of ones to be glossed over by the dominant regional assignments fostered by the Cold War and reinforced by the museum (that is, of Southeast Asia, Latin America, etc.). As a result, broad global initiatives, like the collaboration between UBS and the Guggenheim, become sites of opportunity, where diasporic artists stake their own claims in reimagining Southeast Asian regional identity in the global popular imagination. Diasporic artists also use these opportunities to disrupt humanitarian scripts from assisting organizations (NGOs and museums) to view them as displaced artists who suffer and are transformed into human rights subjects by virtue of the cosmopolitan mobility the museum grants them.

Juxtaposing artists' aesthetic choices with the financial encounters between artists and the international arts market helps illuminate the relationship between arts funding, human rights–oriented arts advocacy, and diversity initiatives in the museum. Close readings of the selected artists' works in *No Country* help situate the fallacies of borderlessness, through both medium and theme, and sheds light on the historical origins of the displacement of refugees and asylum-seekers living at Southeast Asia's

borders. This includes Cambodian refugee and diasporic artist Sopheap Pich, whose large-scale rattan sculptures often exceed both the show's prescribed physical dimensions and the curatorial narratives of the exhibition space, and diasporic Burmese artists Wah Nu and Tun Win Aung, who remix archival film and cast ephemera in white to memorialize Burma's national past.

Diversity and Equity in the Museum and the (Southeast Asian) Arts Market

The International Council of Museums (ICOM), widely regarded as a leading decision-maker in the museum world, currently defines "museum" as "a non-profit, permanent institution in the service of society and its development, open to the public, which acquires, conserves, researches, communicates and exhibits the tangible and intangible heritage of humanity and its environment for the purposes of education, study, and enjoyment."[18] Since 2019 several lengthy proposals from inside the organization to change this generalist definition have led to debates over whether "social justice, global equality, and planetary well-being" should be added. National committees hailing from France, Japan, and Spain have questioned whether these values truly encapsulate what current national museums do, whether museums should be expected to generate profit, and if ICOM's goals should overtly politicize the museum's purpose. In recent years curators, artists, activists, and scholars have criticized the museum for looting Indigenous precolonial artifacts during war and conquest, stealing items for their permanent collections.[19] The tendency to erase original artists, and even the origins of human remains, from their works, characterizes models of colonial excavation and disposession that normalize European plunder.[20] That they *continue* to hold these objects while also curating contemporary art from underrepresented regions sustains the queries about museums' accountability to the publics they serve and the legacies of acquisition they draw upon. Adjacent critiques ask why US museums are slow to curate more recent works from artists from racially and ethnically underrepresented groups and geographic regions.[21] In acknowledging the

breadth of these critiques, a redrafted ICOM statement on the definition of a museum (rejected in 2019) is as follows: "Museums are democratising, inclusive and polyphonic spaces for critical dialogue about the pasts and the futures. Acknowledging and addressing the conflicts and challenges of the present, they hold artefacts and specimens in trust for society, safeguard diverse memories for future generations and guarantee equal rights and equal access to heritage for all people. Museums are not for profit. They are participatory and transparent, and work in active partnership with and for diverse communities to collect, preserve, research, interpret, exhibit, and enhance understandings of the world."[22]

These new aspirational standards, rejected by the larger voting body of the ICOM, still present a challenge to its members and, by extension, to all those in the museum's wake. The proposal for politicization confronts more than the dilemma of the present. It recognizes that museums already acquired "artefacts and specimens" in the past and must mobilize their collections to focus on equality-driven access in the future and also that artists are crucial mediators of the process. How might museum-specific work to diversify translate into broader trends in the international arts market—especially when the economic and political histories of Southeast Asian art within the market are not always legible in the first place?

In his 2017 work, *Art and the Global Economy*, John Zarobell qualifies the impact of globalization in the arts world through a broad study of the "creative economy and the arts." Zarobell suggests that "migration and nomadism are two central practices of critique that have recently emerged to describe how globalization transforms our spheres of experience.... While these challenges are based on traversing spaces of power and representation, artists' collectives have put down roots in unlikely locations around the planet ... global cities, but also in rural enclaves where the terms "artist" and "collective" may have never previously have been in use."[23] This observation, of how artist collectives traverse global cities and rural enclaves, suggests that the accepted terms of the arts market do not fully capture the scale nor transient locations of collectivization, labor, and movement-building. Taking seriously Zarobell's call to examine how art collectives contribute to what gets defined as "rural" and "global," one must

contend with the specter of the Cold War regional identity of Southeast Asian and Burmese diasporic artists. These artists have had to remain flexible, balancing their experiences and practices of locality (sometimes based in the specific craft from rural communities) with globality (or abstraction to indicate cosmopolitan sensibilities) in order to be legible beyond explicit markers of the Cold War. Any artist, curator, or scholar who frames Southeast Asia as a region of borderless cultural encounter faces pressure to address an aggregate of the disparate maritime and mainland nations first named under Cold War–era foreign policy. Under this banner, various ethnic, national, and religious communities who shared recent histories of Spanish, English, French, and Portuguese colonization became the communities about and from whom US and European civil servants and scholars produced knowledge and extracted resources.

The United States has been careful to stage its military interventions in the Asia-Pacific through a narrative of democratic benevolence in order to set itself apart from imperial its forebears. In the decades before the Cold War, following the bloodshed and technological advancements brought on by World War I, US and European governments and institutions looked to museums as a salve that could refocus attention to a "universal humanity."[24] In the aftermath of US imperial expansion, celebrated through world's fairs and public exhibitions at the turn of the twentieth century, the United States' development of museum collections through investments by philanthropic giants became the next order of the day. During World War I the fascination with Japonism, African masks, and avant garde art sparked a growing curatorial interest in world art traditions.[25] At the time the language around museum curation engaged in humanitarian discourse, relying on terms such as "protection," "preservation," and "saving of" artifacts during wartime as a way to reframe the explicit act of looting from ravaged spaces by coercive force. Signed by forty-one nations, the Hague Convention in 1926 marked the first official humanitarian agreement regarding the burgeoning international arts market created under the guise of "protect[ion] of art during war."[26] The convention reads: "In sieges and bombardments all necessary steps must be taken to spare, as far as possible, buildings dedicated to religion, art, science, or charitable purposes,

historic monuments."[27] Yet, unofficially, confiscating precious artifacts was an opportunity to "document for propaganda purposes damage inflicted by the enemy."[28] It bears mentioning that according to this new view of "civilized warfare," official agreements regarding the looting of cultural property were inconsistently applied to groups considered "uncivilized" peoples.[29] In other words, dissident subjects were framed as needing to "pay" for their retaliation in local nationalist revolts against European and American occupation.

When the Guggenheim Museum opened in 1959, it gained immediate legitimacy as the torchbearer of the push to couple universal humanist values of the past with the individualism of the new era, with museums serving as a counterweight to the censorship that characterized the fascist and communist regimes that the United States considered itself set against.[30] This role was short-lived, as the 1960s saw anti–Vietnam War, feminist, and civil rights activists calling out mainstream museums over their imposture of humanism and lack of engagement with global decolonial social movements. Christina Klein, analyzing the global era of Cold War Orientalism in the 1960s and 1970s, asserts that the shifting role of American imperialism in middlebrow intellectual and cultural work decentered notions of racial difference in favor of developmentalist narratives of Asia: "Because US expansion into Asia was predicated on the principle of international integration rather than on territorial imperialism, it demanded an ideology of global interdependence rather than one of racial difference."[31] *No Country* attempts to capture the post–Cold War relationships between the United States and countries of Southeast Asia, taking a cue from Klein's sense of 1960s and 1970s global interdependency but replacing the imaginaries of war and communist conflict with suggestions that the exhibit will traverse globalized and "borderless" Southeast Asia anew.

In order to establish the relationship between the international arts market and the humanitarian industry in the case of Southeast Asian (diasporic) art, it is imperative to outline discourses that have kept the region ripe for diversity initiatives and curation. This includes establishing which issues museums have historically marginalized in their goal for diversification through the inclusion of Southeast Asia. For example,

the tendency toward what some critics and scholars would call neoliberal multiculturalism demonstrates how contemporary efforts to diversify the museum's holdings must also respond to a diversification of international markets.[32] In the case of the Guggenheim, neoliberal multiculturalism manifests in mechanisms of some funders' reparative donations to regions of concern while equating notions of racial justice with entry into global capitalism. Cultural theorist Jodi Melamed suggests that neoliberal multiculturalism signifies a turn to the contemporary workings of globalism that detach racial justice from notions of "openness," "diversity," and "freedom" in cultural institutions: "Whereas racial liberalism and liberal multiculturalism advocated equal opportunity as a necessary precondition for racial equality, thereby restricting meanings of racial justice to those that could exist in the same discursive formation as private property and market economies, in neoliberal multiculturalism matters of the economy themselves express what is meant by freedom from racism, conceived of as an unfair, restricted, or exclusive use."[33] Melamed's critique of neoliberal multiculturalism illuminates how the Global MAP initiative can hold racial justice as a separate concern that is distinct from the goal of benevolence and diversity. Perhaps in this case racial justice might mean a long-term platform for advocating for diasporic artists who have tenuous status or artists of color who hold primary residence in the United States. Rather than a superficial inclusion of different bodies to populate the museum, an alternate version of racial justice might structurally and politically benefit artists and audiences in terms of altering a museum infrastructure to further account for its colonial foundations and legacies. The intersection between an international banking conglomerate's hope to diversify its brand and a museum's desire to court unprecedented financial assistance animates the very conundrum of diversity: primarily, that achieving "diversity" is about representational politics and mass infusions of capital but not necessarily tied to resource redistribution, racial inequality, or cosmopolitan hierarchies in the international arts market.[34]

In the rush to curate emerging postcolonial artists, by and large still absent are the national infrastructures within the United States that can support already marginalized artists who have been recruited to attest to

American art and humanitarian institutions' global scope. According to "Creativity Connects Report: Trends and Conditions Affecting US artists," a 2016 report by the National Endowment for the Arts (NEA) and the Center for Cultural Innovation (CCI), disparities in race, gender, and ability are, perhaps unsurprisingly, as pronounced in the art world as they are in the rest of American society. According to the report, "only 17% of fine artists are non-White and/or Hispanic."[35] In terms of US arts-related foundations, over time no significant changes around these numbers has occurred, as "only about 4% of arts-related foundation funding goes to organizations dedicated to serving communities of color, including of African, Arab, Asian, Latin, or Native American heritage."[36]

Nevertheless, these statistics do not address how communities of color, including those who both do and do not identify the United States as their primary home, face different access barriers to funding by virtue of the simple fact that these groups may traffic in disparate types of cultural capital. When it comes to the diversification of the museum, the diffuse and shifting definitions of contemporary internationalism mean that some artists, including the recently arrived or recently exiled (i.e., with precarious status), do not possess the same qualifications that more mobile diasporic artists with privileged visa status while on fellowship might have. Especially in the United States, in recent years, as public funding of the arts has declined, the position of artists of color, and within that group, artists hailing from postcolonial nations and postauthoritarian societies may by further placed under duress (and in competition) to find and obtain fellowships, residencies, and institutional homes.[37] Engaging contemporary diversity work in the museum is therefore a critical function of the international arts market, which should implore advocates to question the bounded geographies of distinct nations and regions. For example, does an artist's "current place of residence" really indicate the full journey of crossing borders between Southeast Asia and North America, or Burma and the United States? When does an artist "stop" or "start" being "from" a particular nation or region? Advocates, too, must evaluate and assign value to artists' strategic crossings of medium and scale, as the latter traverses through the expectations of different host institutions. Crucially, these

shifting rules do not always map neatly onto how contemporary diasporic artists can, in a practical way, answer curatorial calls for diversity according to stable sets of qualifiers or historical precedents.

One international arts news blogger, Ben Davis, discusses the challenges presented by *No Country* as a diverse show that focuses on the region while attempting to address national differences, nomadism, and hybridity: "Walking the press through the show, curator June Yap stressed that each artist was chosen for the way that she or he defied national stereotypes. Yet 'hybridity' and 'nomadism' are their own kind of contemporary curatorial stereotypes, and the over-reliance on such tropes only raises the question it seeks to head off, which is what this particular cluster of artists is doing together at all. Essentially, the curatorial premise of 'No Country' appears to be, 'Huh?'"[38] Davis's critique came on the heels of something collectors at the international auction houses Christie's and Sotheby's had already noticed: a spike in the 2010s within the international art world, including among New York museums and international collectors, to collect from the ever-shifting category of contemporary Southeast Asian art.[39] In April 2013, two months after the Guggenheim exhibit's opening season, Sotheby's sold 165 works, or 96 percent of those on offer, from its Southeast Asian modern and contemporary art inventory, for a total of $14.5 million; in November 2014 it sold $15.9 million in Southeast Asian art.[40] In 2015 the Southeast Asian modern and contemporary art market experienced yet another unprecedented 28 percent growth in auction sales, with Sotheby's selling approximately $46 million worth of Southeast Asian art (from various eras).

There is no way to prove a causal relationship between the Guggenheim's show and the spike in international Southeast Asian art sales. Nonetheless, the correlation between the two speaks to how Southeast Asian art has been primed by curators and regional policy makers at this moment of international acclaim in ways that do not necessarily translate into transparency for knowing how contemporary artists can meet constantly shifting criteria for inclusion. Pamela Corey, Boreth Ly, Zineng Wang, art historian Nora Taylor, and others have noted that the Southeast Asian contemporary art market is the place where the question of regional

identity and "other modernities" that refuse to center the West are debated.[41] Over the course of the 1960s, the creation of the Association for Southeast Nations, an economic and political organization connecting Indonesia, Malaysia, the Philippines, Singapore and Thailand, and others, attempted to mollify the aftereffects of anticommunist anxiety in the region and took up the cause of Southeast Asian regional arts as a means of showcasing the region's modernity.[42] Taylor has noted that following the wars in Southeast Asia during the 1970s, regional and community-based shows in Southeast Asia were often sidelined at the cost of Global North curators' framing of Southeast Asian artists' work as inherently political and playing up sociocultural contexts of how dissidence arises in local contexts. Taylor notes that by virtue of contact with Western institutions and critics, this quality of dissent has become the focus in the curation of contemporary Asian art in recent decades.[43]

While the Southeast Asian art market first came to the attention of international art dealers in the late 1990s, it was often in the shadow of collectors' interest in the historically more expensive Chinese and Indian art markets.[44] The current Southeast Asian market is based in major urban centers, namely Saigon, Singapore, the Philippines, and parts of Indonesia.[45] This centering often leaves out rural and borderland communities, including Indigenous and refugee communities, asylum-seekers, and diasporic subjects, who are not necessarily named as such but nevertheless operate as active agents in the construction of these new Southeast Asian modernities. Countering a seamless borderlessness, with an insistence on focusing on those who exist in the borderlands, is a unifying theme among the artists featured at the Guggenheim. Experts have attributed the collectability of Southeast Asian art in part to the rise in number of Southeast Asian and East Asian investors in Singapore and Indonesia interested in post–Cold War artwork as a source of investment, rather than academic and art institutions, critics, and activists acting as key interlocutors collecting works for permanent archival collections.[46] Therefore it is not a surprise that the folk art produced by displaced artists moves in and out of legibility, sometimes garnering favor and sometimes skirting the traditional contemporary markets that assign market value. In this environment, *No*

Country taps into the current focus that art historians and curators place on Southeast Asia, who see it not as a "fixed category of geographical reference but as a 'contingent device' for developing knowledge about the region."[47]

No Country, No Borders: Curating Testimonies to Genocide in the Contemporary Museum

By design, *No Country* attempts to capture notions of estrangement and cross-cultural encounter while also attempting to name diverse histories of national uprisings in the region of South and Southeast Asia, troubling the border and contesting who belongs there. The Guggenheim had the difficult task of condensing the histories of two interrelated regions and choosing a curator who reflects the fluidity of movement of some of Southeast Asia's diasporic subjects. Besides this tall order, the person who would eventually take the job needed to somehow represent the various political transformations that began in the region during the latter half of the twentieth century and continue in the contemporary moment. June Yap, an independent curator since 2008, was selected for a two-year residency by a five-person committee of experts in South and Southeast Asian art. The museum's website highlights Yap's ability to introduce regional artists' work into global networks of circulation based on her experiences in the curatorial departments of the Institute of Contemporary Arts in Singapore and the Singapore Art Museum, as well as curating exhibitions in Germany, Hong Kong, Italy, and Malaysia.[48]

However, the discourse of borderlessness that brings together various South and Southeast Asian artists under one roof brings other questions to the foreground: borderlessness for whom, when, and to what ends? Meditating on a parallel issue of "cultural rootlessness," art critic Chin-Tao Wu critiques the undelivered promise of the biennale structure (which is not wholly dissimilar from the typical structure of a regional show) to break economic and political barriers for underrepresented artists and curators. He notes the mercurial movement of artists and curators of biennales in particular, as constantly "on the move" in transnationally elite spaces: "Jetting in and out of likely locations, they have no time to assimilate,

still less to understand, the artistic production in any one place. From the viewpoint of those living and working in distant outposts, mega-curators and global artists may seem well connected; but they remain, by the very nature of the enterprise, more or less culturally rootless. At the same time, this deracination gives them a position of advantage, if not of privilege; for them, biennials do indeed have no frontiers. But for the majority outside the magic circle, real barriers still remain."[49] Wu further notes that the fast-paced movement of the biennale pushes some invited artists and curators to ignore the specificity of race, space, and culture of both themselves and the biennale space. He likens the dizzying "concentrical and hierarchical structure" of the global art world to the upward spiral architectural structure of the Guggenheim itself, pinpointing how for artists to reach the centers, "you need to imagine an uphill journey, starting from the peripheries and passing through the semi-peripheries and semi-centres before you reach the top — though in some cases it may be possible to jump straight from a periphery to one of the centres."[50] To best belong to the frontierless biennale or, alternatively, to the regional exhibition, an artist must often work to some degree within the constantly shifting and deracialized limitations of diversity in order to be legible and even invited to show their work at a host institution. Yet, there is another valence to this statement, one that grounds itself in the movement of artists and tracks another submerged pattern of funders who follow artists.

I extend Wu's description of the dizzying physical structure of the Guggenheim that also hints at how host institutions and their financial backers increasingly experiment in using their investments in underrepresented regional art; they count on these unlikely launching pads to broker more comprehensive borderless relationships with developing markets. The (settler)- colonial foundations of a show's financial history buttresses the obfuscation of previous histories of genocide, ironically, in order to make visible more recent ones. News coverage of the *No Country* exhibit neglected to mention the allegations of criminality that UBS has previously faced for playing a critical role in post–World War II capitalism in Europe. In its previous incarnation as the Swiss Banking Corporation, the corporation came under legal scrutiny in the 1990s for its handling of the

accounts of Jewish people killed in the Holocaust; those individuals' bank accounts had been deemed "unclaimed property" and were stolen by the bank.[51] Several Swiss banks, including UBS, were originally accused of "collaborat[ing] with and aid[ing] the Nazi regime in furthering war crimes, crimes against humanity, crimes against peace, slave labor, and genocide."[52] In 1998, the company renamed itself the Union Bank of Switzerland and attempted to rehabilitate its image through support of the arts, of which the Guggenheim UBS Global Map Initiative is a part.

Various regions featured in the initiative share a common condition: they all have postcolonial economic debt to European and US lenders. Rather than a top-down financing that dictates the museum's curatorial goal of diversification, the borderless enterprise also reflects the museum's hopes to encourage postconflict nations to symbolically alleviate these debts by participating in the transnationally mobile UBS Global Map Initiative. Yap's compelling curatorial call to consider "the impact of ethno-nationalism, historical colonization, and present-day globalization on identities in the region," while committing the show to these goals, materially furthered the exhibit's migration to different metropolitan centers across the world. The traveling exhibit performatively crossed borders between New York, Hong Kong, and Singapore, further amplifying the exhibition's mission to affirm South and Southeast Asia's deterritorialized borders alongside formative histories of colonization and ethnonationalism in the Asia-Pacific, with much pomp and circumstance.[53] Jürg Zeltner, chief executive of UBS Wealth Management, stated in the *New York Times* about the Guggenheim project: "As art is becoming more and more of an asset class, UBS is looking to increase our profile in these kinds of special fields of interest. More and more we are refocusing our strategy to reach emerging markets, and this project seemed like a perfect fit."[54] Zeltner's affirmation of Southeast Asia as a desirable emerging market attests to the increasing corporatization of private art collections and the well-rehearsed pattern of funding international biennales and initiatives meant to foster inclusivity among developing (art) markets and their cultural workers on behalf of its clients and their portfolios.[55] The impulse to cultivate "special fields of interest" and to (financially) cross borders partially distracts from

the bank's previous role in stealing "unclaimed property" of Holocaust victims. Thus, in bringing both Yap's and Zeltner's mission statements to life, UBS's and the Guggenheim's alliance mimics aesthetic nuances of mobility and hybridity in the movement of the exhibit itself; these acts evince the vital places where the international arts market's borderless effects are felt (by artists and curators) and further concentrate where and when arts and humanitarian sensibilities converge.[56] The choice to inaugurate the initiative with a show of South and Southeast Asian art sheds light on how the museum itself is subject to the discourse of constant transformation, such that both entities' successes rely heavily on the encounter of new frontiers at the cost of potentially obscuring previous histories of (post) colonial border-crossing. It seems not to matter that the obfuscation of one genocidal regime underlies the efforts to represent other genocidal regimes, putting legacies of genocide in service of advancing a pluralist notion of diversity in museum programming that aims for constant contemporaneity.

Ultimately, the combination of UBS's vexed history with war bonds in the aftermath of World War II and the $40-million UBS MAP Global Art Initiative in 2012 illuminates how the company's global arts branding program and similar corporate branding projects have the capacity to shape when and whose genocidal histories are celebrated or obscured within the contemporary museum world. The company appears to hope that spotlighting the aftermath of wars in Southeast Asia, among them ethnic cleansing campaigns in the 1970s and 1980s specifically in Cambodia and Vietnam, is redemptive work for UBS's past deeds. However, in the process, the museum conscripts Southeast Asian diasporic artists to participate in broader curatorial trends that favor the transformation of the museum's own colonial past through its diversification—at the cost of obfuscating other histories of genocide. *No Country*'s emphasis on curatorial transformation, predicated on artists' and curators' cosmopolitan mobility, may partially explain the timely opportunity for UBS to transform its own economic profile after the latter was accused of tax evasion in 2012 (the same year as the UBS Global Map Initiative's debut).[57]

Since the Guggenheim's *No Country* show in 2012, US museum culture has been punctuated with news of artists and activists calling out board

members and trustees for their complicity in acts of border-enforcing and mass incarceration. For example, in July 2019 Warren B. Kanders, a vice chairman of the Whitney Museum of American Art, resigned after months of public protests over the actions of his Florida-based company, Safariland. Reportedly the company's tear gas grenades had been used against migrants at the US-Mexico border and elsewhere.[58] Whitney Museum staff and artist and activist protesters from groups such as Decolonize This Place called for Kanders's resignation and removal from the board; the scandal culminated in the withdrawal of eight artists from the prestigious Whitney Biennial that same summer.[59]

In September 2020 the Los Angeles County Museum of Art received a letter that called for the removal of Tom Gores from its board of trustees. According to the letter, Gores, a billionaire CEO of the Beverly Hills–based private equity firm Platinum Equity, had purchased Securus Technologies in 2017, a telecom company that "rakes in more than $700 million per year charging egregious rates for phone calls from prisons, jails, and immigrant detention centers—funds that are primarily siphoned from impoverished families and Black, Brown, and Indigenous communities of color, further constricting the urgent resources of marginalized people."[60] Protests in 2019 at the Museum of Modern Art (MoMA) in New York decried trustees for their financial investments in private prisons, ICE detention centers; and the private military contractor Constellis (formerly Blackwater) came under fire for its mercenary security forces, which were being launched during US wars in Iraq and Afghanistan.[61]

The question of Southeast Asia as a specter to be reckoned with in US museums is familiar. Alisa Cohen presents a listicle of scenarios dating back to the 1960s, when activists and artists pressured art board members and trustees at major museums to resign, particularly politicized "happenings" in 1969 during staged controversies at the MoMA. Activists and artists from the Guerrilla Art Action Group called for members of the powerful Rockefeller family to resign from the MoMA board of trustees after claiming that the family was involved in manufacturing weapons used in the Vietnam War.[62] The group staged a performance piece of two men and two women fighting in MoMA's lobby, eventually ending the brawl

with (animal) blood being spilled across the floor and scattered pamphlets explaining the Rockefellers' connections to the war.[63] This dramatic means of situating the history of Southeast Asia in the US imagination exemplifies many well-documented controversies around how contemporary wars engender protests in art spaces, as well as other controversies honored in memoriam (such as the debates around Chinese American artist Maya Lin's Vietnam War memorial in Washington DC).[64] In this milieu of contemporary art critique, Burma and its diaspora has been something of a looming specter within discussions of Southeast Asia's regional and Burma's national art. For some it is taboo to explicitly discuss themes of censorship, state-sanctioned silencing, imprisonment, and harm toward those who bring attention to military violence.

While these connections may seem surprising at first, there may be answers to why these carceral logics and borderless investments go hand in hand. Cultural historian Neda Atanasoski notes that the United States occupies a crucial position in the debate over imperial power in its own right: "The fiction of the United States as a nation that is morally suited to humanize landscapes of atrocity through imperial military and juridical rule presupposes that, in contrast to the racism of previous European empires and the narrow-mindedness and fanaticism of contemporary ideological foes, with the advent of civil rights, America became an exemplary racial democracy for democratizing nations."[65] Her contention, that the United States is hypocritically trying to distance itself from its own racialized military industrial footprint through a focus on domestic advancements in civil rights, is well taken. While Atanasoski highlights the role of the US global empire in dictating the human rights landscape in the post–Vietnam War civil rights era, the irony of presenting the United States as an "exemplary racial democracy" scaffolds the discourse of *No Country*. This show became a stage on which to reveal postwar US-Southeast Asian financial and cultural investments as manifested in the international art scene in the 2010s. In particular, the language of finance, emerging markets, and asset holdings permeates the talk about the Guggenheim's global initiative as a means of naturalizing the legacy of postcolonial dispossession in South and Southeast Asia, in Latin America, in the Middle East, and in North

Africa. As seen through only this lens, it does not seem to matter that the United States and other imperial regimes have taken the liberty to define Southeast Asia's histories and borders. Rather, *No Country*'s representations of a wide swath of the region also mimics potential routes of arts market expansion in the same places.

These concurrent processes sometimes reinscribe forms of Western-centrism in the museum as a question of funding commitments followed closely by aesthetic commitments. Such engagements further embed the contradictory apparatus of humanitarian financing that apprehends diversity primarily as a "diversification" of markets and only secondarily as an imperative call to decolonize the premise of "diverse" themes, content, and marginalized communities represented in the museum. In this dynamic system, contemporary diasporic artists are encouraged to wrestle with topics of cosmopolitanism, ethnonationalism, and human rights while they are also invited to concede, to a degree, to a specific vision of borderlessness that eclipses parallel histories.

Postcolonial theorist Ankhi Mukherjee argues that the terms of a borderless world should raise caution: "The spatial diffusion and extensiveness of global markets and media give rise to a sense of belonging to a borderless, shared world when the reality is that such developments lead instead to greater polarization and division of nations and regions."[66] Mukherjee contends that this notion of connectedness, inspired by the "borderless" discourse, sometimes obscures the presence of ongoing legacies of colonialism and neocolonialism. Scholars such as Gloria Anzaldúa and Walter Mignolo propose that such borderlands are sites of geographic, political, economic, and cultural contestation that highlight the possibilities of both complicity and resistance to the geopolitics of national borders.[67] Still others within the field of Southeast Asian American studies, among them the feminist cultural theorists Isabelle Thuy Pelaud, Mariam Lam, and Lan Duong in particular, have troubled how Southeast Asia's borders, broadly conceived, call for "attention to diaspora, to provide, cultural, historical, political, economic and geopolitical contexts for the routes of migration and traversal by those on the margins of Southeast Asia."[68]

It is for this reason that artists' contributions provide some dissonance

to the curatorial brief at hand, especially as they refute unidirectional movement (in their own journeys and in the journeys of the communities they belong to) by moving away from exploration of the West. For example, *No Country* featured a traditional Vietnamese woodcarving engraved onto a Louisville Slugger baseball bat by Tuan Andrew Nguyen, a Vietnamese refugee artist who has since returned to Vietnam. The piece merges a traditional form with a contemporary theme in order to reflect on the legacy of US military occupation within Vietnamese culture.[69] The artist collaborated with an artisan from Huế, Vietnam, to carve onto the bat the image of Thích Quảng Đức, a Buddhist monk who protested the persecution of Buddhists by the South Vietnamese government by self-immolating in 1963.[70] Other pieces in the exhibit include *Love Bed* (2012) by Bangladeshi artist Tayeba Begum Lipi. Lipi's piece consisted of a bed frame entirely composed of stainless-steel razor blades, "intended to challenge traditional notions of marriage, childbirth and gender."[71] According to the exhibition catalog, Lipi used the razor blade because of its function as a basic surgical tool during childbirth; while seemingly a cautionary sign, it also reflects the idea that the strength of steel reminds her of the tenacity of women she grew up around.[72] Other artists featured in *No Country* center their work around populations and historical figures who have experienced the threat of having "no country" or are exiled, undocumented, stateless, or living as refugees. Indian artist Amar Kanwar presented a retrospective trilogy of documentary videos—*A Season Outside* (1997), *To Remember* (2003), and *A Night of Prophecy* (2002)—that focused on exiled orators, poets, singers, and musicians of Nagaland in postindependence India; these cultural producers are often at the margins of Southeast Asia. Together pieces in the exhibit reveal how Indigenous, refugee, and migrant dispossession undergirds the possibility of cosmopolitan movement for some artists at some moments but not necessarily borderless movement for others escaping their communities in times of emergency. Artists' attention to the specificities of their communities' transnational and regional movement pushes back at the museum infrastructure, taking to task the notion of the "seamless" border.

When considering how artists actively struggle to stay in the museum's

good graces while refusing to fully succumb, their works perhaps ascribe to the more radical version of borderlessness, beckoning a world to come along. These borderless interventions by artists take a different tactic than the curatorial prompt. Rather, what would happen if museums were to shift the weight of diversification narratives to prioritize the material restrictions faced by artists and their respective communities under the national borders in which they live, rather than the opaque process of borderless capitalist funding?

Wah Nu and Tun Win Aung: "Whiteness" and Bordering Universalism

When it comes to Burmese art's collectability in museums and libraries, its popularity has often relied on the language of antiquity, relic, and tradition. Gearing toward exemplary craft by and large, the most popular Google results for "Burmese art" lead to *parabaik*, a folded bamboo or palm leaf paper medium for painting, writing, and drawing of religious, courtly, and scientific advancements in early modern Burma; to woven fabric and textiles; and to Buddhist sculpture and lacquerware.[73] Contemporary photography and paintings draw heavily on breathtaking pastoral scenes featuring national religious and architectural landmarks and Buddhist religious figures. In contrast, Burmese diasporic cultural work, in its regional Southeast Asian and US contexts, typically fluctuates between the genres of contemporary painting, performance art, digital installation, and sculpture.

Burmese artists Wah Nu and Tun Win Aung, part of this movement since 2003, have mostly exhibited in the Asia-Pacific region, including in Australia, Singapore, and Japan. They began collaborating in 1998 when they were both university students. Wah Nu majored in music and Tun Win Aung majored in sculpture. Wah Nu comes from a family background of nationally recognized filmmakers, poets, and writers, namely her father and grandfather; Tun Win Aung comes from family of artisans who have made religious idols and busts of Buddhist altars, pagodas, and monasteries that are specific to the region of Ywalut in the rural Mon division of the country.[74] According to Wah Nu, the couple wanted to

Diversity and Refuge in the Museum

revitalize the practice of bust-making, even if only briefly, since it produces archival matter deemed lost or irrelevant to the times (plaster-made toys have been abandoned in favor of rubber and plastic).[75] In the context of Burma's public spaces, the memorialization of General Aung San through statues, city parks, state buildings, and national monuments is a naked and austere structuring of nationalist affect among the country's citizens. In recent years these memorials have been located at sites of contestation in ethnic minority states, where the erection of new statues bearing his image are deemed critiques of deferred peace-making processes delayed by the state's military government.[76] By bringing Ywalut artisanal plaster casts to the space of the Guggenheim, Tun Win Aung and Wah Nu disrupt the bounded, easy identification of Yangon histories as representative of the whole of the Burmese state, opting instead for a meditation on boundaries between urban and rural geographies within the nation and beyond the Southeast Asian region as well.

Wah Nu and Tun Win Aung are among the many contemporary Burmese artists of the post-1988 generation who address their position as a newer generation of artists reexamining the national history through combined mediums. The two artists now call Yangon their home base. In recent years Yangon has seen an increase in the number of formal galleries, which have multiplied from a handful to at least thirty.[77] This increase of international interest in contemporary Burmese art is apparent in new digital technologies, film, and installation as mediums of choice.[78] *White Piece #0132: Forbidden Hero (Heads)*, the piece described earlier, is one piece in the artists' longer series *1000 Pieces (of White)*. From the beginning of the project in 2009 to the premiere of the work in *No Country* in 2012 the artists had produced 150 pieces, including installations, sculptures, and videos, framing all in stark white surroundings or dipping or painting individual pieces in white paint.[79]

The reference to "one thousand" pieces implies the constant labor that will need to happen to complete the project. Especially given the encroachment of more mass-produced technologies on traditional methods of construction of plaster idols, *White Piece #0132: Forbidden Hero (Heads)* in particular symbolizes the pressures on these artists' in the amount of

time and labor required. The simultaneous fetishization and devaluation of traditional craft by museums' search for constantly "new" or cutting-edge work can put emerging artists in a tenuous position, all while the contemporary museum can shift its requisites for diversity at a whim when seeking out under-curated work.

As noted earlier, Jürg Zeltner, chief executive of UBS Wealth Management, referred to art as an "asset class." This accumulative discourse can reinforce corporate goals of proliferation in the museum, which put an extractive gloss on curatorial platforms that invite emerging artists to exhibit. Critic, curator, and Asian Americanist scholar Thea Quiray Tagle suggests that particular demands of the arts market can require prolificacy on the part of both artists and curators—and thus a subsequent refusal to comply could be broached through "relational curation" or by "challenging the ways that art institutions only value artists for their productivity . . . a long-term labor in which artist and curator work horizontally toward shared benefits, even when the artist or curator is not being as productive as capitalism mandates they be."[80] What Tagle sees as a possible road map for cultivating long-term relations that could drain curatorial silos of racial capitalist power connects with what others have suggested are closely related initiatives to change the liberal landscape of diversity work in the contemporary museum, from paying superficially inclusive lip service to undertaking actual transformative practices. Aesthetically this may inform an artist's choice of medium as well as the reproducibility of certain kinds of work. Thus, artists must balance the call to challenge accumulative forms of museum curation with the potential longevity of their work in institutional settings.

On its face, the choice of white may seem like a neutral one, but in the context of museum history, it is controversial with regard to both the financial and the aesthetic history of exclusion. Art historian Aruna D'Souza has observed how museums' "whitewalling" is "a neologism that expands in many directions: the literal site of contention; i.e., the white walls of the gallery; the idea of 'blackballing' or excluding someone; the notion of 'whitewashing,' or covering over that which we prefer to ignore or repress; the ideal of putting a wall around whiteness, of fencing it off, of defending

it against incursions."[81] This vocabulary, which captures how contemporary museums' financing can "whitewall," or cordon off topics that misalign with a sanitized version of humanitarian benevolence, is telling: it captures the moment that Southeast Asia finds entry into museum diversification discourses. In *No Country* the aesthetic and curatorial "whitening out" of borders dangerously flirts with premises of neutrality and universalism that can further embed colonial erasure.

As art critic and curator Maura Reilly has noted regarding the challenges of inclusive curation in contemporary art, "instead of constructing a new and inclusive discourse for art in an age of globalization — one that confronts the limits of occidental power and thereby departs from hegemonic Euro-US cultural perspectives and their exhibition projects — most mainstream (non-activist) exhibitions are only interested in including postcolonial Other as long as they speak of their Otherness."[82] For Reilly, the means for most mainstream curatorial activism fall short in their "revisionist" or supplementary approaches and can include marginalized communities and perspectives while still centering Eurocentric canons and discourses. She sees the most hope in relational curatorial approaches that seek to "transcend the 'additive' approach, collaps[ing] the destructive center-periphery binary," and placing diverse works in dialogic relation to one another as a process of co-constitutive meaning-making.[83] In light of Reilly's and Tagle's critiques, the curatorial execution of *No Country* may not simply adhere to a rehabilitative logic that further centers Eurocentric power in the museum. It may instead invite artists to intervene in what qualifies "Southeast Asia" as a unifying category. To consider how the show moves with these tensions, or operates in dialogic relation between curators' and artists' interpretation of mission statements and humanist goals, might constitute a more adaptive framework for engaging contemporary Burmese and Southeast Asian art writ large in this moment.

1000 Pieces (of White) attempts the ambitious and repetitive labor of selecting and bathing one thousand national, family, and personal keepsakes in white paint. On its face the process may seem like a simple concession to museum whitewalling. However, the foundational concept of *1000 Pieces (of White)* engages the possibility of success at completion as much as it

does possible failure. For the artists, the title of this open-ended project is simultaneously a directive and a future-oriented mark that embeds possibilities as much as a refusal to forget the country's recent past. Wah Nu and Tun Win Aung play with the notion of rural folkcraft brushing up against potential erasure by majoritarian nationalist narratives, and their use of white invokes the potential for making these experiences relatable to the viewer. According to Wah Nu, the archive of *1000 Pieces (of White)* is still in progress: "For me, the main idea is the influence of the past 30 years, our image. Sometimes we lose certain ideas. Sometimes we cut them out. We want to create pieces where layer by layer is white by white and it represents disappearing memories. Therefore, we only use white."[84]

Wah Nu's reflection on this period of the past thirty years marks the time following the 1988 student protests. This period challenged artists, their patrons, curators, and audiences, as state censors restricted these communities from publicly sharing Burmese cultural production. Yet her statement gestures outside of more spectacular popular representations of *sangha* and student struggle that characterize this era. The artists' focus on forgotten craft and memories gesture to concurrent neocolonial forces of globalization and their effects on local markets—among them traditional mediums and ethnic minority folkcraft. Wah Nu and Tun Win Aung's exhibit foregrounds looming questions around postcolonial history as it is influenced by the strictures of censorship, authoritarianism, and universalism at various academic, institutional, and governmental archives. The application of white to the busts of *White Piece #0132: Forbidden Hero (Heads)*, and the function of "whitening" more broadly in this exhibit, brings with it the impossibility of having a tabula rasa, given that the Guggenheim assembled these works in part to add "color" to or diversify a primarily Euro-American art canon.

Anne Anlin Cheng has noted whiteness as an aesthetic concern of modernist architecture by citing Mark Wigley: "Wigley also underscores the critical and fraught conversation with femininity in the history of the making of the modern white wall. . . . The history of idealist aesthetics, exemplified by the non-ornamental clean white surface, is a history not only of sexual difference, as Schor and Wigley demonstrate, but also of

Diversity and Refuge in the Museum

racial difference."[85] Cheng aptly articulates how whiteness, as a gendered and racial signifier of modernist idealist aesthetics in the museum, can frustrate the inclusion of racial and sexual difference. By casting nationalist ephemera in white, Wah Nu and Tun Aung propose a tension between hegemonic Burman nationalist histories and minoritarian histories, especially as they operate within the Guggenheim's design (which itself hopes to accommodate underrepresented figures). Wah Nu and Tun Win Aung achieve this tension by moving between traditional and digital mediums, troubling the boundedness of urban and rural geographies and honoring family histories embedded in the official archival footage of marches for Burma's independence. Here, they condense space and time and reorient chosen mediums of archival knowledge; the artists traverse between majoritarian and minoritarian narratives that scholars and museums do not often place alongside each other within Burma's post–World War II independence history.

These latter themes have a longer-standing presence in Tun Win Aung's previous work. In a previous piece entitled *Train* (2003–9), a mixed-media installation with a two-channel thirteen-minute video, the artist presents "a tunnel-like white cube, in which he projects a video showing the movement of the train through these different spaces using stop-animation."[86] Through this small-scale approach projected outward onto a gallery wall, Tun Win Aung metaphorizes small-scale quotidian encounters with Burma's borders and encounters of multiple temporalities, simulating his experiences for his audience onto the filmic geographies of lesser-known or "minor" landscapes. Crossing borders and time zones at the level of neighborhood to city to nation, as represented in this miniature scale, allows Tun Win Aung to focus the audience's attention on the accumulation of circuitous routes he has taken to get where he is.

When viewed up close the footage reveals a small sculpture of a white wooden train that appears as the footage splices between quick documentary flashbacks of childhood haunts and places where he exhibited his work from 2003 to 2009. These disparate spaces include his elementary school, a favorite café, his hometown in Burma, and places where his work took him, including cityscapes in Germany, Japan, and Australia. About his work,

art historian and critic Isabel Ching suggests, "In *Train*, the asynchronous temporalities of the self, the homeland and the world are explored. . . . The train appears to move in a lonely fashion, incompatible with its surrounding, which appear to move at a much faster pace. . . . That the viewer needs constantly to shift his/her perspective to accommodate the different temporalities existing in the narrow space highlights the artist's keen awareness of the contingent nature of perceptions and interpretations."[87] This reading of *Train* alerts the reader to how the artist miniaturizes very real experiences of travel and, potentially, isolation.

While for Ching the artist's journey seems lonely as he reconstructs his experiences of travel, at the same time the train invites the audience to connect to the various spaces he encounters along with him. The viewer can share limited glimpses of the experience of losing one's sense of home, of origin, of one's primary education, as the train moves from his home village to beyond Burma. The artist disrupts perceived borders between traditional and contemporary mediums, between discordant moments of the past and the present, and also between places familiar to him and those yet-to-be-determined destinations where the symbolic train is headed. The small train is immersed in stop-motion, giving material form to the often-stunted process of waiting to cross a border or never quite crossing a border freely. Through this choice the artist suggests that both minor and major moments of upheaval constitute artists' movements as anything but borderless journeys from the Global South to the Global North. By simulating the stops, starts, and periods of movement on the train through footage of experiences of rural life and moments of global travel, the artist refuses to frame his move to the Guggenheim as a linear, upward, or progressive step toward something better. Rather, the artist insists on the value of abandoned movements, not-to-be forgotten sites, and fissures that minor histories offer to majoritarian ones; these are moments that often go uncelebrated in Burma's national history and in the museum.

The theme of movement between rural and urban contexts expressed in *Train* also manifests in Tun Win Aung and Wah Nu's *White Piece #0132: Forbidden Hero (Heads)*, which brings Mon craft and a family trade to an iconic New York arts institution. The piece pulls a famous address to

the nation by General Aung San, which the artists rediscovered in national archival material, as well as black-and-white footage of the 1938 protest marches by Burmese civilians against British presence in Burma. Wah Nu describes that even forty years after the death of this "forbidden hero," the memory of Aung San still lingers in Burma.[88] In her explanation she motions to one of the two black-and-white video projections, which shows General Aung San at a podium addressing Burmese civilians from a wooden stage. The selected clips of Bogyoke Aung San's speech focus on topics such as domestic economy, education, military, and import/export during the late 1940s, shortly before his assassination and only months before official independence. In his speech the general lists the initiatives in Burma that needed to take place in the immediate postcolonial period; he returns to the refrain of what freedom from an empire means—as he defines it, it is independence from external colonial aggression and unity among the various ethnic groups in Burma.

In an interview on opening night of the exhibition, Wah Nu pointed to the right side of the installation in the video and identifies a gentleman carrying a trademark student's satchel at his shoulder; this man had been a film director and writer in Burma. She explained the significance of this commemoration of the leader: "It's true he's no longer here, but General Aung San is always in my heart, in my mind, and in my memory. If I have to start explaining, *1000 Pieces of White* . . . it wasn't just for General Aung San. The one at the end is my grandfather, U Thadu." Wah Nu was referring to other piece of looped video footage, part of *White Piece #0133: Thakin Pe Than's Long March* (2012), which also features footage of anticolonial Burmese marchers in 1938, an event in which Wah Nu's grandfather participated. During her interview, smiling, she shared her personal connection to the archive: "This image is about his march when he was young, in the 1300 Revolution. That is also my memory."[89] Wah Nu brings our attention to the experience of not only witnessing but also reacquainting herself with her grandfather through the archive and a critical moment of national significance to Burma's history of independence. The artist had selected fragments from longer speeches, paused and slowed down parts of the speeches, and provided English subtitles.

By selecting and pausing in parts of the film footage for an effect of sharp focus, she opens up a distinct time and space for viewers to consider alternative evaluations of overlooked national heroes and dissidents in their commemoration of national births and deaths. This strategically punctuated uncovering of her patrilineal heritage for the audience ties the footage to the rural worker movements that led to the politicization of students, sangha, and civilians in Burma's cities on the cusp of independence. This purposeful pairing of footage—of Wah Nu's grandfather and of General Aung San sharing the same stage at the Guggenheim—imbues this moment of personal and national importance with international significance. Even though Wah Nu was not yet born when the footage was taken, the fact that the artist cites this work as part of "her memory" articulates how the call to borderlessness emboldens the artist to loosen intergenerational boundaries between herself, her grandfather, other prominent unnamed independence leaders of the past, and audiences of the present. When the two artists invoke memories of their forebearers combatting colonial aggression, they are also celebrating a mode of decolonization that seems resonant in the 2010s, when agricultural developers, oil companies, urban corporate financiers, and NGOs were looking to benefit from the new markets taking root in Burma. The artists' confrontation with their experiences of crossing and of stasis between the rural and urban contexts borders on anticipation of what renewed imperial relationships might reemerge during Burma's political transition. As they express freedom of movement within the minutiae of the archive, or by sharing previously cloistered footage with the public, they corroborate challenges of border-crossing, not just inside Burma but also in conversation with international audiences in a moment of political transition. The parallel ramifications of attention to the minutiae of borders in Sopheap Pich's large-scale sculptural piece *Morning Glory* (2011), reveals how, by meditating on themes of excess alongside rural, refugee, and migrant dispossession, the artist shifts hierarchal structures that discern marketable content to meet the museum's diversity goals. Notably, while Pich is not a Burmese diasporic artist, his work juxtaposes themes of sparsity and excess as well as regeneration and return in the aftermath of militarization and displacement in Southeast Asia. These themes show

up elsewhere in comparable work of Burmese diasporic artists' work, and Pich's work is instructive in understanding the terms of engagement, as artists navigate return in their work, both on- and offstage.

Sopheap Pich's *Morning Glory*: Genocidal Remembrance at the Borders of Museum Diversity

The global tour of *No Country* included works by a select few other artists from the South and Southeast Asia regions that did not appear in the show's original New York debut.[90] One of the show's headliners, the piece *Morning Glory* by Sopheap Pich, was prominently featured in the *No Country* exhibit only after the initial opening. It also marked the "return" of the exhibit to Southeast Asia, as it traveled from New York to Hong Kong and Singapore. *Morning Glory* is one of the largest installation pieces in the show, the dimensions of which register at a staggering 210 in. × 103 in. × 74 in. and 17.5 feet long. Pich's large woven sculpture of a morning glory flower made of rattan, bamboo, wire, plywood, and steel bolts draws "from indigenous sources in a traditional weaving technique" (fig. 5).[91]

In his broader body of work, Pich sources local materials from Cambodia that include bamboo and rattan, but also burlap from rice bags and beeswax, in earthen pigments.[92] From these he has created sculptures that are inspired by bodily organs, vegetal forms, and abstract geometric shapes.[93] One critic describes the method by which Pich weaves his work in rattan and bamboo: "Splitting them into long ribbons that are then interlaced and secured with tight twists of wire—allows them to define the forms of his sculptures, combining his training as a painter with the spatial conceptualization of a sculptor."[94] In viewing the catalog photos of the piece online, the rattan and bamboo sculpture shows simultaneously structured and porous frames, inviting audiences to look through the intricately woven dimensions to reveal more weaving on the other side, rather than to simply to look at the piece in relationship to its surroundings. In the context of *No Country*, the artist's balancing between the porosity of the sculptural form and the reclamation of hardy rattan and bamboo seems to also fit the call to porous borders within Southeast Asia.

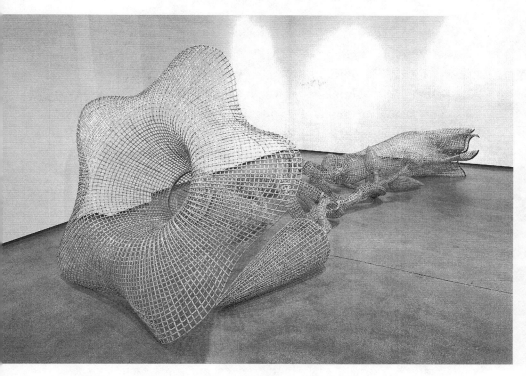

FIGURE 5. *Morning Glory*, 2011. Courtesy of Sopheap Pich Studio and Tyler Rollins Fine Art.

Resting on a slightly elevated platform in the gallery so that it purposefully drags at one end, the hefty flower and winding vines dare the audience to see whether it might slip off the edge of the supporting structure. Like unearthly plant life announcing a stately entrance, the piece made its return from exhibitions in the United States back to Southeast Asia at the Centre for Contemporary Art, Singapore, a national research center of Nanyang Technological University.[95] Traversing the assigned boundaries of geographic region and nation, Pich's large-scale woven sculpture spatially and narratively just barely spills over the platform in the exhibition space, allowing the artist to symbolically "make room" for narratives of refugee movement that overwhelm compact narratives of victimization or liberation through late-coming inclusion into the international art canon. It took Pich six months to complete the piece in 2011, where it debuted at the Tyler Rollins Fine Arts gallery in Chelsea, New York; it also exhibited

Diversity and Refuge in the Museum 131

at the Metropolitan Museum of Art in New York City in 2013 during his solo show, *Cambodian Rattan*.[96]

In the context of *No Country*'s debut in Southeast Asia, the piece's homecoming commemorates the genocide of 1.7 million of Cambodia's population by the communist Khmer Rouge from 1975 to 1979. Pich gestures to the experiences of survivors of the Killing Fields, the sites at which state-sanctioned executions took place. Rather than propagate a seamlessly borderless world, his work demonstrates how he and other contemporary Southeast Asian artists might leverage their vulnerability against the seductive discourse of cosmopolitan hypermobility as a salve for surviving relatively recent state-sanctioned violence. The Khmer Rouge systematically removed families from Cambodia's cities, forced them into rural labor camps, and executed thousands of other citizens in a campaign called "Year Zero." This campaign prescribed agricultural revolution or a "return" to a precolonial agrarian society that demonized urbanization as a symptom of Western imperialism.[97] One of the aims of this state-sanctioned genocide was to eradicate class structure by eliminating "enemies of the state," identified as intellectuals and cultural producers, which underscored encampment and agrarian labor as a last stand of survival for the majority of survivors.

Pich was born in 1971 in Battambang, Cambodia, and grew up in an agrarian community displaced by this nationalist violence. In 1979, when Vietnamese soldiers entered Cambodia, like many others, his family left for refugee camps along the Cambodia-Thailand border.[98] After receiving his early education in English and Khmer at a series of refugee camps in Thailand and the Philippines, he resettled with his family in Amherst, Massachusetts, and eventually attended the Art Institute of Chicago. After struggling financially and conceptually as an artist in the United States, he returned to Cambodia to continue to make art. In 2004 he moved from formal painting to the medium of sculpture and found his trademark style in large-scale rattan and bamboo sculpture by repurposing and making use of the refuse of Cambodia's reemerging agrarian economy and industrial overgrowth.

Especially as *No Country* gives shape to the popular imagination of contemporary Southeast Asia, narratives of refugee mobility are positioned

in the show as testimonies to the success of regional postauthoritarian governance in the aftermath of state-sanctioned genocide. Pich's answer to the show's curatorial call to borderlessness manifests in three ways, namely, in his approach to scale, as he uses large-scale pieces that suggest refugees' experiences of statelessness exceed the purview of nationalist agendas; in his use of recycled materials designated as industrial waste to beautify international art spaces; and in his use of artist statements to exceed the stated goals of the curatorial platform. Pich's use of mundane waste as memorial refuses that inclusion into the museum as necessarily an unequivocal gift. Even though *No Country*'s invitation may suggest that artists "have arrived," in terms of moving through the international arts market more easily and the potential longevity inclusion brings, his work of salvaging surplus troubles the idea that such a state is permanent. Rather, his process challenges the notion that there should be normative time lines of rehabilitation and recovery from war, and that those time lines should operate in tandem with the curatorial processes toward diversification.

Pich's work is an example of what critical refugee studies scholar Cathy Schlund-Vials might call "Cambodian American memory work," since it provides countertestimony to official state narratives of genocide and is "rooted in a legible transnational orientation, is expressly heterotopic in its critical articulation of non-state authorized 'other spaces' for genocide remembrance and justice."[99] Schlund-Vials makes a case for how spaces such as human rights tribunals, defined by linear justice-seeking in prosecution of war criminals and enlisting testimonies of survivors, set a distanced relationship to the majority of mourning publics than other forums. Building on Schlund-Vials's theorization of Cambodian American memory work, Pich's use of space, materials, medium, and narratives around artistic process shows how to actively grow other spaces in which to house remembrance. Viet Lê has noted that the artist draws on the ubiquity of bamboo, rattan, and metal wire as the "common language" of household objects in Cambodia and the makeup of baskets, furniture, and brooms that are easily found in markets of Phnom Penh as well his rural rice-farming community of Koh Kralaw.[100]

In Pich's choice to sculpt the morning glory that, like him, has moved

from Cambodia to the United States to Europe and back, he chooses an artistic medium and physical form that nearly literalizes what Schlund-Vials describes—the rhizomic, transnational, and often nonlinear routes that genocidal remembrance takes, which do not intersect with official state registers of justice. Besides the medium of woven sculpture, the reclaimed bamboo and rattan, even on a granular scale, allows extra space to appear through the pieces' porosity, positing the artist's reclamation of human and nonhuman entities' propensity to sustain life by insisting on the interdependencies of Cambodia's postwar economies.

Rather than a colonial logic of expansion, *Morning Glory* is in dialogue with the displacement and uprooting of Cambodian lives and the intentioned use of natural resources. Viet Lê's artful rendering of the power of "return" in Pich's work signals the refusal to be ingratiated to the United States, a singular site of affirmation for his work as well as the complicated "homecoming" of his pieces to Cambodia. Thus, the artist's choice of symbology and the painstaking methods he and his team must undergo in order to be able to wrangle the raw materials are sometimes placed in paradoxical and productive relation, or what Lê calls both "presents and poisons."[101] Lê draws on the notion that the morning glory is at once an invasive species that "chokes off the Mekong Delta waterways" while also holding seeds that have inherent toxicity to humans and nonhuman life but, yet, also have been used a healing agent for treating migraines, heavy bleeding, and Parkinson's disease.[102] Pich and his team are dealing with the morning glory's symbolic potential for harm as well as hoping to distill its most regenerative properties by using bamboo and rattan to resurrect its form.

Jacqueline Chao, a curator representing Crow Collection of Asian Art, which exhibited another major piece by Pich, *Rang Phnom Flower* (2015), interviewed the artist on the arduous process of making his works. Each large-scale sculpture averages six months to complete and requires the support of several assistants in sourcing materials locally as well as cutting, curing, and preparing the material for use. The reliance on his relationship with local depots and rattan suppliers all happens before the weaving process begins:

JC Can you tell us a bit more about your process for creating this? For example, how is the bamboo and rattan harvested and treated, and how long did the weaving take? How long did the whole project take?

SP We buy whole rattan from a furniture shop a few times a year. Several of my assistants spend a couple of days selecting about a thousand of the most mature trees from each batch at a time. These trees are about four meters long, and we split them into four strands lengthwise with a large knife. They are boiled in diesel gasoline in a custom-made tank to cure the rattan, a process that removes the water and sugar inside the strands and kills any insects. After this, we shave each strand with a sharp blade, which takes about 20 minutes per length. The preparation of bamboo follows a similar process, but we boil it in water instead of gasoline. We still go to different villages to cut bamboo from groves if we require certain parts of the trees that we are not able to get from depots, but, in general, we select the bamboo the same way we do the rattan. *Rang Phnom Flower* took us about six months to make, with a team of seven people.[103]

The artist is particular in his methods of sourcing material, supporting businesses whose livelihoods lay in surplus rattan and bamboo. By sourcing materials from his surrounding community, he enlists the support of local villages and depots and evidences how they generate lifeblood to local economies reviving agrarian practices that the Khmer Rouge denied. The care that Pich and his team of assistants take in selecting thousands of mature trees so as not to stunt the growth of future generations, how they cut and split thousands of tree-length strands, and how the material is cured to the make it malleable and protect it from insect infestation is no small feat. Especially in consideration of the community labor it takes to produce one gargantuan flower and vines at a time, this contemporary work of imagining the future of these industries as they confront genocidal pasts seems a material necessity for the future.

 In his artist statements, Pich emphasizes how the morning glory is a

plant that has kept many people alive—specifically those who survived the Khmer Rouge regime—after the subsequent displacement of communities and the obliteration of agrarian livelihoods. In an inaugural interview with Yap, the artist noted how he and other Cambodian refugees used the plant as the base ingredient in their communal cafeteria during camp life and ingested the flowers as sustenance:

> The morning glory grows easily, where there's water, and it just grows like a weed, you know—you don't even have to plant it. It's kind of an abundant plant. The regime at that time, they don't let you fish, they don't let you hunt, they don't let you take anything out of anywhere to eat, to feed yourself.... They save all the best for whatever they need to, you know, sell it, or whatever, trade to other countries... we were starving a lot, and the morning glory was just an essential plant.[104]

The morning glory, growing "like a weed," further highlights its role as a sustaining source of diet as well as its capacity to feed many in the face of how the Khmer Rouge regime restricted other types of labor such as soil farming, fishing, and hunting. He highlights the balancing act between life and certain death that the morning glory symbolizes when he says it is a pair of "beautiful words" but also "remind us of a bitter time." The contradictions that cohere within this gigantic, unruly, and perpetually blossoming flower attest to survivors' dual strategies of both sustaining and mourning life during periods of environmental devastation alongside ecological, cultural, and political upheaval. By resurrecting surplus materials that were not "even supposed to be here," getting them to bear a second life instead of discarding them, Pich opens up a border between entities considered gone, entities still living, and entities still to come.

The artist's take on borderlessness is not only about a geographic specificity to Cambodia's affected farmlands; it also considers those gatekeeping discourses that keep intergenerational mourners apart. His work interfaces with an already prevalent discourse within critical refugee studies and studies of diaspora over the place but also the appropriate time for unofficial genocidal remembrance, especially when displaced artists must negotiate

refugee status and root "home" to multiple places outside their home nation. Scholars such as Yến Lê Espiritu, Mimi Nguyen, and Eric Tang have argued that the contemporary refugee-making process figures "the refugee" as someone necessarily indebted upon their arrival and considered an excess population to various sites of resettlement.[105] Moreover, scholars in critical refugee studies attend to the nonlinear project of resettlement, which calls into question whether refugee status is ever truly "over." Cultural anthropologist and critical refugee studies scholar Tang refutes the notion that refugee resettlement means a resolution of political status in the lives of those affected: "Refugee temporality is the refugee's knowledge that state-mediated resettlement is a false proposition; it is the disavowal of a resolution, an unclosed refugee sojourn."[106] Through *Morning Glory*, a meditation on past-used materials being put to use to construct potential refugee futures, Pich brings to life the temporal friction Tang articulates in the notion of a perpetual refugee. By putting such long-term planning and labor into each piece, Pich asks if the journey to resettlement was ever the close of a sojourn, and if there is *ever* a specific time or place to mourn or commemorate those who did not survive the journey. For Pich, perhaps these were particular rituals that held fast among communities on the way. These modes of survival, the artist suggests, come with ramifications for the future positioning of refugee and diasporic populations as vulnerable populations to state violence. In returning to his statement on the lack of possibilities for traditional routes of survival, he notes that during war, "they don't let you fish, they don't let you hunt, they don't let you take anything out of anywhere to eat, to feed yourself." The artist's response to the museum's version of borderlessness coheres around the capacity of *Morning Glory* to represent both the masculinist violence of genocide and the resilience of survivors who must take up often-gendered care work to nourish, feed, and raise each other in order to survive.

Pich elaborates on how the artist positions the survivors of the Khmer Rouge: who harvested the morning glory, who remade kinship ties with other survivors, and who refashioned the gendered labor of feeding and family care often traditionally associated with motherhood. The largesse of the morning glory exemplifies how such labor was often redistributed

among those left in the community, creating bonds between people not necessarily existing within heteronormative arrangements of age or gender.[107] Grappling with the redistribution of labor within families in the postwar period, Pich takes up the hardness of "cast away" bamboo materials and infuses them with pliability associated with an abundant flower, metaphorizing the types of hybrid communities of different generations of survivors, during wartime, who were able to reconstitute themselves.

Appropriately, the morning glory takes on a larger-than-life significance and embodies and reorganizes social relations within postwar Cambodia. Specifically, as the piece generates spaces of genocidal remembrance in the Cambodian diaspora, it also highlights the precarities of potential diasporic return for both communities and the land itself. The show's return "home" to the region elicits how postwar legacies include the potential "homecoming" of migrants, diasporic subjects, and refugees (represented by artists from these communities). By resurrecting materials that were thought to have already served their purpose, the artist refuses to equate refugee life with bare survival or death with destruction: he matches materials with different shelf life and different amounts of time being unclaimed. The most dangerous of these materials are literally contained in contemporary Cambodian rural landscapes. Boreth Ly notes the artist's use of metal casings and residue from unexploded bombs, mixed with rattan, bamboo, and wire, to provide scaffolding and depth to the sculptures.[108] Thousands of unexploded land mines laid by the Khmer Rouge and during other wars in Southeast Asia are reported by the Cambodian Mine Action Centre and other nonprofits, which note their ongoing impact to the usability of local farmlands in the region.[109] Cultural historian and Asian Americanist Davorn Sisavath aptly observes a phenomena she calls "metallic violence" with respect to closely neighboring Laos. Casings and bombs are reused and built into villages where bomb remnants make up parts of dwellings and public spaces, become the minute materials remade into jewelry and other arts for tourists, and figure in the demining industry that is primarily composed of women survivors of the US Secret War in Laos. "Metallic violence also draws our attention to the traces of imperial violence that it holds: the visible and nonvisible markers of displacement and destruction

of military operations conducted and unexploded ordinance pollution concentrated in the Global South; new injuries and death from experimental warfare technologies and weapons that have a life of their own; and war metal's potential to enact a different kind of circulation."[110]

In a parallel vein of reflection on the ongoing legacies of metallic violence in the region, Pich has been interviewed on the danger associated with return and reoccupation of Cambodian farmlands, as some were sites of unexploded land mines. These yet-to-detonate land mines become symbols of the legacy of genocide of lives still yet to be lost to state violence.[111] This theme, of a diasporic artist reusing materials of past national trauma, indexes the relationship between consuming, digesting, and "recycling" past struggles in order to imagine a future where postwar Cambodian local economies are supported through such labor. By reclaiming buried remnants of war, which have rested underneath the land and are now dangerous to agrarian users, Pich intuits a different relationship to the work of borderlessness. He rejects a horizontal, aboveground, and violent colonial logic of division, segregation, and expansion of borders previously deployed by the Khmer Rouge, as well as by other Southeast Asian, French, and American military forces during occupations, instead envisioning nonlinear processes of reclaiming Cambodia's resources. Indeed, this is yet another valence of how Pich and other artists plot out regenerative and nonlinear routes of coming to terms with the legacies of war, some of which are embedded within hegemonic renderings of Cambodian history as they are narrated aboveground or in official accounts. By juxtaposing themes that capture seemingly contradictory modes of refugee embodiment that are often racialized and gendered as enduring but vulnerable, the artist invites his audience to consider refugee life as necessarily perpetually resourceful in the face of forced borderlessness. He refuses further narratives of victimization of displaced communities in the midst of war and asks what it means for contemporary Southeast Asian art to attest to postwar survival in perpetuity.

Pich's approach to borderlessness is also informed by the daily coping with the afterlife of war: artists may struggle with their economic livelihoods after resettlement, refusing to equate circulating art internationally

as making peace with the precarity of the multiple resettlements he and other refugees have experienced. *Morning Glory* also metaphorizes a period of frustration and transition in the artist's life, by which his return to Cambodia means facing a new host of struggles for economic stability as well as spiritual sustenance. During an artist talk-back hosted by the Asia Art Archive in America, he reflected on a moment of sacrifice in a homecoming during 2004, when he considered destroying large-scale sculptures that made it hard to occupy the space of his small apartment in Phnom Penh:

> I was so frustrated. After Guy Issanjou [Pich's interlocutor] left, I was so poor, so broke that I moved into an apartment that cost forty dollars a month. I had no space to work or to store [my work]. So the large pieces had to go first. . . . So in order to just get rid of that anxiety or whatever, I wanted to destroy them . . . I saved the sculptures on the rooftop because I was offered a show at a new hotel that just opened up. . . . It's now in the Singapore Art Museum. My philosophy is that if I have made something already, I don't care what happens to it. If nobody wants it, I will just throw it in the river. It's fine.[112]

Pich attempts to make sense of the divide between waste and fruitfulness, productivity and loss. As he describes his lean economic circumstances in the face of the multiplication of his many works, he almost metaphorizes how a wider narrative of refugee excess cannot be contained by institutionalization of this art alone. Rather, he articulates how this process of struggle to house himself in the diaspora, not just house his works, spills into his life beyond what any museum space can hold. In elaborating on his frustration and the economic constraints upon his return to Cambodia, Pich speaks to the quotidian precarity of artistic livelihood in resettlement in a different Cambodia than the one the artist originally left. Rather than dwell on narratives of easy reunification upon coming "home," his approach experiments with folkcraft associated with Cambodian-ness to the point of hoarding pieces that, in this instance, override the sustainability of his own livelihood. Rather than a linear narrative of cosmopolitan triumph through his work, he uses his winding, disruptive,

massive, and symbolically flowering installations to challenge museum space to fully accommodate and mourn genocidal histories alongside the complex personhoods of Southeast Asian artists attempting to return home on their own terms.

Staging *Morning Glory* in Singapore, in a triumphant return of the exhibit to its home region, also gestured to the possibility of return of refugees, diasporic subjects, migrants, and immigrants to Cambodia and the role they might play in the growth of Cambodia's cities and creative industries.[113] Given *Morning Glory*'s "origin" in Cambodia, and its subsequent tours throughout the United States and Europe, as well as its return to be part of the UBS MAP Initiative, the piece invites global audiences to make sense of the piece as a postwar testament to the region's continued healing—from nationalist violence and various US, European, and intra-Asian imperialisms. In addition to the hundreds of thousands of Cambodian refugees who attempted to return to Cambodia after the wars in Southeast Asia in the 1970s, recent news of deportations of Southeast Asian refugees living in the United States to an estranged homeland undercuts the wholly celebratory narratives of borderless diasporic and refugee return.[114] Pich's work is a testament to how refugee communities make sense of their lives in resettlement, not only right after their original migration but in the aftermath of over forty-plus years of war. Within UBS's and the Guggenheim's project of "borderlessness," *Morning Glory* metaphorizes narrative tangents and unruly tendrils, refusing a linear story of rehabilitation and also framing the way contemporary Southeast Asian artists to represent international and intraregional development.[115]

No Country's Afterlife

The Guggenheim's goal of diversity pulls from borderlessness and consequently allows artists to address regimes of humanitarian intervention and militarization to make Southeast Asian nationals visible to international interlocutors outside of NGO and policy arenas. UBS's involvement highlights the contradictory curatorial impulses of humanitarian idealism in the museum. On the one hand the exhibit supports the Guggenheim's goals to

document the histories of ethnonationalist genocide and add a non-Western dimension to its permanent collection. However, the UBS MAP Global Art Initiative and other large investments like it necessitate funding and curatorial practices that allow the museum to help UBS distance itself from its own historical shortcomings of upholding humanitarian ideals. These "diverse" expansions into emerging markets do not necessarily manifest in ways that permanently topple unequal vectors of white supremacy or racial essentialism in the way that border-crossing is imagined as seamless for all parties in the exhibition process.

Given the structure of exhibits such as *No Country*, which attempt to represent the implicitly illusory notion of a coherent regional identity, artists are reliant on contradictory representations of the region as invested in global cosmopolitanism, the active policing of borders, and access to archives of national history. UBS's financing of a contemporary museum that touts humanist ideals in practice may actually work against these very same ideals in order to achieve a borderless aesthetic. Yet, artists are also invited to challenge this call in their actual execution of such ideals, through an approach that reconciles a borderless aesthetic, perhaps in productive relational antagonism with the museum, humanitarian and arts advocates, and the material restrictions historically placed on their practices from their countries of origin and in the diaspora.

In this environment, artists recognize their own role in shaping the narratives of Southeast Asian nations' political transitions, thereby avoiding a simple equation that renders individual states' democratic policies as indicative of comprehensive economic, cultural, and political shifts in the treatment of dissidents and noncitizens.[116] While UBS and the Guggenheim support refugee and diasporic artists from underrepresented regions, these artists are also conscripted to do the work of multiple rehabilitations — to attest to and memorialize authoritarian states in Southeast Asia as well as survive through the benevolence of global humanitarian and arts funding. However, Sopheap Pich's and Wah Nu and Tun-Win Aung's work upend precedent contingencies and narratives of freedom in museum curation.

No Country signals the possible alternate directions for diversity measures to come, encouraging artists to engage in debates around mobility

in tension with displacement of folkcraft and rural existence alongside but not irrespective of land dispossession, irreparable resource extraction, and genocidal legacies. The summer 2017 exhibition *Sunshower*, a collaboration between the National Art Center and the Mori Art Museum, both in Tokyo, premiered by calling itself the first show of its kind to be hosted in Japan. In this retrospective on contemporary Southeast Asian art, curated by a team of Southeast Asian, Japanese, and European curators and featuring work spanning the 1980s to the present moment, two of Pich's rattan works were featured. The timeliness of Pich's work, as museums cement his pieces into the Southeast Asian art canon, attests to how the region is becoming rearticulated in the eyes of its former colonial powers. Going forward, these artists and curators instruct how not to frame Southeast Asia as a region from which to perpetually escape, but instead ask their audiences and funders to envision how multiple regional discourses on national belonging operate on refugee and diasporic artists' everyday lives. Rather than a road map for how similar projects may chart postcolonial and authoritarian legacies, *No Country*, *Sunshower*, and similar international exhibitions speak to the contingencies and contradictions of scale between region, nation, and diaspora, as well as between mobility, migration, and freedom. The works of these artists highlight the behind-the-scenes labor it takes to publicly project alternative accounts of ethnonationalist history, dissent, and genocide through institutions located in the diaspora. How do artists deal with the aftermath of *ongoing* displacement as thematic and aesthetic anchors in their work during their time in New York? The next chapter examines how economies of vulnerability operate at the microcosmic level of the nonprofit arts world by examining performances of vulnerability between nonprofits art granters and artists. How do the thematic and aesthetic anchors surrounding displacement influence the types of arts advocacy that are available to artists who are exiled? How do asylum-seekers cohere aesthetic strategies around the body that lay bare and also refuse their explicit vulnerabilities to erasure? How might funders, advocates, and artists devise strategies of freedom-making under the parallel conditions of thriving and displacement that animate their works?

3
Freedom of Expression, Asylum, and Elastic Vulnerability
The Art of Chaw Ei Thein

In the fall of 2009, behind the door of a lit dressing room at the Grace Exhibition Space, a second-floor loft of an apartment building under the JMZ subway line in Bushwick, Brooklyn, exiled Burmese artist Chaw Ei Thein prepares for her performance. She applies the last strokes of black paint to her body and tucks the tail of her all-white cotton T-shirt into a white *htamein*, a traditional Burmese skirt. There is a palpable hum of people moving in and out of the dressing room backstage. Against this backdrop the artist asks me to find a place to microwave the Uncle Ben's minute rice packet she holds, not to eat but to use as a performance prop. Minutes later, the artist makes her entrance onto the main floor. Loud electronica music fades and an overhead fluorescent light focuses a dim beam onto an empty green chair in the middle of the room. The artist quietly emerges from the back of the room, staggering in on her tiptoes and with a black cloth bag tied over her head. As she moves, the dim light reveals her face and arms "tattooed" in permanent marker, showing dozens of screaming faces that are reminiscent of Edvard Munch's painting The Scream.[1] She struggles to breathe deeply, her breath shallow, constrained, and unsettling to listen to.

The audience watches in nervous anticipation as the artist falls and suffocation seem imminent. A hush descends over the darkened room, then she parts the crowd of mostly young artists, stopping dead in her tracks in front of an alms bowl similar to those used by Buddhist monks for collecting donations. She bends down to a pitcher of water, a pair of leg shackles, and a bowl of cooked (minute) rice resting on the floor. She

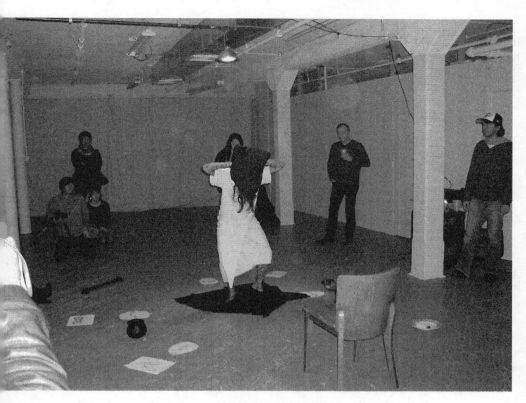

FIGURE 6. Photograph of Chaw Ei Thein's performance *WEs 2026*, 2009. Grace Exhibition Space, Brooklyn, New York. Photo by the author.

rises back up to a half squat, still on her toes, only to quickly release into a prayer position with her forehead to the floor and her body doubled over. She repeats these movements. During one of these repetitions she places a face mask of Aung San Suu Kyi over her hooded face.[2] Suddenly the artist overturns the alms bowl, spilling a group of passport-style headshots of Burmese faces onto the floor—which the audience later learns are images of individuals previously disappeared by the Burmese government.[3] The artist knocks over the vase of water (that she cannot drink), bends down toward rice (that she cannot eat), and buckles herself into the leg shackles. She shakes her head "no," then whimpers, breathes hard, turns on her stomach, and balances all her body weight on her knees and elbows (fig. 6). A man in the audience with an open beer heckles, "Oh baby, I like it when you move it like that . . . Spank that ass!"

Freedom of Expression, Asylum, Elastic Vulnerability 145

The audience member's comment goes unacknowledged, except for the slight bristling from those near him. The artist does not flinch and continues the unsettling performance of self-injury, entitled *WEs 2026*, conjuring an invisible but still hauntingly omnipresent torturer from thin air; she embodies the political prisoner who quivers in fear. Through her whimpering and labored breathing she produces visceral moments that tread between terror, confusion, and even pleasure, as she unapologetically presents the vulnerable, feminine, Southeast Asian, and Burmese body on stage. The man who called out "Spank that ass!" may have interpreted the artist's body crouched in pain as a body present for his pleasure, an invitation to sexually objectify the performer. Yet his interruption also highlighted the discomfort some in the audience felt in their collective, voyeuristic spectatorship of a Burmese woman committing self-injury. It is only later, during the Q&A, that the audience learns that the fate of countless imprisoned comrades is still unknown; they will continue to be absent.

While Chaw Ei Thein's performance is subject to a variety of interpretations, the specter of an audience needing to resolve the inscrutability of an artist's performance of the asylum-seeking body must be confronted. In the case of the audience member who shouted, this resolution came in the form of associating the artist with a militarized history of sexualized fantasy about Asian women caught in the wake of US and European empires. The prophetic moment signals the racial and sexual panic inspired by asylum-seekers' representation of sensual, ecstatic, and prostrate pain in front of live audiences. While such moments may seem incidental, in the realm of performance these encounters of vulnerability between asylum-seeking artists and potential patrons—gagging, self-binding, as well as self-censorship—demonstrate the limits of visibility and freedom of speech in their liberatory capacity as promised by hegemonic human rights discourses. Chaw Ei Thein, as a previous asylum-seeker, sets the stage for a debate over the aesthetic and humanist value of the rescuable body in pain and thus negates legibility as a prerequisite for political and economic support in resettlement. The analysis asks how artists play with illegible human personhood and exposes the limits of the juridical struc-

tures of human rights claims but also animates embodiments of freedom in artists' livelihoods in exile.

By working through the bodily lexicon of self-injury or withholding the knowable self through human rights discourse, some artists assert aesthetic value in positioning their own asylum-seeking bodies in close proximity to imperial and neocolonial violation and therefore articulate a different register of self-control. Queer studies and performance studies scholar Vivian Huang notes this "withholding," in the case of Asian American performances of self-sacrifice, facilitates what she calls an aesthetics of inscrutability, "where a social relation is premised on a dynamic of knowing and obfuscating knowledge."[4] In this way withholding seeks a broader relation to other minoritarian life, where "inscrutability should not be read merely as privacy, insularity, or individualism. Particularly when withholding is attributed to Asian American performance, this mode can be enfolded into white assimilationist narratives of complacency, passivity, and model minoritarian antiblackness."[5] Aligned with Huang's articulation of what is possible to know through the inscrutable, such performances of self-injury unsettle the definition of what is beautiful *about* refugee and asylum-seeking suffering, as well as for *whom* it is meant within the humanitarian and arts industries.

I consider Chaw Ei Thein's self-injurious movements on- and offstage for a variety of reasons, but especially for how they lie squarely outside interlocutors' disciplinary impulse to frame written and spoken human rights discourse in terms of "rescuing" artists in distress. Here, self-injury is differentiated from complicity, where the latter term might be understood as an act that gives in to humanitarian intervention. Celine Parreñas Shimizu interprets some submissive positions as subversive sites of potential political possibility for Asian/American women:

> In reframing the Asian female as bottom (occupying the traditional role of the passive position in a sexual relation), I reveal a site of possibility in power relations and the veneer of perverse sexuality indicated by that bondage.... If we were to accept sexuality as unavoidable to

discourses of Asian women in representation, then let us blow the doors wide open in terms of recasting how to make that sexuality political.[6]

Shimizu argues that cultural producers may render modes of agency in scenarios where they are objects of others' fantasies (of rehabilitation, of respectability, of perverse sexuality) that are not immediately legible, especially when an artist may choose "passivity" by her own hands. Sarita See has theorized that transcendent states, in which postcolonial artists deal in symbolic dismemberment or disembodiment, are potential moments for enacting a "queer decolonizing" politics that can disassemble empire by disassembling their own subjection to it.[7] If hegemonic humanitarian discourse holds up a narrative of rehabilitation of the refugee from statelessness and inhumane treatment to rescue through resettlement, what are the stakes for Chaw Ei Thein's refusal of a legible version of that transformation, and perhaps the transformation altogether?[8]

The labor in artists' performances must be considered alongside their everyday movements as refugees and asylum-seekers who navigate the arts and humanitarian industries.[9] As mentioned previously, elastic vulnerability names a cluster of gestures that artists perform on stage and translate offstage to create conditions for freedom of expression and freedom of movement under constraint. These gestures express their struggles in the context of military violence and censorship in Burma and elsewhere, as well as the fraught conditions of resettlement in which dominant humanitarian discourses suggests they are "free." Thus, I extend Shimizu's theory to consider Chaw Ei Thein's live refusal to narrate resettlement as simply a testament of survival from "inhumane" suffering to unfettered freedom. When Chaw Ei Thein writhes on stage, she troubles legible narratives of overcoming political struggle, taking the roles of both suffering feminine spectacle and refugee subject. These *dis*embodiments of human rights — refusing audible speech and instead opting for whimpering, choking, blindfolding, and shortness of breath — capture how exiled activists do not simply "get over" past and present militarization of their lives once they have migrated to an assumed safe haven. The silencing of refugee and

asylum-seeking artists by Burmese state apparatuses and by the mainstream humanitarian discourse are not the same. The processes differ geographically and politically with regard to scale, intensity, and duration, depending on the artist. However, how Chaw Ei Thein brings communities of humanitarian and arts interlocutors into a shared space and momentary alignment forwards a multipronged approach to expanding the terrain for freedom of expression.

Therefore, instead of treating self-injury as a last resort that asylum-seeking and refugee artists *must* do in order to get the attention of human rights practitioners and arts interlocutors, let us consider this choice to creatively represent political prisoner torture and ask: What does self-injury onstage expose about both arts and humanitarian industries? What does it do for the artist and the communities they hope to support? When exiled artists engage self-injury in order to critique surveillance, torture, and censorship by the Burmese state, what privileges and punishments do they tender at the intersections of the international arts market and humanitarian industries? To what end do once-exiled artists' performances of self-injury translate into political and economic currency or, conversely, as roadblocks for resettled artists in the world of arts-granting in New York?

One focus here is on self-negation: how Chaw Ei Thein deals with the specter of self-censorship in her curatorial endeavors with artist peers; how artists self-efface to meet criteria from granters; and how Chaw Ei Thein engages self-injurious gagging, blindfolding, and binding of the body in online and live performances to upend the conceit of humanitarian rescue. At one time the Burmese government denied Chaw Ei Thein reentry to Burma because Burma's embassy in New York had deemed one of her curated shows as suspect. While at the time the artist felt keenly the impossibility of returning home, more prominent was her frustration with artist peers (including contemporaries of her artist father) "disciplining" her artistic choices in the wake of that infamous show. Some of the artists who critiqued her in a paternalistic way engaged in gender disciplining that assumes feminine refugee subjectivity as necessitating gratitude—not to US officials or humanitarian interlocutors, but to other artists.

How do the terms "distress" and "safe haven," which circulate among

exiled artists in their relationships to nonprofit arts granters, inform the way Chaw Ei Thein and other exiled artists must creatively addend responses to rescue? Sometimes this means working within while also testing the limits around the language of rescue as well as also challenging its premises of freedom performatively on stage in resettlement. The formal properties of self-negation on stage and in narration in grant proposal activities are qualitatively different, requiring different types of embodiment. What connects these modes is how exiled artists eclipse or extend time and space in their performances—to make room and give time to mourn, to celebrate, to adjust their position—and then how they bring to bear these ritualizing aspects on narratives of the self *with* their granters. In turn, granters then adapt strategies to make the cases for artists' support with respect to funders. Instead of focusing explicitly on self-narratives often found in granting materials, I instead take up the flexible labor of how granters, taking a cue from artists' self-negating movements, help artists narrate their struggles. In this way the notion of "the self" that artists present in grant narratives is not a monolith nor a simple vehicle for human rights discourse's tendency to present the "healed self." Instead, the healed self is negated, disaggregated, and remediated by granters in elastic ways to help them forward artists' cases to funders in the hope of ultimately shifting the ways both granters and funders might imagine support as finite and geared toward large-scale migration. In the case of FreeDimensional (fD), this might mean how to frame the qualitative terrain of "cultural workers in distress" and place it in the Global North as the ultimate "safe haven." When these efforts are considered together, this multipronged strategy of elastic vulnerability de-norms typical processes of funding grants that support exiled artists in small-scale and meaningful ways. Thus, elastic vulnerability also accounts for how granters might creatively address and collaborate with artists to facilitate the most expansive version of freedom of expression and the most emboldened version of freedom of movement.

Engagement with one of Chaw Ei Thein's performances reveals the various types of constraint embedded in resettlement through her use of literal restraints on her body, a performance staged in acknowledgment of Aung San Suu Kyi's sixty-fourth birthday in 2009.[10] Through

self-gagging and binding Chaw Ei Thein dispels juridical human rights claims to freedom of speech and freedom of visibility as the means for transcending paternalistic legacies of humanitarian and state violence. Chaw Ei Thein's work connects to and builds on previous traditions of 1960s and 1970s (feminist) body art that often included self-injury as a way to address social upheaval.

Perhaps what best describes elastic vulnerability is the affective and performative residue that artists leave behind and between these spaces, to then be picked up as strategy for sometimes activating momentum but at other times to lay a particular position to rest. The juxtaposition of these scenarios does highlight the elastic vulnerability that artists employ to put those arenas into proximity or in relation that in turn emphasizes the latitudinal labor across these performative registers in arts and humanitarian spaces. Engaging the ways artists wrestle with elastic vulnerability in their work and in the political economy surrounding it affirms the broader stakes of refugee and asylum-seeking artists' creative interventions in scripts of suffering and self-negation, both onstage and in the offstage world of arts grants and fellowships.

This analysis frames the vulnerabilities that artists face as simultaneous rather than successive: namely, the physical, political, and psychological aftermath of detainment by a Burmese military state and the compulsory gratitude artists must maintain upon reaching creative safe haven in the United States. It underscores the fact that attaining freedom of expression does not come simply by physically moving one's location. Again, freedom of movement is not just a de facto move to the Global North. Rather, a more expansive understanding of freedom of movement accounts for the geopolitical regional tensions and challenges that artists must contend with. These artists propose subversive erotics that situate experiences of detainment, migration, and resettlement on a continuum that highlights degrees of rather than the totality of unfreedom and freedom. This accountability also means the freedom to express can hinge upon the stretching of financial and artistic resources to make the most sense for an artist's longevity with respect to future community-building. I suggest that artists' subsequent engagements with arts and humanitarian interlocutors ultimately

disrupts popular assumptions about the conditions and geographies under which authoritarianism and democracy thrive.

Chaw Ei Thein: "The Bind" of a Resident Artist in Exile

Born in 1969 to a family of artists, Chaw Ei Thein, a former lawyer-in-training, has had her work featured in independent galleries in Burma, Canada, Taiwan, Singapore, Thailand, Vietnam, Japan, and the United Kingdom. She lived in Burma during infamous periods of civilian protest in 1988 and 2007, when the Burmese state shut down universities to prevent student political organizing. These interruptions extended many artists' and activists' time to finish a university degree, and furthermore shaped their art; policing, surveillance, and migration became part of Burmese expressive culture. Living in New York since 2009, she has had a series of short fellowships based in Bushwick and Williamsburg, Brooklyn. Her art career has been covered in the international arts press, including in *Asian Art Now, Asian Art Archive, Artforum, Art Asia Pacific, C-Arts,* the *New York Times,* and *Yishu.* In addition to her work as an artist, she is also cofounder and former director of the Sunflower Art Gallery in Yangon. In this capacity she developed and organized art exhibitions and fairs, with special exhibitions for children's art in various parts of Burma and Cambodia and for psychiatric patients in Yangon. Alongside her career as an artist and curator, she has at certain points tried to reconcile the difficulties of funding herself by pursuing a formal degree in fine arts and business at Hunter College in New York. She also has worked providing childcare services to families in New York City and did a few stints in food service.[11] In 2012 she and fellow artist and photographer Kyaw Swar Thant operated a small art gallery from their apartment in Elmhurst, Queens, called art@pt, which doubled as a community meeting space. Even though they immigrated at different periods—he in 1999 and she in 2009—the need to organize has been a palpable feeling among these two artists and others who have resettled in New York.

I was introduced to the artist in 2009 through her residency with the Asian Cultural Council, which included studio time at the International

Studio and Curatorial Program (ISCP) in Greenpoint, Brooklyn. The ISCP is a nonprofit foundation originally housed in an expensive loft in Manhattan, but in 2008 it moved to a former lithography factory (built in 1901) in an industrial neighborhood. Since its relocation the ISCP has, with the help of private donors, hosted hundreds of international artists in residencies in its large industrial warehouse at the edge of the Greenpoint neighborhood. At ISCP, Chaw Ei Thein created an installation entitled *Bed*, a black-canopied bed full of red peppers. In constant stages of decomposition, the peppers represented the precarity associated with resistance to censorship in Burmese contexts.[12] When New York was her home base, her visual art practice included a series of cartoonish and surrealist nude self-portraits set against renderings of exaggeratedly crowded New York City scenes in which her breasts, pelvis, and mouth are obscured in black splotches. When Chaw Ei Thein symbolically decapitates her own body or violently excises her reproductive organs in her self-portraits, she also highlights her anxiety over what kind of life she is making in the United States. This work, she says, represents her feelings of confusion of constantly "living in two worlds" since her "mind is in Burma but [her] body is here."[13]

The artist's existential meditation on the body, metaphorically being in two places at once, suggests that the disciplining of the self between Burma and the United States can happen in ways unsanctioned by a particular government or perhaps unwelcomed by peers as the expression of religious, gender, or ethnic identity. Chaw Ei Thein's various labors, including self-negation, working other occupations, and the gendered labor of facilitating an exiled artist community all contribute to the notion that a state of "asylum" is as full of constraints as it is "free." As she suggests of her work after coming to the United States, "Now I'm more concerned about what's happening inside Burma during this transition time. At the same I time, I'm also thinking: 'How about my transition?' Where do I want to go, what do I want to do, what do I want to change? . . . Because here there is more choice but there the things you are able to do are very limited. Because you have to do self-censorship all the time. . . . Since I've been New York, I've started to think about my work and how I can change. . . . Because I really get bored doing the same things."[14]

Chaw Ei Thein simultaneously references feeling caught in transition and feeling as though her mind and body are separated between Burma and the United States. However, rather than count this as a shortcoming, she imagines the work that distancing from the national body can lead to and what new work is still possible under exhausting conditions. In this moment Chaw Ei Thein wrestles with the habitus of censorship as a prevalent structuring logic; even when away from Burma, diasporic artists continually account to themselves and their peers concerning their own political transitions in resettlement. That is, some artists must deal with policing themselves internally as one type of censorship and also must engage other diasporic masculine peers as critics of their work, an external type of censorship that echoes the actions of the Burmese state.

This policing of asylum-seekers' and refugees' creativity and pleasure as they participate in self-negation is also present among Chaw Ei Thein's exiled artist contemporaries in New York. Other Burmese diasporic artists' responses to her subversive work repeat narratives of an "acceptable" ingratiated racialized refugee affect through gendered terms. For example, one show that Chaw Ei Thein curated, *Contemporary Burmese Art: Ideas & Ideals, A View into Creative Diaspora*, featured the work of sixteen Burmese artists living on the East Coast, mostly in New York. Ranging from still-life paintings of pastoral scenes in Burma to photographs of ethnic minority women in rural areas doing farm work, the exhibit also featured sparse digital renderings of the Shwe Dagon Pagoda and photographs of Burmese families in their homes and kitchens. The Burmese diasporic critique of the exhibit was gendered. However, it wasn't because critics noticed how the show topically included Burmese women or because there were photographs that focused on Burmese domestic spaces. In fact, the title of the show intimated a seemingly benign theme that the missive in the pamphlet elaborated on: "The artwork, and their creators, will bridge the gap between tradition and creativity, between one homeland and another." Echoing what she said during an interview, Chaw Ei Thein posed the curatorial question: "Burmese artists are used to doing self-censorship on ourselves whenever we created our art while we were in Burma to show

the public. The question becomes, are we continuing this self-censorship once away from Burma?"[15]

According to the artist, the embassy was already displeased with her approach to her work, which they deemed were critiques of Burmese military governance, during her residency with the Asian Cultural Council. In the aftermath of the show, when Chaw Ei Thein was under suspicion by the Burmese embassy in New York, her masculine artist peers were quick to verbally discipline her; the call to racialized and gendered deference was directed at her by both the Burmese and US states *and* her peers. During the course of the show, as she later found out, a Burmese embassy representative also caught wind of a painting by a fellow artist of Aung San Suu Kyi's face, which was a late addition to the show. The piece was a large stencil covering one of the gallery's walls almost top to bottom with blue, red, green, and yellow handprints in acrylic paint made by the artist's daughter, wife, and other community members. As Aung San Suu Kyi was under house arrest in Burma at the time, the "political" image became the most salient image representing the exhibit in subsequent news coverage and blog posts. Chaw Ei Thein and fellow artist Kyaw Swar Thant noted that the painting had hung in Aung San Suu Kyi's house while she was a member of Parliament in 2012.

However, at that time the embassy had not approved Chaw Ei Thein's request to return to Burma. The artist who provided the portrait had not previously discussed using the Aung San Suu Kyi piece and had originally promised a different piece. The Aung San Suu Kyi portrait was first unveiled at the show's opening. Chaw Ei Thein surmised that after seeing Aung San Suu Kyi's image, this embassy representative reported the exhibit to embassy officials, citing its "political" nature, at which point her applications to visit Burma began to be denied. Chaw Ei Thein described the challenges of organizing the show as a curator dealing with some artists' lack of transparency: "We had several meetings. I told them already that this is New York not Burma. You can do whatever you like. We gave the [show's] title and they never discussed it. But, on opening day because of him [paper muralist] — How did I get into trouble? How could I get back to Burma?

. . . Another artist told us, 'The embassy knows about this.' The embassy has all the artists on the list. Because of this Aung San Suu Kyi painting."[16] This unfolding of events stirred controversy among an adjacent group of artists, who then proceeded to ostracize Chaw Ei Thein, accusing her of exposing them to the risk of not being able to return to Burma. Chaw Ei Thein explained to me that they thought that the show was a pretense for galvanizing support for her individual claim for asylum; she summarized the sentiment from this group, as told to her: "This is politics. This is you taking advantage. This is not a real art show."[17] In chiding her and her work for "having her own political agenda," some of these Burmese masculine diasporic artists attempted to discipline Chaw Ei Thein's show—calling it an inappropriate representation of the oeuvre of Burmese diasporic art. Her colleague's patriarchal statement also assumes that as a woman and artist having a political bent to her curatorial work obviates her ability to recognize "real" art, as opposed to critiquing the outlook that she needed affirmation from her masculine peers. Instead, her commitment to the show was framed as a transgressive misstep in terms of botched caretaking for her community and "taking advantage of them."

This particular exchange highlights the contradictory and divisive nature of how liberal notions of freedom map onto refugee and asylum-seekers' struggles, especially those whose affective labor is already racialized and gendered by humanitarian and art industries as un/deserving of asylum. Chaw Ei Thein notes the absence of critique as a form of engagement between diasporic artists: "We need critics. We don't have that practice. If someone criticizes your work, they think you hate them. . . . We don't have arguments. That means controversy." Kyaw Swar Thant adds, "They are afraid of controversy. Controversy in Burma."[18] Here, as these artists lament "controversy," or what might cohere as a fear of critique after living under Burmese state, the gendered dynamics of the same controversy in the United States merit further examination.

Chaw Ei Thein expressed feeling scapegoated as both an ungrateful asylum-seeker and as someone who does not defer enough to her masculine elders or heed the paternalistic tone of US art venues that discern how "desirable" asylum-seekers should act. Leveraging expressions of deference

and ingratiation, which are often essentialized as feminine, punctuate asylum-seekers' work to produce themselves as intermittently grateful subjects to US host institutions and to each other. Chaw Ei Thein has bemoaned that artists who have faced government scrutiny in Burma and now live in the United States are wary of a culture of critique, such that any form of critique is easily conflated with dissidence, which is a punishable offense in Burma. As art historian Melissa Carlson notes, since the 1960s under General Ne Win's Burma Socialist Programme Party government, Burmese artists have been subjected to different iterations of a formal censorship board.[19] The board created a power dynamic between the state and artists in the definition of national identity as it prohibited any artwork that "opposed Myanmar traditions and culture."[20] Carlson argues that this clause left open broad room for interpretation of which traditions and culture are subject to protection and what constitutes a threat, such that "a lack of clear standards and ad hoc enforcement fostered habits of self-censorship among artists that persist even today."[21] I extend Carlson's argument to consider the form that self-censorship takes with regard to Burmese diasporic artists who may not be followed as closely by the Burmese state while in exile but who still feels its effects.

Chaw Ei Thein's sense of artistic freedom upon resettlement to the United States has been shaped by disagreement among her peers as to how to market and circulate Burmese art in New York. Her comments suggest that the mechanism of self-censorship is a form of policing that mirrors the censorship of the Burmese state. She suggests this is a mechanism that artists carry with them in the diaspora—a mechanism that sometimes keeps exiled artists from imagining new work in their resettlement. "Whenever I ask them [other artists], they answer 'We value our tradition, we value our culture.' But is it also being brainwash[ed]? All the time the government warns, 'This is what Western culture is like' in their propaganda. They [artists] also keep those things until they get here. This is the USA. This is New York. But this is little Burma, inside their body" (*Moves her hands to show the scale of difference between large and small.*)[22]

Chaw Ei Thein and Kyaw Swar Thant both comment that self-censorship has deterred many skilled artists from expressing more unconventional

themes, an effective brainwashing, and that those diasporic artists allowed to return to Burma effectively carry a "little Burma" inside them as a self-censoring mechanism wherever they produce art. Though Chaw Ei Thein sees other artists' refusal to abandon their self-censorship as a hindrance to their careers, the point of tension between self-censorship and self-injury is elastic vulnerability most *at work*: the artist moves between modes of self-negation on- and offstage as a means of obviating various types of Burmese state and humanitarian interlocutors' disciplining of freedom of expression and exerting extreme self-discipline. Chaw Ei Thein's use of elastic vulnerability *lives* in moments between dealing with self-censorship in front of her peers and then still choosing to self-negate on stage for audiences; these moments situate the dual registers at which the exiled artist must remain flexible to several fronts of critique. From these positions artists are able to snap back from such critiques and reposition themselves (both their bodies and their political positions) to deal with future encounters with varied diasporic, state, and humanitarian interlocutors.

In dealing with controversy, and "getting into trouble"— translated colloquially from Burmese to mean "trouble with authorities"—Chaw Ei Thein's use of self-injury on stage might achieve a two-pronged goal. One is to address the haunting of state censorship in Burma as it manifests as patriarchal scrutiny among diasporic peers; the other is to show that artists meet the challenge of this haunting (compounded by humanitarian imperialism) that still persists and shapes diasporic artists' lives postmigration.[23] While she suggests that self-censorship restricts her and others from producing art about Burma, this viewpoint suggests that— even if one conquers self-censorship—humanitarian, arts, and scholarly arenas can perpetuate dissident, asylum-seeker, and refugee self-negation and hyperdeference devoid of easily legible value and even "appropriately feminine" affect.[24] Granters and artists also collaborate on how to present their clients' physical, social, and economic vulnerabilities to garner sustainable conditions for artists in the midst of navigating crises. In granters' efforts to help ameliorate the alienation that artists deal with, they end up decentering "moves to the West" as the ultimate goal of emergency and temporary grants. Humanitarian interlocutors and artist grant foundations,

in order to guarantee funding, also play a critical role in framing artists' fraught narratives of freedom from persecution, which artists also leverage on- and offstage themselves.

Nonprofit Arts Organizing Alongside Elastic Vulnerability

I return to the discourse of resolving the condition of human rights subjects' suffering as it relates to performative registers outside the parameters of formal performance spaces for artists. This offstage work within the arts and humanitarian industries includes things such as mundane processes within arts advocacy, such as the completing intake forms that detail the vulnerabilities of an exiled artist's situation to produce a narrative arc of "distress" in order to secure funding. Artists must develop practices of elastic vulnerability to navigate both their own and their supporters' desires for their legibility as vulnerable subjects even as they strive for freedom of expression.

This process does not guarantee that a specific artist can be a definite match for the call of a specific fellowship. I did not ask interviewees what they said on their individual intake forms, since revealing these personal details is both counterintuitive to an allied approach to ethnography and takes a cue from the hints of irresolution artists intentionally leave their audiences with on stage. Additionally, some observations might fall into the category of broader information about the granting landscape and might help make grants more widely available to artists. In this vein, the questions asked on intake forms as they are available to the public on granter websites create the frame: What values around the "distress" of exile or the security of "safe haven" cohere in artists' interactions with granters, especially as these terms and forms circulate at the intersection of the international arts market and humanitarian industry? Parallel to the stressors and inspirations that aesthetically motivate artists, the collaboration between artists and their granters also shifts the dominant discourses of need and rescue that exist at the intersection of the humanitarian and arts industries. Conversely, granters' work is also a creative process that necessitates artists' "elasticity" to reach eventual goals and outcomes.

Rather than framing the grantee as always indebted to the granter, artists negotiate elastic vulnerability as a set of performative encounters that they develop *alongside* granters. Taking a cue again from Shimizu, these efforts can creatively intervene in workings of racialized and gendered power from presumedly "submissive" positions. Acknowledging how these organizations craft systems of support alongside artists, the notion of elastic vulnerability demonstrates how they operate both in concert and sometimes in friction with their officially stated goals of support for artists. While arts organizations assist artists, they do so by surveying artists' needs and applying this information toward crafting their own set of grant rationales on artists' behalf, rather than as a top-down dispersal of support. In tracking the machinations of elastic vulnerability within this arena, artists' interactions with granters topically cover granters making sense of the distress that candidates experience—internal distress that organizations deal with in mediating resources for artists and their own long-term goals in supporting displaced cultural workers.

In 2013 I interviewed grant facilitators from FreeDimensional and the Asian Cultural Council (ACC) at their individual headquarters in New York City's Chinatown and near Koreatown, respectively.[25] At the time, Siddhartha "Sidd" Joag was the director of fD, a multicountry-based collective of international resource organizations geared toward supporting artists, scholars, and journalists identified as "cultural workers-in-distress." Especially as granters and artists both deal with parallel forms of precarity, improvising resources and meeting unforeseen challenges has become part of their modus operandi rather than something to disavow. At the time of the interview, fD was in the midst of moving offices, a small reminder that precarity also informs their improvisational and fast-paced work in identifying a creative "safe haven" for artists.[26] Thus, while fD works with artists to frame artists' vulnerabilities to political and economic distress, fD also draws inspiration from artists in situating their own organization's precarities to dissolution. I see elastic vulnerability in how fD challenges the premise that arts advocacy organizations must exist permanently in order to facilitate systemic change in how funders can support artists. While not the same as ephemeral performance art, fD does engage in a type of

self-negation that hinges on the organization's eventual dissolution such that artists will build on networks and contacts left in its wake.

At the time, fD operated in tandem with an entity called the Creative Resistance Fund, in cooperation with the Festival Against Censorship in Bilbao, Spain. This fund started in 2010 and allows a recipient one travel grant per annum. Small "distress grants" are given to evacuate a cultural worker from a dangerous situation, to cover living expenses while weighing long-term options for safety or to act on a strategic opportunity to effect social change. Once an application is received, the fund typically awards a grant within two weeks. The fund's committee is made up of the executive director of fD and two or three members from the board of directors.[27] fD's website notes that it has expanded its grants to support cultural workers based on the types of cases it has already encountered. The organization has found "the need for an emergency fund to quickly respond to victims of work-related persecution or systemic marginalization."[28]

"Distress" is an amorphous term for a cultural worker in a precarious situation. According to Joag, rather than seeing a one-dimensional meaning, the organization defines "in distress" in terms of both how to select and how to fund their candidates in conjunction with the actual political circumstances that artists and advocates describe in their applications.[29] The fit of a candidate as a "cultural worker in distress" includes making a clear link between how their cultural practice goes hand in hand with the friction they have experienced when working to enact social change:

> The creative resistance fund is not for producing work or touring a performance. We've had cases where people have members of their family who are trying to kill them and poison them because of the nature of the work. "You are in distress. . . . That's for sure." But it's not because of your work. I think that's our cut-off. The way in which the artist, the way the cultural worker engages the community, or engages social issues—if their creative process finds them in a situation of danger, that's the cases we'll work with.[30]

The process fD uses to tailor a set of resources to an artist involves discerning whether the artist's precarity is the result of a broader social issue

or due to smaller-scale interpersonal community or family dynamic. Joag notes that fD's goal is to support the cultural worker in distress first and foremost and cannot necessarily fulfill requests to relocate the family or immediate colleagues of an artist facing a precarious situation.[31] Aiming to gather a more detailed profile, fD's intake form includes a self- or nominator's assessment of area(s) of work, latest projects as related to a current situation, and persecution experienced as part of the artwork—threats, attacks, harassment, arrests, instances of being socially marginalized or blacklisted, as well as dates, locations, and key individuals involved.[32] Getting into even deeper detail, the intake form asks the applicant for a narrative that details the difficulties of the persecution they are experiencing as related to race, class, ethnicity, gender, or sexual orientation. The ideal cultural worker in distress varies by occupation, region of origin, type of assistance requested, and resources needed.

In balancing out the pull between quantitative evidence and the qualitative criteria used to define the notion of cultural worker in distress, the latter is not a necessarily stable qualifier for the ideal candidate. To be considered for a grant, applicants must situate themselves in recent historical and political contexts in order to demonstrate to the board that their circumstances are indeed deeply time-sensitive and can be directly attributed to their creative practices. Subsequently, while the pool of applicants fD considers may be from wide-ranging circumstances, the data from the applicant pool conversely influences the consideration of fit, and the organization may tweak its own mission statement, its own goals, and the application process itself to better suit future candidates. While Joag does compare some of fD's process to that of social service and case management services, he simultaneously recognizes the limits of what is possible for fD to give. fD sets itself apart from direct service organizations when it intentionally recognizes its undoing of status quo procedures toward resettlement while remaining elastically vulnerable or flexible to the obstacles it expects will arise, rather than despite them. By narratively stretching the category of cultural worker in distress and allowing successful applicant criteria to shift the term's meaning over time, fD is able to change and adapt field and organizational conventions to address what

Joag notes is its desire to fund future grantees to "engage community and social issues" rather than allowing the terms of distress to stay the same.

The next step in fD's process includes mediating this set of variables to gauge whether and how conditions of distress are met in each case and then to assemble resources that must work within a specific countdown to possible relocation of the candidate. In other words, whether or not a grant is possible depends on timing of the emergency, available resources at the time of application, geographic proximity of resources, and how those resources might lessen the severity of the applicant's political circumstances. In fD's employment of the term, the type of distress that necessitates funding and resources needs to meet these criteria weighed together. Rather than a stable fixed monetary amount, the fit of the grant is decided by factoring in the breadth of resources fD can assemble based on an initial request of unspecified need that is then customized for the chosen candidate. In this arena, no two grant packages will be the same. In cases where fD is not able to make a grant to an applicant, which is most of the time, the hope is to widen that applicant's available resources and contacts so that they may still find support.

fD does not directly help applicants or grantees with official intragovernmental asylum paperwork itself; however, it does try to assist where other organizations and professional associations are unable to. fD's work supplements an initial application for asylum by helping an artist show evidence of the importance of their work and the circumstances of their persecution and, subsequently, potentially garner a larger profile, which makes for a better case for asylum. For most unfunded applications, fD will circulate the application to contacts at other organizations, who may be able to assist the artist according to the parameters used by these other organizations. Joag notes that cases usually come to them through a partner organization. For example, Joag describes the ongoing back-and-forth relationship with the Committee to Protect Journalists, which operates worldwide and has sent cases to fD when it has "hit a wall," and vice versa.

In other words, a specific fD fellowship or grant is not the only thing that applicants may find. The situation is parallel to how an exiled artist might have to adjust their artistic content to make it legible to different

audiences or, alternately, refuse legibility at all. Rather than one fellowship standing as a final destination or a culmination of support, fD stands by its articulation of a network as the ultimate goal. Joag notes that the uniqueness of each case makes it hard to get as many through to the stage where fD is able to commit a grant package, but that the ultimate goal is to create a field change "so that human rights organizations understand that artists, not typical frontline activists, are facing the same kind of dangers so they can extend their resources to artists and cultural workers." Thus, this public mode in which fD negates hegemonic versions of what a frontline activist is in order to broaden a sense of artistic community and political possibility is something that fD mirrors in terms of artists' use of elastic vulnerability to discipline their own bodies on stage.

Even as granters deal with a wide array of factors of assessment, the toughest part of the job of initial assessment is to gather evidence as to why the candidate is not only a fit but is simultaneously legible as an activist *and* as a cultural worker. Thus, rather than cleaving to a goal of making artists' vulnerabilities exactly legible to potential funders' terms, Joag hopes that fD subverts granters' expectations of who comprises "activist" communities and what political contexts qualify for a grant package. This elastically vulnerable mode mirrors how artists experiment in conveying the position of their bodies and narratives as testaments to their vulnerability to garner support. Joag's hopes for the eventual negation of the organization's existence is not simply a capitulation to narratives of worthy suffering. Rather, it is a means to create conditions such that artists and funders may recognize a shared pursuit to extend and stretch out resources farther than they originally intended to go.

While uniformity in how to treat cases would make the job "easier," Joag also explains that what makes the qualitative part of fD's work challenging is framing artists' profiles and presenting them to funders in such a way that those capable of extending resources might consistently give, "for art spaces to realize they have a lot of excess and they can utilize that for something." The organization's job is to give "context": to situate a candidate's political circumstances and offer a particular light in which funders may able to see the urgency of the candidate's circumstances and the fit for a particular

residency or grant: "A lot of what we do is contextualize things . . . is this person a scholar, not a scholar? We create a situation where we tailor a response to a situation of danger as best we can. Leverage resources and advocate for them." This "leveraging of resources" as a consistent behavior in global arts advocacy is part of the broader and sustained field change fD hopes to see in the goals of other global art spaces: to foresee its long-term goals as flexibly inclusive of support for the visual and performance artists facing immediate precarity.

Mediating Asylum through Creative "Safe Haven"

Joag articulates the term "safe haven" (which drives the work of some sectors of nonprofit arts organizing) as a state of freedom of expression for artists. For some, safe haven is a geographical destination. For others, safe haven materializes when a granter facilitates and secures timely regional connections rather than manifesting "a [permanent] move to the West." Of utmost importance in being able to define the terms of safe haven is the commitment of the artist to work with fD's often Southeast Asian regional networks while they arrange funding and housing for artists in "emergency situations." According to Joag, fD's system attempts to avoid alienating artists from their surroundings and also considers an artist's initial fit within a regional space (depending on the artist's current location) and how to extend finite resources for an exiled artist looking for temporary relocation or permanent resettlement.

In our conversation Joag gave one example of a journalist fleeing political persecution as someone who would ideally receive assistance in a matter of weeks. He recounted the process of attempting to match resources to the artist's specific case, showing how the process can go awry:

> We need to also know that there is an investment on the part of the artist. We understand they might be coming from a situation of trauma where they're unhinged because of recent whatever it is, Imprisonment. Harassment. But that they're committed to the process as well. We had a case of a journalist from Iran who ended up

in Kuala Lumpur. And it was amazing the resources we were able to mobilize. Six months free housing. Office space. All of these things. There are all these people waiting in Kuala Lumpur for me to say something . . . these resources won't last forever. But we got this stuff for him. I didn't hear anything back from him or his contact for two weeks. Then I got a very brief, nonchalant email that was like, "We decided that Kuala Lumpur wasn't for him," and so he got to Los Angeles and he's seeking political asylum in the United States. (*Takes deep breath*.) That's great. That's your decision, but if you had told me two weeks ago, literally two weeks later there's another case about another journalist from Iran who ended up in Kuala Lumpur that came up. Then they didn't respond. All the people who had mobilized the resources. So that is another difficulty is assessing the commitment or the ability of the artist to commit to the process . . . when you have to talk about it quantitatively, it feels counterintuitive to the essence of doing that work. You realize that people need the support at a crucial time. As an organization, we have to be careful about . . . how we leverage those resources. Making sure the people who are putting themselves out . . . don't feel like they are being used or the resources are not being valued.

In the case of the fD candidate in question—who ultimately rejected the proposition to relocate to Malaysia—Joag had already used connections, drew upon relationships, posed inquiries to manifest resources, and secured a residency before the applicant and the nominator rejected the arrangement. The organization's efforts to not overexhaust its network of global sponsors relies on artists who in the end may renege on their agreement midway through the process. If one candidate passes up a particular package for funding or regional site for fellowship, it might mean that sets of contacts and resources might be lost, and not just for that individual alone. The organization may not be able to provide the same connections or support when a similar case appears in the future—an unplanned strain on both the applicant's journey and fD's resources. As the money and space that would have been there for one potential cultural worker must

be allocated to another applicant (or it may simply disappear because of the time sensitivity of the available housing or funds), some factors disrupt how distress is framed by some human rights advocates to be ameliorated by artists simply *reaching* a safe haven.

This example attests to fD's creative balancing work on two fronts. First, in order for it to survive, fD cannot burn bridges or alienate its networks of support—dozens of curators, funders, and gallery operators they have built contact with over the course of their careers. Second, fD undertakes a risk while also prioritizing the high stakes of a cultural worker's emergency in with the context of the fast-paced process of identifying a safe haven. This process can engender certain risks of network-breaking as much as it does network-building for all parties involved. Thus, fD must keep in mind that with every case it cannot exert too much pressure on one particular residency or safe haven to manifest resources too quickly. Overburdening a sponsor who must deal with funding other cases of cultural workers in distress decreases the overall effectiveness of the fD network's ability to provide the *most* cultural workers in distress with funding, resources, and space.

The way fD deploys safe haven suggests that this concept is as diversely defined as distress in situating a process *and* a destination to help an artist stretch their potential for longer-sustaining growth, including resources and networks that will support the artist's arrival and acculturation and fostering support for other future artists. Even as they encourage artists' applications for temporary residences or fellowships, granters also need to stretch the "use" they get out of these fellowships. Their labors in each case also extend how long their organizations are able to manifest resources while staking their reputations as advocacy organizations. In other words, they meet the risk that artists take on in putting their own organizations' reliability at risk, especially when artists reject resources that have been assembled.

Artists partially plan and at times improvise their elastic vulnerability to meet concerns over state and humanitarian disciplining while also trying to satisfy their own hopes for freedom of expression. In a parallel fashion, granters' work of "balancing risk" on behalf of an artist is also suffused throughout the process of application, of awarding the grant,

and of planning the artist's arrival and transition into a safe haven space. Ultimately what counts as safe haven or a temporary space of freedom does not rely on an artist's perception of their own safety or their embodiment of freedom alone. Rather, safe haven depends on an organization's multifaceted risk of exhausting limited resources. That is, it relies on the perception of grantmakers themselves as vulnerable to caprice while they advocate for lessening artists' vulnerabilities. In that way vulnerability *itself* is a discourse they must also be careful not to exhaust to the point of rote rhetoric. The idea that a site will continue to be "safe" for both fD and for an artist becomes one of the determining factors of safe haven as a possibility. With each new case, fD attempts to extend the terms of safe haven and nuance qualifications for distress in order to both better the outcome of each case and weigh new data for future funding decisions. Thus, the elastic vulnerability that grantmakers help shape and stretch on behalf of artists can have a breaking point too.

In situations that are most urgent, providing safe haven counterintuitively might include discouraging an artist who is fleeing a dangerous situation from doing so without a visa or other form of documentation already in hand. In the scenarios that Joag encounters, fit is not usually a matter of grantees having a shared itineraries, genres (ranging from journalism to performance art), or trajectories (coming from particular geographical region). In such safe haven scenarios, which are qualitatively different than the typical museum context for curatorial purposes, the type of networking that is possible is the unifying apparatus for what makes the best fit between grantee and the proposed safe haven site. Joag notes the ways in which artists' desires for relocation to a specific country may not match fD's resource pool nor align with the artist's own notion of a "free" versus an "unfree" space. Joag gave an example of how fD's system for relocation must weigh what asylum would mean in the short term versus the long term and the difficulty of securing a subsequent resettlement site:

> We have a case now that is really difficult. An Afghan theater artist who fled to Delhi with two children . . . how do we help her in India? We reached out to all these contacts in India. In the meantime she got

some advice to apply for political asylum in India. But nobody told her that if you apply for political asylum in India you have to stay in India. (*Pauses.*) Third country resettlement [in India], it's a long process and you're not guaranteed. After we reached out to all the contacts in India, the point person who was communicating for her was like, "She doesn't want to stay in India. She doesn't like it. She'd rather go to a country in Western Europe or North America."

While the organization was not able to offer another option, the case is still telling in how Joag's evaluation criteria for what is safe can shift meaning according to a geopolitical and economic environment, and not simply rehearsing the binary of free versus unfree spaces. This case further illuminates that while fD deals with cases of immediate emergency, what life will look in the long term for the artist after an immediate situation of precarity factors into the evaluation process:

> There are cases where the artist, they are forced to leave. They feel a situation of danger and they leave. In a lot of cases there is something that happens where I think there is an opportunistic sort of view of things that takes over . . . that going to the West is somehow going to be really great, but being an Afghan woman with two children, a single mother who does not speak English, what do you think is going to happen in New York? New York is not an easy place and it's way more expensive than India. This is also the binary, the way the field works is that artists from the developing world are extracted and they are placed in "free places." So a part of what we're doing with regional networks is to create a situation where an artist, if we had something in place in India already, like a proper residency program that could house [them], then that transition would be a lot easier for her . . . the money we could raise for you, if we can get like a five-thousand-dollar grant, that money will last you exponentially longer in India than it would in the United States. It's sort of a juggling act. It's trying to figure out how to work with the artist, but we also can't tell her, Just stay in India.

Freedom of Expression, Asylum, Elastic Vulnerability

Though this specific case was not funded, it was clear that Joag still reached for the most expansive idea of safe haven in this situation of distress. This expansive version takes into consideration regional geopolitics and the artist's position of precarity in their immediately "unsettled" surroundings, as well as the potential for future stretching of limited economic resources invested in artists' long-term survival. Joag and his colleagues must weigh notions of risk, for instance, in cases where the political situation in a new country—which may have an ongoing history of conflict with the artist's home country—might put the artist in an equally dangerous situation. In not naming the West as the typical site of safe haven, Joag notes that it can be a gamble when weighing whether the struggle of migration and financial burden of recent immigration will eventually merit the "freedoms" of resettlement for individual candidates. The risk of potentially mismatching an artist to a site is reminiscent of how Chaw Ei Thein risks onstage to render freedom of expression without being able to fully anticipate the eventual outcomes of support for her public self-injury. The elastically vulnerable self-positioning of the organization in this situation means that it does all it can to expand conditions for freedom of expression to take hold, with risk in mind and not despite it.

Considering that a safe haven must also account for immediate issues of isolation and intense depression by a relocated artist, Joag notes that some artists can receive bad advice in a moment of crisis and may "make rash decisions, which include applying for political asylum in the wrong country." Once an artist is displaced, forced away from friends and family and cast into unfamiliar surroundings, fD attempts to account for how an artist's entire life and livelihood is uprooted and can be further exacerbated by the safe haven process. With respect to sites that may be the best fit on paper because of the combination of funding and length of residency, isolation from cultural surroundings does not equate to an ideal situation for an artist's long-term resettlement. A fellowship in Oslo for a Burmese artist may look great on paper, but matching a Burmese artist to a residency in Thailand, regionally, may make even more sense. However, placing such an artist in China is unlikely to work out well:

There is a huge cultural abstraction, where they are put in these places where, in a sense, they are, by default, on display. But they don't have access. There's no community for them to engage with. I think what ends up happening, the sense of isolation become overwhelming. And even though these are great residency placements, two years, fully funded residency. But they are not spending that time making proper decisions because they are lost. Lost in isolation. I think the idea is that there should be more steps in the process. That an artist from Burma, instead of immediately ending up in Oslo, could maybe go to Thailand first. If the place is trusted, they could stay there, think about it, make the decision, the next move. So, there is a certain cultural connection which I think helps people make decisions. But then there's geopolitical relations, which is really difficult. You could put an artist from Burma in Thailand, but you wouldn't put an artist from Burma in China. You can take an artist from Cambodia and put them in Thailand but you wouldn't put them in Vietnam. So, figuring all that out as well is difficult. Within Southeast Asia, there are a lot of prejudices, the way different indigenous ethnic minorities view each other. So, it's figuring out how to navigate . . . I think the idea is that if the artist, they're moving . . . eventually ends up in New York, it's fine. Our idea is not, You're in trouble, come to New York, but it's actually, You're in trouble, what's the best place for you to go?

Joag is referring to artists experiencing cultural abstraction: placing an artist in a space where they have little cultural context to make sense of their surroundings or within a host community that lacks culturally relevant resources and may not be able to robustly accommodate an exiled artist's engagement within a new community. The idea of "free space" and how Joag intervenes in this language tempers how freedom is affected by shifting regional geopolitics as they influence artists' well-being, as well as the length of time the artist may spend adjusting to new surroundings. Statements by Joag and the ACC vary with regard to fit of a fellowship for

a grantee, especially with respect to short- versus long-term needs. fD sees an obligation to craft scenarios that lessen the initial distress of an exiled artist in new surroundings and Joag must consider the potential aftermath of placing an artist into inhospitable surroundings for the foreseeable future after they have fled a politically precarious situation. In the case of the ACC, the stakes of ameliorating distress are expected with an explicitly temporary fellowship, where artists almost always return to their home country after a number of months.

Both granters attempt to increase the cultural capital they offer artists in excess of direct funds without the expectation to be entrenched forever in the lives of grantees. These aspects of temporary hosting also have ramifications for the long term in how the broader arts and humanitarian industries might shift their funds and use of long-term networks for general arts advocacy. Joag highlights the possibilities of fD stepping back from artists' lives at a certain point just when they are "falling off the radar" postfellowship. While this sometimes creates a difficult situation, this may signal that arts advocacy networks must step up to fill in and eventually obviate the need for mediators and granters:

> The idea behind fD is not to put ourselves in the position where artists depend on us.... But to create an understanding between funders, between human rights organization, and art spaces that if they think creatively between all of them that they can do this. That's our whole point, we're doing it by existing. But when we expire [when fD stops existing], keep doing it. And that this will be something, arts spaces hosting activists as a concept is very new. And a lot of funders have invested in that idea as a result of fD's work. A lot of spaces have created specific residency programs for artists at risk. So that's really the sea change that we hope to see in the field.

The sea change that Joag hopes for would create a different relationality between funders, granters, and artists (with activist backgrounds) and would orient the field of arts advocacy in a circuit of mutual aid. Rather than this network being completely upended by one organization ceasing to exist, a rhizomic set of connections is what Joag hopes artists and other

advocates will be able to continue to build upon. This might require a few people with financial means in these networks being able to perennially replenish a specific residency for artists at risk, obviating the need for fD to be the central connective link and being able to divert advocates' energies elsewhere. Thus, when considering the "end game" of elastic vulnerability, fD pivots away from relationships embedded in rescue and instead hopes to redistribute resources and shift relationships among networks of artists, granters, and funders. In this proposed model, no one organization and no one artist is responsible for dealing with the physical, political, or psychological aftermath of violence from authoritarian states alone, nor does a displaced artist's gratitude remain compulsory upon reaching creative safe haven in the United States.

Since funding applications by fD are guided by artists' improvisations and vice versa, it leaves the question of how artists might translate these tactics around time-sensitivity and geographic constraint back to the stage in an aesthetically compelling way to audiences, being able to secure future opportunities and sustain their communities' livelihoods. In the next section I provide context to how Chaw Ei Thein reinvents the recognizable political message of Aung San Suu Kyi's liberal feminist and humanist image of rescuability to intervene in the humanitarian disavowal of the illegible feminine asylum-seeking and exiled body. In these efforts to be elastically vulnerable and redesign the rubrics of vulnerability applied by most funders, her work vouches for the possibility of freedom of expression, in the bodily minutiae and at sensate level of self-injury, which evades legible human rights recognition.

Homages Away from Home

On June 11, 1963, South Vietnamese Buddhist monk Thích Quảng Đức self-immolated in Saigon as an act of protest against the American-backed Diem government, which had violently suppressed Buddhist protests in the midst of the Vietnam War. Malcolm Browne's iconic press photograph, which captured Đức burning in a seated position, was one of the first times an act of self-immolation as political protest was caught on

camera.[33] Performance studies scholar and historian Øyvind Vågnes, in reference to an interview by Judith Thurman for the *New Yorker*, makes a case for the instantaneous and transformative impact that Thích Quảng Đức's self-immolation had on then-sixteen-year-old Serbian student Marina Abramović, now called "the godmother" of 1970s self-injurious performance art.[34] For many witnessing secondhand, the image captured a stunning act of self-injury that subsequently swayed global discourse to decry the American military's presence in Vietnam. Rhetorician Yong C. Cho argues that public self-immolation like Thích Quảng Đức's can be a potent form of necropolitical resistance and subaltern embodiment, and can "forge one's body (or death) into a political message."[35] Considered alongside other public-facing instances of corporeal and self-inflicted violence, such as maiming, sewing eyes and mouths shut, hunger strikes, and hanging, Cho argues that self-injury has increasingly become a political tactic for those who have been abandoned by public spaces and excluded from formal political participation.[36]

During the Cold War simultaneous postcolonial uprisings throughout Asia, Latin America, Africa, and Eastern Europe, as well as movements for race, gender, and class equality in the United States, sought to overturn the status quo in all forms of social relation.[37] Performance historian Rosemarie Brucher has argued that this confluence also sparked a generation of European and American artists, including Abramović, Valie Export, Dennis Oppenheim, Chris Burden, Franko B, Gina Pane, and many others, engaging "body art" as a medium that relies heavily on the "radical confrontation with dependency on the body and its vulnerability."[38] In terms of medium, body art moves the depiction of bodily mutilation from the medium of panel painting to the medium of the live body, usually through drastic means such as "razor blades, shards of glass, knives, nails, and pins and ever-riskier actions involving injury by cutting, pricking, and burning."[39] Famously, in 1964 Japanese artist Yoko Ono began to perform *Cut Piece*, in which the artist invited audience members to cut away at pieces of her clothing with scissors on stage, an act of "radical giving" from her to them, which at the time was received a type of exotic striptease by many critics.[40]

As Brucher suggests, political activists and performance artists alike

insisted on the autonomous command of one own's body as a "battleground," where lost territory could be regained: "[As] part of the protest movements of the 1960s, consciousness was raised about the heteronomy of the individual through the normalization, the regulation, and the tabooing of the body, the very procedures by which the social order and its mechanisms of repression and exclusion constitute themselves."[41] Drawing on Brucher and Jones, the momentum of the reproductive justice, immigrant justice, and labor movements of the 1970s might also frame the work of postcolonial, queer, and women of color artists like Coco Fusco and Ana Mendieta, where they consider questions of decolonization as critical to feminist body art and seek to "radically embody" the feminine subject in ways that do not simply reinforce objectification.[42]

Marking these precedents is not meant to propose an overarching "origin story" of feminist and/or self-injurious body art that is directly inspired by one monk's self-sacrifice. Tracing that lineage limits the comparative and multidirectional ways in which genealogies of self-injury—and various forms of it—are both a form of protest and a form of art that dynamically operates, converges, and responds to disparate geographic and political milieus. However, to consider this specific intersection of art and protest, this proximity between self-injurious (queer and feminist) performance art and Southeast Asian self-immolation at the height of the Cold War does incur a specific racialized or gendered inheritance on the part of Southeast Asian (feminist) artists who engage self-injury on stage and contend with the period's afterlife today. Chaw Ei Thein was born in 1969, six years after this particular confluence of art-meets-protest-via-self-injury took place. However, this is not to suggest that body art as performance or self-immolation as Southeast Asia–based protest was a predestined form for Chaw Ei Thein and others to follow. Rather, it is to emphasize the particular milieus that already shaped these artists' entrance and reception into the contemporary art world following the Cold War.

As contemporary Burmese diasporic artists reclaim racialized and gendered agency in the face of contemporary necropolitical forces at the intersection of arts and humanitarian industries, they may confront the racialized and feminized Southeast Asian body enmeshed in Cold War

militarization whether intending to or not. Amelia Jones suggests that 1960s and 1970s body art sought transformation of subject/object relations within the arts discourse itself, that "refusing to confirm anything other than the absence of the body/self (the subject's contingency on the other), body art refuses to 'prove' presence."[43] Departing from canonical forms of "body art" from the 1960s and 1970s, contemporary instantiations of elastic vulnerability in Burmese diasporic artists exist as self-injury but also revive previously forbidden public rituals of celebration, mourning, and rest, as artists cultivate inscrutability to deflect the mundane violence of arts and humanitarian industries. Thus, in addition to counteracting dehumanizing effects of state violence, exiled artists perform self-injury on stage to expose the Burmese state and the disciplinary measures of humanitarian rescue that upend the healed human self as the ideal subject of humanitarian rescue and arts diversification.

In the days following Myanmar's Saffron Revolution of 2007, when monks, nuns, and students marched in protest of gas prices inflated by 500 percent in various cities throughout Burma, the secret police arrested hundreds and assaulted thousands.[44] Typical gathering areas such as tea shops and *la-pet-yeh-sain* were no longer safe spaces. Sometimes organizers would assemble a party of five or more people in order to make very public their own arrests by the secret police. For a time in New York, exiled artists hoped to recreate spaces and pockets of time, making possible the community gathering once held at tea shops.

Some audiences and diasporic community members travel regionally to attend Chaw Ei Thein's New York shows. To some degree these diasporic encounters foster a connective tissue that links different generations of immigrants and refugees in the United States. While the diasporic community may be a key interlocutor for their work, for artists this does not necessarily equate to commercial success. Art spaces that host a diasporic community also facilitate commercial, social, and pedagogical camaraderie, allowing different forms of socialization to occur simultaneously.[45] Chaw Ei Thein's flexible affective labor includes repetitive performances of self-injury, various occupations to sustain her economic livelihood, and

also managing anxieties among herself and other exiled peers over the (a)political content of what diasporic art "should" be. Part of the work of fostering diasporic community includes expanding the breadth and content of what is possible while facing the constraints of assembling disparately situated communities across various sites and time zones.

Chaw Ei Thein's fans have also responded to this balancing act. In addition to her blog updates on the solo and group shows, fellow Burmese artists and fans have posted recordings of her performance work online. In a piece entitled *Homage to Happy Japan (by Arai) Happy Burma*, filmed and uploaded to YouTube, Chaw Ei Thein references the work of Japanese performance artist Arai, who often appears nude in front of audiences with a ball gag in his mouth.[46] To critics' ruffled feathers, in *Happy Japan!* he "shits" red paint onto a canvas, then smears it with his bare backside to create a Japanese flag. *Brooklyn Rail* writer Warren Fry has identified Arai as "chart[ing] moments in globalization, Japanese history, and intellectual culture upon the metaphorical pincushion of his body."[47] This critic's comparison of Arai's body to a pincushion captures a similar spirit of risk and imminent discomfort that also appears in Chaw Ei Thein's homage when she starts to choke. Parallel studies of queer kink and BDSM practices, such as that of queer studies scholar Brenda Gardenour Walter, have theorized how *kinbaku*, a contemporary Japanese form of BDSM rope kink, relies on Shinto spiritual traditions and uses physical restraints to showcase the aesthetics of bondage "to delineate sacred boundaries, as well as the historical tradition of rope binding and hoisting as a form of criminal punishment and public humiliation."[48] In preparing an homage to both Arai and Aung San Suu Kyi, Chaw Ei Thein illuminates how simultaneously engaging submission and liberation can reclaim power at the site of the "beautifully suffering" Asian feminine body on multiple scales, namely, in the context of a majority Burman Buddhist nation that the artist was not allowed to return to as well as by a Southeast Asian woman transgressing assumptions of victimhood in humanitarian scenarios in the United States. In the context of US popular media and film, the former can easily conjure the imagery of rescue of orphans and widowed refugees in the aftermath

of the Vietnam War and, alternately, as hypersexualized victims of sex work economies in the long aftermath of intra-Asian, European, and US militarization throughout Asia and the Pacific.

Within the infrastructure of humanitarian aesthetics, the genre of performing "beautiful suffering" is not wholly distinct. As Mimi Thi Nguyen asserts about beauty, which is "so often aligned with truth, justice, freedom, and empowerment," it must be interrogated "not as [having] unambiguous values but as transactional categories that are necessarily implicated and negotiated in relation to national and transnational contests of meaning and power."[49] To put Chaw Ei Thein's earlier assertion of "torture positions as kind of beautiful" into conflict with the extended market for bildungsroman, her framing of her own performance perhaps aligns with Joseph Slaughter's critique of the linear rehabilitation of the protagonist through human rights. She refuses to beautify the body through a "coming of age" story having linear plot points of suffering to relief through the gaining of human rights. Chaw Ei Thein's moments on stage of "beautifying" torture on stage, or giving them an extended life through aesthetic transformation, is a way to sensately disrupt the bildungsroman in humanitarian and arts spaces through performance. What makes Chaw Ei Thein's suffering "beautiful" is not necessarily that it aims to please or be complicit in hegemonic performances of vulnerability designed to secure aid or support. Rather, by refusing to "develop" the self into a figure transformed or "incorporated," and thus freed by the human rights discourse, a different set of power relations are opened up to a consideration of the relation between "rescuer" and "rescued"—or it upends this relation entirely.

Chaw Ei Thein begins her homage to Burma and Arai by sitting in a front of a painted mural of a large crowd of monks in orange robes encircled by armed military guard. This scenario is a salient marker of the Saffron Revolution, resonating with familiar scenes of battered civilians featured in the news, on YouTube, in blogposts about monks' protests in 2007, and in the 2009 Oscar-nominated documentary *Burma VJ*. By placing the bodies of monks in the background in both the physical and the virtual space, the artist reminds the audience that during the Saffron Revolution, many monks were brutalized, exiled, or disappeared by the government

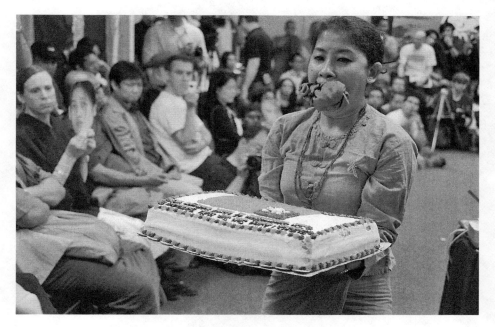

FIGURE 7. Photograph of Chaw Ei Thein's performance *Quiet River (Dedicated to Aung San Suu Kyi's 64th Birthday)*, June 2009. United Nations Plaza, New York. Photo courtesy of the artist.

for political activity; some fled the country. There is a starkly open space in the middle of the mural surrounding a fetus, outlined in red paint, where Chaw Ei Thein has painted the words "Burma Next What." This rendering of nascent Burmese life and nationhood is an intentional meditation on the 2007 protests and the shift to Burma's political future. The YouTube member who posted the video has the camera angled so the online audience can see that the room beyond the mural is decorated to celebrate Aung San Suu Kyi's 64th birthday on June 19, 2009.[50] Printed photographs of then-incarcerated Aung San Suu Kyi featured at makeshift altars loom in the background of the performance space, simultaneously marking her and Chaw Ei Thein's gendered Burmese-ness (fig. 7).

 Chaw Ei Thein begins her eight-minute performance by laying out yellow roses in a pattern of a larger flower—possibly *za-beh* or jasmine—the trademark flower Aung San Suu Kyi wears in her hair. Afterward, Chaw Ei Thein kneels with a piece of a maroon cloth rag—the color of monk's robes—that she gags in her mouth. Gardenour Walter comparatively

Freedom of Expression, Asylum, Elastic Vulnerability 179

elaborates on kinbaku's contemporary potential for sensuous and subversive play by feminine subjects, given its longer history of a Japanese masculine-dominated art since the 1890s that has relied on the tortured feminine body as an artifact of patriarchal fear and source of sexual desire: "For many women and female-identified folx, their consent to be bound by a Bakushi, or rope master, is simultaneously an act of submission and liberation. Bound in knots, their bodies are reinscribed as sacred precincts, or *kekki*, of their own design—an intoxicating and empowering experience beyond socio-cultural restraint."[51] This is not meant to conflate the disparate traditions of kinbaku and Chaw Ei Thein's work with monk's robes. Yet Gardenour Walter's comparable analysis of kekki as a self-reflexive form of binding that lives between submission and liberation, opens up room to consider how Chaw Ei Thein risks herself physically and spiritually when "opening" her own body to self-injury. Per monastic vows, Burmese Buddhist monks are traditionally forbidden from physical contact with women, from afternoon meals, and from touching money. These vows of celibacy, hunger, and sacrifice of material comforts are considered part of the process of spiritual enlightenment that renounces worldly pleasures.[52] As Chaw Ei Thein swallows more cloth, suppressing her own coughs while her eyes tear up, her transgressive act of "eating" a monk's robe situates her own orifices as an agential site of several forms of trespass.[53] She theatricalizes what Shimizu calls the difficult "bind" of hypersexuality and race when she kneels and offers to her audience her body in distress. However, by offering this difficult digestion of a monk's robe, she also offers a doubly forbidden mourning of sacred lives lost: as both an exiled community member seeking asylum far from home and as a Burmese Buddhist woman in sensuous and self-injurious proximity to a sacred robe and the body of a monk it might have once clothed. She interrogates those previous referents of Southeast Asian and Burmese femininity that saturate various social milieus she has participated in before she arrived on stage.

Looking at the intersections between studies of human rights and studies of affect, we can see how exiled artists push the boundaries of who, where, and when healing from trauma happens. Sharon Sliwinski has examined

the relationship between spectatorship, visual artifacts (primarily photographs), and human rights to illuminate the shortcomings of an exclusively juridical orientation in studies of human rights. Decentering international human rights law and formal state and nonstate institutions that uphold legal processes, Sliwinski instead turns to the powerful role of affect in shaping human rights discourses, including artists' passion, grief, and rage. She argues that affect has the power to assemble together, even if only momentarily, disparately situated audience members and human rights subjects, to "tear us from ourselves, bind us to others, transport us, undo us, implicates us in lives that are not our own."[54] As the author endows affect with a type of disruptive power, I argue that the tactile vocabulary of performative acts—tearing, binding, undoing, transporting—does parallel work in live exchanges between audiences and artists. Sliwinski contends that human rights "belong . . . to the world of aesthetic judgment," out of the purview of activists and litigators alone.[55] Sliwinski's proposal even further accounts for how Chaw Ei Thein juxtaposes rituals of mourning (monk deaths) and celebration (Aung San Suu Kyi's life) to the wrestling with power in the moment and long after, knowing that interlocutors will judge their performances not only as admissions of "beautiful suffering" but as aesthetic processes that might merit support from arts and humanitarian interlocutors.

In this discomforting act of ingesting a monk's robe, she dares to open a conduit of affiliation, of shared vulnerability, between Burmese Buddhist women and Buddhist monks and also confronts the disparities between these groups in terms of Burmese social status. Scholarly and popular discourse frames these women and monks as existing in a codependent alliance in which their shared effeminacy has been attributed to their lack of political invisibility. As Burmese feminist historian Tharaphi Than notes of the deeply entrenched symbiotic relationship of monk and lay alliance, specifically monks and Buddhist women followers, these relationships have been historically key to affirming Burmese independence in the face of British colonization and other neocolonial influences: "the survival of monks has come to depend on women, who form the army of everyday alms donors to hundreds of thousands of monks nationwide. Women,

who are generally considered possessing lower hpone or charisma or accumulated merits than men, also depend on the monks for fulfilling their duties as Buddhists, particularly in banking merits in Dana or charity. . . . Such a form of co-dependence renders a unique lay-monk alliance, and with the increased politicization of monks during the independence movement, women became natural followers of the political monks."[56] Elsewhere Tharaphi Than has recognized how these powerful historic patterns of alliance have amplified in some cases anti-Muslim xenophobia in Burma in recent years among Wunthanu ("Loving one's own race") followers and Burman supremacists who have been able to engage some Burmese Buddhist women's groups as ardent supporters. While these latter genocidal politics have been particularly brutal, most visibly in the context of the ongoing Rohingya genocide, their power only further illuminates the complicated politics and risk of engaging in gendered and racialized transgression with regard to lay-monk alliance.

Chaw Ei Thein's acts on stage draw on these nuanced alliances and trouble the notion of lower *hpone* (social status and spiritual power) as ascribed to Burmese women in these relationships. She subverts them to suggest that this "bind" and bond between Buddhist monks and laypeople (especially women) is politically and economically vital. On the inverse, this political symbiosis has meant that both of these communities have been the subject of calls to rescue by humanitarian interlocutors from the Global North.[57] The artist illuminates the public means by which specifically Burmese women's bodies are feminized, rejecting Buddhist social mores in order to manifest freedom of expression under literalized restraint.

Throughout the whole performance, she intermittently gags herself with more cloth in her mouth. As she is choking and tearing up, she goes to the back of the room to retrieve a lit birthday cake and then circles around the room, inching back and forth toward the audience, as if inviting them to share the cake with her. The painted mural backdrop of monks and military bodies, combined with the artist's physical invitation to share birthday cake, makes a public and bittersweet acknowledgment of the imprisonment of the Burmese democracy leader while also celebrating her. Chaw Ei Thein takes pleasure as an artist but simultaneously bears self-gagging as a type

of endurance; she epitomizes an elastic vulnerability, taking an extended period of time within the performance to transition in and out of trespass, mourning, and then celebration. This moving between modes disrupts the linearity of a "settled" state, both in regard to the artist refusing to situate the body as still or at peace and in refusing resettlement as a timely condition that simply heals injuries of past and present Burmese statecraft.

In Q&A sessions following performances she sometimes reveals that her performances are inspired by the stories of prisoners detailing the stress positions they endured as part of torture in political prisons. Instead of interpreting these stories as sites of shame, scenes entirely perverse and "unspeakable," Chaw Ei Thein insists on their afterlife through acts other than speech, thus reinterpreting them as an invitation to other diasporic community members to publicly honor and remember those who died during protests, those whose futures are upended, and those still imprisoned. In inching back and forth she creates an ephemeral zone of contact between herself and the audience in which they might realize desires for forbidden proximity to and mourning for monks and Aung San Suu Kyi.

Beyond the specific acts of self-gagging or self-binding, Shimizu's theoretical framework of bondage or the bind itself also illuminate broader investments in Asian and Asian American women's agency under duress or capture, "the restriction and constraints limiting Asian/American women's choices, made within aggravated situations, in order to open the possibilities of redefining sex, race, and representation in an open-ended fashion, rather than shutting them down."[58] Together these acts situate the possibilities of what it means for exiled artists to subvert submissive racialized and sexualized positioning as a means of exerting agency over the way these bodies have been represented and "placed" into scenarios of reenactment of humanitarian benevolence and as they are disciplined under Burmese state surveillance, Burmese Buddhist state religious mores, and censorship.

Shimizu's embrace of less restrictive definitions of Asian/American women's sexuality on screen and in life leads to consideration of Chaw Ei Thein's work, which also displaces the "abject refugee" script, which centers an artist's pleasures and agency in parallel "aggravated situations" or, in

this case, asylum-seeking and resettlement. Rather than make her experiences of asylum-seeking a static script of victimhood, she challenges the mainstream promises of economic and political mobility made by human rights organizations (such as the United Nations) as bound to resettlement. Chaw Ei Thein's art can be read as a means of coping with the effects of an uncertain political status in the United States, including simultaneously the Global North, humanitarian, and Western feminist moralism on the bodily comportment of feminine refugee and asylum-seekers.

As Chaw Ei Thein engages art that is often exhausting and violent in relation to her own body, she suggests that the conditions under which asylum-seekers labor in host spaces (at the micro level of individual host countries and art institutions) and communicate their experiences can be repetitive and tiring as well. Just because a fellowship or safe haven is located in the Global North does not guarantee unfettered freedom of expression, even in comparison to the experiences of censorship and surveillance in a country of origin:

> These artists are *a'nah deh* [feeling obligated/ guilty] all the time. We do not want to discuss openly . . . These habits and traditions [of self-censorship] are really killing us to develop. Last night I was watching documentary about Ai Wei Wei. Whenever I saw a scene about artists from other parts of Asia, from Thailand, from Korea, they all finish studying in the US or England or other countries. Then their ideas change. I don't know if Burma is the problem here. I'm really scared . . . I want to be moving, growing. I can't really do the same thing repeatedly.[59]

By opening herself up to experimentation with how to generate economic and political support, she comments on barriers to freedom of expression in Burma. Yet, she also invokes these barriers that exist in multiple states that discipline immigration status, that contribute to lack of access to steady means of education (especially after experiencing the Burmese government's shutdown of universities), and provoke fear of not being able to artistically develop in resettlement at any given moment.[60] After decades of stringent Burmese censorship, lack of humanitarian aid, eco-

nomic isolationism, state censorship, and periods of martial law in which artists report being stifled, performative gestures that attempt to free the body from positions of bondage have a stake in self-determination as compared to the broader interventionist cries from the Global North in their desires to "free Burma."[61]

By harnessing modes such as illegibility and inaudibility—through choking and self-shackling—Chaw Ei Thein and other artists circumvent the need for distinct, utterable human rights testimony of torture that might permeate other human rights advocacy spaces. Through strategies of elastic vulnerability such as self-injury, artists assert control over what is highly sensational about their Burmese stories and instead insist on sensory registers through which to engage their audiences. They highlight the fraught position many Burmese artists find themselves in—sometimes positioned to repeatedly articulate for funders their foreclosed histories of struggle against the state for their livelihoods while trying to develop other narratives and practices for their own sense of artistic growth. For some, their efforts to refashion the liberal transformation of US resettlement as the ultimate safe haven for freedom of expression and freedom of movement continuously redefines their role in shaping their own safety in concert with grant-making initiatives as well.

Returns from Exile

Chaw Ei Thein and granters engage a framework of elastic vulnerability through strategic onstage acts of self-injury as performers and offstage as grant seekers working alongside grant makers. As artists use elastic vulnerability to frame their ambivalent relationship to narratives of freedom and further circulate their work in resettlement, they critique the dominant terms by which resettling in the United States is understood as reaching "freedom," while also contextualizing their struggles within the constraints of previous experiences of military violence and censorship. Rather than a neat reconciliation of "past" military violence, cordoned off by discrete amounts of time and space, artists wrestle with previous experiences that affect their current and future economic and political livelihoods in the

diaspora. Artists define both the "exhaustive" conditions of their exile in the United States and their "freeing" psychic experience in detainment, highlighting various and contradictory forms of coping with detainment and resettlement systems as they exist on a continuum, not in opposition. This includes how these experiences feature as part of artists' and grant makers' narratives that subvert scenarios of rescue, in which they adapt and remain elastic to what frameworks of distress and safety do and do not work to secure opportunities, and share them with a wider pool of contacts and resources, in hope that they one day might be more transparent.

At Cornell University in the fall of 2014, in an event tied to a conference called "Burma/Myanmar Research Forum: Critical Scholarship and the Politics of Transition," Chaw Ei Thein showcased a piece called *Need* (2014), which she conceived during a hiatus from performing self-injury during her pregnancy. In the debut, soon after Chaw Ei Thein welcomed the arrival of a child, the piece pointed to the physically and emotionally exhaustive gendered labor of onstage performances of vulnerability and self-injury that was no longer sustainable. The piece was distinct from her previous work showing tools and materials that one might find in a Burmese diasporic household or offering a tea service while wearing traditional women's garments. In her introduction to the audience she stated, "I am tired . . . of doing hard performance[s]." In the time since that performance, the artist moved to Santa Fe, New Mexico, to open an art studio and gallery, where she also exhibits and curates a range of performances, sculpture, and visual art. This move happened, in part, because of New York City's unaffordability. In the face of rent hikes and a high cost of living, modes of elastic vulnerability helped the artist push her practices to stretch what is economically, physically, and politically possible within material constraints versus transcending constraints altogether.

Outside of the performance space, the combination of having to work several jobs to survive, having to find both funding and available gallery space, and still working to create pieces that straddle being commercial and accountable to diasporic community experiences, all influence how "freedom of expression" can be fleeting. Yet artists still work in the spirit of manifesting more. In the same breath, with elastic vulnerability, artists

are able to create necessary breaks from the work of self-negation when art markets and audiences seem to stake geopolitical interests in Burma in response to political changes from authoritarian to democratic governance and back again. In the next chapter I suggest another strategy of elastic vulnerability, "unraveling," maps onto how artists experiment with different strategies for evidencing vulnerability, sketching a broader landscape populated by failed and successful attempts by artists and funders to employ discourses of vulnerability to further extend resources and expand the terms of freedom of expression, safe haven, and distress.

4

Htein Lin
Unraveling the Dissident Body and Buddhist Transcendence

On November 9, 2012, a Burmese art exhibition entitled *Yay-Zeq* ("Water drop") opened at the International Studios Curatorial Program (ISCP) in Greenpoint, Brooklyn.[1] Receiving an unprecedented amount of exposure for an art event that explicitly invoked the legacies of Burmese military violence, the exhibit featured three exiled Burmese artists: Chaw Ei Thein, Sitt Nyein Aye, and Htein Lin. The artists were then based in New York, Mumbai, and London, respectively, and had not seen each other in over a decade or more. The featured works had been produced in secret while the artists were in prison and/or held in refugee camps.

While the *Yay-Zeq* exhibition catalog provided a brief overview of each artist's career, what the curators and artists also chose to spotlight were brief glimpses into previously secret periods of creativity under duress—a performance piece that simulated political prison, pencil drawings and pamphlets featuring scenes within a refugee camp at the Burma-India border, and, most compellingly, a secretly filmed video of a politically infused performance art piece recorded fifteen years prior, which had been sent anonymously to Htein Lin. According to the curators, the video was not a proposed part of the original program of the overall exhibit.[2] Developed quickly into an installation, the secret video featured a performance piece by Htein Lin at the Inya Gallery of Art in Yangon in 1994, where he splashed himself with fake blood and contorted his body while very slowly writhing, trapped under a small net. The piece simultaneously broadcast a Union of

Myanmar state radio address that stated the tenets of the regime, which would have been familiar to those living under the military regime at the time. The curators and the artist had no idea of the identity of the person who sent the tape to Htein Lin; only that the individual was still unwilling to be publicly revealed and that they saw fit to hide the tape until deeming it safe to circulate it seventeen years later.

In the ISCP gallery the piece is projected onto a white wall adjacent to the rest of the exhibit, with one lone viewing chair facing the wall. The video runs on loop. While Htein Lin's theatrical mode of self-injury on screen is not unfamiliar, the artist's staging is yet another salient intervention of elastic vulnerability through unraveling. This "unraveling" of the performance piece can be taken in multiple ways, one being that it took seventeen years to come to light and was not fully revealed to the public by its anonymous maker until 2012, following Burma's transition to civilian government. The lone chair in the gallery invites only one viewer, creating a semiprivate and singular experience, an experience that previously lived only in the memory of those who were present for the original 1994 performance. Like other forms of self-injury, this piece's mode of elastic vulnerability is sensitive to nonlinear forms of community healing, which are often paired with extended moments of silence and can disorient some audiences waiting to hear testimony, thus subverting the expectation of it altogether. This mode of covering and uncovering, obscuring and making visible, allows the artist to cultivate improvised moments of intimacy with and distance from difficult experiences.

From the video, the harsh static of a Burmese state radio address hauntingly echoes over the gallery space; the audience member sits alone, watching Htein Lin on screen but also able to peripherally see the small crowd gathered in the Inya Gallery years before. As each consecutive audience member shares the experience of the piece one by one, they are let into a long-held secret staged at a ceremonial pace set by the artist, thus making them, too, part of the installation's unfurling backstory. The performance's pace honors its sharing: it is not necessarily meant to "reveal" its intimacies fully or shockingly. A dominant pattern within humanitarian media is the reveal of spectacular suffering of human rights subjects that typically relies

on the immediate viscerality of human suffering. For instance, a reveal might turn to images of unnamed emaciated individuals to signify global famine or may move to show people with untreated wounds to signify war. These images and clips often become part of a humanitarian campaign to compel audiences to act, even if those photographed are not able to give their consent to be shown. Dislodging the reveal of the spectacular suffering of human rights subjects that often underpin mainstream humanitarian efforts, Htein Lin's unraveling focuses on a micro level reordering of sights, national memories, and sounds, shifting the focus to minor moments of potential refuge eclipsed by majoritarian national histories. The piece does not just recreate the original Inya gallery experience. By adding new audience members one by one, it creates new live layers of mediation and accrues more and more witnesses, bringing those in the present in fleeting contact with those in the past. Current attendees of the *Yay-Zeq* show who watch the artist performing seventeen years prior become part of the original performance's afterlife: a reclaimed legacy of producing diasporic and international audiences that had been originally foreclosed to the artist and videomaker due to the dangers of Burma's state censorship at the time of its creation.

The exhibit's full title, *Yay-Zeq: Two Burmese Artists Meet Again*, acknowledges the initial connection between Sitt Nyein Aye, who taught then–law student Htein Lin to "draw on the forest floor" when both were being held in a refugee camp at Manipur, India, located on the Burma-India border, after the former fled Burma following the 8.8.88 uprisings. That period sparked Htein Lin's artistic career in cultivating his now-trademarked improvisational approach that relies on sparse materials. Both artists, whose careers and friendship have intersected while living in exile after the 1988 protests, were reunited so that they could introduce an installation piece and dozens of drawings, paintings, and photography to eager Brooklyn curators, fellow artists, sponsors, and patrons.[3] To open the event, artist Chaw Ei Thein performed the piece that opened this book: self-binding, hooded, and struggling to breathe, all drawn from experiences of political imprisonment as related to her by friends and colleagues.[4]

In their opening remarks, the exhibition's Delhi-based curators, Zasha

Colah and Sumesh Sharma, explained the logic behind the exhibition as two-fold: to feature the friendship of two exiled and previously incarcerated artists and to examine how the artists revived the traditional festival form of extended dramatic revue (*anyeint*) and its recent history as a genre of political satire.[5] Htein Lin emceed the event by intermittently offering comments, while the presence of Chaw Ei Thein, dressed in an embroidered satin green formal Burmese htamein and *aingyi*, signaled anyeint's traditional structure, which pairs the figures of the comedian and the princess.[6] Anyeint traditionally features a mix of dance, comedy routines, singing, and a live band. The genre has been appropriated by satirical comedians protesting Burma's government and the harsh conditions in the country.[7] Contemporary Burmese performance artists also draw on the form's ephemerality to shield artists from government surveillance: performers can break down sets easily, use minimal props, avoid large fees for space rental, and quickly evade unwanted attention.[8]

The exhibit also featured a series of self-portrait photographs of Htein Lin dressed in monk's robes and sandwiched between cartoon chalk renderings of monk's bodies that, within each successive still, pushes the artist farther right until he "disappears" from the last frame. The artist may well be referencing the transient Burmese Theravadan Buddhist practice of novices entering monkhood and nunhood in donning a robe as a rite of passage.[9] But the series also begs the question of where the monks' bodies went or where they had been secreted away to in the aftermath of military state violence against the civilian and sangha Saffron Revolution protests. During the 2007 Saffron Revolution, named after the color of monks' robes, monks and civilians took to the streets in protest of 500 percent increase in gas prices across the country; military police forcibly disrobed monks and nuns before assaulting, detaining, or killing them in order to symbolically dissociate themselves from the violation of coercive disrobing.[10] While disrobing of monks can be voluntary, coercive disrobing can be a punishment of transgression.[11]

The curators also discussed the three artists "reaching safety" in order to exhibit their art in the Global North after years of making art in secret under conditions of Burma's state censorship and policing. For example,

after the initial creation of work during incarceration, Htein Lin smuggled some of his works out of prison with the help of guards and other prisoners.[12] Art institutions that now host this work reference the fugitive aspect of the artist's work in their publicity materials and prefatory wall text. One could argue that Htein Lin's art accrues further value in part because of its precious "smuggled" quality, from periods and places of artistic constraint and physical precarity to "safely" reaching unrestraint in a destination outside their country of origin, all with the idea that the art itself is finally curated or "housed" in a place where it can be accessible to the public.

Yet artists, due to their risk of exile, resist such all-encompassing discourses of safety associated with institutionalization and curation. As part of their challenges to the discourse of safety, they perform anyeint in the diaspora. Rather than just another state of exile that one is relegated to, exile as staged by Htein Lin, Chaw Ei Thein, and Sitt Nyein Aye is a long exercise and balancing act between risking discovery in postauthoritarian contexts and gauging curatorial institutions' desires to see artists' work reach "safety." In turn, the pedagogy of the exhibit encodes "freedom of expression" as an impermanent state that is possible at US art sites and also at spaces that artists inhabit while in transit or while living in diasporic spaces in between nations. More broadly, *Yay-Zeq* offers artists' diasporic genealogy of strategies, inviting future cultural producers in political distress to adapt some of these strategies in order to navigate exile and arts advocacy beyond their initial collaboration in New York.

The ephemeral comedic or dramatic skit becomes part of the performance's unraveling, a practice and an embodied approach used by some refugee and asylum-seeking artists to uncover and then recover parts of the body and invite audiences to witness in ways that foreground the artist's own understandings of safety. Rather than oriented around requirements of legible suffering for humanitarian and arts interlocutors, unraveling manifests through artists' use of protective materials that are put in contact with their bodies and alternate with uncovering for prolonged and eclipsed periods of time. The artists' unravelings in their pieces argue for a currency different than what is found in "safe" work that has reached a secure destination and will not be taken down for reasons of state censor-

ship. These elastically vulnerable aspects of artists unraveling, alternating between hiding and revealing their bodies and life stories in front of arts and human rights audiences, employ shifting definitions of safety, home, and return, particularly in their relationship to human rights and arts advocates. Seen in this light, *Yay-Zeq* is not simply a diasporic reunion nor site of human rights affirmation for Burmese exiled art in New York, where audiences might celebrate exiled artists' rescue from Burmese state censorship and surveillance.

What does this unraveling do to international curatorial efforts to preserve or institutionalize (performance) art that by design is not meant to leave a trace? What does the work to continuously unravel yet refuse to fully reveal the asylum-seeking body challenge at sites of human rights and arts advocacy? In the face of the hegemonic narrative that US resettlement is the solution to refugee displacement, how does unraveling precipitate the uncertainty of return from exile, or other unsettling trajectories?

For Htein Lin, the use of a monk's robe to cover and uncover the body and the performative application of temporary plaster to cover old scars sustained during political incarceration allow the artist to wrestle with the ongoing effects of displacement and detainment years after the fact. These examples of unraveling include "redress," both as a performative act meant to redress a wound and also an indictment of the shortcomings of state and humanitarian accountability. Unraveling emphasizes an artist's agency over when and where to symbolically revisit traumatic sites and times in public, and whether or not to show scars, if at all. Confronting the periods of upheaval that led to scars often includes exerting control over mass-mediated scenes of violence in international media about Myanmar. Rather than just replay them, Htein Lin manipulates images and footage to focus on individuals disappeared by military police, some of whom were never found. Thus, unraveling recreates times and spaces of Burmese civilian struggle, especially for those who were exiled or displaced abroad and not able to live in Myanmar, including the artist himself. Unraveling as a performative approach allows Htein Lin and others additional time and space to collectively acknowledge losses within their communities and commemorate those never publicly mourned. Subsequently, unraveling

leans on Theravadan Buddhist rituals to facilitate communal healing for those present and to acknowledge those no longer here.

Indeed, such work challenges dominant tenets of Western curation of exiled art as liberation from or liberal transformation of censored pasts. The notion that previously censored art is safe once it reaches an international audience and that artists are also safe once they flee from an authoritarian regime are not foregone conclusions. Nevertheless, unraveling, like other strategies of elastic vulnerability, does not necessarily define healing from authoritarian violence nor does it imply that humanitarian rescue is a finished or neat cathartic process. Unraveling, as a strategy of elastic vulnerability, allows the artist to remain both vulnerable and flexible when processing displacement, flight, and migration in front of humanitarian and arts audiences on their own terms. Performatively, as an artist subjects themself to the violence and potential retraumatization of these sensoria, being elastically vulnerable allows them to hit "pause" (on footage), to rest their body, to direct their own pace, as they recover their bodies (with protective layers) and sense the affective responses of other (diasporic) community members in the room.

This strategy does not necessarily define the answer to the difficulties in securing an institution to "house" an artist's work or a residency to "host" the artist. These acts do not prescribe one particular time line or site in the Global North as "freedom." Some of Htein Lin's artistic projects have taken years to come to the fore. He and others have waited for the right time for work to become public while balancing the unsafety of incarceration or refugee encampment as well as the vagaries of exile. Rather, unraveling is a strategy of elastic vulnerability precisely because it facilitates an artist's freedom to move onstage under physical constraint and also, most glaringly, to move between spaces that reflect the political constraints of state surveillance and humanitarian benevolence. An artist uses unraveling as a strategy of elastic vulnerability to help them lay in wait, emerging as quickly or as slowly from traumatizing experiences as they need to in order to navigate exile.

Htein Lin's artistic and political background give a broad introduction to how themes of exile, Buddhist pedagogy, and detainment undergird

his work and his movement throughout the diaspora. This foregrounding shows how he and other artists who unravel on stage sometimes adapt aspects of their performative strategies to the world of grant narratives, fellowships, and residences, and where they (sometimes after being labeled as dissident) also work against a linear narration of their physical return to a country of origin as reaching a place of safety. This does not leave an artist "nowhere," but instead asks the audience(s), in performance spaces and in grant spaces, to consider the artist's interior conditions of displacement, exile, and return even while living and working in a temporary residence or maintaining a fellowship. Asian Americanist feminist and Cold War studies scholar Crystal Baik poignantly gestures to the possibility of what diasporic returns allow for cultural producers who must contend with the ongoing violences of both militarized pasts and the present: "'Diasporic return' as verb and noun: a return registers a process of arriving at a destination or departure point while also signaling what Nadine Attewell and S. Trimble describe as 'disturbing' elements affixed to this 'act of going back.'"[13] To consider unraveling a performative mode that lingers in the register between departure and arrival is to reconcile what it means to leave the future "disrupted" following a physical or symbolic return to a homeland. Instances of unraveling offstage also upend the conceit of linear human rights discourses such that some artists, when invited, refuse to cohere in a healed self that moves unfettered throughout the diaspora.

Unraveling using the support of long-embedded cultural institutions in New York may seem counterintuitive or contradictory. Both Chaw Ei Thein and Htein Lin have been Asian Cultural Council (ACC) grantees, which means they may pose artistic concepts that merit placing them in conversation.[14] However, the embeddedness of human rights and arts advocacy in the diaspora reflects other histories of Cold War interest in the "development" of Southeast Asian arts and artists. So, as artists perform, collaborate, and share their approaches to freedom-making on various stages, they must dialogue with granters' shifting desires for ideal grantees. Artists' and granters' efforts reveal the tensions within New York arts advocacy to both norm artists to a vision of an ideal grantee with a set of common experiences and at the same time respect the circuitous, unprecedented,

nonlinear, and illiberal routes that "bringing knowledge back to a home country" may actually require.

The subsequent analyses cover two related performances in which unraveling animates long-awaited moments of contact, touch, and healing to old wounds among diasporic community members and interlocutors who bear witness. In the first, Htein Lin leads Buddhist meditation in a performance space in 2012, momentarily transporting a Brooklyn audience to 2007 civilian protests against military governance in Yangon. The artist makes his own body vulnerable, extending his arms and chest to become a screen and thus a momentary vessel of time travel on which to rewind, replay, and remix hegemonic forms of media in the Global North that are intended to "reveal" censored images from an authoritarian environment. Taking a cue from Htein Lin's aesthetic approaches to unraveling, the works of Mel Chen, Jack Halberstam, Vivian Huang, Yoko Ono, and Dahlia Schweitzer are useful for understanding masking, radical passivity, and striptease and to examine how artists combine strategic and processual uncovering of the body with Buddhist meditation to transcend the body and undo the implicit rescue narrative of safety for those in exile.

In a second long-running performance that began in late 2012 following Burma's official transition to a civilian government, Htein Lin started a "process that is never finished": he coats his own body parts and those of other dissidents in plaster (another type of covering) and enacts yet another form of open-ended healing that privileges the sanctity of incarcerated experiences shared by both healer and comrade from decades past. I turn to debates among aligned theorists like Patricia Stuelke and Saidiya Hartman, who both debate what political resolutions might be made possible through reparations and repair. Stuelke sees limitations in dominant forms of reparation and repair in forums of official redress (tribunals, government-backed hearings, etc.) as well as in the critical debates around "the feel good fix" in radical activists' and artists' responses to neoliberal racial capitalism.[15] As Stuelke argues, the tendency to seek reprieve or repair can limit political action in the face of neoliberal racial capitalism through "the embrace of reparative modes as a critical and even ethical response to US imperial formations—the casting of such formations

as legible and evident, and the corresponding turn to feeling and care as ends in themselves and limit points of possible action."[16] Instead of a legible and evident human rights–led regimen of repair toward the "healed" self, there are consequences to Htein Lin's unraveling, especially in shifting the unspoken rules of engagement around legible "suffering" at the intersection of humanitarian and arts arenas. Stuelke's critique is considered alongside Hartman's approach to redress, especially in how Hartman sees redress as cohering to a set of relations to cope with the ongoing, open-ended, and unresolvable nature of confronting irreparable imperial violence.

At a Crossroads: "Resident Artists" in Exile

When identifying Htein Lin and others as "resident artists" in exile, I call attention to the contradiction of what it means to be expelled from a home nation but also the focus of international host institutions that seek to "house" or offer temporary artist residencies to stateless artists. No artist necessarily intends to be in exile at the start of their career. Htein Lin was born in 1966, in Ingapu, in the Ayerawaddy Division of Myanmar. As collaborators, he and Chaw Ei Thein first crossed paths when Chaw Ei Thein was a law student in 1995. Before turning to art, Htein Lin was a student protestor in 1988. With other activists, he fled refugee camps on the Burma-India border. There he became a student leader in the All Burma Students' Democratic Front (ABSDF). He illustrated and wrote for ABSDF publications and returned to Yangon in the mid-1990s, where he finished his law degree while pursuing performance art informally (since the collegiate universities that taught art were shut down at this time).[17] However, staging these performances was never explicitly stated as the reason he was incarcerated. Htein Lin was charged and sentenced to six and a half years (1998–2004) for suspicion of having participated in 1988 democracy protests when, ten years later, someone he had once considered a comrade mentioned his name in a letter to the authorities.[18]

While incarcerated, Htein Lin managed to secretly produce several hundred paintings and over one thousand drawings—including haunting "skeletal" drawings of prisoners in Insein Prison's small cells—which have

since toured internationally through London and Chiang Mai, Thailand. Htein Lin drew or painted on white cotton prison uniforms or plastic bags. He has described how he befriended and bribed prison guards to smuggle in paint.[19] Instead of a paintbrush, he used various quotidian objects he traded with other prisoners: cigarette lighters, pieces of glass, plates, nets, razor blades, syringes. After his release in 2004, he met his future wife, Victoria Bowman, then the British ambassador to Burma. When released from prison, he was temporarily houseless, and Bowman took his work under her care, loaning pieces to the Burma Archives Project at the International Institute of Social History in Amsterdam.[20] He moved with her to London before they eventually moved their family back to Burma in 2012.[21]

The growing international interest in his art, due to its politically sensitive subject matter, helped him eventually secure political asylum in the United Kingdom and subsequent "housing" for some of his art in archives in Europe. After his release from prison, partially due to the efforts of human rights lobbyists, Htein Lin faced houselessness. Once again cast into an international spotlight in the United Kingdom, he gained enough transnational clout to return from exile. His life's trajectory exemplifies the nonlinear political and economic precarity faced by some refugees and asylum-seekers. From 1988 to 2012 a lack of occupational mobility while under military rule often influenced what materials exiled artists could afford and where they could display their work without fear of prosecution. For artists who looked for opportunities outside Burma, this immobility also affected which organizations were able to house their work, given artists' visas, language skills, and availability of residencies.

Chaw Ei Thein's and Htein Lin's time as students during periods of civil unrest in Burma make them likely coconspirators. Perhaps their artistic bond is even more stark in that they have been able to connect over decades and across distant diasporic sites — New York and London, and back to Yangon again. At the same time, the artists diverge in their firsthand experiences of incarceration, periods of detainment, restricted routes of migration, and circumscribed spaces of resettlement. Nonetheless, what has remained constant is each artist's artistic reflection on periods and

sites of detainment, uprooting, and statelessness that track the far-reaching effects of militarization on their lives as artists in the diaspora. In their work in the early 2010s both artists often recreated the space of Burma's borders with Thailand and China by providing roughly sketched maps on stage; at other times they represented experiences of political prison. These strategies of place-making simultaneously illuminate less visible state's military refashioning of Burma's rural territories into land used for prisons, refugee camps, and labor camps.[22]

The metaphysical time travel enabled by the calculated and just-shy-of-improvisational exhibit's inclusion at the 1994 Inya Gallery installation, as well as the "late-coming" aspect of the structure of the piece itself, made it one of the more elastically vulnerable parts of the exhibition. Slowly teased out of hiding as part of a long-kept secret, this installation's call to unravel set the tone and structure of the resulting overall exhibit and the performance pieces that came later. This move condensed the narrative, time, and space through themes of uplift, safety, and assimilation in an attempt to normalize the exiled, dissident, and/or refugee body that might usually unfold.[23] Instead, the exhibit as a whole sat squarely in the "fractures" left by the state, a previously forbidden creation of allotted time and space to assemble present and past audiences through which the artists highlight their communities' subjection to state policing of borders and expulsion from the nation as the necessary foundation of their own diasporic community-building. Rather than presenting a final resolution, this mechanism of unraveling allows artists to survive political and economic precarity, deciding where and when and at what pace it is safe to show their work rather than assuming safety as simply migration to the Global North. This microlevel work of palpably situating uncertainty rather than making it avoidable also frames the concurrent work happening between granters and artists in frontloading political and economic vulnerability, all as part of culling the most out of every fellowship or residency experience in the diaspora.

Asian Cultural Council

The Asian Cultural Council identifies itself as "a small foundation which supports cultural exchange in the visual and performing arts between the countries of Asia and the United States." Its long-standing history as a small foundation has been made possible through support from the Rockefeller Foundation. The endowment founding the ACC was developed with perpetuity in mind from the long-held philanthropic goals of John D. Rockefeller III, of the famed Rockefeller family, during the Cold War.[24] However, the ACC's origin story is even more deeply embedded within the New York architectural and national philanthropic infrastructure, with roots in the late nineteenth century. Going against the grain of anti-Asian xenophobia propelling the anti-immigration laws of the early to mid-twentieth century, Rockefeller was a famed collector of Asian art and founder of the Asia Society; he resurrected the Japan Society in the United States after World War II. In 1963, when the Cold War was at its height, it was not possible for Asian communities to immigrate or travel to the United States without suspicion of communist activity. Rockefeller engaged art historian and curator Porter McCary, who had started the international program at the Museum of Modern Art, to conduct an exhaustive study on the best use of funds to support mutual understanding and cultural exchange in the arts between countries in Asia and the United States. From their collaboration came a memorandum then–ACC program officer Jane calls "kind of our bible. Our origin myth."[25] The memorandum recommended creation of a program to promote individual fellowships for artists, scholars, and specialists to "give them the opportunity for meaningful experiences in the US, in order that they forge a deep understanding of . . . life in the United States, and what they would bring back to their home countries."[26]

In 1978, following Rockefeller's death in a car accident, his family founded the Asian Cultural Program, combining monies from his estate and their own fundraising into a fund in his name. The family then established the ACC, a public foundation, using endowment funds raised from several sources. Jane notes that initial hopes for the ACC included

cultivating the fellowship to shift the cultural landscape of countries in Asia through their grantees: "Mr. Rockefeller, like many Americans of his generation, and of his inclination, believed that the individual had the power to change the world. So by investing in the individual, you have the opportunity to have an enormous impact in that community's home country."[27] As Cold War historian Christina Klein notes, at the time hundreds of thousands of US civil servants, soldiers, diplomats, foreign aid workers, missionaries, technicians, professors, students, businesspeople, and tourists set out on exploratory and educational missions to gather information throughout Asia and the Pacific about those they considered potential communist threats to US democracy.[28] The ACC's artist fellowship structure in some ways attempts to make the funding of Asian artists to visit the United States reciprocal in order to "gain knowledge" of US (art) contexts in the aftermath of the Cold War.

I first met Jane (now retired from ACC) at the ISCP, when Chaw Ei Thein was showing her *Bed* series in 2009. Jane served as program officer of the ACC since the midnineties, being a longtime advocate for Southeast Asian artistic cultural exchange in the United States. Jane helped connect Chaw Ei Thein with a lawyer when she was dealing with visa issues after finding herself in exile. Upon being asked about her entrée into Burmese art, Jane notes that previously the ACC had not funded many projects from Burma, for "obviously political reasons." Supporting Chaw Ei Thein when she was already exiled was atypical. Still, the ACC has hosted several Burmese artists since the mid 2000s. Leading up to the country's official political transition, the long work of the ACC in building connections between Asian countries and the United States has also built up the organization's ability to weather the storms of short-term political upheaval that would break other organizations.

Even though influencing local artists' impact in their home countries is the organization's intention, artists and granters also push the limits of what types of conceptual interventions are possible in the absence of return. Jane notes that adjusting the organization's expectations for artists' return to their country of origin in times of political upheaval can be a challenge, but that this challenge is nevertheless the granter's responsibility:

One of the criteria we have to look at, is whether or not they'll go back. For Burma, it's been a different kind of situation. We want people to go back, we want them to go back and contribute something to their country. In the case of Chaw Ei, we knew that she'd eventually end up back in her home country. She was in exile when we made a grant to her. We weren't sure what her future was going to be and we were willing to work with that. With Cambodia [in] postwar years after occupation, there were people that didn't go back to Cambodia, you couldn't blame them. They've gone back. After Tiananmen, people stayed. People want to live in their home countries. It's usually waiting out a period of time, be understanding about that.

The ACC attends to the cyclical nature of various Asian countries' political transitions, taking the long view that upheavals may die down but may also resurface in the future. Some ACC grantees take on the political challenge of what needs to happen before returning to their country of origin — they seek to ensure that physical return is not even more fraught with political impediments to freedom of expression than staying in exile. A parallel exists in the ACC's mode of advocacy and artists' own onstage strategies (like Htein Lin's disrobing) to unraveling or very carefully choosing where and when it is advantageous to showcase (an artist's) vulnerabilities versus when it is more advantageous to "slow down" the expository process for an artist's political and economic sake. While not exactly the same as the physical and affective work that happens onstage, this longer play to get an artist to experience safety on their own terms, applies pressure to traditional arts and humanitarian advocates' hegemonic prescriptions of safety for refugees and equating this to migration itself.

Beyond the scale of individual artist, a comparison of FreeDimensional (fD) and ACC foregrounds how these organizations diverge in some ways and converge in others, particularly in how they imagine their impact on global arts advocacy; both organizations want artists to thrive once the organization is absent from their lives.[29] For Jane and the ACC, meeting this overarching goal requires leaving room for artists who experience political precarity to shape the parameters of their own return, both phys-

ically and ideologically, and revisit the spatial and temporal possibilities in exile if need be. The onus then lies on the ACC to provide as many options as possible for an artist on fellowship to circulate their art on their own terms, not least by putting the artist in conversation with multiple sets of New York–based audiences that may not typically encounter their work but may offer support at a later time.

Even though an artist's original political climate might make exile permanent, in Jane's experience some exiles do return to their home countries. Instead of making Burma's political environment an exceptional case, the ACC errs on the side of waiting and supporting an artist until the political climate is more favorable for the artist to return "home" again. Jane is right in that Chaw Ei Thein was eventually able to return. However, changed by her time in exile, the return was only a visit, and she now lives in the United States. Htein Lin was initially welcomed back to Burma from exile after his ACC grant, but the 2021 Burmese military coup then separated him from Burmese civil society through (political) incarceration that lasted until November 2022. The idea of "riding out the storm" versus attending to an artist's urgent relocation or more time-sensitive distress is perhaps the main idea that differentiates the time line and goals of a deeply embedded local foundation like ACC and a transient transnational operation like fD. This difference is most obvious in how the ACC helps shape the narrative, asking cultural workers to express in their applications what they envision as a trajectory of return. Taking inspiration from the call of the ACC's application: How can an artist contribute "upon return" when the Burmese state forecloses returning dissidents from more fully participating in society? How do granters attend to the pressures of the liminal spaces between states that artists may find themselves in?

Jane suggests that the process the ACC uses when searching for a candidate is very different than the process used by fD, especially where each organization places the onus of the initial application process:

> It's hard. We try to cut people slack. Nobody is born knowing how to write an application, and you know there are certain things we're going to look for that people aren't going to know . . . when we got

an application from a dancer this year, it said, "I want to audition and then join an American dance company." She's just being honest and that's not really what you're supposed to say. But it's a tough situation. Where she's from, an underdeveloped country, it's probably the best thing for her, to spend five years with an American company. It would probably make a really big difference back home . . . you can't control [what] people [say]. You want people who are committed to their home country and home community and have that sense of it . . . that's why meeting people is so important, and if you can visit with them in their home country to see what their studio is like, what their personality is like . . . and what kind of work they're going to do. Again, not everyone we make a grant to is firmly committed to their community.

In Jane's comments, the discourse of "what you're supposed to say" could be understood as artists demonstrating commitment to fostering knowledge within their home countries postfellowship. Since the ACC does not explicitly publicize its work as emergency-oriented—unlike with fD—its process does not foreclose nor forecast that it might assist artists dealing with politically difficult situations.[30] These unspoken rules code particular cues for artists on how to unravel or slowly reveal their own circumstances as well as when this type of unraveling might find the right audience who is positioned to give support.

By emphasizing the idea that the artist who is able to demonstrate a commitment to their "home" country gets priority consideration, the artist profile that Jane describes is necessarily not just what is written in the application but can be bolstered by external factors such as a site visit, which allows an ACC representative to see the artist in context even before the application is reviewed. If an artist is recommended by a previous fellow or visited by a representative of the ACC, or, increasingly more common, if the artist is able to provide a legible commitment to their home country upon return, this early indication helps satisfy what the granters are looking for, rather than dealing with an artist who insists on a lack of connection to a home space. Artists who apply must include a portfolio as well as a list

of their scholarly presentations, exhibitions, and institutional affiliations. The applicant must confirm that they are a visa holder or foreign national whose paperwork for travel is intact. The application asks, "How many cities outside of your city of residence have you traveled to?" This is not just to list a recent history of travel but asking artists to detail how a fellowship might enrich their lives and those around them, implying that a residency obtained by the ACC ultimately means adding another city to the list. As Jane notes, the ACC does not aim to rehearse the "old boy's club" model, but its more conservative screening process cultivates applications from candidates who may already have informal feedback from these visits and previous experience of travel; these help the organization narrow down the search before more of its resources and energy are spent.

While unraveling as a performance tactic that artists use on stage can slow down or fully refuse to reveal trauma, artists also extend these strategies offstage to create periods of reprieve, freedom of expression, and freedom of movement while navigating grant applications. Unraveling, that is, deciding *where* and *when* it is advantageous to admit one's vulnerabilities, has also become part of both applicants' and granters' long-term strategies to adjust the physical and geographic conditions of the granting process that may fall out of the official time lines set by the ACC. In conversation with each other, these parties find other informal spaces and times in and at which to push back and forth on the qualifications that make an ideal grantee and the conditions that meet the stated criteria of a residency. As a result of these strategies, over time the criteria for the grant may also unravel, or become more loose or flexible to an applicant's needs. At the extreme, it could mean an unplanned exile or shift in the artist's political status.

Instead of a simple formula, where an applicant applies and then receives or does not receive a grant, a more robust view of the whole process might include things that go unmentioned on the application webpage, such as the artist's own cultivation of a notable regional career before applying or, in turn, the ACC's dispatching contacts to visit a prospective grantee. After the application submission, the work to unravel continues, as artists may stay in informal contact with the ACC over multiple seasons and qualitatively frame their narrative to convince evaluators that they are prepared

to broaden their exposure to international art audiences over time and through travel. By articulating their specific needs around the types of contacts they might need, especially in cases when an artist's return home would be dangerous and they must extend their time abroad, grantees push the ACC out of its comfort zone to hold less tightly to its officially stated goals of a six-month fellowship alone.

In return, the ACC often pushes an artist to leave their own comfort zones to make sense of a new environment during the fellowship itself. In the six-month fellowship, rather than having multiple fellows living alone in different parts of New York City, the ACC often arranges a set of apartments for a cohort of fellows to live in close proximity, in order to foster community.[31] In addition, the ACC has also formalized some aspects of grantees' experiences to familiarize artists with the city itself, with recommended itineraries of visits to galleries, museums, and performances, including but not limited to making professional contacts and fostering expanded networks in the community. It also encourages grantees to do their own research on the contacts they want to make, assists them in sending preliminary emails, and then follows up with those connections. For some grantees, after receiving a grant, unraveling (or disclosing vulnerabilities at an individual pace) shifts to a mindset of networking, developing contacts, and gaining political support. This is different than situations in which an arts granter may assume that a standard fellowship package or experience works well for every artist on fellowship.

The process is not seamless. Jane notes that artists acculturating to the six-month time frame and new surroundings in a large urban environment may mean that ACC grantees face the disruptions of moving—including getting to know their neighborhood, the city, their living situation, other grantees, and transportation. Rather than the "urgency" that fD faces with their applicant pool in dealing with precarity, a different sense of urgency is placed upon ACC's grantees as they seek to make time-sensitive connections. In scenarios where artists are not necessarily equipped to make connections, the fellowship initiates contact when possible. At the same time, the ACC encourages unplanned networking and planning that might mean deviation from an artist's proposed goals:

People go through stages of sort of culture shock. They arrive. They're thinking, Oh my god. It's six months, how am I going possibly get everything done? We say, Just get over your jet lag. Get to your know your neighborhood. Get to know your way around. That makes them nervous. We try to set up some meetings. We also try to encourage people to be open to what they find and not to be rigid about, This is what I said I was going to do. So, I'm going to do it. If you find something else, if there is another track your research brings you to . . . then you should be open to taking it . . . you know, some people get stressed out, some people get very cranky when they first arrive . . . some people get depressed halfway through. Ideally you have someone fairly relaxed and happy with enough sense of themselves, who they are, that they can deal with stresses in a different culture. It's not always easy. That's where we make grants to young, emerging artists to midcareer artists to senior specialists. It's probably easier to deal with people who are more midcareer, they are more mature, better skills to deal with this sort of thing.

In highlighting the short time in which a fellowship takes place alongside affirming an artist's accomplishments, Jane notes the struggles of some artists in dealing with the immediate stressors of temporary displacement. However, rather than considering "culture shock" a disruptive process to the fellowship, this lack of adjustment is a necessary and processual unraveling among grant recipients, who later must adapt to accomplishing artistic work while on fellowship. Jane's suggestion of culture shock might be another modality that helps artists under political constraint generate agency during the process of displacement, helping them diversify the ways they relay political constraint to their audiences. In noting that it is probably "easier" for the ACC to deal with artists who have had prior international residency experiences, Jane speaks of this discomfort as a temporary situation and par for the course of the fellowship, since the eventual return home of the artist is imminent. Yet, in contrast, consider the moments when Htein Lin built global notoriety before his fellowship, as well as the multiple and sometimes long-term displacements, when

he made discomfort for himself and his audience part of the DNA of his artistic repertoire. An artist experimenting with strategies of unraveling on- and offstage must wrestle with the transformative work of unraveling that stretches the senses beyond the comfort, safety, and security associated with "home," shifting the relationship between artist and interlocutor.

Unraveling Live

At the beginning of the performance that introduced the exhibition to the Brooklyn audience, Htein Lin stood in a dark corner of the ISCP gallery, clothed in a monk's robe and singing a slow, haunting, and singular chant. One older Burmese audience member follows Htein Lin, clasping his hands to his forehead, rocking back and forth, closing his eyes and repeating the chant in Burmese: "May all beings be free from enmity and danger. May all beings be free from mental suffering. May all beings be free from physical suffering. May all beings have ease of heart." Chanting this Theravada Buddhist invocation of *metta*—typically chanted at a Buddhist temple or at community gathering—in a gallery instead is to momentarily unfix time and space. In this moment of quiet pause, Htein Lin's morning prayer slows the pace of the day and simultaneously transforms the ISCP gallery space in Greenpoint into an alternative Burmese meeting place. The artist's choice to extend Theravada practice into the gallery suggests that coping with the afterlife of detainment can take place at home, at a shrine, in a public area, or in one's office—he democratizes what is considered a sacred or state-sanctioned site of religious observance (fig. 8).

The prayerful calm does not last for long. Htein Lin's shadow slowly moves across the space; his chanting halts as his body crumples; a monitor screen showing a video recording of 2007 protest footage from the documentary film *Burma VJ* (2008) lights up the space.[32] Spliced into the live performance, the video reminds the audience that the monks who survived police brutalization were incarcerated or forced into exile.[33] Hundreds of monks involved in that protest sought political asylum in other countries in the Global North.[34] Htein Lin brings our attention to the

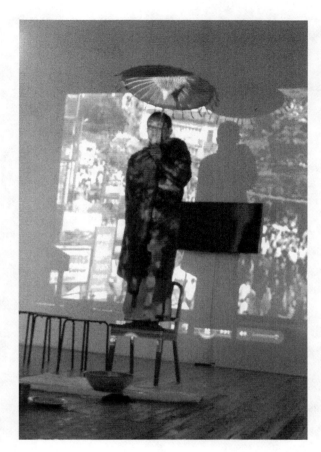

FIGURE 8. Photograph of Htein Lin's performance *Moving Monument*, November 2012. ISCP Studios, Brooklyn, New York. Photo by the author.

real-time experiences of those monks, subsequently living in the United States or the United Kingdom, their livelihoods dependent on repeating their testimonies after international screenings of this footage. Their religious and political positioning in the diaspora have become critical to Burma's debates over economic, political, and religious unrest. The artist momentarily stakes a common ground between himself and these similarly politicized figures.

The robe itself has significance, since the practice of wearing one in Burmese Buddhist Theravada practice is governed by the time of day and whether a monk is meeting mentors or mentees in the monastery or in public. Depending on the environment and occasion, the monk is more

or less clothed. Breaking down the sacred barrier between the figure of the monk and the public, Htein Lin guides the audience into a new morning. He stops chanting and starts to unravel the top half of his robe. He unrolls a section of cloth material across his chest; this material acts as a second screen, where film footage is cast. Htein Lin's performance invokes the images of the dead and brutalized monks, which appeared in smuggled news footage of the 2007 protests along with reports that some monks and nuns had their robes taken from them by force before they were beaten and arrested by police.[35] Since Buddhist monks and nuns occupy a revered status in Burma and especially in the eyes of Theravadan Buddhist practitioners, these egregious acts were met with outcry.[36]

The footage flickers across the artist's otherwise nude chest, which is now vulnerable to the audience's gaze. Htein Lin reclaims the vulnerable spectacle of the Burmese monk's body, using his own body as a screen that mediates the 2007 uprisings. As gunshots on the film ring out, Htein Lin turns his back to the audience and starts to rotate his arms to match the pandemonium on the screen. He refuses to allow the audience's eyes to rest on his chest or the footage displayed on it. Then, nimbly wrapping and unwrapping robes around his frame throughout the rest of the performance, he repeatedly "clothes the monk"—a play on an act of goodwill outside the performance space, as donating money to pay for robes is considered a good Buddhist deed.

As Htein Lin uses his own body as both a partial stage and a protective layer, he guides audiences through his interpretation of the visual and aural cues of the violent scene. He renders himself a shield, vulnerable to the violence replaying on his body and vulnerable to our gaze as well. Htein Lin's alternation between disrobing and enrobing the figure of the monk also exposes his own body to the risk of retraumatization through images and sounds of military violence, yet he carries on. Even considering this risk, what might the stakes be for an exiled artist living in a "safe" place but choosing to submit themselves in this way? Drawing from Black feminists such as Sadiya Hartman and postcolonial feminists such as Saba Mahmood and Gayatri Spivak, Jack Halberstam questions the political ends of similar performative refusals of the self: "Can we think about this refusal of self as

an anti-liberal act, a revolutionary statement of pure opposition that relies not upon the liberal gesture of defiance but that accesses another lexicon of power and speaks another language of refusal?"[37] The short scene replays on Htein Lin's robe, but from a closer-in view. There is screaming from the crowd and bodies run in every direction. Suddenly the video freezes on a scene of a group of monks walking peacefully in the streets immediately before the crackdown. The sound of a triangle gently struck three times from offstage accents the moment of stillness. Htein Lin turns to face the audience and a pixelated still of one nameless monk's face is projected onto his bare chest. As the video remains paused, Htein Lin slowly rewraps and adjusts his robe yet again.

Htein Lin's sharing of Burmese Theravadan Buddhist ritual in this Brooklyn space while also unraveling his own body as a screen deflects the end goals of humanitarian intervention to forcibly "save" or, alternatively, "make safe" or legible the dissident, refugee, and asylum-seeking body. By speeding up and slowing down footage of the 2007 civilian protests, zooming in on what that artist wants viewers to notice, he guides the audience through his diasporic time line of national events years after the fact and in time zones thousands of miles away. The artist alters the temporality at which audiences might digest these events, facilitating an elasticity between forbidden footage and the linear and sanctified Burmese state versions of national civil upheaval in the country. Lingering in some moments and completely pausing in others, he deejays the audience's perception of time and uses his own body as a stage in order to highlight the sensoria associated with being surveilled and shot at. In sum, he offers a different blueprint for "knowing" the violence of the militarized Burmese state against civilian uprising.

Halberstam traces the performance of radical passivity as tangible through acts of "cutting" and "collage" that are apparent in the work of Yoko Ono, Kara Walker, and Marina Abramović, who negate and fracture the self and challenge legibly liberal feminist approaches to "freeing" the body versus demonstrating possession over one own's body.[38] According to Halberstam, acts of self-negation, anti-humanism, sacrifice, and silence are usually denigrated in Western humanist formulations of womanhood but

could be interpreted as antisocial modes of subject formation that actually "offer up a critique of the organizing logic of agency and subjectivity itself, but that also opts out of certain systems built around a dialectic between colonizer and colonized."[39] Htein Lin's refusal to "play it safe" expresses freedom in a way that disrupts Western humanist and liberal feminist sensibilities and engages vulnerable subjects' power to lay claim over their own bodies. Furthermore, Htein Lin pushes against what a supposedly "freed" refugee or asylum-seeking body supposedly looks, feels, and sounds like to humanitarian and arts advocates.

One of Halberstam's main case studies is Yoko Ono's recurrent performance *Cut Piece*, where the artist famously invites her audience to snip away at her clothes as an example of "female masochism."[40] Similar to Htein Lin's performances, Yoko Ono's own work on radical "self-giving" is inspired by her reconciling a Buddhist ethos in ascertaining the responsibility of the artist to her audience or the individual to the collective. Ono's feminist embodiment of political refusal, which she likens to a meditative state, could help us problematize normative concepts of refugee subjectivity: just because a refugee is physically vulnerable, why must they also be considered divorced of place, sentience, and agency? In Ono's own reflections on *Cut Piece*, she has called it "a ridding of the ego" that allows a person to give to one's surrounding community without consideration of themselves. Each time Ono has performed *Cut Piece* the performance has spiked her own fear of the times when she had been rendered naked or made to bleed by her audience. She interprets this as the antithesis of violation, however: "*Cut Piece* is about freeing yourself from yourself.... In other words, the artist must give the artist's ego to the audience. I had always wanted to produce work without ego in it.... Instead of giving the audience what the artist chooses to give; the artist gives what the audience chooses to take. That is to say, you cut and take whatever part you want."[41]

By turning to antisocial feminism or politics rooted in masochism, hunger strikes, or a refusal to speak, these thinkers and artists track how some artistic practitioners seek to make obsolete the racist, xenophobic, patriarchal structures already embedded in postcolonial state practices and social life.[42] Vivian Huang furthermore suggests that Ono's own rhetoric

of unconditional giving in *Cut Piece* thwarts repetitive Western discourses that conflate radical forms of hospitality with female sacrifice and Asian docility.[43] In the case of exiled artists like Htein Lin, forgoing ego by unraveling the self can thwart the hegemonic refugee and arts advocacy that sometimes downplays asylum-seeking communities' capacity for political agency and social and economic mobility *on their own terms*.[44]

I borrow from Ono's "radical giving" and Halberstam's "radical passivity" as queer feminist modes that encourage participants, such as artists working within arts and humanitarian industries, to "unknow" colonizing logics by taking into their own hands the powers once thought to be in colonizers' hands, even if this risks eliminating the self.[45] When Burmese exiled artists and activists invoke the performative sacrifice of the self they also trouble the boundaries between the interior and exterior self, between savior and victim, beneficiary and donor, nation and diaspora. By embodying Buddhist meditative states as a coping mechanism for the quotidian challenges of these industries, Htein Lin refuses legible ways to be an ingratiated refugee and asylum seeker toward a "benevolent" United States, thus unmooring its position as an ultimate arbiter of an asylum-seeker's fate.

Htein Lin's performance begs the question, What is the endgame of unraveling if it potentially "ends" the artist engaging in it? What traces does it leave behind so that others might follow? In political and cultural theorization around neoburlesque and striptease, similar arguments surround the hegemonic assumptions of racialized and sexualized power that shirk the dominant ideals of white and heteronormative forms of intimacy and domesticity.[46] While monks disrobing in Southeast Asia do not necessarily have to weigh the same political stakes as striptease performers in the Global North, Htein Lin does play with prescriptions of traditional Theravadan austerity around the im/materiality of the human form. He models how others might similarly recalibrate the uncertainty of time and space faced by asylum-seekers, where safety coheres, if ever, inspiring a different dynamic of power as it operates between exiled artists and their advocates.

Like Ono's invitation for others to cut at her clothes onstage and risk

her safety and also like Schweitzer's invitation to consider the transgressive politics of undress, Htein Lin's public unraveling of the monk involves his own revisitation of a violent spectacle—in his case, to help himself and others like him to momentarily transcend the physical constraints of postresettlement life and the inability to return to who they once were in their country of origin. Enrobing once more, Htein Lin holds one corner of the robe in his mouth, wrapping himself tighter and looser into abstract and oblong shapes. He hides and reveals only obscured body parts at any given moment, making the threat of disappearance seem imminent. Htein Lin then transforms his body into a live canvas when he adjusts the robe so that it is enclosed around his face and mimics a protracted camera's lens with the length of his arm—his own face is at the end as if to communicate that he has returned to this site and is watching government agents just as they had surveilled the movements of monks and civilians.

He watches the audience watch the footage on the screen, which moments prior was projected onto his own body. He momentarily returns to Burma in 2007 and takes viewers along with him, only to jarringly bring the audience back to Brooklyn in the present. Exposing his own senses and his own flesh—which has withstood torture, incarceration, and camp life—he offers himself up as a conduit such that the audience may tap into sensate experiences of military state surveillance and then join him in also "watching" back. Is he taking back power from the Burmese state by transforming himself into a symbolic camera surveilling them instead? Is he playing the diasporic interlocutor by watching the Burmese state from abroad? Or is he watching the audience, encouraging viewers to participate as an international collective of improvisational "cop-watchers?" Even if one were to get these answers while in the space, Htein Lin's "masking" still provides a site of encounter between himself and his audiences. He reimagines the role of dissidents, or potential asylum-seekers-in-the-making, who deflect their pervasive spectacularity and continual lack of protections from victimization through the human rights gaze.

In their article "Masked States: Between Security and Disability," Mel Y. Chen argues that different coverings—from medical masks and burqas to hoods of torture victims and police helmets—can be used to manage

a range of international and local state anxieties around racial alterity: "Masks both symbolize and effect security; by both representing and doing, they are performative technologies of a sort. As such, they bespeak action and transformation. Yet at the same time, they cover, conceal, and hide, and in so doing simultaneously perform a very different sort of vulnerability. They suggest the robbing of sentience as a cost of that security, and thus a radically different model of personhood."[47] Chen's attention to the "radically different model of personhood" engendered through masks is instructive about the inscrutability of subjects who refuse hegemonic humanitarian and arts advocates' impulses to racialize dissidents and asylum-seekers as inherently vulnerable subjects. For Huang, the masking of the body, ranging from head coverings to face masks in BDSM aesthetics, activates "the inscrutable surface as queer racial form" and connotes the long-standing construction of "Asian/Eastern/Orientalist styles" as threat.[48] These styles are conflated as threatening because they connote "inaccessible interiority and suspicious passivity" that have historically inscribed both fear and fetish onto the Asian body.[49] Alongside Chen, Huang seeds the possibility of masking as having power in "refusing speech and legibility, submitting to muteness" that aligns with how Htein Lin employs masking to challenge how exiled, refugee, and asylum-seeking artists are only legible to human rights interlocutors in limited ways. In these transformations of his body with robes, Htein Lin attributes explicit agency to moving *within* registers of vulnerability that, like other strategies of elastic vulnerability, produce more time and space to facilitate previously foreclosed community assembly under the constraints of military violence and humanitarian benevolence. Htein Lin's use of the unraveled robe to conceal his body, reveal his chest as a screen, and then transform himself into an apparatus of surveillance refuses a neat version of a vulnerable asylum-seeker while also refuses the "security" of what masking could allow its subject. The refusal to make the refugee or asylum-seeking body secure or safe means protecting the audience with his body while making it temporarily "unsafe" for himself. All the while, Htein Lin asserts his agency as a formerly incarcerated dissident, staging a defiant deployment of elastic vulnerability — playing explicitly with the temporality of and site

of trauma, that is, who gets to dictate the terms of security: the state, the advocate, or the dissident.

Htein Lin's symbolic undressing of his monk's body, a seemingly irreverent act, references how military police configured monks into civilians in order to maim, brutalize, or eliminate them. His undressing also unravels official accounts of Burmese governance in times of political upheaval. Rather than freeing those on film, Htein Lin implores the audience to "free" our own previous sensorial understandings of Burmese dissidents in popular media. As an alternative, he proposes a purposeful disordering of the ways that protests have been understood, handled, and disseminated. He also expresses the severed condition of exile of the mind when distanced from the body and diasporic communities from the nation; lingering in this mode of "fracture" could transform how diasporic community members imagine themselves, opening the possibility of symbolic return to play a role in Burma's future. At the close of the performance, Htein Lin weaves his way through the audience to the exit door. Expanding the perimeter of the designated performance space, he chants in Burmese once more: May you have peace; may you have love.

After enduring various types and various periods of incarceration and detainment—ranging from days to years—in camps, in hiding, and in prison, Htein Lin has incorporated the language of unraveling into how he narrates his experiences of freedom of expression in front of his live audiences, most notably how he coped during incarceration. Htein Lin acknowledges that during periods of solitary confinement or what would seem to be the most isolating version of imprisonment, he drew on Buddhist meditative practice, an ephemeral freeing from the self, as a coping mechanism, and it has constantly reappeared in his artistic practice ever since: "Every day was the same and I was able to go deep inside my mind. I saw that freedom is not outside the facility or the institution. Freedom is inside your mind. This was surprising to me."[50] Htein Lin turns to this philosophy of transcendence through meditation (*vipassana*) as part of leading a principled Burmese Theravadan Buddhist life in order to provide mental focus and remain prolific, regardless of whether inside or outside of prison.[51]

However, by comparing the prison facility and the "institution"—a heavily surveilled gallery, a state-funded museum, a university shut down for political activity, a religious gathering place, or a government office—Htein Lin illuminates the limitations on freedom of movement for Burmese citizens and their access to surrounding society. To be able to "go inside his mind" to periodically escape these constraints and define freedom as a negotiation between exterior and interior space, Htein Lin forwards a radically different understanding of "freedom" and which subjects are able to access it. More specifically, Htein Lin's meditative strategy counters the hegemonic notion of traditional refugee advocacy organizations, which assert that freedom exists in the Global North upon migration. He thus upsets the power dynamics inherent in what Aihwa Ong calls "refugee love," or a unidirectional compulsion to save refugees through patronizing care. Ong brings attention to intersecting and diverse forms of structural violence within detainment and immigration systems that refugees and asylum-seekers have encountered, and also their coping mechanisms, which are not always immediately apparent as political acts.

Htein Lin has described creating art as therapeutic and transcendent in conditions where political prisoners were kept in solitary confinement twenty-two hours per day and forbidden to communicate verbally with other prisoners. "In prison, art was like when you go underwater, you need a regulator. It is essential. . . . It was very difficult to survive at that time and [not be] depressed. [Having] only political belief was not enough, that's why even political prisoners looked for ways to write poems, sing songs, read poet[ry]."[52] Producing art, like meditation, is a means of survival in conditions of solitude and torture. Htein Lin suggests that for him, producing art can replace speech or speaking out, a necessarily cathartic act. To compare the violence that he experienced in prison to the experience of being underwater, Htein Lin suggests he and others relied on artmaking as a type of necessary unraveling, a choosing of when and where to "regulate" the discomfort of the body and mind during difficult times. Perhaps it is not surprising that in *Yay-Zeq* he externalized this interior space to show others what helped him cope with the material conditions of solitary confinement and incarceration.

In 2013 Htein Lin expanded upon the tension between how he has experienced freedom of expression inside and outside prison. He says the repetitive nature of prison life was a necessary catalyst for meditative processes: "As a political prisoner, every day I saw the same images, the same food, the same people, and the same decay. Before [prison] I felt we were very limited, constrained outside. We had no freedom because of the government and the censorship policy. In there, I was completely free from the art market, and it made me free."[53] To say that his prison experience was freeing from the art market should not be overstated. Rather, it is important to recognize how the artist's words characterize the uneasy slippage between how the freeing site of his art was a space of confinement and torture—suggesting that this space existed in relation to what he found politically and economically restrictive about surrounding Burmese society.[54] He suggests that even in his "freedom" from incarceration the elements of his life that are free or empowering illuminate the continuities between incarceration and daily policing in Burmese society, as well as other experiences of unfreedom and freedom.

In his Q&A after the performance, Htein Lin regaled the crowd with stories of living at the India-Myanmar border in the jungle with other political dissidents escaping Burmese state persecution. He often interweaved seemingly contradictory light humor to these dark stories. For example, he described getting an eye infection from unfamiliar insect stings and his fear of partial blindness due to lack of medical care while in hiding. Htein Lin punctuated this narrative with his own laughter, feigned disbelief, and the refrain, "Can you believe it?" The (in)security of this condition actually contributes to the safety of the art now being housed or kept in residence, as well as the artist himself feeling safe after his release from prison. However, Htein Lin defines freedom on his own terms, alternating between finding asylum/safe houses for both himself and his art and disrupting the linear narrative that formerly incarcerated, asylum-seeking, or refugee subjects need permanent support or residence in the Global North.[55]

Htein Lin has made the act of momentarily transcending the body through meditative practice a critique of martial law and corporeal punishment by unraveling his own body, taking the power to expose what is

vulnerable about his embodied experience into his own hands. Similar to the performance piece that opened the *Yay-Zeq* exhibit, Htein Lin's definition of the "freedom" of mind also reorders sensory awareness towards the Burmese military state, still leaving its trace on asylum-seekers' lives once they have left Burma. He extends some of the same principles of adjusting or unraveling the sites where freedom lives when he agreed to be interviewed by media outlets.[56] As Htein Lin extends this moment of the monk's (robe) unraveling to his life beyond the stage, he also plays with time and space in order to guide the audience in the back-and-forth visiting between that occurs between his and others' present exiles and dissident pasts. During Htein Lin's exile, he exhibited his prison paintings, or meditations on detainment, at cosmopolitan venues; the works seem to demonstrate what the most mobile moments of exile can look like and refutes exile as a static state of statelessness.

In the *Yay-Zeq* exhibit the three artists mobilize their own bodies in various stages of undress, self-injury, and distress to reveal the tension of diasporic imagination from positions of exile, while the curators frame them as bearers of testimony to Burma's then-transition into a democratic state. The exhibition represents the diasporic body—Htein Lin unraveling a monk's robes—as a site of pain, but also of sensoria. These artists' undressing and redressing the exiled body (both physically and politically) highlight the work of various iterations of the Burmese military state to cover up its treatment of purported dissidents or, rather, to disavow their injuries in public media.[57]

Perhaps uncoincidentally, *Yay-Zeq* happened on the heels of various trips to Myanmar by then President Obama, then Secretary of State Hillary Clinton, and US State Department representatives to open up conversations about Myanmar's economic and political lag in the transition out of military rule and isolationist policies.[58] In contrast to the narrative of "reunion" the curators pose, the exiled artists provide a snapshot of the deferred friendships of in their community in diaspora and refuse a redemptive narrative of a "whole" national body. In their collective efforts to unravel, these artists all reject the idea that diaspora is *merely* an injured, vulnerable, and fractured version of the nation state, or that reunion is a

salve for the ruptures of displacement. Rather, in troubling the refugee and asylum-seeking body as safe upon its migration to the Global North and refusing wholeness, these artists reframe this reunion to stage their own and their communities' vulnerabilities through self-negation, reauthoring the perception of their "injury" coded as either due to Burmese statehood's all-encompassing omniscience or the failure of humanitarian benevolence to do its work.[59]

In sum, instead of mapping people as fluidly migrating from the precarity of asylum-seeking to the assumed security of resettlement, *Yay-Zeq*'s cartography of Burmese diasporic movement roots itself in interrupted resettlements; it tells us that the story of migration (including asylum and exile) is often a nonlinear experience. The artists insist on moments of rupture, on their uneven suturing of diasporic histories, on ellipses of time and space, and on the spillage of scarring and tissue into nonlinear recollection of recent upheaval. They set a different precedent for the safety of the refugee and asylum-seeking body. In the scenarios that *Yay-Zeq* proposes, periods and spaces of disruption are key for arts and human rights advocates invested in the future of refugee and asylum-seeking communities within both the democratic and the postauthoritarian states that receive them. Artists like Htein Lin at times refuse linearity and instead indefinitely prolong their healing process, defining where and when safety is constituted in the aftermath of state and humanitarian violence in national and transnational contexts.

Confronting Redress in the Afterlife of Political Incarceration

In 2014 Htein Lin debuted his project *A Show of Hands*, which featured dozens of plaster arms piled on top of each other in his studio space in Yangon. Unattached to any bodies, each plaster cast starts at the hand and ends bluntly at mid-forearm; all stretch their fingers upward toward an unseen force, or perhaps reaching for each other. Each hand is slightly different from the next in the width and length of fingers and the spread of the hand. Scrawled in black marker on white masking tape on the wrist

of each cast, sometimes in English and sometimes in Burmese, is the name of a former political prisoner from whom the cast was made. Eerie and sculpture-like reminders of the flesh, skin, and bone they once held, the pieces are also symbols of the harm done by the Burmese state that never fully goes away with time. The "healing" for those communities is not yet finished.

In *A Show of Hands* Htein Lin refuses to show the literal scars of formerly incarcerated communities in the aftermath of mass incarceration of civilians taken up by the Burmese state. Instead, his approach of casting small memorials, each a remnant meant to symbolically acknowledge and even heal their wounds, commemorates the time former prisoners spent incarcerated.[60] Rather than situate the time of his and others' initial detainment and release, through *A Show of Hands* the artist suggests it is never too late to start the process of healing a community after mass incarceration—a notion that aligns with his other work, where he invokes Buddhist prayer with audiences during performances. In 2014 his other work consisted of volunteering as a Buddhist meditation instructor in Burmese prisons in which both prisoners and prison guards participate. In early 2013, after a seven-year period of exile, Htein Lin was able to repatriate to Burma, during which time he began a process of what he called "hoarding arms."[61] By taking plaster casts of the arms of formerly incarcerated friends and strangers, he symbolically attends to the healing of the those who still endure long-term physical and psychological injury from their time in prison while simultaneously collecting and archiving their oral histories.

In 2014 Htein Lin was engaged with the news that the government in Burma had planned to release three thousand political prisoners as evidence of a changing government.[62] At that time, the unprecedented release of hundreds of political prisoners from Burma's Insein Prison had been timed to coincide with diplomatic visits by foreign officials. These events raised concern that Burma's shifts toward reform were only a show for humanitarian interlocutors in order to court international developers to invest in the country.[63] In the traveling exhibit at the Asia Society on New York City's upper West Side in 2017, three years after its original conception, Htein Lin recreated the installation. The casted hands were lined up next

to each other on pristine shelves in a large white gallery. On a portable television screen on one of the walls was a short documentary piece on loop. In the video Htein Lin interviews the former prisoners as he casts their hands. Htein Lin gently focuses the light on each interviewee while he moves around them, to accommodate their reclining or sitting position, mimicking the process, as he suggests, like a doctor at work. However, while sitting in their homes or at his studio, the artist physically works *around* his subject, cueing into their comfort, whether seated or laying down. Rather than a top-down prescriptive process, in this scenario the "healer" must indefinitely adjust and orient to the "patient's" need in the plastering process.

In interviews with the press, Htein Lin notes the process of collecting casts involves allowing unexpected "old wounds" to resurface: "As I have plastered my subjects, old memories and even old allergies have returned; a former prisoner who suffered a bad allergy to water while in jail found a similar rash build up under her damp cast."[64] Htein Lin's production of casts traces how stories of "allergies returning" or old wounds opening up should not be shoved under the rug. Instead, he suggests that the healing process is an activity that is both a gesture toward the future and a public acknowledgment that is never quite complete. Especially as the premise of freedom happens primarily within the visual and aural registers, seen and heard, Htein Lin expands upon what other tactile registers of healing are possible. The language of "redress," as it often operates in the context of human rights testimony, operates here in the form of re-dressing a wound. Redress, in addition to referencing a cast's healing properties, also describes a form of political counternarrative in the context of Burmese nation-building, through which the state is held accountable for past wrongs, such as human rights abuses, in order to move forward.

Htein Lin's method relies on the tactile nature of the sculpted open hand, which beckons redress from outside the hegemonic written, visual, or auditory realms and refuses to put bodies on display in the most discernible ways that human rights audiences are used to. In Htein Lin's case, elastic vulnerability invites audiences to sit in the gallery space and face the astounding weight of thousands of casts and the not-fully-knowable

stories they contain within them. Situating "vulnerability" as the double-edged condition of being wounded and to wound, Htein Lin engages in an elastic circumvention of a story of rehabilitation vis-à-vis incarceration of dissidents by the state and also a deflection and being a subject of rescue by humanitarian interlocutors. The artist chooses to honor and revisit each moment in which interlocutors' wounding happened, on his and on their own terms. This is not to stage a forced resolution between formerly incarcerated dissidents and the state, but rather it is an invitation by the artist and his formerly incarcerated peers for the public to sit in the discomforting open-endedness of where this public reckoning could lead.

Some Burmese prisoners' injuries were never treated, or even acknowledged by the state, and the denial of torture and disappearance of activists by the government have been called out by both local civil society and international organizations.[65] Sadiya Hartman imbues the "redress of the pained body" within dehumanizing institutions such as slavery with the power to enact Black community assembly, such as communal religious observance, dances, sharing meals, and satirizing the master: modes that create moments of freedom within the violence of slavery and are intended to eliminate community bonds and "possess the body and black needs and possibilities."[66] Hartman's configuration of redress provides a radically different context for considering how this concept also informs others types of fugitivity in regimes of political imprisonment and state-sanctioned torture. Redress, in the case of Htein Lin's, is taking to task who and what narratives often dominate popular media coverage of the state's mass imprisonment of anyone deemed dissident. Redress here situates both the possibility of addressing the systemic harms of both mass incarceration, refugee-making, and exile in all sectors of Burmese society openly, rather than behind closed doors, and the open-ended possibilities for survivors through community-based initiatives for mutual aid including family, legal, medical, and job placement support.

Rather than an invasive procedure of spectatorship that seeks to make each subject's inner turmoil visible, in this acknowledgment-but-refusal to reveal what is inside the cast, Htein Lin reveals possible routes of healing. This gesture toward healing underscores the role that long-standing

legacies of colonial occupation and nationalist violence plays in the lives of contemporary dissident artists. In *A Show of Hands* the performative possibility of healing does not happen in immediately legible mediums, such as forums for monetary reparations, medicalization, or human rights tribunals. Rather, this healing marks itself apart from the postauthoritarian state and global humanitarian "rehabilitation" of dissidents and exiled subjects. It is made possible by confronting the recent past as a means for treating the wounds of political imprisonment and other types of incarceration and detainment that are still ongoing.

In 2019, before his most recent arrest and prison sentence in aftermath of the most recent military coup, Htein Lin both lamented and articulated the necessity of the project, so that future generations will not forget the recent past: "Unfortunately, *A Show of Hands* is a project that never ends. There are so many former political prisoners, but, even now, our supposedly democratic government is creating new ones."[67] Htein Lin's words sit heavy in the throat after the most recent coup in 2021, which has torn down all semblance of a democratic government and resulted in thousands of arrests, imprisonments, and sentences-in-the-making, including Htein Lin's and his wife's, who both served one-year prison sentences. Such circumstances exemplify the urgent need for ongoing forms of community healing and humanitarian response that do more than just celebrate the release of those deemed dissident and the ability to "return" to Burma; they make a future political (but really all) incarceration unthinkable and make irrelevant the conditions that make dissidence so easily punishable. The necessity of the project, now more than ever, lies in its goal of healing formerly incarcerated prisoners even as the state is continuously creating new ones. Such timeliness speaks to the necessity of this project in the present, as well as its necessity in the future, for these communities yet to heal. In a radical rendering of redress, Htein Lin suggests that the state must also "heal" by dismantling its broken systems in order to accommodate formerly incarcerated communities' return to civilian life—safeguarding them from continual police violence and bolstering their employability. In other words, to support former political prisoners—as Htein Lin writes of his project of "hoarding arms"—means establishing nodes of connectivity

between comrades' experiences as they deal with the continual impact of incarceration on their livelihoods: "It is a process of community engagement, performance, and public art. I have found old jail comrades and new friends, put faces and arms to names of those whom I never met but heard about through the prison grapevine. I have found them in their new environments: monasteries, teashops, newspaper offices, hospitals."[68] The diasporic geography of the project and the hands themselves dramatize this notion of spread and breadth, but not necessarily release, as the only conditions of freedom, as formerly incarcerated communities find their way back to public spaces and to each other, who then are able to advocate for those who are still caught up in the system of detainment. Even though he notes that, "unfortunately," the project may never be finished, the work continues to live, as former prisoners have gotten in touch with him to request casts. Through the project, some participants have been able to find lost relatives and comrades in exile.[69]

In addition, to recognize how some Burmese artists access transcendent mental and physical states through Buddhist meditative gestures is to recognize how these artists remain flexible to the shortcomings of the mission of some humanitarian and arts institutions' ideals to provide a deep artistic freedom. To call back momentarily to the overarching goals of any international museum as a permanent, public-facing institution that "acquires, conserves, researches, communicates and exhibits the tangible and intangible heritage of humanity," Htein Lin offers terms that poetically exceed this humanity and perhaps investigate the tangible aspects of this heritage that are in/humane.[70] Here, elastic vulnerability helps discern the artist's flexibility to remain legible to the arts industry while simultaneously navigating unraveling as an extended process for reclaiming communal vulnerabilities: to heal, to rebuild. The projected work ahead will not be easy.

More than a referent, the hands symbolize an outward-facing and future-oriented ontology. Outside of the immediate moments when activists use these gestures, the artist offers a nonmedicalized and extra-legal prescription for healing from regimes of state violence and detainment that suggest future-oriented epistemologies around liberation. Htein Lin

invokes concepts such as redress by bringing attention to foreclosure on long-term medical care for dissidents who remain stateless and require a different practice of "resistance." While vital, these long-term visions of care tied to political liberation are often extraneous to the "emergency" narratives of immediate humanitarian aid. Instead of narrating a story of liberation that names suffering state violence in order to find freedom in the United States or Europe or other sites in the Global North, Htein Lin asks us to imagine states of freedom and constraint differently—to apply pressure to humanitarian ideals in order to critique a present moment in which these ideals have yet to be met, to sculpt a future in which they might be.

Diasporic Futures

In 2014 Htein Lin permanently relocated to Burma to see what changes he might effect with the technologies and media now available in the country. Until the 2021 military coup and his subsequent arrest, he advocated for formerly incarcerated political prisoners in several ways, namely, by collecting and storing their testimonies. Chaw Ei Thein successfully visited Burma again as well; since the coup and in recent years, she co-organized shows in absentia in Yangon with her sister, who is also an artist, featuring weaving of Burmese textiles, a kind of work considered "women's art" in a Burmese context.[71] In Chaw Ei Thein's studio and gallery space in Santa Fe, New Mexico, small group shows are still being held, into which other Burmese diasporic artists are invited. Since the most recent military coup, thousands more in Burma have undergone political incarceration, proliferating the acts, existences, and statuses that count as dissidence against the Burmese state.

During the COVID-19 pandemic, and the continuing time of racialized political upheaval in the United States, the notion of hand gestures as a sign of local and international diplomatic engagement is shifting. For example, world leaders, under medical advice during the pandemic, opted for elbow bumps or gesture of "namaste," bowing and bringing the palms together before the face or chest, instead of shaking hands. The gesture of namaste

has a historical, religious, and cultural specificity derived from a Hindu gesture of conveying greeting or gesture of respect acknowledging oneness with others, and is widely used in South, East, and Southeast Asia and their diasporas.[72] This change also flagged unspoken compliance with the guidelines of the World Health Organization to socially distance and limit physical contact with others; guidelines that some leaders have publicly shirked. Moving from the question of daily bodily comportment and how to move forward in times of emergency or crisis, it perhaps makes sense to gather lessons from ongoing movements that have always made room for crises, not as an exceptional state but as an inevitability.

At the intersection of the global human rights and arts advocacy milieus, diasporic artists, turned informal ambassadors, must remain vigilant and savvy to the discourses of passivity and aggression attached to their bodies that afford them cultural capital. How artists manage "appropriate" racialized and gendered vulnerability illuminates how affectations of pacifism and militancy are rewarded by arts and humanitarian interlocutors when embodied by some artists of color, immigrants, and refugees, but not necessarily by others. This is not to place blame on individual artists who put their bodies at risk. Rather, attention must be directed to how artists participate in global humanitarian and arts industries, indeed how economies of vulnerability celebrate narratives of the rehabilitated dissident to grateful citizen subject, as symbolized by some artists' welcome into museums and galleries but not others. These artists, as representatives of US democratic benevolence, spotlight contingencies and degrees between different states of detainment, including exile and refugee encampment alongside incarceration. They implore their audiences to consider different states of captivity alongside each other, especially as the parallels between some of these experiences alter the notion of where freedom is thought to reside—outside the museum, and not necessarily in migration from the Global South to the Global North.

Exhibits originating in the United States that spotlight postcolonial art can rely on diasporic artists to perform, in some ways, "maimed" subjectivity that is "liberated" from postcolonial injuries. Yet, when artists are faced with the precarity of exile stemming from the content of their work

or exhibition practices, they might take up a residency or a place to temporarily "house" themselves and their art. In these environments, for refugee, asylum-seeking, and previously incarcerated communities, employing disarming and historically potent body language is vital to communicating both the legacies and contemporary presences of necropolitical violence. In gesturing toward an abolitionist future, contemporary dissident artists' staging of the role of the "body open to injury" will continue to de-anchor who is the appropriate subject of human rights concern and if, how, when, and where this subjectivity becomes translatable. These similarities speak to what comparative thinking about invocations to nonviolence can do for all of us, what calls to militant refusal can do for all of us, and what these calls might inspire us to do as a society. Given the legacies that the civil disobedience movement will inevitably engender in the political imaginary of Burmese diasporic communities, our work to trace disparate histories of civil unrest might help us identify future potential spaces for, times of, and movements toward solidarity.

Epilogue

The discussion presented here considers how diasporic artists cope with the legacies of state censorship and military policing beyond their initial experiences of displacement and/or political, economic, and state violence. In particular, the focus has been on diasporic, refugee, and asylum-seeking artists and activists who challenge the notion that resettlement alone promises freedom of expression and freedom of movement. Strategies of elastic vulnerability suggest a way of identifying and analyzing how contemporary diasporic subjects garner financial and political support as they wrestle with humanitarian ideals in their performances and thereby appeal to, and simultaneously shift, the discourse of rescuability in the international arts market. Events in New York in the 2010s encapsulate a particular moment in which Burmese refugee and exilic aesthetics responded to and shaped the intersection between the humanitarian industry and the arts market, asking these systems to nuance resettlement as the end goal of human rights activism.

While elastic vulnerability takes its cue from the heavily militarized context of Burmese state governance, the exhibitions I have examined reflect on multiple contexts: the transnational, the regional, the racialized refugee, the exile, and abolitionist futures. The themes I have discussed highlight the concurrent relationalities of survivance that artists share among state regimes of censorship and surveillance and transnational regimes of humanitarianism. This tendency regarding survivance speaks to the elasticity of "Burmese diasporic" art in conversation with those who

insist on forging communities among those with alternate experiences of exile and state violence and from which to understand the current stakes of mass incarceration, dissidence, and legacies of militarization. When artists play with embodiments of sensory deprivation, self-injury, and distortions of documented past and present state violence, their works highlight the elisions between subjecthood and objecthood that they must cope with in militarized contexts and their afterlife. The discussion has also called necessary attention to the informal disciplining tactics of the arts and humanitarian industries, as well as how artists subvert them to offer something new.

Yet, in just a matter of a decade, following what was a growing scene of Burmese diasporic art and artists in New York, some artists have once again dispersed. While this is perhaps a correlation and not a cause, post-2012 some diasporic Burmese artists were invited by the then-civilian government to engage in "cleansing" past wrongs of the state just as the vibrant Burmese diasporic arts scene in New York lost momentum. The mythical rise, freedom from house arrest, and subsequent "fall" of Aung San Suu Kyi as a human rights heroine coincided with a particular "return" trajectory for formerly exiled Burmese communities. While Aung San Suu Kyi openly recommitted to the rule of law alongside a deeper entrenchment of military ideologies into civilian governance, the idealization of Aung San Suu Kyi as a human rights icon also dissipated for many. Yet, upon yet another indefinite period of incarceration with the onset of another military coup in early 2021, she has again become synonymous with the pervasiveness of Burmese authoritarian violence.

In a parallel fashion, some of the most visible figures in popular media coming out of the Civil Disobedience Movement have been youths and women.[1] Burmese feminist anthropologist Chu May Paing presciently reminds us that in the aftermath of Myanmar's military coup, social media activism across the diaspora has been of urgent importance to imagining forms of unexpected collectivity as well as of dissent.[2] During the coup, women's collectives began a transnational and diasporic movement that features supporters waving *htameins* (Burmese skirt wraps) as flags and hanging them on street poles to symbolically "shame" or lower men's

hpone (social standing or power), specifically the hpone of the military personnel walking under them. In news surrounding one of Aung San Suu Kyi's recent birthday celebrations (while incarcerated and in solitary confinement), the *New York Times* and Human Rights Watch reported that in some Burmese cities and towns, soldiers physically assaulted women in flower shops and in the streets, sometimes rounding up those who posted on social media holding a flower or wearing a flower in their hair in tribute to Aung San Suu Kyi; human rights lawyers feared for these women's subsequent interrogation and torture.[3] International calls for support have meant increased visibility for not just democracy activists, but also garment workers on strike and ethnic minority women's organizations trying to address the long-standing aftermath of military tactics of political, sexual, and economic violence against women.[4] With "return" to Burmese civil society being an option for some and not others, what does this mean for the circulation of the aesthetics of self-injury and abstraction that was previously prominent?

As of 2024, most of the artists profiled here, at least those who were not already traveling from Burma and had retained their citizenship, have either moved on to other places in the United States, have been invited to return to Burma from exile for permanent residence (to be unexpectedly incarcerated again or exiled), or have visited the country. Chaw Ei Thein has moved to Santa Fe to open a studio and gallery, in part due to high cost of living in New York. Htein Lin had moved back to Yangon to continue to pursue art and prisoner advocacy work following his most recent release from another period of political imprisonment. These artists continue to live with the legacies of the transnational connections they made over the last decade, which have allowed them to continue to build communities. Looking forward, as these artists are working to define what is next, they also must negotiate the future direction of their work while Burma's coup reaffirms a commitment to authoritarian rule and the United States facilitates militarized police violence against its own student activists and deepens its funding of settler-colonial violence abroad.

What types of future political economies do current economies of vulnerability point to? What new political economies within the arts and

the humanitarian industries and what new patterns of diasporic return as well as exile-to-come of growing refugee and asylum-seeking communities might emerge? What are the long-standing political, economic, and social effects of performances of vulnerability and the racialization and gendering of subsequent generations of refugees and asylum-seekers within the humanitarian industry? What types of political economies between funders and recipients will continue to develop, based on the notion of cultural workers who are in immediate political and economic distress? How do grant organizations and funders create hierarchies in the circulation of aid based on performances of vulnerability or the rejection of such performances?

In the United States' major cities, with the advent of increasingly unsustainable housing costs and the lasting pressures of COVID-19, diasporic artists will additionally be under the duress that others have experienced in the freelance and gig economy. Some artists will continue to foster association with organizations that work to advise clients who are vulnerable to authoritarian state violence in their nations of origin, working to find temporary safe housing and helping them apply for grants. Those who are still potential candidates for fellowships, short-term artist residencies, or, in extreme cases, relocation within the same region or abroad, still must meet the flexible criteria of what counts as persecution of their human rights. Some candidates for services take on this identifier strategically in order to meet demands of the humanitarian industry for varying amounts of time since these terms are useful to them. My hope is that this task of providing support becomes even more accessible to artists, granters, and advocates alike.

Artists and activists find themselves in shifting relationships with organizations of aid, assistance, and humanitarian benevolence, as well as the multidirectional means of value-making around art, which falls out of the language of humanitarian capitalist exchange. Organizations financially support artists' careers and also introduce them to networks in the art market, including galleries, foundations, curators, and other artists, so that they might further relationships for themselves in the future—

futures still in the making. This is not a call to eradicate all auspices of the humanitarian industry nor the international arts market, but rather a dismantling of the structures that continually purport to make possible goals that are impossible.

As Yến Lê Espiritu and Lan Duong have noted, Southeast Asian Americanist and critical refugee studies' orientations to asynchronous periods of injury, "joy," and "survival" are part of an ethics of stewardship over the long aftermath of war and displacement in the lives of survivors and their descendants. From these theoretical genealogies the *excesses* rendered from region-affirming knowledge are key to helping scholars in ethnic studies and area studies move toward a transformation of codes by which displaced communities are deemed un/worthy of humanitarian intervention. Recognizing the intertwined *and* divergent theoretical genealogies between Asian and Asian American studies also expands the dialogue to account for the seemingly flexible or "elastic" geographic and ideological parameters of "Southeast Asia" and "America" as contingent rather than stable.

In recent years debates around Southeast Asian communities' claims to US citizenship and belonging has shifted to account for the deportation of "1.5 generation" Vietnamese, Indonesian, and Cambodian refugees, as carceral and detainment policies have furthered their entanglement with anti-immigration policies.[5] In the wave of xenophobic travel bans that surfaced in the United States over recent years, refugees from Myanmar and other nations have been caught up in similar policies; even when "asylum" has been granted, resettlement proceedings can be irrevocably interrupted. These recent patterns also use a mistaken shorthand for understanding how diasporic communities have challenged questions of their agency in place-making in the United States with regard to racialization alongside other communities of color.

Refugees, exiles, and asylum-seekers living in encampments, those seeking asylum, or even those dealing with deportation to their estranged "home countries" problematize national and regional borders as finite, particularly when they also *exceed* the terms of entry or insist on world-making at sites at which various nations claim their statelessness. Now, more

than ever, the call to transnational solidarity and sustained attention to these communities' world-making remain crucial. Simultaneous attention to nonstatist interventions is not tangential. Rather it is fundamental to unmaking human rights assumptions and furthering the ongoing work of survivors engaged in regional and potential South-South solidarities.

Notes

Introduction

1. Though I refer to Chaw Ei Thein as a Burmese exiled artist, not all artists who have been displaced from Burma identify primarily as "Burmese," as doing so sometimes denotes both the Burman ethnic majority and the Burmese state.
2. I use the word "Burma" to refer to the country of "Myanmar." Colloquially many immigrants, exiles, and asylum-seekers from this country refer to the country as "Burma" in nonalignment with the current status quo. In 1989 the ruling military government officially renamed the nation of Burma to Myanmar. Many people continue to use the name Burma as a rejection of the legitimacy of the military government. I use the name Burma, and its demonym, Burmese, when referring to people, places, and the diaspora. I also sometimes use the name Myanmar and the demonym Burmese interchangeably when referring to the military government, the nation, or the state. I also intermittently use Burma/Myanmar to indicate the slippage in perception between the two terms.
3. Since Chaw Ei Thein was the first artist of a long lineup to receive questions from the audience, the emcee addressed the crowd to say that every artist was limited to five minutes to answer questions "because they had many performers ahead."
4. Yangon is the former city capital of Myanmar. During the colonial period the city was also called Rangoon.
5. Thein, "Independent Artists Projects, NYC."
6. In one panel the discussed subjects were as varied as the ability of reality television and documentary filmmaking to be able to account for labor violations

to the form of the novel as a type of postcolonial genre able to account for nationalist violence.

7 Here the narrative structures of theater, film, performance, and Q&A were conducted mostly in English and intended for nonprofit, academic, and artistic communities from the Global North.

8 In human rights–laden art and advocacy spaces, "freedom of expression" tacitly invokes Article 19 of the UN's Universal Declaration of Human Rights, which states, "Everyone has the right to freedom of opinion and expression; this right includes freedom to hold opinions without interference and to seek, receive and impart information and ideas through any media and regardless of frontiers" (United Nations, "Universal Declaration of Human Rights," accessed March 22, 2022, https://www.un.org/en/about-us/universal-declaration-of-human-rights).

9 American Civil Liberties Union, "Freedom of Expression," accessed March 22, 2022, https://www.aclu.org/other/freedom-expression; Amnesty International, "Freedom of Expression," accessed March 22, 2022, https://www.amnesty.org/en/what-we-do/freedom-of-expression/.

10 UN, "Universal Declaration of Human Rights."

11 Ma Thida, "A 'Fierce' Fear," 323. In other discursive iterations of "freedom of expression" within Myanmar, writer Ma Thida, founding president of the PEN Myanmar Centre and advocate of free expression, has spoken to the material significance of freedom of expression in Myanmar, which she argues should be "granted constitutionally, legally, institutionally and individually by amending the 'Right to Information' and the 'Freedom of Information' Bills." She includes calls to broader legal protections for minority-language rights and educational reform, as well as speech that might not constitute hate speech or incitements to violence.

12 Hirsch, "Marked by Memory," 72.

13 Jeffers, *Refugees, Theatre and Crisis*, 104.

14 Several of the artists featured in this book have claimed their identities as Burmese (exiled) artists in the aftermath of the 1988 civilian uprisings. These same artists have weathered further political shifts: following the 2007 civilian uprisings against yet another military regime, a transition to a civilian government in 2011 and an overturn of this government early in 2021.

15 Zarobell, *Art and the Global Economy*, 5.

16 Zarobell, *Art and the Global Economy*, 169.

17 Zarobell, *Art and the Global Economy*, 169.

18 Curtis, "Picturing Pain," 24.
19 With suspicion following the advent of this type of photography, Curtis notes that there were even those who were US audiences skeptical of these images as real or trustworthy. Curtis, "Picturing Pain," 23.
20 Thus, this brand of humanitarianism abroad was a simultaneously bolstered by domestic approaches in "yellow journalism" as well as evangelical abolitionism (in response to slavery in the Americas). Curtis, "Picturing Pain," 25.
21 Curtis, "Picturing Pain," 25.
22 Curtis, "Picturing Pain," 25.
23 For a small sample of such studies, see Beiser, "Longitudinal Research to Promote Effective Refugee Resettlement"; Beiser, "Sponsorship and Resettlement Success"; Lamba, "The Employment Experiences of Canadian Refugees"; and Peisker and Tilbury, "'Active' and 'Passive' Resettlement."
24 There are various immigration advocacy websites that provide information on how to write an application for asylum using terms that may be most beneficial to the applicant. For example, see the work of Immigration Equality, a legal services clinic, "Immigration Equality Asylum Manual."
25 Nguyen, *The Gift of Freedom*.
26 Lê, *Return Engagements*, 51.
27 Jeffers, *Refugees, Theatre and Crisis*, 13.
28 Caswell and Cifor, "From Human Rights to Feminist Ethics," 31.
29 Caswell and Cifor, "From Human Rights to Feminist Ethics," 29.
30 Berlant, *Compassion*, 9.
31 Berlant, *Compassion*, 4.
32 These exchanges are related to but also work in excess of embodied cultural capital as theorized by Pierre Bourdieu and others. Bourdieu, "The Forms of Capital."
33 R. Hadj-Moussa and M. Nijhawan, *Suffering, Art, and Aesthetics*, 6.
34 R. Hadj-Moussa and M. Nijhawan, *Suffering, Art, and Aesthetics*, 6.
35 Chuh, *The Difference Aesthetics Makes*, 21.
36 Chuh, *The Difference Aesthetics Makes*, 21.
37 Speer, "Urban Makeovers," 578.
38 Paul Farrell and Oliver Laughland, "Reports of Lips Sewn Together as Asylum Seekers Stage Hunger Strike," *Guardian*, January 13, 2014, http://www.theguardian.com/world/2014/jan/14/lips-sewn-together-asylum-seekers; Matt Siegel, "Hundreds Protest, Some Sewing Lips Shut, Amid Rising Tension in Australian Refugee Camp," Reuters, January 13, 2015, https://www.reuters

.com/article/world/hundreds-protest-some-sewing-lips-shut-amid-rising-tension-in-australian-refugee.

39 Authors Michael Balfour and Nina Woodrow contend that corporeal interventions—immolation, suicide, riot, stitching of the body—are often intended to thwart techniques of disappearance utilized by state apparatuses. Balfour and Woodrow, "On Stitches," 18.

40 Ho, *Romancing Human Rights*, xviii.

41 Muñoz, "Vitalism's After-Burn," 91.

42 Fusco, "The Other History of Intercultural Performance," 143.

43 Muñoz, *Cruising Utopia*.

44 While this project considers Burmese diasporic community organizing as one of the mechanisms that makes such interactions possible, the community is but one node of a larger network in which human rights subjects are created.

45 I point to arenas where government officials guilty of human rights abuses have been made publicly accountable based on the testimony of injured parties. See Weizman, *The Least of All Possible Evils*.

46 For an abbreviated history on tribunals, see Brysk, *Globalization and Human Rights*. For an analysis of what human rights tribunals achieve, see Weizman, *The Least of All Possible Evils*.

47 Slaughter, *Human Rights, Inc.*, 13.

48 Pruce, "The Spectacle of Suffering," 216.

49 Others have cited the limits of "compassion fatigue," a term often used in the context of social activism and healthcare connected to human rights that describes the numbing psychological effects of secondary trauma among those treating, witnessing, reading about, or visually interpreting trauma to the point of exhaustion and burnout. See Campbell, "The Myth of Compassion Fatigue"; Moeller, "Compassion Fatigue."

50 Skidmore, *Karaoke Fascism*, 68.

51 Skidmore also writes at length about her and others' fears of surveillance. In her experience, many of her interviewees living in Yangon resisted speaking with her. While Skidmore's analyses, as a feminist from the Global North, speaks to her fieldwork experience in Burmese cities in 1996, she has also been critiqued for her voyeurism and that the participatory elements of her research were obtrusive and potentially retraumatizing to her interviewees. According to journalist and senior researcher in the Asia Division of Human Rights Watch David Mathieson, "Her relaying of testimony from drug addicts, prostitutes, physically abused women and abortion patients borders

on the unethical and intrusive. One wonders how these women felt about Skidmore's intrusive questions and whether they were left re-traumatized as a result of meeting her" ("Scared Stiff").

52 Fink, *Living Silence*, 5.
53 Carey, *Burma*, 222; Delang, Karen Human Rights Group, and Heppner, *Suffering in Silence*; Grundy-Warr, "The Silence and Violence of Forced Migration," 228; Lee, "A Politician, Not an Icon"; Skidmore, "Darker than Midnight"; Than, *Women in Modern Burma*, 95.
54 He also previously served as an advisor in General Thein Sein's military government (in power until 2011). Center for Diversity and National Harmony, "Devex"; Hlaing, "Review of *Living Silence*."
55 Stein, "Burma Bans Chanting and Marching"; Heller, "Isolated from the World for 60 Years."
56 Boyle, "Shattering SilenceBui, "East Asia's Vietnam"; Christensen, "Piecing Together Past and Present in Bhutan"; Gonzalez, "Mass Media and the Spiral of Silence"; Nguyen, *Memory Is Another Country*; Hannum, "International Law and Cambodian Genocide."
57 Salverson, "Change on Whose Terms?," 120.
58 Patel, "The Role of Testimony."
59 Balfour and Woodrow, "On Stitches," 18.
60 Cheung, *Articulate Silences*; Duncan, *Tell This Silence*; Kang, *Compositional Subjects*; Minh-ha, "Not You/Like You."
61 Duncan, *Tell This Silence*, 15.
62 In an interview with the BBC activist Thinzar Shunlei Yi noted, "The main message of the silent strike is to honour the fallen heroes and heroines and to reclaim the public space as our own," adding that the aim was to send a clear message that the military "shall never rule us" (*BBC News*, "Myanmar Coup Anniversary").
63 With respect to this point, throughout this book, Burmese names transcribed in English are not organized by surname but listed in full, in line with Burmese naming convention.
64 Trieu and Vang, "Invisible Newcomers."
65 Chuh, *Imagine Otherwise*.
66 In this book the term "postcolonial" signals the condition through which Burma has been subject to Japanese and British colonialism until World War II and the United States' strategic staging of land routes to China and the Asia-Pacific. Simultaneously, "postcolonial" does not fully capture precedent

regional histories in Southeast Asia that have made Burma a strategic exchange point on intra-Asian trade routes between India and China, nor its long-entangled conflict with neighboring Thailand over land, trade, and refugee encampment.

67 Aung-Thwin and Thant Myint-U, "The Burmese Ways to Socialism," 68.
68 Harootunian and Miyoshi differentiate French and British interests in area studies programming in the immediate post–World War II years. Acknowledging their ideas, I note that these disparate genealogies benefited the post-decolonization project of "patrolling and controlling intimate and violently defined interior cultural boundaries" and its divergence from US goals of strategizing foreign policy based on perception of foreign "enemy" territories. Harootunian and Miyoshi, "Introduction," 3.
69 Harootunian and Miyoshi, "Introduction," 3.
70 Wallerstein, "The Unintended Consequences of Cold War Area Studies," 200.
71 Hall, *A History of South-East Asia*, 5.
72 Kratoska, Raben, and Norholdt, "Locating Southeast Asia," 7.
73 Harootunian and Miyoshi, "Introduction," 14; Harootunian, "Postcoloniality's Unconscious," 151; Szanton, *The Politics of Knowledge*, 2.
74 Bonura and Sears illuminate today's configuration of Southeast Asia as territories "contained as threat," pushing area studies paradigms to account for shifting geopolitics post-9/11 and the unstable nature of Southeast Asian cartographies. Bonura and Sears, "Introduction," 3.
75 Yanagisako, "Asian Exclusion Acts," 176.
76 Lê Espiritu, *Body Counts*, 11.
77 Lê Espiritu, *Asian American Panethnicity*; Lê Espiritu, *Filipino American Lives*; Võ and Bonus, *Contemporary Asian American Communities*.
78 Ngo, "Learning from the Margins," 53; Maramba and Palmer, "The Impact of Cultural Validation," 516.
79 Iftikar and Museus, "On the Utility," 943.
80 These authors admit that "much remains to [be] learned about the racialization of Southeast Asian American experiences" in order to reach a "more holistic understanding of how their struggles diverge from or converge with other communities of color." Iftikar and Museus, "On the Utility," 943.
81 Iftikar and Museus, "On the Utility," 937.
82 The Critical Refugee Studies Collective, https://criticalrefugeestudies.com/.
83 The Critical Refugee Studies Collective, https://criticalrefugeestudies.com/.
84 The Hart-Celler Act (or Immigration and Nationality Act of 1965) established

new quotas and guidelines for immigration. This critical moment in Asian American history and migration derived from a US desire to court skilled workers and those with advanced degree from mostly South and East Asia to forward technological and scientific advancement in the United State while excluding other groups. Cheah, "The Function of Ethnicity," 199.
85 Cheah, "The Function of Ethnicity," 201.
86 Lê Espiritu, *Body Counts*, 6.
87 Baik, *Reencounters*, 12–13.
88 On the US side, formally identified refugees and asylees from Burma have resettled mostly in Minneapolis, Dallas–Fort Worth, and New York City, with notable thousands in San Francisco, Atlanta, and Los Angeles. See Pew Research Center, "Burmese in the U.S. Fact Sheet."
89 "Burmese diasporic subjects" refers to the more recently arrived (over the last ten to twenty years) who came as political refugees or those in the midst of seeking asylum, especially when used in reference to artists. This identifier, when applicable, is also used to describe intergenerational audiences who immigrated and settled in the United States during the decades prior to the civil unrest of 1988, after the US 1980 Refugee Act, and yet still farther back as immigrants in the post-1965 era.
90 World Vision, "Forced to Flee."
91 *BBC News*, "Myanmar Coup"; Regan, "Myanmar: Second Official from Aung San Suu Kyi's Party Dies in Military Custody—CNN."
92 Assistance Association for Political Prisoners, "Torture in Prison"; Lewis, "Lobbyist to Be Paid $2 Million."
93 This aforementioned data doesn't yet account for the aftermath of the most recent ongoing military coup that has taken hold of Myanmar (as of February 2021), which would include the aforementioned ethnic minority communities. See Regencia, "Myanmar Coup Displaces Thousands."
94 In some instances "state violence" signifies precarity with regard to police surveillance, censorship, detainment, and incarceration for any purportedly "dissident" activity, especially seemingly minor offenses. In others, "state sanctioned violence" can take the shape as armed warfare, resource deprivation, and legal political suppression, leading to genocide and targeted minority ethnic cleansing.
95 The US Fulbright scholarship was originally conceived of as part of post–World War II foreign policy and data collection. In addition, the availability of Fulbright and other fellowships remains intermittently unstable due to

periods of formal Western sanctions on trade with Burma beginning in the midnineties and as a means of pressuring the country to improve its human rights records. See Lebovic, "The Origins of the Fulbright Program."

96 National Gallery Singapore, "Art for Us—Burmese Edition"; Art Basel, "Breaking New Ground"; Ardia, "10 Burmese Contemporary Artists"; Bonhams, "Fresh Collections."

97 For more see film *For My Art* (2015). This recent short ethnofictive documentary piece, a piece of art in itself, documents the work of women performance artists working within the constraints of public scrutiny and public space in Yangon.

98 Creative Resistance Fund, "About."

99 Creative Resistance Fund, "About."

100 The American Midwest has several centers of Southeast Asian studies at universities such as the University of Illinois, University of Northern Illinois, and University of Wisconsin. Some of these programs were created in response to Cold War interest in Southeast Asia and were designed to train US civil servants for work abroad via language study. After the Cold War and wars in Vietnam, US involvement in Southeast Asia meant that refugees and migrants from affected regions ended up resettling around these same areas in the United States and now became hubs of the resettlement of various displaced communities, teaching English to Burmese speakers.

101 Lê Espiritu and Duong, "Feminist Refugee Epistemology," 589.

102 Lê Espiritu and Duong, "Feminist Refugee Epistemology," 588.

103 Lê Espiritu and Duong, "Feminist Refugee Epistemology," 589.

104 Taylor discusses the tactics of the Argentine military during the "Dirty War" (1976–83) in *The Archive and the Repertoire.*

105 Cho, *Haunting the Korean Diaspora*; Clough, "The Affective Turn"; Cvetkovich, *An Archive of Feelings*; Hartman, *Scenes of Subjection*; Gordon, *Ghostly Matters.*

106 Ngô, "Sense and Subjectivity," 118.

107 Fink, *Living Silence*, 4.

108 Schlund-Vials notes, "These means of remembering also hold the danger of conforming to dominant state-sanctioned narratives that eschew radial memories of the past in favor of convenient linear narratives. The ever-important question of how to represent the 'unspeakable' often collides with culturally specific arguments about the form such representation should take" ("Cambodian American Memory Work," 809).

109 Jeffers, *Refugees, Theatre and Crisis*, 110.
110 Suspicion of the authoritarian, racist, and masculinist silencing by the state and by global liberal humanist initiatives can further objectify those most directly impacted by liberation-intensive humanitarian discourse.
111 Aung San Suu Kyi was detained under house arrest for approximately fifteen years following her election to Parliament in 1990 for her role in the political party that opposed the ruling military regime. As of September 2024, she is under house arrest again.
112 She held these addresses after her release from house arrest, addressing the Burmese diasporic community and the broader human rights community.
113 This artist shares a pseudonym with the birth name of General Aung San. In addition to integrating meditative practices into his work, Htein Lin employs the discourse of Theravada Buddhist meditation in his artist statements, interviews, and public addresses.
114 Historian Jean Bricmont defines "humanitarian imperialism" as a lasting set of technologies that discipline the religious, economic, political, and educational life of postcolonial spaces inherited from eighteenth-century European imperialism. See Bricmont, *Humanitarian Imperialism*.

1 The Humanitarian Industry

1 When the concert camera zooms in for a close-up of some concertgoers, the viewer can see the fans are wearing black-and-white T-shirts with Aung San Suu Kyi's face sandwiched between text that reads "Burma" above and "Aung San Suu Kyi" below.
2 Betteridge, "U2Tours.Com."
3 While I was an editorial assistant at an academic press working on political science and Asian studies acquisitions, the 2007 Saffron Revolution—a student, monk, and civilian protest movement against military rule in Burma—was gaining momentum. Unsurprisingly, perhaps, in the same season I was assigned to review one of a spate of new biographies on then-incarcerated Burmese human rights figure and former Burmese Parliament member Aung San Suu Kyi. She was first incarcerated under house arrest in 1988 for organizing a democratic party against the then-military state and her name invariably comes up in any discussion about Burma's human rights records in the latter half of the twentieth century. Before her release from a previous house arrest in 2011, the prescient question "If Aung San Suu Kyi were free"

was tied with presumptions in popular media that Burma could successfully transition to a liberal democracy. Before 2021 she had been under intermittent periods of house arrest for approximately fourteen years over a span of twenty-two years. In February 2021 she was arrested and has been detained since the most recent Burmese military coup took power.

4 The album, *All That You Can't Leave Behind*, featuring the single "Walk On," was subsequently banned in Burma because of its apparent support for the pro-democracy movement in Burma and the National League of Democracy leader, Aung San Suu Kyi. In 2000 the state penalty for illegally downloading the album was anywhere between three and twenty years' imprisonment. *ABC News* originally reported on the correspondence between Myint Maung Maung, a reporter for the Democratic Voice of Burma, and the British music magazine *NME*. *NME News*, "U2's Criminal Record."

5 Repo and Yrjölä, "The Gender Politics of Celebrity," 48.

6 While various cultural producers employ Aung San Suu Kyi's image to cultivate an aesthetics of vulnerability, rescuability is one of the many other possible facets interlocutors fixate on in an effort to continually perpetuate the humanitarian industry.

7 Zucconi, *Displacing Caravaggio*, 76.

8 Littler, "The New Victorians?," 482.

9 Good et al., "Medical Humanitarianism"; Fechter and Schwittay, "Citizen Aid."

10 Martone, "Relentless Humanitarianism," 149.

11 Ülkü, Bell, and Wilson, "Modeling the Impact of," 153; Aflaki and Pedraza-Martinez, "Humanitarian Funding," 1275.

12 John, Ramesh, and Sridharan, "Humanitarian Supply Chain Management," 500.

13 Mohanty, "'Under Western Eyes' Revisited."

14 Spivak, *Can the Subaltern Speak?*

15 Previously these goals were geared toward advocacy of humanitarian causes such as improvement in prison conditions; temperance in use of alcohol; abolition of slavery and capital punishment; and recognition of the rights of labor, women, and nonwhite people. Zhulina, "Performing Philanthropy," 51.

16 Littler, "The New Victorians?," 476.

17 Littler defines the celebrity branch of "philanthrocapitalism" as entrepreneurial, frequently star-based projects that are framed around their charitable impact, such as Bono's involvement in the RED campaign or Bill and Melinda Gates's Global Development Programme. Littler, 476, 479, 480.

18 Notable examples are actors-turned-humanitarians Audrey Hepburn and Angelina Jolie. Littler, 477.
19 Jayawickrama, "Humanitarian Aid System."
20 While this may seem tangential to the colonial infrastructure the author describes, he also notes that in his experience, the industry is often under capacity and operates with a high turnover rate due to worker burnout, with growing scandals of sexual misconduct, corruption, discrimination, and racism within the industry's ranks. Jayawickrama.
21 Jayawickrama, "Humanitarian Aid System."
22 Konyndyk, "Rethinking the Humanitarian Business Model."
23 Chouliaraki, "The Theatricality of Humanitarianism," 3, 4.
24 Chouliaraki, "The Theatricality of Humanitarianism," 3.
25 Mostafanezhad, "Angelina Jolie and the Everyday," 28.
26 James, "John Yettaw."
27 This was John Yettaw's second attempt to reach her, after a first failed attempt a year prior.
28 James, "John Yettaw."
29 Based on her ethnographic research in Thailand, China, and the United States while working with various NGOs and service providers, Shih has deftly argued that some US antitrafficking projects demonstrate how global markets (specifically mass tourism and commerce) have catalyzed global concern against sex trafficking in Thailand while also facilitating antitrafficking humanitarian activism in the country. She observes how Thailand-based antitrafficking activists fuel the rescue industry by imposing Christian missionary work on former sex workers and by pivoting their labor to alternative economies, such as the production of small local handicrafts sold to patrons of their organizations. Shih, "Freedom Markets," 769.
30 Lê Espiritu, *Body Counts*, 42; Sen Nguyen, "US Operation Babylift 'Orphans' Still Seeking Their Vietnamese Parents," *South China Morning Post*, September 28, 2019, https://www.scmp.com/week-asia/people/article/3030533/us-operation-babylift-orphans-are-still-seeking-their-vietnamese.
31 Enloe, *Maneuvers*, 94.
32 Enloe, *Maneuvers*, 94.
33 Baik, *Reencounters*; Eng, "Transnational Adoption and Queer Diasporas"; Lê Espiritu, "Toward a Critical Refugee Study"; Parreñas, *Illicit Flirtations*; Park Nelson, *Invisible Asians*; Gonzalez, *Securing Paradise*.
34 Woods, "Ceasefire Capitalism," 747.

35 Hadar, "US Sanctions against Burma."
36 While Dale admits that this paradigm does not cover all relationships that exist between corporate responsibility initiatives and Burmese freedom movements, he shows that in some cases the alliance between American corporate responsibility advocates and Free Burma movement advocates results in mutual benefits for all parties advancing their agendas. Dale, *Free Burma*, 4.
37 McLagan and McKee, *Sensible Politics*.
38 McLagan, "Principles, Publicity, and Politics," 605.
39 In particular, McLagan and her contemporaries suggest that circulation of these forms of media inspire a politics that pushes audiences to act, often placing pressure on their own governments to shift policies and economic relations with countries that have sobering human rights records. McLagan, "Introduction."
40 Caesar, "First Lady."
41 Caesar, "First Lady."
42 Brooten, "The Feminization of Democracy," 134.
43 Brooten analyzes select *Newsweek* articles from the 1990s and 2000s to arrive at this point. Brooten, "The Feminization of Democracy," 134.
44 Ho also engages one of the most salient analyses on Aung San Suu Kyi's political career, noting that Aung San Suu Kyi and other Burmese women writers engage a tactics of displacement that "consciously negotiate[s] her performative power and her cultural and linguistic fluency to deploy persuasive discourse of political ethics, critical agency, local culture, national sovereignty and community loyalty." Ho, *Romancing Human Rights*, 68.
45 Two English-language documentaries are *They Call It Myanmar* (2012) and *Kayan Beauties* (2013). Clandestinely filmed to evade authorities, *They Call It Myanmar* documents daily life under Burma's military regime prior to the country's transition to civilian governance, though it largely excludes women from its narrative. *Kayan Beauties* examines human trafficking of ethnic minority Kayan women across the Burma-Thailand border.
46 Pederson, *The Burma Spring*.
47 Aung San Suu Kyi's title was "state counsellor." The position presides over the president's office, the foreign ministry, the energy ministry, and the ministry of education. As of 2024 she is under house arrest again.
48 Biopics that relate these struggles through predominantly masculine protagonists include but are not limited to *Gandhi* (1982) and *Malcolm X* (1992), both

which won mass recognition. British Indian actor Ben Kingsley garnered an Oscar nomination for his portrayal of Gandhi, the Indian nonviolent nationalist who led a movement against British rule; Black American Denzel Washington portrayed the militant Black nationalist; that film was released two years before *Beyond Rangoon*'s premiere in 1994. In the years following the release of *The Lady* (2011), popular figures of social movements within the United States and international heroes were more heavily featured in films such as British Nigerian actor David Oyelowo playing Martin Luther King Jr. in *Selma* (2014), Chicano actor Michael Peña in *Cesar Chavez* (2014), and Ghanaian- Sierra Leonean British actor, Idris Elba, in *Mandela: Long Walk to Freedom* (2013).

49 Mirante, "Escapist Entertainment."
50 Ho mentions the work of Sylvester Stallone in the final installation in the *Rambo* series in 2008, in which the titular protagonist bloodily defends Karen Christians from the military arm of the then-junta. Ho, *Romancing Human Rights*, 22.
51 Tamara Ho's treatment of *Beyond Rangoon* focuses on the valorization of Euro-American femininity through the saving of Brown women. This aspect of Aung San Suu Kyi's silence, as it is represented in the film, coheres with Western humanitarian/ feminist ideologies. Ho, *Romancing Human Rights*.
52 Hughey, *The White Savior Film*, 2.
53 For more on the genealogy of the white savior complex in film, see Hughey, 9.
54 While this military government by name was officially dissolved in 2011, many generals of the regime continue to hold positions of power within the current democratic government.
55 Perak, Malaysia, is a former British colonial stronghold and the site of the now-defunct Malaysian tin mining industry.
56 Dickson, "A Good Man in Burma."
57 Dickson, "A Good Man in Burma."
58 *Beyond Rangoon* was made a few years after the 1988 Burmese student and civilian uprisings.
59 Michelle Yeoh is a Chinese Malaysian actress whose previous credits include blockbuster martial arts and dramatic hits of Chinese, and more broadly Asian, and now American cinema, including *Crouching Tiger Hidden Dragon* (2000) and *Crazy Rich Asians* (2018).
60 This staging was not just for the scene of house arrest but to recreate sunrises and light filtration the way they would have appeared within the home.

61 Assistance Association for Political Prisoners, "Torture in Prison"; PageSix, "The Lady Is a Champ in Burma."
62 AAPP, "Torture in Prison."
63 PageSix, "The Lady Is a Champ in Burma."
64 At the time of filming the project had the French title *Dans la Lumière* (In the light), and the cast and crew signed confidentiality agreements so as "to avoid offending the authorities, who would possibly order the shoot shut down, scripts carry[ing] a deliberately insipid working title that gives no clue to their content." Marshall, "The Lady."
65 Gorsevski, *Peaceful Persuasion*, 104.
66 Gorsevski, *Peaceful Persuasion*, 99.
67 The term "strategic essentialism" is not to be confused with Gayatri Spivak's concept of the same name, nor Lisa Lowe's extension of it as it applies to Asian American studies; both references are absent from Gorsevki's text.
68 Taylor, "'The Lady.'"
69 Ma, "'The New Chinese Landscape,'" 25; Asia Society, "Background & History."
70 "Soros's conception of the 'Open Society,' fueled by his avowed disdain for laissez-faire capitalism, communism, and Nazism, privileges political dissent that works firmly within the constraints of bourgeois liberal democracy" (Rodríguez, "The Political Logic of the Non-Profit Industrial Complex").
71 Rodríguez, "The Political Logic of the Non-Profit Industrial Complex."
72 Rodríguez, "The Political Logic."
73 Luc Besson was previously involved in both the award-winning *Fifth Element* and in *La Femme Nikita*. As of 2019 he has been accused of sexual assault by various women throughout his career.
74 Asia Society, "Love Is."
75 These questions track with Lisa Brooten's argument that the use of Aung San Suu Kyi's face and "frail figure" in popular media reinforces the notion of female leaders as inherently soft, mothering, and nonviolent. Brooten, "The Feminization of Democracy."
76 Marshall, "The Lady."
77 "Suu Kyi Film Chat with Bond Girl," *BBC News*.
78 Marshall, "The Lady."
79 Marshall, "The Lady."
80 Suu Foundation, "Board Statement."
81 IPI is a not-for-profit think tank dedicated to "managing risk and building resilience to promote peace, security, and sustainable development." It was

founded in 1970 by US philanthropist Ruth Forbes Young and Indian major general Indar Jit Rikhye in close consultation with the UN secretary-general at the time, Burma's U Thant. International Peace Institute, "Jean Todt"; "Mission & History."

82 Littler, "The New Victorians?," 481.
83 The idea for the Suu Foundation's partnering with US institutions came out of Suu Kyi's previous visit to Honolulu in 2013. Craig Gima, "Suu Foundation in Hawaii Will Help Myanmar," *Honolulu Star-Advertiser*, March 9, 2014, https://www.staradvertiser.com/2014/03/08/breaking-news/suu-foundation-in-hawaii-will-help-myanmar/.
84 Gima, "Suu Foundation in Hawaii Will Help Myanmar."
85 East-West Center, "Mission and Organization."
86 In 2012, upon the heels of Burma's political transition and democratic reforms following Aung San Suu Kyi's release, Hillary Clinton, US secretary of state, made a historic visit to Burma to greet her. Former First Lady Laura Bush also still currently serves in a capacity as honorary chair of the board of the Suu Foundation.
87 Chen, "A Critical Analysis," 41.
88 When architects of the event chose Hawai'i to stage Burma-in-transition for the world, they further cemented Hawai'i as a contested site of US colonial settlement in the Asia-Pacific and imbued Burma with the potential to join a "familial" settler-colonial dialogue of liberal human rights engagement vis-à-vis violent inclusion. For more on histories of racialized and gendered inclusion and exclusion in the context of settler colonialism in Hawai'i see Arvin, Tuck, and Morrill, "Decolonizing Feminism"; Arvin, *Possessing Polynesians*; Fujikane and Okamura, *Asian Settler Colonialism*; Saranillio, "Why Asian Settler Colonialism Matters"; Rowe and Tuck, "Settler Colonialism and Cultural Studies."
89 Trieu and Vang, "Invisible Newcomers."
90 "In New York, Reverence for Myanmar's Opposition Leader," *New York Times*, September 22, 2012, https://www.nytimes.com/2012/09/23/nyregion/daw-aung-san-suu-kyi-draws-reverent-crowd-in-new-york.html.
91 Two of the students had traveled from Roanoke, Virginia, a four-hour drive, to attend the event. One of them had been in the United States for three years and was working toward a master's degree in economics.
92 One international studies undergraduate student from Vassar College mentioned that she would like to see Aung San Suu Kyi address the refugee/

diasporic population. In her address to the crowd Aung San Suu Kyi answered questions about the role diasporic communities might play—cautioning them that the process of return is not an easy one and that they would not find the country immediately changed.

93 At first, unbeknownst to me and others in line, Aung San Suu Kyi was actually slotted to give two talks that day: one in English, intended for Queens College alumni, students, and staff; and the other primarily in Burmese, for the local diasporic community. Local politicians in Queens got wind of the English-language event and took it as an opportunity to shine publicity on local efforts. This back-to-back scheduling of events manifested in a delay between the first and second talks, with explicitly invited diasporic community members having to wait. The first talk included two local Democratic Party leaders, New York City Council speaker Christine Quinn and Congressional Representative Joseph Crowley; American celebrities such as actress Anjelica Huston, reading Aung San Suu Kyi's essay "Freedom From Fear"; and singer-songwriter and Queens College alumna Carole King, who sang her classic hit "You've Got a Friend," with adapted lyrics, "You've got a friend in Aung San Suu Kyi." By design, attendees had to choose between the two events since it was not possible to sit in the first one while also waiting in line for the second. This timing issue effectively separated the two events, prematurely segregating the local political and diasporic communities even though the had overlapping investments in the event.

94 The Queens College event began at 9:00 a.m. According to reports of the event, to close the session the crowd of politicians and artists on stage held hands with Aung San Suu Kyi and together sang King's revised song.

95 Author's transcription of Kyi, "Speech at Queens College to Burmese Community."

96 Aung San Suu Kyi.

97 This is in addition to being refused Burmese and Bangladeshi citizenship for over two hundred years. Today Rohingya Muslim communities occupy the western part of the Rakhine State of Burma, a northern territory that borders Bangladesh. Human Rights Watch, "Burma/Bangladesh."

98 In recent responses to citizenship policies regarding Muslim Rohingya communities, she has firmly defended her point that the Burmese government has been observing the "rule of law" with regard to the state's management of civil unrest. Some celebrities and pundits have called for the revocation of her Nobel Peace Prize. Al Jazeera, "Aung San Suu Kyi Denies Ethnic Cleansing."

99 "Myanmar Army Admits Rohingya Killings."
100 United Nations High Commissioner for Refugees, "Rohingya Emergency."
101 Sykes, "Bono, Bob Geldof."
102 "On behalf of our audience who campaigned so hard for her, we reached out several times to speak to Aung San Suu Kyi directly about the crisis in her country and the inhumanity being directed at the Rohingya people. We expected to speak to her this week, but it appears this call will now not happen." U2 News, "This, We Never Imagined."
103 Biswas, "Amnesty Strips Suu Kyi of Its Top Prize."
104 See Littler, "I Feel Your Pain," for discussion on the narrow focus of celebrity and corporate activism in the humanitarian arena that chooses "safe" topics for their fanbase and consumer constituencies and therefore addresses only the symptoms rather than the core problem. She gives the telling example of "providing, for example, tools for illiteracy rather than addressing the problem of core funding in schools or economic inequality" (243).
105 Suu Foundation, "Board Statement."
106 Suu Foundation, "Board Statement."
107 Littler, "The New Victorians?," 481.

2 Diversity and Refuge in the Museum

1 The artists' gesture to this punishment seems apt for the installation, since Bogyoke Aung San's assassins were never identified. Some sources have asserted that they were colleagues of his in collusion with the British government and that he suspected an impending assassination attempt on his life that others hoped would unite Burma under other Burmese military leaders. Naw, *Aung San and the Struggle*.
2 Jason Chow, "Christie's Spotlights Southeast Asian Art," *Wall Street Journal: Scene Asia*, May 23, 2013, http://blogs.wsj.com/scene/2013/05/23/christies-spotlights-southeast-asian-art/.
3 While international art dealers started be interested in Southeast Asian art in the late 1990s, it is only recently that international auction houses such as Christie's and Sotheby's have noticed a spike in sales of art from this region. Experts have attributed the collectability of Southeast Asian art in part to private investors from Singapore and Indonesia, rather than public art institutions interested in growing permanent archival collections. See Chow, "Christie's Spotlights Southeast Asian Art."

4 Guggenheim Museum, "No Country."
5 Here "folk art" is art that wrestles with transmitting tradition. For more see Congdon, "Toward a Theoretical Approach," 96.
6 Guggenheim Museum, "Wah Nu and Tun Win Aung."
7 Guggenheim Museum, "Wah Nu and Tun Win Aung."
8 Made in 2012, the year of the show's opening, the pieces are: *White Piece #0131: Forbidden Hero (Breeze Before Storm); White Piece #0132: Forbidden Hero (Heads)*; and *White Piece #0134: His Last Speech We Heard from Myanmar Radio on 19 July of Some Years Ago*. Guggenheim Museum, "Wah Nu and Tun Win Aung."
9 Jacobin Magazine, "Art Museums in the US Are Facing a Reckoning."
10 Carol Vogel, "Guggenheim and UBS Project Plan Cross-Cultural Program," *New York Times*, April 11, 2012, http://www.nytimes.com/2012/04/12/arts/design/guggenheim-and-ubs-project-plan-cross-cultural-program.html.
11 See Hyperallergic, "Obama's 2012 Budget Cuts"; Annie Lowrey, "Federal Deficit for 2012 Falls to $1.1 Trillion," *New York Times*, October 12, 2012, https://www.nytimes.com/2012/10/13/business/federal-deficit-for-2012-fiscal-year-falls-to-1-1-trillion.html.
12 Vogel, "Guggenheim and UBS Project."
13 Vogel, "Guggenheim and UBS Project."
14 Bishop, "Antagonism and Relational Aesthetics," 53.
15 Downey, "Towards a Politics of (Relational) Aesthetics," 271; Martin, "Critique of Relational Aesthetics," 376; Reckitt, "Forgotten Relations," 133.
16 Bishop, "Antagonism and Relational Aesthetics," 70.
17 Grady, "If Museums Want to Diversify"; BLACK ART IN AMERICA, "Equity and Diversity in Museums."
18 In 1926 the League of Nations created the International Museums Office (forerunner of the International Council on Museums, or ICOM). McClellan, *The Art Museum from Boullée to Bilbao*, 34; Stephens, "ICOM Museum Definition."
19 Gbadamosi, "Stealing Africa"; Greenberger, "Looting, Plundering, and More"; vazirafyz, "'Looting.'"
20 These critiques have been met with some efforts by museums to repatriate these entities. Nicole Daniels, "Should Museums Return Looted Artifacts to Their Countries of Origin?," *New York Times*, October 16, 2020, sec. Learning Network, https://www.nytimes.com/2020/10/16/learning/should-museums-return-looted-artifacts-to-their-countries-of-origin.html.

21 Critics also ask why more diverse audiences do not exist as part of the mainstream museum's outreach to the public. Greenberger, "White Cubes"; Olivares and Piatak, "Exhibiting Inclusion."
22 Stephens, "Icom Museum Definition."
23 Zarobell, *Art and the Global Economy*, 262.
24 Andrew McClellan notes that many blamed the war on the increased value placed on global economic competition and the catastrophic death toll on technological efficiency. McClellan, *The Art Museum from Boullée to Bilbao*, 32.
25 McClellan, *The Art Museum from Boullée to Bilbao*, 34.
26 McClellan, *The Art Museum from Boullée to Bilbao*, 33.
27 McClellan, *The Art Museum from Boullée to Bilbao*, 33.
28 McClellan, *The Art Museum from Boullée to Bilbao*, 33.
29 "The British thought nothing of confiscating the Benin Bronzes in Africa in the late 1890s in retaliation for local revolts against foreign occupation, yet similar actions by Napoleon in Italy warranted the strongest condemnation." McClellan, *The Art Museum from Boullée to Bilbao*, 34.
30 McClellan, *The Art Museum from Boullée to Bilbao*, 40.
31 Klein, *Cold War Orientalism*, 16.
32 Melamed, *Represent and Destroy*, 42.
33 Melamed, *Represent and Destroy* 42.
34 See Van den Bosch, "Museums"; American Alliance of Museums, "American Alliance of Museums to Launch."
35 National Endowment for the Arts and Center for Cultural Innovation, "Creativity Connects."
36 National Endowment for the Arts and Center for Cultural Innovation, "Creativity Connects."
37 In 2012, when the Guggenheim's *No Country* show opened as well as in 2018, cuts to the NEA and NEH have been on the rise. See Hyperallergic, "Obama's 2012 Budget Cuts"; Peggy McGlone, "Trump's Budget Eliminates NEA, Public TV and Other Cultural Agencies. Again," *Washington Post*, February 12, 2018, https://www.washingtonpost.com/news/arts-and-entertainment/wp/2018/02/12/trumps-budget-eliminates-nea-public-tv-and-other-cultural-agencies-again/.
38 Davis, "How Did the Guggenheim's?"
39 Within the contemporary Southeast Asian art market, in recent years it has led collectors to be primarily interested in painted works from Singapore,

Indonesia, and the Philippines. For example, the Guggenheim also hosted the inauguration of Asia Week 2013, in which specialists, curators, artists, and patrons in the field of "Asian art" (defined broadly) met to celebrate with a series of events and fundraisers that coincided with *No Country*'s first months. In summer 2013 both the Rubin Museum of Art and the Bard College Art Gallery hosted exhibitions that focused on "Himalayan Asia," including exhibits called *Fiercely Modern: Art of the Naga Warrior* and *Confluences: An American Expedition to Northern Burma, 1935*. Both exhibitions featured cultural artifacts, spears, and clothing made by Naga artisans in the 1930s and paired these items with merchandise for sale to promote the exhibit, including with Naga cloth work and textiles made by contemporary artisans. In March 2015 the Asia Society kicked off an event it called "Myanmar's Moment." It was a concentration of Buddhist sculpture from the country as well as contemporary short films.

40 According to the *Wall Street Journal*, the bidding process for these works went more quickly and at lower price points than for those for works by top Chinese contemporary artists who have dominated auction results in recent years. Chow, "Christie's Spotlights Southeast Asian Art."

41 Taylor, "Art without History?"

42 Brunei, Laos, Vietnam, Cambodia, and Myanmar (Burma) later joined this formation. While this formation has been critiqued for its inheritance of both colonial and nationalist paradigms that reduce the complexity of regional upheaval and shift, some have noted how the facilitation of the communities that cohere in these networks provides key interlocutors with rebuilding local infrastructure for national economies and regional alliances in postwar contexts.

43 The museum's inclusion of particular themes of dissent with respect to Southeast Asia does not necessarily acknowledge parallel independent efforts to institutionalize (Southeast) Asian diasporic art nor articulate these traditions implicit relationship to (settler)-colonial forms of curation. For curatorial efforts towards this see Pelaud et al., *Troubling Borders*.

44 Galligan, "In the New Siam."

45 Chow, "Christie's Spotlights Southeast Asian Art."

46 "Collectors are looking for something new," says Eric Chang, a specialist for Asian twentieth-century and contemporary art in Hong Kong. Compared to Chinese art, he added, the prices for Southeast Asian art are "quite a bit lower." Chow.

47 Antoinette, *Reworlding Art History*, 4.
48 At the time of the original New York opening, Yap was a PhD candidate in the Cultural Studies in Asia program at the National University of Singapore. Her concurrent work in curation includes an exhibition of the work of Ho Tzu Nyen, a Singaporean video and performance artist who works with the built environment, for the Singapore Pavilion at the Venice Biennale in 2011. In 2010 Yap curated *You and I, We've Never Been so Far Apart: Works From Asia* for the Center for Contemporary Art in Tel Aviv for the International Video Art Biennial Guggenheim UBS MAP Curator, South and Southeast Asia, accessed June 5, 2015, http://www.guggenheim.org/new-york/about/staff-profiles/curators/june-yap.
49 Wu, "Biennials Without Borders?"
50 Wu, "Biennials Without Borders?"
51 See Reig and Gribetz, "The Swiss Banks Holocaust Settlement," 122, for reports that UBS originally pushed back against the allegations but admitted to the likelihood of the company's involvement in trading stolen gold, securities, and other assets during World War II. The case was eventually settled for $1.25 billion for survivors and heirs. In addition, UBS was later embroiled in a controversy when a forensic archivist discovered evidence of the company's collusion with the Nazis during World War II and its attempt to destroy sensitive files.
52 Reig and Gribetz, "The Swiss Banks Holocaust Settlement."
53 In recent years a group of New York museums and international collectors have followed the trend of collecting contemporary "Southeast Asian art." In particular, they have focused on artists from the borderlands between the regions of South and Southeast Asia in conversation with themes of contemporaneity and modernity. In summer 2013 both the Rubin Museum of Art and the Bard College Art Gallery produced exhibitions that focused on "Himalayan Asia," featuring cultural artifacts, tools, weapons, and clothing, respectively titled *Fiercely Modern: Art of the Naga Warrior* and *Confluences: An American Expedition to Northern Burma, 1935*. In March 2015 the Asia Society kicked off an event it called "Myanmar's Moment," which showed a concentration on Buddhist sculpture from the country as well as contemporary short films.
54 Vogel, "Guggenheim and UBS Project."
55 In the past UBS has supported initiatives such as Art Basel and Art Basel Miami Beach and institutions such as the Beyeler Foundation, a museum

56 initiative also based in Basel, Switzerland, as part of plans to expand its cultural branding program. See www.ubs.ch/en/fondation-beyeler/art.html.
56 Yap, *No Country*.
57 Davis, "How Did the Guggenheim's?"
58 Kander's company also sold military and law enforcement supplies in the form of bulletproof vests, bomb-defusing robots, gun holsters, and tear gas. Elizabeth A. Harris and Robin Pogrebin, "Warren Kanders Quits Whitney Board After Tear Gas Protests," *New York Times*, July 25, 2019, https://www.nytimes.com/2019/07/25/arts/whitney-warren-kanders-resigns.html.
59 Jacobin Magazine, "Art Museums in the US Are Facing a Reckoning."
60 Stromberg, "Major Artists Demand LACMA Remove Board Member Who Owns Prison Telecom Company."
61 Jacobin Magazine, "Art Museums in the US Are Facing a Reckoning."
62 The performance piece, titled *Blood Bath*, preceded another antiwar piece that more successfully entered the canon. The Art Worker Coalition's poster, *And babies?* (1970), overlaid the text "Q. And babies? A. And babies." over a war photograph by Ron Haeberle of dead Vietnamese citizens. The text came from a television interview in which *CBS* reporter Mike Wallace asked US soldier Paul Meadlo how many people in a Vietnam village he and his cohort had rounded up and killed on Lt. William Calley's orders. Meadlo explains, "I fired them on automatic so you can't . . . you just spray the area, so you can't know how many you killed 'cause they were going fast. So I might have killed 10 or 15 of them." Wallace asked: "Men, women, and children . . . and babies?" Meadlo famously replied, "And babies." MoMA initially agreed to distribute *And babies?* but ultimately pulled its support. New York lithographers printed over fifty thousand copies of the Art Worker Coalition poster, and newspapers around the country reproduced the scathing poster and its graphic image. Cohen, "10 Major Museum Scandals."
63 Cohen, "10 Major Museum Scandals."
64 Sturken, "The Wall, the Screen, and the Image."
65 Atanasoski, *Humanitarian Violence*, 4.
66 Mukherjee, "Borderless Worlds?," 62.
67 See Anzaldúa 25 for a discourse of *la frontera* that rejects the notion that the US- Mexico border is solely a "frontier" dictated through military occupation. See Mignolo, "Geopolitics of Sensing and Knowing," 274, for more on the relationship between borders and decoloniality.
68 Pelaud et al., *Troubling Borders*, 3.

69 Guggenheim Museum, "Tuan Andrew Nguyen on Baseball and Wood Carving."
70 See Guggenheim Museum, "Tuan Andrew Nguyen on Baseball."
71 Guggenheim Museum, "Tayeba Begum Lipi: Love Bed."
72 Guggenheim Museum, "Tayeba Begum Lipi: Love Bed."
73 Herbert, "The Making of a Collection," 60.
74 Author interview of Wah Nu, February 22, 2013.
75 Wah Nu interview.
76 Olivius and Hedström, "Spatial Struggles and the Politics of Peace," 278.
77 Philip Heijmans, "New Freedom for Myanmar's Artists," *New York Times*, December 2, 2014, http://www.nytimes.com/2014/11/28/arts/international/new-freedom-for-myanmars-artists.html.
78 Naji, "Freedom to Create."
79 Wah Nu interview.
80 Kina et al., "A&Q," 62.
81 D'Souza, *Whitewalling*, 9.
82 Reilly, *Curatorial Activism*, 104.
83 Reilly, *Curatorial Activism*, 23, 25, 31.
84 Wah Nu interview.
85 Cheng, "Skins, Tattoos and Susceptibility," 103.
86 Ching, "Art from Myanmar," 445.
87 Ching, "Art from Myanmar," 445.
88 Wah Nu interview.
89 The 1300 Revolution, named for the Burmese calendar year equivalent to 1930, occurred during a crucial year that marked a wave of strikes and protests by students and rural workers. The movement began with farmers in central Burma's oil fields who went on strike and moved to the country's biggest cities, Rangoon and Mandalay, thereby spreading the cause for Burma's independence from the British. They are important dates in Burma's history, especially with respect to populations outside the city that point to the struggles of national sovereignty and national identity. Wah Nu interview.
90 Hue, "The Guggenheim's *No Country* as Refuge."
91 Guggenheim Museum, "Sopheap Pich."
92 Chao, "An Interview with Sopheap Pich."
93 Chao, "An Interview with Sopheap Pich."
94 Metropolitcan Museum of Art, "Cambodian Rattan."
95 The piece was on display at the Centre for Contemporary Art from May 20 to July 20, 2014.

96 Tyler Rollins Fine Art, "Artists—Sopheap Pich."
97 In pursuit of this goal, the Khmer Rouge dissolved property owning, banned religion, burned books, outlawed education, and sanctioned the killing of teachers. Schlund-Vials, *War, Genocide, and Justice*, 2.
98 Guggenheim Museum, "Sopheap Pich."
99 Schlund-Vials, *War, Genocide, and Justice*, 20.
100 Lê, *Return Engagements*, 206.
101 Lê, *Return Engagements*, 212.
102 Lê, *Return Engagements*, 212.
103 Chao, "An Interview with Sopheap Pich."
104 Guggenheim Museum, *Artist Profile: Sopheap Pich*.
105 See Tang, *Unsettled*, 14; Lê Espiritu, *Body Counts*, 91; and Nguyen, *The Gift of Freedom*, 24, for more on the historical race-making processes around refugees. In particular, Tang argues that "refugee exceptionalism" often reifies xenophobic and anti-Black discourses and pits refugee communities against other immigrants and communities of color.
106 Tang, *Unsettled*, 159.
107 Schlund-Vials states that following the fall of Democratic Kampuchea, approximately 65 percent of Cambodia's population was female, highlighting the number of male genocidal deaths(*War, Genocide, and Justice*, 3).
108 Ly, "Of Trans(National) Subjects and Translation," 123.
109 Cambodian Mine Action Centre, "About CMAC."
110 Sisavath, "Metallic Violence," 2.
111 DeBevoise, "Presentation by Sopheap Pich."
112 DeBevoise, "Presentation by Sopheap Pich." Guy Issanjou is director of the French Cultural Center.
113 For more on the histories of Cambodian refugee attempts to return to Cambodia, see Um, *From the Land of Shadows*, 218.
114 For more on the recent detention and deportation of Cambodian refugees living in the United States, see DeBevoise, "Presentation by Sopheap Pich."
115 See Manalansan, "Queer Worldings," 567, for an analysis of the queer Filipino lives often coded in terms of "disorder" and "mess," which Manalansan seeks to situate as productive to "apprehend[ing] the circuitous and un-even terrains of queer global cities."
116 Some have argued that in the Burmese political sphere these processes of state violence are intensified through the influx of international capital and the promise of the Burmese government to make a good public show of hu-

manitarian ideals, such as the release of political prisoners, even in the face of continued detainment of internally displaced persons. For example, US president Barack Obama reintroduced the possibility of economic trade sanctions on Burma until state-sanctioned violence in the Rakhine state in Myanmar was stopped. White House Office of Press Secretary, "Notice."

3 Freedom of Expression, Asylum, and Elastic Vulnerability

1. I later learn that this process of drawing on herself takes at least forty-five minutes.
2. As discussed in chapter 1, in the summer of 2009 I documented media coverage of the band U2, who featured a summer tour as a nod to Amnesty International's Ambassador of Conscience Award bestowed on imprisoned Burmese democracy leader Aung San Suu Kyi. The band instructed concertgoers via their web campaign to don masks of her face that were free for download online.
3. The State Peace and Development Council was the military regime that overtook the government in 1988 following student and civilian protests. They were in power until 2010.
4. Huang, *Surface Relations*, 172.
5. Huang, *Surface Relations*, 181.
6. Shimizu, *The Hypersexuality of Race*, 16.
7. See, *The Decolonized Eye*, xxiii.
8. On the FAQ page of its website, the UNHCR defines resettlement as a "a voluntary, safe, and regulated transfer of people in need of international protection from the country where they are registered to another country which has agreed to admit them as refugees. Resettlement is intended as a long-term solution." United Nations High Commissioner for Refugees, "Frequently Asked Questions: Resettlement."
9. Aung San Suu Kyi orients the roles of speech and visibility in contemporary popular scenarios of rescue that focus on prisoners of conscience. Contemporary global representations of the Burmese state's disciplining of Burmese femininity and domesticity are similarly invested in this larger milieu of rescue of authoritarian states. As human rights interlocutors reconcile aspects of recent postauthoritarian national identity with a global humanitarian landscape, racialized and gendered renderings of state prowess become enmeshed in how the world perceives it, in Burma's and other

postauthoritarian countries' most recent claims of political transition to civilian governance.

10. At the time, Aung San Suu Kyi was a political prisoner under house arrest, had not yet been a member of the Burmese Parliament, nor rearrested again in 2021.

11. Kyaw Swar Thant and Chaw Ei Thein even relayed that a colleague of theirs has started bringing his teenage daughter for informal art lessons from Chaw Ei. For Burmese diasporic artists in New York, pursuing a full-time career in graphic design, commercial art, or performance is not always possible, so they take other jobs: hotel management, food service, and domestic work. Author interview of Chaw Ei Thein and Kyaw Swar Thant, August 12, 2012.

12. The color red is still considered taboo in Burma because it has been associated with nonviolent student and civilian protest and the National League for Democracy, Aung San Suu Kyi's opposition political party. Kylie Knott, "Paintings Banned in Myanmar to Go on Show," *South China Morning Post*, October 20, 2014, http://www.scmp.com/lifestyle/arts-culture/article/1618586/paintings-banned-myanmar-go-show.

13. When she received news of her formal exile while in New York, she cited feelings of uneasy transition that are sensorially jarring to her in her daily life and have influenced the themes in her work: "I'm still struggling. Recently, I am also trying to find myself. Because I still feel like I live in the two worlds—here and there. So, I cannot really make sure that I'm here [hits the table gently]. But I'm here [hits it again, then pauses] . . . I get confused . . . It happens all the time. So I think my current work is not so much about very serious politics, which is related to Burma, but more related to my personal experience living here . . . My mind is there, my body is here, right?" This sensorial discontinuity of the mind separated from the body is an apt description for some dimensions of the diasporic experience, especially the coercive relationship between the state and asylum-seekers. In coming to terms with this separation, the disordering that artists perform in their work (distancing from the body in order to maintain mental clarity) often muddles the line between diasporic affectation and the limits of human sensation in the context of state-sanctioned torture. Chaw Ei Thein and Kyaw Swar Thant interview.

14. Chaw Ei Thein and Kyaw Swar Thant interview.

15. She opened the same show with a performance in which she slowly emerges from a black box that shakes and starts with her inside.

16 Chaw Ei Thein and Kyaw Swar Thant interview.
17 When asked why these artists have chosen pastoral scenery or pagodas as themes in their "realist" art, they reply that they have both been frustrated with answers that circumvent the issue of peer-to-peer critique, which is reminiscent of controversial themes with regard to authority and that would mean a jail sentence in Burma. Chaw Ei Thein and Kyaw Swar Thant interview.
18 Chaw Ei Thein and Kyaw Swar Thant interview.
19 Carlson, "Painting as Cipher," 128.
20 Carlson, "Painting as Cipher," 128.
21 Carlson, "Painting as Cipher," 128.
22 Chaw Ei Thein and Kyaw Swar Thant interview.
23 Seen in this light, the way Chaw Ei Thein dramatizes the experience of constraint does not reflect solely on the context of Burmese censorship that surrounded the art's production. Rather, "constraint" structures the reception of the art as testimony to an unsmooth resettlement among peers and patrons in the diaspora.
24 This incident also further amplifies Aung San Suu Kyi's image as an ideal symbol of incarcerated femininity throughout many other instances of exiled artists' work in the United States.
25 Chaw Ei Thein has been a grantee of both organizations, and fellow artist Htein Lin was also an ACC grantee. I first came across these community members through Chaw Ei Thein, who has gained artist residencies/grants and built networks throughout the New York City metro area postexile, by association with these organizations.
26 Granters such as fD deal with artists in immediate distress while navigating their organizations' own potential displacement as in times of austerity in the national funding for the arts and rent increases in New York.
27 The site discloses that the average response time would be three days to a week due to the volume of requests.
28 Creative Resistance Fund, "About."
29 In the organization's 2013 intake form, the person filling out the form must self-identify as "an artist at risk," " a nominator," or a "friend/ family member filling out the application."
30 Author interview of Siddhartha Joag, February 28, 2013. All comments from Joag are taken from this same interview.
31 "Definitely first thing is family status. Just because you're looking at exponentially more research resources. A grant for a single journalist, we can swing it. A

grant for a journalist who has a wife, children, or a husband, you're looking at quadruple the money . . . it feels really counterintuitive, but I almost feel like there's a red flag that goes up. . . . The investment it'll take to help you we could help . . . and I know this sounds like very quantitative. But that's what it ends up being. It's also an issue of 'there are limited resources,' so we need to know. And this is something we're sort of systematizing more now." Joag interview.

32 In addition to a general biographical sketch, such as residence, date of birth, name, country(ies) of citizenship (if any), the applicant is asked extensive questions first and foremost about the assistance needed, namely, psychological, legal, medical, or employment. While also following up on the applicant's current employment and employer's contact info if relevant to their situation, the applicant is also asked to provide details about their education, current housing situation, hopes for professional development, and community engagement. To get an even fuller picture of the support the artist is already receiving, applicants also must acknowledge whether they have been in touch with any or are currently members of organizations, academic institutions, or professional associations, alongside contact information of representatives of individuals at these organizations who may be able to vouch for the applicant and provide further support.

33 According to Yang, the photo captured a turning point in a months-long and escalating conflict between South Vietnamese Buddhists and the American-backed Diem regime. "Monks had begun large-scale demonstrations in May 1963 to protest the restrictions Diem had placed on their religious worship. . . . Buddhists were harassed by the police and angered by the regime's favoritism towards Catholics. Forbidden from publicly flying their flag to commemorate Buddha's birthday, the Buddhists took to the streets. . . . Protestors were wounded and killed by grenades and crushed by military vehicles with unheeded rumors circulating that two monks would commit suicide in order to protest the government's actions" (Yang, "Still Burning," 2).

34 Vågnes, "The Unsettling Moment," 149; Urist, "What to Make of Marina Abramović."

35 Cho, "The Art of Self-Concretization," 22–23.

36 Cho, "The Art of Self-Concretization," 22–23.

37 As Vågnes suggests, "the event of Duc's self-immolation, carefully staged with the presence of foreign press in mind, coincides with the emergence of a new 'art of the ordeal, spawned by the generational conflicts and social upheavals

of the nineteen-sixties'—an art which involved various stagings of a ritualistic form of self-harm by artists. " Vågnes, "The Unsettling Moment," 149.
38 Brucher, "Self-Injuring Body Art," 155–56.
39 Brucher, "Self-Injuring Body Art," 151; Jones, *Body Art/Performing the Subject*.
40 For more on the piece's reception see chapter 4 herein and Rhee, "Performing the Other," 110–12.
41 Brucher, "Self-Injuring Body Art," 151.
42 Jones, *Body Art/Performing the Subject*, 167.
43 Jones, *Body Art/Performing the Subject*, 36.
44 Mathieson, "Crackdown."
45 These diasporic contingencies from Burma formed after landmark moments, such as independence British and Japanese colonization in 1947, the rise of one-party military rule in 1962, the fleeing of university and civilian demonstrators in 1988 and 2007, and refugees' movements today.
46 While I do not conflate different uses of tools and toys in BDSM with how Arai and Chaw Ei Thein use them, it is worth noting that uses of restraints and sensory deprivation hoods also feature in the latter's work. Guglielmi and Reddy-Best, "BDSM, Dress, and Consumption," 4.
47 Fry, "Petit Retrospective of Arai Shin-Ichi Works."
48 Gardenour Walter, "Wicked Knots," 99.
49 Nguyen, "The Biopower of Beauty," 359.
50 In some online contexts the piece is also identified as *Quiet River (dedicated to Aung San Suu Kyi's 64th Birthday)* and as being performed on the grounds of the United Nations Plaza in New York.
51 Gardenour Walter, "Wicked Knots," 99.
52 Kawanami, *The Culture of Giving in Myanmar*, 73.
53 Buddhist studies scholar Hiroko Kawanami notes that Buddhist nuns in Myanmar often act as informal treasurers in service of Buddhist monks, since the latter are forbidden from handling money and cash transactions, which would mean "taking on suffering" of those who have previously possessed the money. Kawanami, *Renunciation and Empowerment*, 99, 195.
54 Sliwinski, *Human Rights in Camera*, 7.
55 Sliwinski, *Human Rights in Camera*, 7.
56 Than, "Nationalism, Religion, and Violence," 19.
57 South, "The Politics of Protection in Burma."
58 Shimizu, *The Hypersexuality of Race*, 17.
59 Chaw Ei Thein and Kyaw Swar Thant interview.

60 Chaw Ei Thein and Kyaw Swar Thant interview.
61 For more on the Free Burma movement see Zarni, "Chapter Three"; and Dale, *Free Burma*.

4. Htein Lin

1 The exhibit's introductory placard noted: "In Burmese thought *Yay-Zeq*, a water-drop, signifies a present or future encounter caused by an act of merit performed by two people in the past." In other words, a kind of temporally fluid ripple effect.
2 Author discussion with Zasha Colah, November 9, 2012.
3 After the 1988 protests, Htein Lin and many of his fellow activists fled to the India border, where they lived in exile until being told by India's authorities that they had to leave the country. Upon returning to Burma, the group fled through the jungle to join democratic activists living near the China border.
4 In their inaugural performances both Htein Lin and Chaw Ei Thein dressed, redressed, and undressed their own bodies: in Chaw Ei Thein's case, by blindfolding, gagging, and shackling herself; in Htein Lin's case, by meticulously draping and undraping a monk's robe over himself. Sitt Nyein Aye, Htein Lin's mentor, also displayed a host of pencil drawings made during the time of this shared detainment; these were of the camp structures—makeshift huts, women washing clothes by the river, shadowy figures of ominous mountains near the camp—and seemed to contradict the "free" and open spaces dictated by the gallery space at ISCP.
5 The artists were invited by a nonprofit organization, the Clark House Initiative, which houses a gallery and artists' colony started by Delhi-based curators Zasha Colah and Sumesh Sharma. These curators sought to explore "philosophical and cultural strategies that have served to withstand or conjure tectonic, social and political shifts of upheaval or change" (ISCP, "Fall Open Studios 2012"). In addition to the stories of the artists who were present, the exhibit elaborated on the friendship between Htein Lin and the comedian Zarganar (whose name means "tweezers"), which began in Yangon during their university years in the mid-1980s and survived each other's multiple imprisonments and exiles. While at university they reinvigorated in two directions the ancient comedy and dance tradition *anyeint*. According to the exhibit's wall text, this took the form of standup comedy routines. Thein and Lin, *Yay-Zeq*.

6 The performers also used this structure several decades prior, before each of their respective journeys in exile, while producing an unsanctioned performance art piece in the streets of Yangon. After that joint performance piece, *Mobile Gallery + Mobile Market Street Performance*, Chaw Ei Thein and Htein Lin were detained and interrogated for creating interactive performance art in which they critiqued Burma's economic inflation of the 1990s and early 2000s; they sold tiny trinkets, such as small drawings, key chains, and toys, for one *kyat*—the smallest currency note in Burma that is rarely used. Chaw Ei Thein stated that the piece was intended to remind people who had not seen the note in years to remember a time when it was possible to purchase something so cheaply. Even in these initial collaborations their public performances called attention to the economies of vulnerability produced by the friction between the unaffordability of quotidian metropolitan life in Burma's then–capital city, the state's accountability to its citizens, and the terms by which the artists risk their freedom of movement through public spectacle.

7 Diamond, *Communities of Imagination*, 195.

8 Diamond, Colah, and Sharma's accounts of contemporary *anyeint* converge on how the form is sometimes malleable for artists who use it to avoid the risk of discovery and at other times allows them to fly under the radar of politics (in contrast to mass protest in Burma). Audiences are encouraged to leave for meals and sleep, but can also return. These performances and series of skits can last hours or all evening. According to Catherine Diamond, these events also celebrate births, housewarmings, novice initiation ceremonies for young monks, the deaths of beloved monks, the propitiation of *nats*, coming-of-age ceremonies such as ear-piercing for girls, or business openings. Sharma, "Curator's Statement"; Diamond, *Communities of Imagination*, 195.

9 Studies of eighteenth-century historical archives suggest that monks can be disrobed by other members of the sangha or religious order only if they have committed the highest forms of transgression, or *parajika* (including violating vows of celibacy, committing theft, committing murder, or making false claims of spiritual attainments), and are giving up monastic status thereafter. Kirichenko, "The Making of the Culprit," 213.

10 Moe and Sot, "A Monk's Tale."

11 For those who enter the sangha for the first time and for those who recommit to Buddhist principles at various points in their life, donning the robe is a symbol of entry. Thus, inversely, returning to lay life is accompanied by disrobing. Kirichenko, "The Making of the Culprit," 213.

12 Biswas, "Htein Lin Interview"; Yuan, "For Ex-Myanmar Prisoner"; Thomas Fuller, "Back to a Burmese Prison by Choice," *New York Times*, December 6, 2014, http://www.nytimes.com/2014/12/07/world/asia/u-htein-lin-back-to-a-burmese-prison-by-choice.html; Jane Perlez, "From a Burmese Prison, a Chronicle of Pain in Paint," *New York Times*, August 13, 2007, https://www.nytimes.com/2007/08/13/world/asia/13prisoners.html; Liu, "Myanmar Junta Detains Artist-Activist Htein Lin"; "A Prisoner's Tale," *Economist*, accessed March 7, 2023. https://www.economist.com/books-and-arts/2007/08/02/a-prisoners-tale.

13 Baik, *Reencounters*, 101.

14 Chaw Ei Thein received grants in both 2008 and 2009 while in New York; Htein Lin received a grant in 2012 while embarking on the early stages of a transition back to living in Burma.

15 Stuelke, *The Ruse of Repair*, 10, 29.

16 Stuelke, *The Ruse of Repair*, 9.

17 His performances in 1996, before serving jail sentences, included titles such as *The Little Worm in the Ear* and *Guitarist*.

18 Yuan, "For Ex-Myanmar Prisoner."

19 This particular instance refers to an artist's talk that Htein Lin gave to help open the *Yay-Zeq* exhibit on November 9, 2012, at ISCP Studios in Brooklyn, New York.

20 Fuller, "Back to a Burmese Prison by Choice."

21 Biswas, "Htein Lin Interview."

22 These artists choose to draw symbolic maps of Burma in their work and even trace Burma's borders in the performance space between themselves and the audience. By choosing to highlight these border territories in symbolic maps, they also highlight peripheral or "forgotten" ethnic minority groups who have been tensely at odds with the Burmese national government for recognition.

23 "Norming of the body" refers to comments by Aihwa Ong, who convincingly argues that the seemingly antithetical notions of refugee love and refugee suffering play a large role in feminist and humanitarian projects meant to forcibly rehabilitate refugees' bodies to be fit for the project of citizenship. Ong argues that this "love" directed toward refugees often reifies a colonial project of rehabilitation that involves both retraumatizing events of medical examination and the prescriptions of not only occupation, language, and socialization but also the micromanagement of "smells" of cooking that might offend one's neighbor. This interpellation of sensorial choices, or how not to offend

one's neighbor (i.e., the American citizen-subject), actually sets the stage for a host of other types of subjectivities that asylum-seekers and diasporic populations broach more broadly in the wake of humanitarian benevolence and organized forms of humanitarian activism that are meant to advocate for these communities. See Ong, *Buddha Is Hiding*.

24 John D. Rockefeller, John III's grandfather, was at one time the richest man in the United States and the country's first billionaire, who originally founded Standard Oil in 1870, an empire that controlled almost all oil refinery in the United States. The Rockefellers later dedicated themselves to philanthropy, including stamping their legacy on the Rockefeller Center in Midtown Manhattan, at the University of Chicago, and at Rockefeller University, among other pursuits. The Rockfellers' real estate holdings in New York and the foundation's financial clout perhaps makes it easier to weather the perennial fluctuation of American national funding for the arts. Thus the ACC does not face the same financial precarity as other organizations. "Rockefeller Family."

25 I refer to this interlocutor as Jane, who is retired from the organization, in order to preserve her anonymity.

26 In addition to recommending support of individual artists, the study recommended supporting institutions that were invested in cultural exchange.

27 Author interview of Jane, April 4, 2013. All comments from Jane are taken from this same interview.

28 Klein, *Cold War Orientalism*, 5.

29 In addition, the majority of ACC applicants are not living in explicit distress at the time of application, as their grants are awarded annually rather than throughout the year.

30 Joag also articulated that fD's main goal in arts advocacy is to assist artists in elaborating on their political and recent historical contexts in order to convince funders to provide resources.

31 "We work very closely with the individuals who have our fellowships. They stay in apartments that we have leases on. We meet with them quite often in the beginning. We give them lists of things to do. We take them to galleries to performances. We introduce them to each other. Our grantees have been clustered in certain areas. We are in the process of moving everyone to one apartment building. So that is a nice network in New York, in Manhattan. People talk to each other" (Jane interview).

32 When Htein Lin induces the calm of a morning prayer in the dead of afternoon, one could argue he is initiating an intergenerational community

healing moment that commemorates losses during civilian protests in 2007 as well as 1988.
33 *Burma VJ.*
34 US Commission on International Religious Freedom, "Annual," 32.
35 Moe and Sot, "A Monk's Tale."
36 Moe and Sot, "A Monk's Tale."
37 Halberstam, *The Queer Art of Failure*, 139.
38 Halberstam, *The Queer Art of Failure.*
39 Halberstam, *The Queer Art of Failure*, 131.
40 Halberstam differs from many contemporaries in cleaving to antisocial feminism, which goes against the grain of liberal feminist political organization being defined by its accrual of momentum or visibility for vulnerable populations, such as publicly rallying for political caucuses, voting, and even mass protest. Instead, Halberstam prefers foreclosed modes of politics traditionally associated with unproductivity or failure. The author argues that Yoko Ono's performance, where the artist offers up herself to the audience, embodies the notion of antisocial feminism or "a feminism grounded in negation, refusal, passivity, absence, and silence, [which] offers spaces and modes of unknowing, failing, and forgetting as part of an alternative feminist project" Halberstam, *The Queer Art of Failure*, 131.
41 Ono, "Cut Piece (1964)."
42 For example, Halberstam revisits Spivak's influential essay "Can the Subaltern Speak?" in order to suggest the illegibility of agency of the "burning widow," who throws herself on her husband's funeral pyre. The burning widow does not read as resistant but complicit in the wishes of her community, that she belongs with her husband in the afterlife. Halberstam and Spivak might argue that this refusal is a refusal to inhabit the subjectivity of an inherently oppressed "Third World woman" who needs to be saved from indigenous patriarchal constraints by similar paternalistic infrastructures in the form of Western feminism. As the contemporary humanitarian industry invests in the visibility of the refugee body in need, performance and visual artists have responded in kind by representing these bodies as embodying coping mechanisms to censorship by performing silence, invisibility, and self-sacrifice in their domestic contexts before and after migration. Halberstam, *The Queer Art of Failure.*
43 Huang, *Surface Relations*, 49.
44 Halberstam differs from many contemporaries in suggesting that an anti-

social feminism that goes against the grain of political organization that is solely defined by accruing momentum or visibility for vulnerable populations, including political caucuses, voting, and even mass protest. Instead, Halberstam prefers foreclosed modes of politics traditionally associated with unproductivity or failure. Halberstam, *The Queer Art of Failure*.

45 Yoko Ono explained *Cut Piece*'s foundations through the lens of stories of Buddha, where he is made to give up his wife, children, and ultimately his own life to a tiger that wished to eat him, through which he gained enlightenment: "That's a form of total giving as opposed to reasonable giving like 'logically you deserve this' or 'I think this is good, therefore I am giving this to you.' The audience was quiet and still, and I felt that everyone was holding their breath. While I was doing it, I was staring into space. I felt kind of like I was praying. I also felt that I was willingly sacrificing myself. It wasn't a feminist issue, per se. It has to do with the positive and negative side of giving, but we can make it positive. And the funny thing was, most people thought of the other side, which is the body being violated." Ono, "Cut Piece (1964)."

46 Comparably, Schweitzer has called striptease a form of transgressive spectacle that historically draws on uncovering as a type of "subversion of dominant cultural paradigms." Schweitzer, "Striptease," 65.

47 Chen, "Masked States and the 'Screen,'" 79.

48 Huang, *Surface Relations*, 7.

49 Huang, *Surface Relations*, 7.

50 Pollman, "Burmese Artist Htein Lin Breaks Free."

51 For example, Shwe Dagon Pagoda was part of Yangon's precolonial urban planning to be the city's tallest building, such that any city dweller from any vantage point in the city could see its stupa. In this way Buddhist prayer is part of the daily infrastructure that cuts across class, occupation, and, to some degree, gender.

52 Pollman, "Burmese Artist Htein Lin Breaks Free."

53 Pollman, "Burmese Artist Htein Lin Breaks Free."

54 This is not to downplay the very material conditions of long-term torture or imprisonment for many in Burma's general prison population, who do not have the cultural capital that Htein Lin seems to accrue outside of prison as a political prisoner, artist, and former student leader.

55 This language of "housing" or "preserving" the art in an institutional context becomes another allegory: by detaining the art and mimicking the artist's

detained condition before entering official exile in London, detention becomes equated with "freeing" it.

56 The artist's project included the goal to meet and create hand molds of a thousand former political prisoners. Htein Lin, "Hands Tell the History."

57 This held true in a 2022 Human Rights Watch report that stated that the military coup authorities have not seriously investigated six cases of National League of Democracy activists being secretly tortured and fatally maimed by militarized police. Human Rights Watch, "Myanmar."

58 In April 2012 the United States officially sent representatives to meet Burma's president U Thein Sein to discuss economic and political developments in Burma. Talks between President Obama and President U Thein Sein included plans to resume US charity efforts and economic aid that had been closed off from the country for most of the previous twenty-five years following military crackdown on civilian and student protests in 1988. In this scenario, Obama is a figure that embodies the often fetishized "postracial" America, which signifies racial harmony and the successes of the US "melting pot" at a moment when Burma's new state still encounters "ethnic conflict" among its populace. The situation positions Burma as inherently having to learn more about managing "ethnic conflict," such as the recent state violence martialed at Rohingyas, a Muslim minority in Burma. Visits of US representatives at this time position the United States as a guide toward liberal democracy and racial equality.

59 Once these site-specific forms move outside of Burmese-state jurisdiction, the international communities they encounter at art exhibition sites often consider these exiled voices (some have been exiled for more than twenty years) as the authentic voice on current Burmese politics.

60 Due to political sensitivity, the image of the *Show of Hands* installation is not included, but the author encourages the reader to engage this work online.

61 Htein Lin, *A Show of Hands*.

62 *BBC News*, "Myanmar to Release 3,000 Prisoners."

63 Michaels, "Burma Releases Political Prisoners."

64 Htein Lin, *A Show of Hands*.

65 The Irrawaddy, "Artist Htein Lin Explores Political Prisoners' Woes."

66 Hartman, *Scenes of Subjection*, 49.

67 Biswas, "Htein Lin—Interview"; Lisa Movius, "Outspoken Myanmar Artist Htein Lin Arrested by Military Government and Sent to Infamous Prison," *Art Newspaper*, August 25, 2022, https://www.theartnewspaper.com

/2022/08/25/outspoken-myanmar-artist-htein-lin-arrested-by-military-government-and-sent-to-infamous-prison.
68 Htein Lin, *A Show of Hands*.
69 His artist statement further elaborates: "*A Show of Hands* is being both recorded and being extended via the social media. Through the website http://www.hteinlin.com/ and through Facebook and other social media, word of the project is spreading, and more former prisoners are tracking me down. We are putting political prisoners in touch with their friends and families in exile. Even as the plaster dries, former prisoners have recorded and uploaded their own casting experience. They have been contacted across continents by Skype with friends in the diaspora, using social media and internet opportunities which we did not even dream of at the start of our struggle in 1988. These connections represent the importance of the community in Myanmar, and reinforce the importance of treating our fellow men and women with respect, compassion and loving kindness. People often ask us how we survived under the military regime, and how we survived in jail. Each of us had our survival strategies, but the main answer to that question is that we had the support of our community, and we had solidarity between individuals, just as plaster of Paris supports the arm and the healing bone" (Htein Lin, *A Show of Hands*).
70 Stephens, "ICOM Museum Definition Plan Moves Forward."
71 As previously noted, the artist received a visa to return to Burma in March 2015. Author interview of Chaw Ei Thein and Kyaw Swar Thant, August 12, 2012.
72 *BBC News*, "Coronavirus."

Epilogue

1 Sidhu et al., "She Was Shot Dead."
2 Wachpanich, "If I Don't Post?"
3 Aung San Suu Kyi has historically worn flowers in her hair. Richard C. Paddock, "In Myanmar, Birthday Wishes for Aung San Suu Kyi Lead to a Wave of Arrests," *New York Times*, June 23, 2023, https://www.nytimes.com/2023/06/23/world/asia/aung-san-suu-kyi-myanmar.html.
4 Women League of Burma, "Programs."
5 Jeff Gammage, "Deporting Asian Refugees, Activists Say, Is Anti-Asian Violence—and Removals Are Up," *Philadelphia Inquirer*, April 24, 2021, https://www.inquirer.com/news/immigration-immigrant-southeast-asia-asian-violence-cambodia-vietnam-laos-deportation-detention-20210327.html.

Bibliography

Aflaki, Arian, and Alfonso J. Pedraza-Martinez. "Humanitarian Funding in a Multi-Donor Market with Donation Uncertainty." *Production and Operations Management* 25, no. 7 (2016): 1274–91. https://doi.org/10.1111/poms.12563.

Anzaldúa, Gloria. *Borderlands/La Frontera: The New Mestiza*. San Francisco: Aunt Lute, 1999.

Al-Jazeera. "Aung San Suu Kyi Denies Ethnic Cleansing of Rohingya." Accessed September 3, 2019. https://www.aljazeera.com/news/2017/04/aung-san-suu-kyi-denies-ethnic-cleansing-rohingya-170406081723698.html.

Al-Jazeera America. "Refugees in Australian Camp Sew Own Lips Shut in Protest." January 17, 2015. https://web.archive.org/web/20150119222340/http://america.aljazeera.com/articles/2015/1/17/refugees-in-australiancampsewlipsshutinprotest.html (site discontinued).

American Alliance of Museums. "American Alliance of Museums to Launch National Museum Board Diversity and Inclusion Initiative." January 15, 2019. https://www.aam-us.org/2019/01/15/deai-initiative/.

American Civil Liberties Union. "Freedom of Expression." Accessed March 22, 2022. https://www.aclu.org/other/freedom-expression.

Amnesty International. "Freedom of Expression." Accessed March 22, 2022. https://www.amnesty.org/en/what-we-do/freedom-of-expression/.

Antoinette, Michelle. *Reworlding Art History: Encounters with Contemporary Southeast Asian Art After 1990*. Amsterdam: Rodopi, 2014.

Ardia, C. A. Xuan Mai. "10 Burmese Contemporary Artists and Where to Find Them." Culture Trip, July 17, 2014. https://theculturetrip.com/asia/myanmar/articles/10-burmese-contemporary-artists-and-where-to-find-them/.

Art Basel. "Breaking New Ground, S.E.A. Focus Puts Southeast Asian Art in the Global Spotlight." Accessed October 6, 2022. https://www.artbasel.com/stories/sea-focus-singapore-puts-southeast-asian-art-in-the-global-spotlight.

Arvin, Maile Renee. *Possessing Polynesians: The Science of Settler Colonial Whiteness in Hawai'i and Oceania.* Durham, NC: Duke University Press, 2019.

Arvin, Maile, Eve Tuck, and Angie Morrill. "Decolonizing Feminism: Challenging Connections between Settler Colonialism and Heteropatriarchy." *Feminist Formations* 25, no. 1 (2013): 8–34.

Asia Society. "Background & History." Accessed August 21, 2023. https://asiasociety.org/about/background-history.

———. "Love Is Aung San Suu Kyi's Weapon of Mass Construction." Accessed January 16, 2021. https://asiasociety.org/new-york/love-aung-san-suu-kyis-weapon-mass-construction.

Assistance Association for Political Prisoners. "Torture in Prison." Accessed April 23 and June 15, 2020. https://aappb.org/2017/06/toture-in-prison/.

Atanasoski, Neda. *Humanitarian Violence.* Minneapolis: University of Minnesota Press, 2013.

Aung San Suu Kyi. "Speech to Burmese Community." Queens College, New York, September 23, 2012.

Aung-Thwin, Maureen, and Thant Myint-U. "The Burmese Ways to Socialism." *Third World Quarterly* 13, no. 1 (1992): 67–75.

Baik, Crystal Mun-hye. *Reencounters: On the Korean War and Diasporic Memory Critique.* Philadelphia: Temple University Press, 2019.

Balfour, Michael, and Nina Woodrow. "On Stitches." In *Refugee Performance: Practical Encounters,* edited by Michael Balfour, 15–34. Chicago: University of Chicago Press, 2012.

BBC News. "Coronavirus: Indian Greeting Namaste Goes Global." Accessed November 19, 2020. https://www.bbc.com/news/av/world-asia-india-51854798.

———. "Myanmar Army Admits Rohingya Killings." January 10, 2018. https://www.bbc.com/news/world-asia-42639418.

———. "Myanmar Coup Anniversary: 'Silent Strike' Marks Two Years of Military Rule." February 1, 2023. https://www.bbc.com/news/world-asia-64481138.

———. "Myanmar Coup: Party Official Dies in Custody after Security Raids." March 7, 2021. https://www.bbc.com/news/world-asia-56312147.

———. "Myanmar to Release 3,000 Prisoners." October 7, 2014. https://www.bbc.com/news/world-asia-29517697.

---. "Suu Kyi Film Chat with Bond Girl." December 7, 2010. https://www.bbc.com/news/world-asia-pacific-11937246.

Beiser, Morton. "Longitudinal Research to Promote Effective Refugee Resettlement." *Transcultural Psychiatry* 43, no. 1 (March 1, 2006): 56–71. https://doi.org/10.1177/1363461506061757.

---. "Sponsorship and Resettlement Success." *Journal of International Migration and Integration / Revue de l'integration et de La Migration Internationale* 4, no. 2 (December 2003): 203–15. https://doi.org/10.1007/s12134-003-1033-z.

Besson, Luc, dir. *The Lady*. Entertainment Film Distributors (UK), Europa Corp Distribution (France), 2011. 132 min.

Berlant, Lauren, ed. *Compassion: The Culture and Politics of an Emotion*. New York: Routledge, 2004.

Betteridge, Brian. "U2 Tours—U2 Dates, News & More." U2tours.com, accessed September 1, 2024. https://u2tours.com/tours/u2-360-10-little-things-about-the-worlds-biggest-tour.html.

Bishop, Claire. "Antagonism and Relational Aesthetics." *October* 110 (2004): 51–79.

Biswas, Allie. "Htein Lin Interview: 'I Wanted to Show That I Could Also Continue to Create While in Jail.'" Studio International—Visual Arts, Design and Architecture, February 22, 2019. https://www.studiointernational.com/index.php/htein-lin-interview-a-show-of-hands-sculpture-political-prisoners-myanmar-burma.

Biswas, Soutik. "Amnesty Strips Suu Kyi of Its Top Prize." *BBC News*, November 12, 2018. https://www.bbc.com/news/world-asia-46179292.

Black Art in America. "Equity and Diversity in Museums: Much Ado But Little Progress." October 15, 2021. https://web.archive.org/web/20220630232046/https://www.blackartinamerica.com/index.php/2021/10/15/equity-and-diversity-in-museums-much-ado-but-little-progress/.

Bonhams. "Fresh Collections of Indonesian, Burmese and Vietnamese Art to Dazzle at Bonhams Southeast Asian Art Sale." Accessed October 6, 2022. https://www.bonhams.com/press_release/34418/.

Bonura, Carlo, and Laurie J. Sears. "Introduction: Knowledges That Travel in Southeast Asian Area Studies." In *Knowing Southeast Asian Subjects*, edited by Laurie J. Sears, 3–32. Seattle: University of Washington Press, 2007.

Boorman, John, dir. *Beyond Rangoon*. Columbia Pictures, 1995. 99 min.

Bourdieu, Pierre. "The Forms of Capital." In *The Sociology of Economic Life*, 3rd ed., edited by Mark Granovetter, 78–92. New York: Routledge, 2011.

Boyle, Deidre. "Shattering Silence: Traumatic Memory and Reenactment in Rithy

Panh's *S-21: The Khmer Rouge Killing Machine.*" *Framework: The Journal of Cinema and Media* 50, no. 1 & 2 (2009): 95–106.

Bricmont, Jean. *Humanitarian Imperialism: Using Human Rights to Sell War.* New York: Monthly Review Press, 2006.

Brooten, Lisa. "The Feminization of Democracy Under Siege: The Media, 'the Lady' of Burma, and US Foreign Policy." *NWSA Journal* 17, no. 3 (Fall 2005): 134–56. https://doi.org/10.1353/nwsa.2005.0057.

Brucher, Rosemarie. "Self-Injuring Body Art: Strategies of De/Subjectivation." *New German Critique* 46, no. 2 (August 1, 2019): 151–70. https://doi.org/10.1215/0094033X-7546220.

Brysk, Alison. *Globalization and Human Rights.* Berkeley: University of California Press, 2002.

Bui, Long. "East Asia's Vietnam: Trauma Returns and the Sub-Empire of Memory." In *Routledge Handbook of Trauma in East Asia*, edited by Tina Burrett and Jeff Kingston, 395–407. New York: Taylor & Francis, 2023.

Caesar, Ed. "First Lady: Aung San Suu Kyi." Dazed, October 2012. http://www.dazeddigital.com/artsandculture/article/11715/1/first-lady-aung-san-suu-kyi.

Cambodian Mine Action Centre. "About CMAC." Accessed August 26, 2022. https://cmac.gov.kh/.

Campbell, David. "The Myth of Compassion Fatigue." In *The Violence of the Image: Photography and International Conflict,* edited by Liam Kennedy and Caitlin Patrick, 97–124. New York: Routledge, 2014.

Carey, Peter B. R., ed. *Burma: The Challenge of Change in a Divided Society.* London: Palgrave Macmillan, 1997.

Carlson, Melissa. "Painting as Cipher: Censorship of the Visual Arts in Post-1988 Myanmar." *Sojourn: Journal of Social Issues in Southeast Asia* 31, no. 1 (March 2016): 116–72.

Caswell, Michelle, and Marika Cifor. "From Human Rights to Feminist Ethics: Radical Empathy in the Archives." *Archivaria* 81, no. 1 (2016): 23–43.

Center for Diversity and National Harmony (CDNH). "Devex." Accessed January 27, 2022. https://www.devex.com/organizations/center-for-diversity-and-national-harmony-cdnh-69019.

Chao, Jacqueline. "An Interview with Sopheap Pich." Crow Collection, 2017. https://crowcollection.org/behind-the-scenes/interview-with-sopheap-pich/.

Chaw Ei Thein. "Independent Artists Projects, NYC." Q&A Session at John Jay College of Criminal Justice, New York City, March 14, 2013.

Chaw Ei Thein, and Htein Lin. *Yay-Zeq: Two Burmese Artists Meet Again*. Exhibit at ISCP Studios, New York City, November 9, 2012.

Cheah, Joseph. "The Function of Ethnicity in the Adaptation of Burmese Religious Practices." In *Emerging Voices: Experiences of Underrepresented Asian Americans*, edited by Huping Ling, 199–217. New Brunswick, NJ: Rutgers University Press, 2008.

Chen, Mel Y. "Masked States and the 'Screen' Between Security and Disability." *WSQ: Women's Studies Quarterly* 40, no. 1–2 (2012): 76–96. https://doi.org/10.1353/wsq.2012.0004.

Chen, Rong. "A Critical Analysis of the US 'Pivot' toward the Asia-Pacific: How Realistic Is Neo-Realism?" *Connections* 12, no. 3 (2013): 39–62.

Cheng, Anne Anlin. "Skins, Tattoos and Susceptibility." *Representations* 108, no. 1 (Fall 2009): 98–119.

Cheung, King-kok. *Articulate Silences*. Ithaca, NY: Cornell University Press, 1993.

Ching, Isabel. "Art from Myanmar." *Third Text* 25, no. 4 (July 2011): 431–46. https://doi.org/10.1080/09528822.2011.587688.

Cho, Grace M. *Haunting the Korean Diaspora: Shame, Secrecy, and the Forgotten War*. Minneapolis: University of Minnesota Press, 2008.

Cho, Young Cheon. "The Art of Self-Concretization as a Necropolitical Embodiment: The Self-Immolation of Chun Tae-Il." *Quarterly Journal of Speech* 102, no. 1 (January 2, 2016): 21–40. https://doi.org/10.1080/00335630.2015.1136073.

Chouliaraki, Lilie. "The Theatricality of Humanitarianism: A Critique of Celebrity Advocacy." *Communication and Critical/Cultural Studies* 9, no. 1 (March 1, 2012): 1–21. https://doi.org/10.1080/14791420.2011.637055.

Christensen, Line Kikkenborg. "Piecing Together Past and Present in Bhutan: Narration, Silence and Forgetting in Conflict." *International Journal of Conflict and Violence (IJCV)* 12 (February 28, 2018): 1–11. https://doi.org/10.4119/ijcv-3108.

Chuh, Kandice. *The Difference Aesthetics Makes: On the Humanities "After Man."* Durham, NC: Duke University Press, 2019.

———. *Imagine Otherwise: On Asian Americanist Critique*. Durham, NC: Duke University Press, 2003.

Clough, Patricia T. "The Affective Turn: Political Economy, Biomedia and Bodies." *Theory, Culture & Society* 25, no. 1 (January 1, 2008): 1–22. https://doi.org/10.1177/0263276407085156.

Cohen, Alina. "10 Major Museum Scandals Sparked by Trustees and Directors." Artsy, April 22, 2019. https://www.artsy.net/article/artsy-editorial-10-major-museum-scandals-sparked-trustees-directors.

Congdon, Kristin G. "Toward a Theoretical Approach to Teaching Folk Art: A Definition." *Studies in Art Education* 28, no. 2 (January 1, 1987): 96–104. https://doi.org/10.1080/00393541.1987.11650552.

Creative Resistance Fund. "About." Accessed August 24, 2019. http://creativeresistancefund.org/about/.

Critical Refugee Studies Collective. Accessed July 31, 2020. https://criticalrefugeestudies.com/.

Curtis, Heather D. "Picturing Pain." In *Humanitarian Photography: A History*, edited by Heidi Fehrenbach and Davide Rodogno, 22–46. Cambridge: Cambridge University Press, 2015.

Cvetkovich, Ann. *An Archive of Feelings: Trauma, Sexuality, and Lesbian Public Cultures*. Durham, NC: Duke University Press, 2003.

Dale, John G. *Free Burma: Transnational Legal Action and Corporate Accountability*. Minneapolis: University of Minnesota Press, 2011.

Davis, Ben. "How Did the Guggenheim's 'MAP Global Art' Show Get So Lost? Blame the Bankers." Artinfo, March 2013. http://www.blouinartinfo.com/news/story/872920/how-did-the-guggenheims-map-global-art-show-get-so-lost-blame.

DeBevoise, Jane. "Presentation by Sopheap Pich." *Asia Art Archive in America* (blog), October 2011. http://www.aaa-a.org/programs/presentation-by-sopheap-pich/.

Delang, Claudio O., Karen Human Rights Group, and Kevin Heppner. *Suffering in Silence: The Human Rights Nightmare of the Karen People of Burma*. Irvine, CA: Universal, 2001.

Diamond, Catherine. *Communities of Imagination: Contemporary Southeast Asian Theatres*. Honolulu: University of Hawaii Press, 2012.

Dickson, E. Jane. "A Good Man in Burma." *Independent Magazine*, December 3, 1994. http://www.maryellenmark.com/text/magazines/independent%20magazine/923T-000-004.html.

Downey, Anthony. "Towards a Politics of (Relational) Aesthetics." *Third Text* 21, no. 3 (May 1, 2007): 267–75. https://doi.org/10.1080/09528820701360534.

D'Souza, Aruna. *Whitewalling: Art, Race & Protest in 3 Acts*. Illustrated ed. New York: Badlands, 2018.

Duncan, Patti. *Tell This Silence: Asian American Women Writers and the Politics of Speech*. Iowa City: University of Iowa Press, 2009.

East-West Center. "About: Mission and Organization." Accessed August 28, 2020. https://www.eastwestcenter.org/about-ewc/mission-and-organization.

Eng, David L. "Transnational Adoption and Queer Diasporas." *Social Text* 21, no. 3 (2003): 1–37.

Enloe, Cynthia. *Maneuvers: The International Politics of Militarizing Women's Lives*. Berkeley: University of California Press, 2000.

Fechter, Anne-Meike, and Anke Schwittay. "Citizen Aid: Grassroots Interventions in Development and Humanitarianism." *Third World Quarterly* 40, no. 10 (October 3, 2019): 1769–80. https://doi.org/10.1080/01436597.2019.1656062.

Federation Internationale de l'Automobile. "Jean Todt." Accessed January 26, 2022. https://www.fia.com/profile/jean-todt-0.

Fink, Christina. *Living Silence: Burma Under Military Rule*. London: Zed, 2001.

Forbes. "Rockefeller Family." Accessed August 16, 2019. https://www.forbes.com/profile/rockefeller/.

Fry, Warren. "Petit Retrospective of ARAI Shin-ichi Works from 1999–2009." The Brooklyn Rail, accessed August 1, 2015. http://www.brooklynrail.org/2009/06/artseen/petit-retrospective-of-arai-shin-ichi-works-from-1999-2009.

Fujikane, Candace, and Jonathan Y. Okamura, eds. *Asian Settler Colonialism: From Local Governance to the Habits of Everyday Life in Hawai'i*. Honolulu: University of Hawaii Press, 2008.

Fusco, Coco. "The Other History of Intercultural Performance." *Drama Review* 38, no. 1 (Spring 1994): 143–67.

Galligan, Gregory. "In the New Siam." *Art in America Magazine*, June 1, 2010. http://www.artinamericamagazine.com/news-features/magazine/in-the-new-siam/.

Gardenour Walter, Brenda S. "Wicked Knots: Kinbaku, Witchcraft, and Kinky Liberation." In *Binding and Unbinding Kink: Pain, Pleasure, and Empowerment in Theory and Practice*, edited by Amber R. Clifford-Napoleone, 199–212. New York: Springer, 2022.

Gbadamosi, Nosmot. "Stealing Africa: How Britain Looted the Continent's Art." Al-Jazeera, October 12, 2021. https://www.aljazeera.com/features/2021/10/12/stealing-africa-how-britain-looted-the-continents-art.

Gonzalez, Hernando. "Mass Media and the Spiral of Silence: The Philippines from Marcos to Aquino." *Journal of Communication* 38, no. 4 (1988): 33–48. https://doi.org/10.1111/j.1460-2466.1988.tb02068.x.

Gonzalez, Vernadette Vicuña. *Securing Paradise: Tourism and Militarism in Hawai'i and the Philippines*. Durham, NC: Duke University Press, 2013.

Good, Byron J., Mary-Jo DelVecchio Good, Sharon Abramowitz, Arthur Kleinman, and Catherine Panter-Brick. "Medical Humanitarianism: Research

Insights in a Changing Field of Practice." *Social Science & Medicine* 120 (2014): 311–16.

Gordon, Avery F. *Ghostly Matters: Haunting and the Sociological Imagination.* Minneapolis: University of Minnesota Press, 1996.

Gorsevski, Ellen W. *Peaceful Persuasion: The Geopolitics of Nonviolent Rhetoric.* Albany, NY: SUNY Press, 2004.

Grady, Constance. "If Museums Want to Diversify, They'll Have to Change. A Lot." Vox, November 11, 2020. https://www.vox.com/the-highlight/21542041/museums-diversity-guston-national-gallery-hiring.

Greenberger, Alex. "Looting, Plundering, and More: 20 Cultural Treasures That Have Faced Claims of Theft." *ARTnews.com* (blog), February 26, 2021. https://www.artnews.com/list/art-news/artists/most-important-looted-plundered-works-1234584727/.

———. "White Cubes: Do Exhibitions at US Museums Reflect Calls for Diversity?" *ARTnews.com* (blog), August 5, 2019. https://www.artnews.com/art-news/news/u-s-museums-exhibitions-diversity-survey-13065/.

Grundy-Warr, Carl. "The Silence and Violence of Forced Migration: The Myanmar-Thailand Border." In *International Migration in Southeast Asia*, edited by Aris Ananta and Evi Nurvidya Arifin, 228–72. Singapore: Institute of Southeast Asian Studies, 2004.

Guggenheim Museum. *Artist Profile: Sopheap Pich on "Morning Glory" as Food and Artwork.* 2015. https://www.youtube.com/watch?v=ib95sNIjx_E.

———. "No Country: Contemporary Art For South And Southeast Asia." Accessed August 10, 2017. https://www.guggenheim.org/arts-curriculum/resource-unit/no-country-contemporary-art-for-south-and-southeast-asia.

———. *Sopheap Pich on Morning Glory as Food and Artwork.* Interview by June Yap. Video recording, 2013. https://www.guggenheim.org/video/sopheap-pich-on-morning-glory-as-food-and-artwork.

———. "Tayeba Begum Lipi: Love Bed." https://www.guggenheim.org/artwork/31321.

———. "Tuan Andrew Nguyen on Baseball and Wood Carving." https://www.guggenheim.org/video/tuan-andrew-nguyen-on-baseball-and-wood-carving.

———. "Wah Nu and Tun Win Aung." Accessed February 6, 2024. https://www.guggenheim.org/artwork/artist/wah-nu-and-tun-win-aung.

Guglielmi, Juliana, and Kelly L. Reddy-Best. "BDSM, Dress, and Consumption: Women's Meaning Construction Through Embodiment, Bodies in Motion, and Sensations." *Clothing and Textiles Research Journal* 42, no. 2 (2024): 0887302X211061020. https://doi.org/10.1177/0887302X211061020.

Hadar, Leon T. "US Sanctions against Burma: A Failure on All Fronts." Cato Institute, March 16, 1998. http://www.cato.org/publications/trade-policy-analysis/us-sanctions-against-burma-failure-all-fronts.

Hadj-Moussa, R., and M. Nijhawan, eds. *Suffering, Art, and Aesthetics*. New York: Palgrave Macmillan, 2014.

Halberstam, Judith. *The Queer Art of Failure*. Durham, NC: Duke University Press, 2011.

Hall, D. G. E. *A History of South-East Asia*. London: Macmillan, 1955.

Hannum, Hurst. "International Law and Cambodian Genocide: The Sounds of Silence." In *Cambodia: Change and Continuity in Contemporary Politics*, edited by Sorpong Peou, 82–138. New York: Routledge, 2001.

Harootunian, H. D. "Postcoloniality's Unconscious/Area Studies' Desire." In *Learning Places: The Afterlives of Area Studies*, edited by Masao Miyoshi and Harry Harootunian, 150–74. Durham, NC: Duke University Press, 2002.

Harootunian, H. D., and Miyao Miyoshi. "Introduction: The 'Afterlife' of Area Studies." In *Learning Places: The Afterlives of Area Studies*, edited by Masao Miyoshi and Harry Harootunian, 1–18. Durham, NC: Duke University Press, 2002.

Hartman, Saidiya V. *Scenes of Subjection: Terror, Slavery, and Self-Making in Nineteenth-Century America*. New York: Oxford University Press, 1997.

Heller, Steven. "Isolated from the World for 60 Years." *Atlantic*, April 16, 2015. https://www.theatlantic.com/entertainment/archive/2015/04/a-rare-glimpse-into-burma/390567/.

Herbert, Patricia. "The Making of a Collection: Burmese Manuscripts in the British Library." *British Library Journal* 15, no. 1 (1989): 59–70.

Hirsch, Marianne. "Marked by Memory: Feminist Reflections on Trauma and Transmission." In *Extremities: Trauma, Testimony, and Community*, edited by Nancy K. Miller and Jason Daniel Tougaw, 71–91. Champaign: University of Illinois Press, 2002.

Hlaing, Kyaw Yin. Review of *Living Silence: Burma under Military Rule*, by Christina Fink. *Journal of Southeast Asian Studies* 34, no. 1 (2003): 177–79.

Ho, Tamara C. *Romancing Human Rights: Gender, Intimacy, and Power Between Burma and the West*. Honolulu: University of Hawaii Press, 2015.

Hong, Emily, Mariangela Mihai, and Miasarah Lai, dirs. *For My Art*. Ethnocine, 2016. 20 min.

Htein Lin. "Hands Tell the History." *Htein Lin* (blog), April 12, 2014. http://www.hteinlin.com/hands-tell-the-history/.

———. "A Show of Hands." *Htein Lin* (blog), October 2013. http://www.hteinlin.com/a-show-of-hand/.

Huang, Vivian L. *Surface Relations: Queer Forms of Asian American Inscrutability.* Durham, NC: Duke University Press, 2022.

Hue, Emily L. "The Guggenheim's *No Country* as Refuge: Sopheap Pich and Bordering on Diversity in the Museum." *LIT: Literature Interpretation Theory* 29, no. 1 (2018): 29–44.

Hughey, Matthew W. *The White Savior Film: Content, Critics, and Consumption.* Philadelphia: Temple University Press, 2014.

Human Rights Watch. "Burma/Bangladesh: Burmese Refugees in Bangladesh—Discrimination in Arakan." Accessed August 1, 2015. http://www.hrw.org/reports/2000/burma/burm005-02.htm.

———. "Myanmar: Death of Activists in Custody." Accessed September 13, 2022. https://www.hrw.org/news/2022/09/13/myanmar-death-activists-custody.

Hyperallergic. "Obama's 2012 Budget Cuts NEA, NEH Funding by 13%." Accessed February 15, 2011. https://hyperallergic.com/18840/obama-budget-cuts/.

Iftikar, Jon S., and Samuel Museus. "On the Utility of Asian Critical (AsianCrit) Theory in the Field of Education." *International Journal of Qualitative Studies in Education* 31, no. 10 (2018): 935–49.

Immigration Equality. "Immigration Equality Asylum Manual." Accessed January 15, 2020. http://www.immigrationequality.org/get-legal-help/our-legal-resources/immigration-equality-asylum-manual/.

International Peace Institute. "Mission & History." Accessed January 28, 2019. https://www.ipinst.org/about/mission-history.

International Studios Curatorial Program (ISCP). "Fall Open Studios 2012." Accessed January 19, 2018. https://iscp-nyc.org/event/fall-open-studios-2012.

The Irrawaddy. "Artist Htein Lin Explores Political Prisoners' Woes." July 27, 2015. https://www.irrawaddy.com/news/burma/hands-of-hardship-artist-htein-lin-spotlights-political-prisoners-travails.html.

Jacobin Magazine. "Art Museums in the US Are Facing a Reckoning." Accessed December 1, 2020. https://jacobin.com/2020/10/us-art-museums-workers-organizing-racism-unions.

James, Randy. "John Yettaw: Suu Kyi's Unwelcome Visitor." *Time*, May 20, 2009. http://content.time.com/time/world/article/0,8599,1899769,00.html.

Jayawickrama, Janaka. "Humanitarian Aid System Is a Continuation of the Colonial Project." Al-Jazeera, February 24, 2018. https://www.aljazeera.com

/indepth/opinion/humanitarian-aid-system-continuation-colonial-project-180224092528042.html.

Jeffers, Alison. *Refugees, Theatre and Crisis: Performing Global Identities, Performance Interventions*. London: Palgrave Macmillan, 2012.

John, Lijo, A. Ramesh, and R. Sridharan. "Humanitarian Supply Chain Management: A Critical Review." *International Journal of Services and Operations Management* 13, no. 4 (2012): 498. https://doi.org/10.1504/IJSOM.2012.050143.

Jones, Amelia. *Body Art/Performing the Subject*. Minneapolis: University of Minnesota Press, 1998.

Kang, Laura. *Compositional Subjects*. Durham, NC: Duke University Press, 2002.

Kawanami, Hiroko. *The Culture of Giving in Myanmar: Buddhist Offerings, Reciprocity and Interdependence*. London: Bloomsbury, 2020.

———. *Renunciation and Empowerment of Buddhist Nuns in Myanmar-Burma: Building A Community of Female Faithful*. Leiden, Netherlands: Brill, 2013.

Kina, Laura, Alexandra Chang, Lawrence-Minh Bùi Davis, and Thea Quiray Tagle. "A&Q: Curation as Decolonial Practice." *Verge: Studies in Global Asias* 8, no. 2 (2022): 46–64.

Kirichenko, Alexey. "The Making of the Culprit: Atula Hsayadaw Shin Yasa and the Politics of Monastic Reform in Eighteenth-Century Burma." *Journal of Burma Studies* 15, no. 2 (2011): 189–229. https://doi.org/10.1353/jbs.2011.0013.

Klein, Christina. *Cold War Orientalism*. Berkeley: University of California Press, 2003.

Konyndyk, Jeremy. "Rethinking the Humanitarian Business Model." Center for Global Development, 2018, 12. https://www.cgdev.org/sites/default/files/rethinking-humanitarian-business-model.pdf.

Kratoska, Paul H., Remco Raben, and Henk Schulte Nordholt. "Locating Southeast Asia: Geographies of Knowledge and Politics of Space." In *Locating Southeast Asia*, edited by Remco Raben, Henk Schulte Nordholt, and Paul H. Kratoska. Leiden, Netherlands: Brill, 2005.

Lamba, Navjot K. "The Employment Experiences of Canadian Refugees: Measuring the Impact of Human and Social Capital on Quality of Employment." *Canadian Review of Sociology* 40, no. 1 (February 1, 2003): 45–64. https://doi.org/10.1111/j.1755-618X.2003.tb00235.x.

Lê, Việt. *Return Engagements: Contemporary Art's Traumas of Modernity and History in Sài Gòn and Phnom Penh*. Durham, NC: Duke University Press, 2021.

Lebovic, Sam. "The Origins of the Fulbright Program." *OUP blog*, August 2013. https://blog.oup.com/2013/08/origin-fulbright-program-education-exchange/.

Lee, Ronan. "A Politician, Not an Icon: Aung San Suu Kyi's Silence on Myanmar's Muslim Rohingya." *Islam and Christian-Muslim Relations* 25, no. 3 (July 3, 2014): 321–33. https://doi.org/10.1080/09596410.2014.913850.

Lê Espiritu, Yến. *Asian American Panethnicity*. Philadelphia: Temple University Press, 1992.

———. *Body Counts: The Vietnam War and Militarized Refugees*. Berkeley: University of California Press, 2014.

———. *Filipino American Lives* (*Asian American History & Culture*). Philadelphia: Temple University Press, 1995.

———. "Toward a Critical Refugee Study: The Vietnamese Refugee Subject in US Scholarship." *Journal of Vietnamese Studies* 1, no. 1–2 (February 1, 2006): 410–33. https://doi.org/10.1525/vs.2006.1.1-2.410.

Lê Espiritu, Yến, and Lan Duong. "Feminist Refugee Epistemology: Reading Displacement in Vietnamese and Syrian Refugee Art." *Signs: Journal of Women in Culture and Society* 43, no. 3.(March 1, 2018): 587–615. https://doi.org/10.1086/695300.

Lewis, Simon. "Lobbyist to Be Paid $2 Million to 'Explain' Myanmar's Coup on Behalf of Junta." Reuters, March 10, 2021. https://www.reuters.com/article/us-myanmar-politics-lobbyist-usa-idUSKBN2B20AR.

Littler, Jo. "'I Feel Your Pain': Cosmopolitan Charity and the Public Fashioning of the Celebrity Soul." *Social Semiotics* 18, no. 2 (June 1, 2008): 237–51. https://doi.org/10.1080/10350330802002416.

———. "The New Victorians? Celebrity Charity and the Demise of the Welfare State." *Celebrity Studies* 6, no. 4 (October 2, 2015): 471–85. https://doi.org/10.1080/19392397.2015.1087213.

Liu, Jasmine. "Myanmar Junta Detains Artist-Activist Htein Lin." *Hyperallergic*, August 26, 2022. http://hyperallergic.com/756262/myanmar-junta-detains-artist-activist-ko-htein-lin/.

Ly, Boreth. "Of Trans(National) Subjects and Translation: The Art and Body Language of Sopheap Pich." In *Modern and Contemporary Southeast Asian Art: An Anthology*, edited by Nora A. Taylor and Boreth Ly, 117–30. Ithaca, NY: Cornell University Press, 2012.

Ma, Lesley. "'The New Chinese Landscape' in the Cold War Era." In *Visual Representations of the Cold War and Postcolonial Struggles: Art in East and Southeast Asia*, edited by Midori Yamamura and Yu-Chieh Li, 9–30. New York: Routledge, 2021.

Manalansan, Martin F., IV. "Queer Worldings: The Messy Art of Being Global in

Manila and New York." *Antipiode* 47, no. 3 (2015): 566–79. https://doi.org/10.1111/anti.12061.

Marshall, Andrew. "The Lady: Aung San Suu Kyi's Fight for Freedom." *Time* Magazine, December 27, 2010. http://content.time.com/time/magazine/article/0,9171,2037417,00.html.

Martin, Stewart. "Critique of Relational Aesthetics." *Third Text* 21, no. 4 (July 2007): 369–86.

Martone, Gerald. "Relentless Humanitarianism." *Global Governance* 8 (2002): 149.

Mathieson, David Scott. "Crackdown." Human Rights Watch, December 6, 2007. https://www.hrw.org/report/2007/12/06/crackdown/repression-2007-popular-protests-burma.

———. "Scared Stiff." The Irrawaddy, July 2005. https://www2.irrawaddy.com/article.php?art_id=4820.

McClellan, Andrew. *The Art Museum from Boullée to Bilbao*. Berkeley: University of California Press, 2008.

McLagan, Meg. "Introduction: Making Human Rights Claims Public." *American Anthropologist* 108, no. 1 (2006): 191–95.

———. "Principles, Publicity, and Politics: Notes on Human Rights Media." *American Anthropologist* 105, no. 3 (2003): 605–12.

McLagan, Meg, and Yates McKee, eds. *Sensible Politics: The Visual Culture of Nongovernmental Activism*. New York: Zone, 2012.

Melamed, Jodi. *Represent and Destroy*. Minneapolis: University of Minnesota Press, 2011.

Metropolitan Museum of Art. "Cambodian Rattan." Accessed August 2, 2015. http://www.metmuseum.org/exhibitions/listings/2013/sopheap-pich.

Michaels, Samantha. "Burma Releases Political Prisoners Ahead of US State Visit." The Irrawaddy, May 17, 2013. http://www.irrawaddy.org/news/burma/burma-releases-political-prisoners-ahead-of-us-state-visit.html.

Mignolo, Walter D. "Geopolitics of Sensing and Knowing: On (de)Coloniality, Border Thinking and Epistemic Disobedience." *Postcolonial Studies* 14, no. 3 (September 1, 2011): 273–83. https://doi.org/10.1080/13688790.2011.613105.

Minh-ha, Trinh T. "Not You/Like You: Post-Colonial Women and the Interlocking Questions of Identity and Difference." *Inscriptions* 3–4 (1988): 71–77.

Mirante, Edith. "Escapist Entertainment: Hollywood Movies of Burma." The Irrawaddy, March 2004. https://www2.irrawaddy.com/article.php?art_id=932.

Moe, Wai, and Mae Sot. "A Monk's Tale." The Irrawaddy, April 2008. http://www2.irrawaddy.org/article.php?art_id=11186.

Moeller, Susan D. "Compassion Fatigue." In *Visual Global Politics*, edited by Roland Bleiker, 75–80. New York: Routledge, 2018. https://doi.org/10.4324/9781315856506.

Mohanty, Chandra Talpade. "'Under Western Eyes' Revisited: Feminist Solidarity through Anticapitalist Struggles." *Signs: Journal of Women in Culture and Society* 28, no. 2 (January 2003): 499–535. https://doi.org/10.1086/342914.

Mostafanezhad, Mary. "Angelina Jolie and the Everyday Geopolitics of Celebrity Humanitarianism." In *Celebrity Humanitarianism and North–South Relations*, edited by Lisa Ann Richey, 27–48. New York: Routledge, 2015.

Mukherjee, Ankhi. "Borderless Worlds?" In *Conflicting Humanities*, edited by Rosi Braidotti and Paul Gilroy, 61–74. London: Bloomsbury, 2016.

Muñoz, José Esteban. *Cruising Utopia: The Then and There of Queer Futurity*. New York: New York University Press, 2009.

———. "Vitalism's After-Burn: The Sense of Ana Mendieta." *Women and Performance* 21, no. 2 (2011): 91–98.

Myanm/art. "About." Accessed October 5, 2012. https://myanmartevolution.com/about-myanmart/.

Naji, Cassandra. "Freedom to Create: Myanmar's Artists Explore an Open Society." Art Radar, September 27, 2013. http://artradarjournal.com/2013/09/27/freedom-to-create-myanmars-artists-explore-an-open-society/.

National Endowment for the Arts, and Center for Cultural Innovation. "Creativity Connects: Trends and Conditions Affecting US Artists." September 2016. https://www.arts.gov/sites/default/files/Creativity-Connects-Final-Report.pdf.

National Gallery Singapore. "Art for Us—Burmese Edition." Accessed October 6, 2022. https://www.nationalgallery.sg/magazine/art-for-us-burmese-edition.

Naw, Angelene. *Aung San and the Struggle for Burmese Independence*. Chiang Mai, Thailand: Silkworm, 2001.

Ngo, Bic. "Learning from the Margins: The Education of Southeast and South Asian Americans in Context." *Race Ethnicity and Education* 9, no. 1 (March 1, 2006): 51–65. https://doi.org/10.1080/13613320500490721.

Ngô, Fiona. "Sense and Subjectivity." *Camera Obscura* 26, no. 1 (76) (May 1, 2011): 95–129. https://doi.org/10.1215/02705346-2010-016.

Nguyen, Mimi Thi. "The Biopower of Beauty: Humanitarian Imperialisms and Global Feminisms in an Age of Terror." *Signs: Journal of Women in Culture and Society* 36, no. 2 (January 2011): 359–83. https://doi.org/10.1086/655914.

———. *The Gift of Freedom: War, Debt, and Other Refugee Passages*. Durham, NC: Duke University Press, 2012.

Nguyen, Nathalie Huynh Chau. *Memory Is Another Country: Women of the Vietnamese Diaspora: Women of the Vietnamese Diaspora*. Santa Barbara, CA: ABC-CLIO, 2009.

NME News. "U2's Criminal Record." November 24, 2000. https://web.archive.org/web/20090203080033/http://nme.com:80/news/u2/5391.

Ocula Magazine. "Sopheap Pich." August 2, 2015. http://ocula.com/artists/sopheap-pich/.

Olivares, Alexandra, and Jaclyn Piatak. "Exhibiting Inclusion: An Examination of Race, Ethnicity, and Museum Participation." *VOLUNTAS: International Journal of Voluntary and Nonprofit Organizations* 33, no. 1 (February 1, 2022): 121–33. https://doi.org/10.1007/s11266-021-00322-0.

Olivius, Elisabeth, and Jenny Hedström. "Spatial Struggles and the Politics of Peace: The Aung San Statue as a Site for Post-War Conflict in Myanmar's Kayah State." *Journal of Peacebuilding & Development* 16, no. 3 (December 1, 2021): 275–88. https://doi.org/10.1177/1542316620986133.

Ong, Aihwa. *Buddha Is Hiding: Refugees, Citizenship, the New America*. Berkeley: University of California Press, 2003.

Ono, Yoko. "Cut Piece (1964)." Onoverse, August 20, 2014. https://web.archive.org/web/20140820120830/http://onoverse.com/2013/02/cut-piece-1964/.

Østergaard, Anders, dir. *Burma VJ*. Oscilloscope Laboratories, 2008. DVD, 84 min.

PageSix. "The Lady Is a Champ in Burma." *Page Six* (blog), December 15, 2011. https://pagesix.com/2011/12/15/the-lady-is-a-champ-in-burma/.

Palmer, Robert T., and Dina C. Maramba. "The Impact of Cultural Validation on the College Experiences of Southeast Asian American College Students." *Journal of College Student Development* 56, no. 1 (January 2015): 45–60. https://muse.jhu.edu/article/556685.

Park Nelson, Kim. *Invisible Asians: Korean American Adoptees, Asian American Experiences, and Racial Exceptionalism I*. New Brunswick, NJ: Rutgers University Press, 2016.

Parreñas, Rhacel Salazar. *Illicit Flirtations: Labor, Migration, and Sex Trafficking in Tokyo*. Stanford, CA: Stanford University Press, 2011.

Patel, Ian. "The Role of Testimony and Testimonial Analysis in Human Rights Advocacy and Research." SSRN Scholarly Paper. Rochester, NY: Social Science Research Network, November 27, 2012.

Pederson, Rena. *The Burma Spring: Aung San Suu Kyi and the New Struggle for the Soul of a Nation*. Berkeley, CA: Pegasus, 2015.

Peisker, Val Colic, and Farida Tilbury. "'Active' and 'Passive' Resettlement: The Influence of Support Services and Refugees' Own Resources on Resettlement Style." *International Migration* 41, no. 5 (December 1, 2003): 61–91. https://doi.org/10.1111/j.0020-7985.2003.00261.x.

Pelaud, Isabelle Thuy, Lan P. Duong, Mariam B. Lam, and Kathy L. Nguyen. *Troubling Borders: An Anthology of Art and Literature by Southeast Asian Women in the Diaspora*. Seattle: University of Washington Press, 2014.

Pew Research Center. "Burmese in the U.S. Fact Sheet." Accessed July 29, 2019. https://www.pewsocialtrends.org/fact-sheet/asian-americans-burmese-in-the-u-s/.

Pollman, Lisa. "Burmese Artist Htein Lin Breaks Free of Censorship and Prison—Interview." *Art Radar: Contemporary Art Trends and News from Asia and Beyond* (blog), May 28, 2013. http://artradarjournal.com/2013/05/28/burmese-artist-htein-lin-breaks-free-of-censorship-and-prison-interview/#sthash.HP2PWPWx.dpuf.

Pruce, Joel R. "The Spectacle of Suffering and Humanitarian Intervention in Somalia." In *Media, Mobilization and Human Rights: Mediating Suffering*, edited by Tristan Anne Borer, 216–37. London: Zed, 2012.

Reckitt, Helena. "Forgotten Relations: Feminist Artists and Relational Aesthetics." In *Politics in a Glass: Case Feminism, Exhibition Cultures and Curatorial Transgressions*, edited by Angela Dimitrakaki and Lara Perry, 7: 131–56. Liverpool: Liverpool University Press, 2013.

Regan, Helen. "Myanmar: Second Official from Aung San Suu Kyi's Party Dies in Military Custody." CNN, March 10, 2021. https://www.cnn.com/2021/03/10/asia/myanmar-nld-deaths-military-intl-hnk/index.html.

Regencia, Ted. "Myanmar Coup Displaces Thousands as Global Refugee Numbers Rise." Al-Jazeera, June 18, 2021. https://www.aljazeera.com/news/2021/6/18/unhcr-urges-action-as-refugees-hit-record-high-of-82-4-million.

Reig, Shari C., and Judah Gribetz. "The Swiss Banks Holocaust Settlement." In *Reparations for Victims of Genocide, War Crimes and Crimes Against Humanity: Systems in Place and Systems in the Making*, edited by Carla Ferstman, Mariana Goetz, and Alan Stephens, 169–202. Leiden, Netherlands: Brill, 2009.

Reilly, Maura. *Curatorial Activism: Towards an Ethics of Curating*. Illustrated ed. New York: Thames & Hudson, 2018.

Repo, Jemima, and Riina Yrjölä. "The Gender Politics of Celebrity Humanitarianism in Africa." *International Feminist Journal of Politics* 13, no. 1 (2011): 44–62.

Rhee, Jieun. "Performing the Other: Yoko Ono's Cut Piece." *Art History* 28, no. 1 (2005): 96–118. https://doi.org/10.1111/j.0141-6790.2005.00455.x.

Rodríguez, Dylan. "The Political Logic of the Non-Profit Industrial Complex." *S&F Online* 13, no. 2 (Spring 2016). https://sfonline.barnard.edu/navigating-neoliberalism-in-the-academy-nonprofits-and-beyond/dylan-rodriguez-the-political-logic-of-the-non-profit-industrial-complex/.

Rowe, Aimee Carrillo, and Eve Tuck. "Settler Colonialism and Cultural Studies: Ongoing Settlement, Cultural Production, and Resistance." *Cultural Studies ↔ Critical Methodologies* 17, no. 1 (February 1, 2017): 3–13. https://doi.org/10.1177/1532708616653693.

Salverson, Julie. "Change on Whose Terms? Testimony and an Erotics of Inquiry." *Theater* 31, no. 3 (2001): 119–25.

Saranillio, Dean Itsuji. "Why Asian Settler Colonialism Matters: A Thought Piece on Critiques, Debates, and Indigenous Difference." *Settler Colonial Studies* 3, no. 3–4 (November 2013): 280–94. https://doi.org/10.1080/2201473X.2013.810697.

Schlund-Vials, Cathy J. "Cambodian American Memory Work: Justice and the 'Cambodian Syndrome.'" *Positions: Asia Critique* 20, no. 3 (August 1, 2012): 805–30. https://doi.org/10.1215/10679847-1593555.

———. *War, Genocide, and Justice: Cambodian American Memory Work*. Minneapolis: University of Minnesota Press, 2012.

Schweitzer, Dahlia. "Striptease: The Art of Spectacle and Transgression." *Journal of Popular Culture* 34, no. 1 (Summer 2000): 65–75.

See, Sarita Echavez. *The Decolonized Eye: Filipino American Art and Performance*. Minneapolis: University of Minnesota Press, 2009.

Sharma, Sumesh. "Curator's Statement." Presented at *Yay-Zeq: Two Burmese Artists Meet Again*, ISCP Studios, New York City, November 8, 2012.

Shih, Elena. "Freedom Markets: Consumption and Commerce across Human-Trafficking Rescue in Thailand." *Positions: Asia Critique* 25, no. 4 (November 1, 2017): 769–94. https://doi.org/10.1215/10679847-4188410.

Shimizu, Celine Parreñas. *The Hypersexuality of Race: Performing Asian/American Women on Screen and Scene*. Durham, NC: Duke University Press, 2007.

Sidhu, Sandi, Helen Regan, Ivan Watson, and Salai TZ. "She Was Shot Dead, Her Body Dug Up and Her Grave Filled with Cement; But Her Fight Is Not Over." CNN, March 12, 2021. https://www.cnn.com/2021/03/12/asia/myanmar-protester-angel-democracy-martyr-intl-hnk/index.html.

Sisavath, Davorn. "Metallic Violence in the Aftermath of the US Secret War in Laos (1964–73)." *Critical Ethnic Studies* 6, no. 2 (Fall 2020): 2–18.

Skidmore, Monique. "Darker than Midnight: Fear, Vulnerability, and Terror

Making in Urban Burma (Myanmar)." *American Ethnologist* 30, no. 1 (2003): 5–21. https://doi.org/10.1525/ae.2003.30.1.5.

———. *Karaoke Fascism: Burma and the Politics of Fear*. Philadelphia: University of Pennsylvania Press, 2012.

Slaughter, Joseph R. *Human Rights, Inc.: The World Novel, Narrative Form, and International Law*. New York: Fordham University Press, 2007.

Sliwinski, Sharon. *Human Rights in Camera*. Illustrated ed. Chicago: University of Chicago Press, 2011.

South, Ashley. "The Politics of Protection in Burma." *Critical Asian Studies* 44, no. 2 (June 1, 2012): 175–204. https://doi.org/10.1080/14672715.2012.672824.

Speer, Jessie. "Urban Makeovers, Homeless Encampments, and the Aesthetics of Displacement." *Social & Cultural Geography* 20, no. 4 (May 4, 2019): 575–95. https://doi.org/10.1080/14649365.2018.1509115.

Spivak, Gayatri Chakravorty. *Can the Subaltern Speak?* Basingstoke, UK: Macmillan, 1988.

Stein, Sylvie. "Burma Bans Chanting and Marching." *Foreign Policy* (blog), June 24, 2010. https://foreignpolicy.com/2010/06/24/burma-bans-chanting-and-marching/.

Stephens, Simon. "ICOM Museum Definition Plan Moves Forward." Museums Association, May 24, 2022. https://www.museumsassociation.org/museums-journal/news/2022/05/icom-museum-definition-plan-moves-forward/.

Stromberg, Matt. "Major Artists Demand LACMA Remove Board Member Who Owns Prison Telecom Company." Hyperallergic, September 16, 2020. https://hyperallergic.com/588856/open-letter-lacma-tom-gores/.

Stuelke, Patricia. *The Ruse of Repair: US Neoliberal Empire and the Turn from Critique*. Durham, NC: Duke University Press, 2021.

Sturken, Marita. "The Wall, the Screen, and the Image: The Vietnam Veterans Memorial." *Representations*, no. 35 (July 1, 1991): 118–42. https://doi.org/10.2307/2928719.

Suu Foundation. "Board Statement: The Coup and the Foundation's Response." Accessed July 15, 2020. https://suufoundation.org/.

Sykes, Tom. "Bono, Bob Geldof Call Out 'Handmaiden to Genocide' Aung San Suu Kyi Over Rohingya Silence." Daily Beast, November 13, 2017. https://www.thedailybeast.com/bob-geldof-bono-attack-aung-saan-suu-kyi-over-ethnic-cleansing.

Szanton, David, ed. *The Politics of Knowledge: Area Studies and the Disciplines*. Berkeley: University of California Press, 2004.

Tang, Eric. *Unsettled: Cambodian Refugees in the New York City Hyperghetto*. Philadelphia: Temple University Press, 2015.

Taylor, Diana. *The Archive and the Repertoire: Performing Cultural Memory in the Americas*. Durham, NC: Duke University Press, 2003.

Taylor, Ella. "'The Lady': Self-Sacrifice, For Her Country's Sake." NPR, April 12, 2012. http://www.npr.org/2012/04/12/150297416/the-lady-self-sacrifice-for-her-countrys-sake.

Taylor, Nora. "Art without History? Southeast Asian Artists and Their Communities in the Face of Geography." *Art Journal* 70, no. 2 (Summer 2011). http://www.aaa.org.hk/Collection/Details/47943.

Than, Tharaphi. "Nationalism, Religion, and Violence: Old and New Wunthanu Movements in Myanmar." *Review of Faith & International Affairs* 13, no. 4 (October 2, 2015): 12–24. https://doi.org/10.1080/15570274.2015.1104974.

———. *Women in Modern Burma*. New York: Routledge, 2013.

Thida, Ma. "A 'Fierce' Fear: Literature and Loathing after the Junta." In *Myanmar Media in Transition: Legacies, Challenges and Change | ISEAS Publishing*, edited by Lisa Brooten, Jane Madlyn McElhone, and Gayathry Venkiteswaran, 407. Singapore: ISEAS, 2018.

Trieu, Monique Mong, and Vang. "Invisible Newcomers: Refugees from Burma/Myanmar and Bhutan in the United States." Washington, DC: Asian and Pacific Islander American Scholarship Fund, 2014.

"Tuan Andrew Nguyen." tuanandrewnguyen.com. Accessed August 11, 2022. https://www.tuanandrewnguyen.com/.

Tyler Rollins Fine Art. "Artists—Sopheap Pich." Accessed August 30, 2024. http://www.trfineart.com/artist/sopheap-pich/.

U2 News. "This, We Never Imagined." Accessed December 1, 2018. https://www.u2.com/news/title/this-we-never-imagined/news/.

Ülkü, M. Ali, Kathryn M. Bell, and Stephanie Gray Wilson. "Modeling the Impact of Donor Behavior on Humanitarian Aid Operations." *Annals of Operations Research* 230, no. 1 (July 1, 2015): 153–68. https://doi.org/10.1007/s10479-014-1623-5.

Um, Khatharya. *From the Land of Shadows*. New York: NYU Press, 2015.

United Nations. "Universal Declaration of Human Rights." Accessed March 22, 2022. https://www.un.org/en/about-us/universal-declaration-of-human-rights.

United Nations High Commissioner for Refugees. "Frequently Asked Questions: Resettlement." Accessed February 3, 2023. https://help.unhcr.org/faq/how-can-we-help-you/resettlement/.

———. "Rohingya Emergency." Accessed June 15, 2020. https://www.unhcr.org/rohingya-emergency.html.

Urist, Jacoba. "What to Make of Marina Abramović, the Godmother of Performance Art." *Smithsonian Magazine*, accessed March 13, 2024. https://www.smithsonianmag.com/arts-culture/what-make-marina-abramovic-godmother-performance-art-180960821/.

US Commission on International Religious Freedom. "Annual Report." Washington, DC: US Commission on International Religious Freedom, May 2010. http://www.uscirf.gov/sites/default/files/resources/annual%20report%202010.pdf.

Vågnes, Øyvind. "The Unsettling Moment: On Mathilde Ter Heijne's Suicide Trilogy." In *Ethics and Images of Pain*, edited by Asbjørn Grønstad and Henrik Gustafsson, 262–77. New York: Routledge, 2012.

Van den Bosch, Annette. "Museums: Constructing a Public Culture in the Global Age." *Third Text* 19, no. 1 (January 1, 2005): 81–89. https://doi.org/10.1080/09528820412331318587.

vazirafyz. "'Looting': The Revolt of the Oppressed." Hyperallergic, June 5, 2020. https://hyperallergic.com/569283/origin-of-word-looting/.

Võ, Linda Trinh, and Rick Bonus. *Contemporary Asian American Communities: Intersections and Divergences*. Philadelphia: Temple University Press, 2009.

Wachpanich, Nicha. "'If I Don't Post, Am I Part of the Revolution?': Social Media Activism in Myanmar." Visual Rebellion, July 28, 2023. https://visualrebellion.org/features/if-i-dont-post-am-i-part-of-the-revolution-social-media-activism-in-myanmar.

Wallerstein, Immanuel. "The Unintended Consequences of Cold War Area Studies." In The Cold War and the University: Toward an Intellectual History of the Postwar Years, edited by Noam Chomsky. New York: New Press, 1997.

Weizman, Eyal. *The Least of All Possible Evils: A Short History of Humanitarian Violence*. London: Verso, 2011.

Women League of Burma. "Programs." Accessed April 24, 2021. https://womenofburma.org/programs.

Woods, Kevin. "Ceasefire Capitalism: Military-Private Partnerships, Resource Concessions and Military-State Building in the Burma-China Borderlands." *Journal of Peasant Studies* 38, no. 4 (October 1, 2011): 747–70. https://doi.org/10.1080/03066150.2011.607699.

World Vision. "Forced to Flee: Top Countries Refugees Are Coming From." July 1, 2019. https://www.worldvision.org/refugees-news-stories/forced-to-flee-top-countries-refugees-coming-from.

White House Office of the Press Secretary. "Notice—Continuation of the National Emergency with Respect to Burma." May 15, 2015. https://www.whitehouse.gov/the-press-office/2015/05/15/notice-continuation-national-emergency-respect-burma.

Wu, Chin-Tao. "Biennials Without Borders? Landmark Exhibitions Issue." *Tate Papers* 12 (Autumn 2009). https://www.tate.org.uk/research/publications/tate-papers/12/biennials-without-borders.

Yanagisako, Sylvia. "Asian Exclusion Acts." In *Learning Places: The Afterlives of Area Studies*, edited by Masao Miyoshi and Harry Harootunian, 175–89. Durham, NC: Duke University Press, 2002.

Yang, Michelle Murray. "Still Burning: Self-Immolation as Photographic Protest." *Quarterly Journal of Speech* 97, no. 1 (2011): 1–25.

Yap, June. *No Country*. Accessed February 22, 2013. https://www.guggenheim.org/video/no-country-an-introduction.

Yuan, Elizabeth. "For Ex-Myanmar Prisoner, Art Is a Uniform Exercise." CNN, April 11, 2008. http://edition.cnn.com/2008/WORLD/asiapcf/04/10/myanmar.artist/.

Zarni. "Chapter Three: Resistance and Cybercommunities: The Internet and the Free Burma Movement." *Counterpoints* 59 (2000): 71–88.

Zarobell, John. *Art and the Global Economy*. Berkeley: University of California Press, 2017.

Zhulina, Alisa. "Performing Philanthropy from Andrew Carnegie to Bill Gates." *Performance Research* 23, no. 6 (August 18, 2018): 50–57. https://doi.org/10.1080/13528165.2018.1533762.

Zucconi, Francesco. *Displacing Caravaggio: Art, Media, and Humanitarian Visual Culture*. London: Palgrave Macmillan, 2018.

Index

Page numbers in *italics* refer to illustrations.

Abramović, Marina, 22, 174, 211
abstraction, 6, 20–22
aesthetics, 18–19, 25; of inscrutability, 146–47, 215; relational, 102–3; of vulnerability, 1, 3, 6–7, 17–19, 147–48
affective labor, 90–92, 156, 176–77, 180–81, 194
affective residue, 14, 19, 151
All Burma Students' Democratic Front (ABSDF), 197
anyeint, 191, 192
Art and the Global Economy (Zarobell), 106–7
arts industry, 7–18, 40; and "artwashing," 101; as asset class, 101, 103–4, 111–12, 123; relationship to museums, 108–9; risk, 8–9. *See also* humanitarian industry; UBS MAP Global Art Initiative
Asian Americans: Burmese as, 30–31, 38; Southeast, 33–34, 233
Asian American studies, 32–34, 233–34
Asian Cultural Council (ACC), 160, 200–207
Asia Society, 80–81, 200–201. *See also* Rockefeller, John D., III

Aung San (general), 69, 97, 100, 122. *See also* Wah Nu and Tun Win Aung
Aung San Suu Kyi, 53, 230–31; popular media representation of, 68–70; as rescuable, 54, 63–64, 78–80, 259n9; and US Congressional Medal of Honor, 86–92. *See also* Besson, Luc; *Beyond Rangoon*; Boorman, John; *Lady, The*

Bed (Chaw Ei Thein), 153, 201
Besson, Luc, 76–78, 80–81, 248n73. *See also* Aung San Suu Kyi; *Lady, The*
Beyond Rangoon (Boorman, dir.), 71–76, *72*, 247n51, 247n58
body art, 174–76. *See also* elastic vulnerability
bondage: and Asian and Asian American women, 183–84; *kekki*, 180; *kinbaku*, 177–78, 180. *See also* elastic vulnerability
Bono, 52. *See also* U2
Boorman, John, 73–75. *See also* Aung San Suu Kyi; *Beyond Rangoon*
Buddhism: artists' appropriation of, 125, 145, 191, 193–94, 208, 209–11,

Buddhism (*continued*)
225; and gender, 180–82; as marker of ethnic majority identity, 88, 181–82, 209–10, 269n51; in Vietnam, 173–74

Burma, 23, 235n2; asylum-seeker vs. exile vs. migrant vs. refugee, 33; fictive landscapes, 73, 74–75, 76–78, 83, 85–86; international relations, 65–66, 94; military government, 26–27, 36–37, 94–95, 152, 188–89, 226; 1988 uprisings, 36, 69–70, 72–73, 125; 2021 military coup, 26, 36–37, 94–95, 224, 230; 2007 Saffron Revolution, 36, 176, 178, 191, 208–10

Burma VJ (documentary), 178; in Htein Lin performance, 208

Burmese diasporic communities, 30–31, 34–38, 39, 43–44, 176–77; as Asian Americans, 30–31, 38; in New York City, 1–2, 7–8, 39–42, 87–89, 153, 230

censorship: by Burmese state, 26–27, 73–75, 84, 125, 148–49, 153–57; gendered, 156–57; self-, 146, 149, 153–58

Chaw Ei Thein: biography of, 149, 152–53, 198–99; *Contemporary Burmese Art* (exhibition), 154–56; "Performance and Justice: Representing Dangerous Truths" symposium, 1–4, 6–7, 13. See also *Bed*; *Homage to Happy Japan (by Arai) Happy Burma*; *WEs 2026*

Civil Disobedience Movement, 37, 230

critical refugee studies, 32, 34, 44–45; as "gift of freedom," 12. *See also* rescuability; transformation

Cut Piece (Ono), 174, 212–13

displacement: asylum, 146–47, 153, 183–84, 214; exile (impact on artists), 163–64, 192–95, 197–98, 219–20; resettlement, 23–24, 136–37, 139–41, 148–51; sensorial discontinuity, 157–58, 216, 260n13

dissidence: on behalf of Rohingya, 88; against Burmese state, 7, 47, 74, 154–57, 208–11, 224–25; as channeled by arts or humanitarianism industry, 80–81, 89–90, 112; conflation with critique, 156. *See also* Aung San Suu Kyi

donors, 43, 56. *See also* nonprofit arts organizations

elastic vulnerability, 20–24, 38, 148, 150–51, 158–60, 229–30; and "the bind," 150, 177, 179–84; as grant strategy, 205–7; masking and, 214–15; and self-injury, 3, 19, 22, 147–49, 175–78; and self-negation, 149–51, 153; and unraveling, 189, 193–95, 198–99, 218–19. *See also* Halberstam, Jack; vulnerability

embodiment, 6–7, 146, 174, 184–85, 194, 228; and abstraction, 6, 20–22; and COVID-19, 226–27; disembodiment, 148–49, 216–19. *See also* elastic vulnerability

empathy, 13–16; radical, 13–14. *See also* humanitarian industry; vulnerability

ethnic minorities, 37–38, 88–90, 92, 231. *See also* Rohingya Muslims

fellowships and residencies, 23–24, 110, 184–85, 197–99, 227–28. *See also*

Asian Cultural Council; Free Dimensional
feminism: antisocial, 211–12; critique of Western, 57–58, 72–73. *See also* rescuability
folk art, 99, 100, 103, 125
Free Dimensional (fD), 87, 150, 203, 267n30; and Creative Resistance Fund, 161; and relocation, 161–63, 166, 167–69; and resources for artists, 161, 163–65, 167–73
Fusco, Coco, 22, 175

gender. *See* racialization and gendering
Geneva Convention (1951), 12–13
genocide: as erasure, 88, 93–95, 116; by the Khmer Rouge, 132, 136–38; remembrance of, 132–34, 136–41
Global North, 150–51, 191–93, 219–20, 226
Guggenheim Museum: legitimacy of, 108–9; as a metaphor for art world, 97–99, 114

Hague Convention (1926), 107–8
Halberstam, Jack, 210–13
Hart-Celler Act (1965), 35
healing. *See* redress; transformation
Homage to Happy Japan (by Arai) Happy Burma (Chaw Ei Thein), 177–80, *180*, 182–83
Htein Lin: biography, 197–99, 203, 217–18. See also *Moving Monument*; *Show of Hands, A*
humanitarian industry, 3, 7–10, 11–19, 104; celebrity philanthropism, 55, 59–60, 61–62; as colonial project, 59–61, 62, 64–65, 249n88; disciplining, 10, 15, 19–20, 147, 158, 176;

and media representation, 66–68; philanthrocapitalism, 55, 59–60, 80, 84; pictorial humanitarianism, 9–10, 189–90; theatricality of, 61–62, 85, 89–91. *See also* arts industry; Aung San Suu Kyi; transformation; U2
human rights: affect, 181; artists' risk of illegibility, 3–4, 8, 85–86, 148, 195–97, 212–13; and freedom of expression, 4–5, 11–12, 156, 192, 216–18; and freedom of movement, 4–5, 11–12, 151, 217. *See also* humanitarian industry; transformation
Human Rights, Inc. (Slaughter), 25, 178

incarceration, 76–77, 221, 224–25
Insein Prison, 63, 77, 90–91, 197, 221
International Council of Museums (ICOM), 105–6. *See also* museums
International Studio and Curatorial Program (ISCP), 153, 188, 208
Inya Gallery, 188–89, 199

Joag, Siddhartha. *See* Free Dimensional

Khmer Rouge, 132, 136–38

Lady, The, (Besson, dir.), 71, 72, 75–85, *77*
Lê, Việt, 12, 133–34
Lê Espiritu, Yến, 32–33, 35, 44–45, 137, 233
liberal humanism, 18–19, 52–54; critique of, 18, 80–81

masking, 214–15
McCarthy, Cormac: *No Country for Old Men*, 98–99

Index 297

Mendieta, Ana, 22, 175
"metallic violence," 138–39
Morning Glory (Pich), 129–34, *131*, 135–39, 141
Moving Monument (Htein Lin), 188–90, 208–11, *209*, 213–16
museums, 100–102; calls for accountability by, 116–18; colonial past of, 102–3, 105; "diversity" of, 101–4, 109–11, 119, 123–24; as "housing" for displaced artists' work, 39, 140, 192, 193–94, 198, 218. *See also* Hague Convention (1926)
Myanmar. *See* Burma

No Country (exhibition): artists' subversion at, 102–4, 119–21, 142–43; touring additions, 130; Jane Yap (curator), 97, 98–99, 102, 111, 113
No Country for Old Men (McCarthy), 98–99
nongovernmental organizations (NGOs). *See* humanitarian industry
nonprofit arts organizations: and artist funding, 109–10, 149–50; and narratives of "distress," 159–63; in shaping artists' narratives, 150–51, 195–96, 203–4

Ono, Yoko: *Cut Piece*, 174, 211, 212–13

"Performance and Justice: Representing Dangerous Truths" symposium, 1–4, 6–7, 13
performativity: afterlife, 22, 58, 93–96; as method, 44–47, 91–92; temporality, 21–22, 136–37, 150–51, 176, 193; of vulnerability, 12–13, 15–17;

withholding, 146–47. *See also* elastic vulnerability; trauma
philanthrocapitalism, 55, 59–60, 80, 84
photography, colonial, 52–55
Pich, Sopheap: materials used by, 134–35, 136, 139–40. *See also Morning Glory*
Project Reach, 87

Quiet River (Dedicated to Aung San Suu Kyi's 64th Birthday) (Chaw Ei Thein), 177–80, *179*, 182–83

racialization and gendering: of bodies, 146, 175–76, 177–78; by humanitarian industry, 53–55, 60–61, 156–58, 183–84; of Southeast Asia, 31, 96, 103–4, 181–82; of vulnerability, 139, 154
radical empathy, 13–14
radical passivity, 23, 211–13
Rangoon. *See* Yangon
redress, 21–22, 134–37, 141, 180–81, 196–97, 221–25. *See also* transformation
Refugee Act (1980), 7, 35
refugees: gendering, 149, 156–57; gratitude, 90, 149, 151, 156–57; temporality, 136–37, 150, 176, 193
relational aesthetics, 102–3
relational curation, 123–24
rescuability, 54, 57–59, 96, 100–101, 148, 227–28; of racialized and heterosexist femininity, 68–69, 79, 82–83. *See also* transformation
Rockefeller, John D., III, 200–201
Rohingya Muslims, 89–90, 92, 93–95, 182

safe haven, 165–73. *See also* fellowships

and residencies
"Sailing to Byzantium" (Yeats), 98–99
sangha, 125, 129
Schlund-Vials, Cathy, 133–34
self-injury, 3, 19, 22, 147–49, 175–78
self-negation, 149–51, 153
Show of Hands, A (Htein Lin), 220–226
silence, 26–27, 29–30, 148–49
Sitt Nyein Aye, 190
Slaughter, Joseph: *Human Rights, Inc.*, 25, 178
Southeast Asia: arts market of, 111–12, 253n39; as "borderless," 99, 104–5, 113–16, 119–21, 136–37, 139–40; US intervention in, 59–60, 63–65, 107–8, 138, 201, 219, 231
Southeast Asian studies, 31–33
suffering, 3–4, 9–10, 15–17, 18–19; audience response to, 16–17, 146–47; "beautiful," 147, 177–78, 181. *See also* human rights
Sunshower (exhibition), 143

testimony, 25–29, 132–33, 185, 189. *See also* silence; witness(ing)
1000 Pieces (of White) (Wah Nu and Tun Win Aung), 99–100, 122–23, 124–26
traditional dress, 89–90, 191, 230–31
Train (Tun Win Aung), 126–27
transformation, 17, 54–56, 73, 81, 95–96, 104, 266n23; artists' refusal of, 17, 147–48, 176, 178, 215; "healed self," 5–6, 150, 195, 197. *See also* human rights; rescuability
trauma, 6, 21–22, 148–49; afterlife, 22, 39, 139–40, 183, 208–9, 230

Tun Win Aung: *Train*, 126–27

U2, 52–54, 62–63, 93–94
UBS MAP Global Art Initiative, 101–2, 109, 116, 141–42
Union Bank of Switzerland (UBS): Holocaust profiteering by, 114–16
United Nations Declaration of Human Rights, 4–5
unraveling, 189, 193–95, 198–99, 218–19

vulnerability, 9, 15–17, 151; economies of, 11–17, 58, 66–67, 103–4, 146; racialized and gendered, 18, 23; as wound, 5–7, 21–22, 223. *See also* elastic vulnerability

Wah Nu and Tun Win Aung: biography of, 121–22. See also *1000 Pieces (of White)*; *White Piece #0132: Forbidden Hero (Heads)*; *White Piece #0133: Thakin Pe Than's Long March*
WEs 2026 (Chaw Ei Thein), 144–47, 145, 150–58
White Piece #0132: Forbidden Hero (Heads) (Wah Nu and Tun Win Aung), 97–98, 98, 100, 127–28
White Piece #0133: Thakin Pe Than's Long March (Wah Nu and Tun Win Aung), 128–29
whitewalling, 123–26
witness(ing), 26, 66–67, 174; art as, 128–29. *See also* silence; testimony

Yangon, 26–27, 41–42, 76–77, 122
Yay-Zeq: Two Burmese Artists Meet Again (exhibition), 188–92, 208–11, 214, 219–20; Zasha Colah and

Yay-Zeq (*continued*)
　Sumesh Sharma (curators), 90–91;
　Inya Gallery, 188–89, 199. See also
　Moving Monument
Yeats, William Butler: "Sailing to
　Byzantium," 98–99
Yeoh, Michelle, 76, 82–84

Yettaw, John, 63, 94. *See also* Aung San
　Suu Kyi; U2

Zarobell, John, 8–9; *Art and the Global
　Economy*, 106–7
Zeltner, Jürg, 115–16, 123